ON RECORD | 1992 | G. BROWN

CONTENTS

ON RECORD ENTRIES ARE NOT ORDERED ALPHABETICALLY, BUT ORGANIZED INTUITIVELY— A MIXTURE OF SEGUES BY MUSICAL GENRE OR STYLE.

007 INTRODUCTION

008 SOUL ASYLUM
010 THE BLACK CROWES
012 GIN BLOSSOMS
014 BLIND MELON
016 ALICE IN CHAINS
018 STONE TEMPLE PILOTS
020 SCREAMING TREES
022 SUGAR
024 DANZIG
026 RAGE AGAINST THE MACHINE
028 BEASTIE BOYS
030 L7
032 ROLLINS BAND
034 BODY COUNT
036 ICE CUBE
038 SIR MIX-A-LOT
040 DJ QUIK
042 KRIS KROSS
044 ARRESTED DEVELOPMENT
046 ME PHI ME
048 DADA
050 CRACKER
052 LIVE
054 THE JAYHAWKS
056 DEL AMITRI
058 LITTLE VILLAGE
060 BRUCE SPRINGSTEEN
062 PETER GABRIEL
064 LOU REED
066 TOM WAITS
068 LOS LOBOS
070 LYLE LOVETT
072 K.D. LANG
074 TORI AMOS
076 SARAH McLACHLAN
078 LOREENA McKENNITT
080 INDIGO GIRLS
082 MICHELLE SHOCKED
084 SUZANNE VEGA

086 MELISSA ETHERIDGE
088 SOPHIE B. HAWKINS
090 MARY-CHAPIN CARPENTER
092 SHAWN COLVIN
094 JOHN GORKA
096 LOUDON WAINWRIGHT III
098 MICHAEL PENN
100 MICHAEL W. SMITH
102 PATTY SMYTH
104 10,000 MANIACS
106 COWBOY JUNKIES
108 SUN-60
110 BARENAKED LADIES
112 THE B-52'S
114 COL. BRUCE HAMPTON & THE AQUARIUM RESCUE UNIT
116 PHISH
118 THEY MIGHT BE GIANTS
120 WALT MINK
122 THE SAMPLES
124 SONIA DADA
126 THE CURE
128 THE JESUS AND MARY CHAIN
130 CURVE
132 RIDE
134 NED'S ATOMIC DUSTBIN
136 THE SOUP DRAGONS
138 INXS
140 SPINAL TAP
142 KISS
144 DEF LEPPARD
146 MEGADETH
148 IRON MAIDEN
150 TESTAMENT
152 BON JOVI
154 DAMN YANKEES
156 JACKYL
158 SLAUGHTER
160 YNGWIE MALMSTEEN
162 IZZY STRADLIN
164 UGLY KID JOE
166 PETRA

168 DREAM THEATER	**244** PRINCE & THE NEW POWER GENERATION	**296** JOHN MICHAEL MONTGOMERY	**352** 4 NON BLONDES
170 WHITE ZOMBIE	**244** R.E.M.	**300** CLINT BLACK	**352** CONCRETE BLONDE
172 SUICIDAL TENDENCIES	**244** DAN BAIRD	**300** MARK CHESNUTT	**356** THE CHIEFTAINS
174 FAITH NO MORE	**248** KEITH RICHARDS	**300** COLLIN RAYE	**356** HARRY CONNICK, JR.
176 HELMET	**248** ROGER WATERS	**304** BILLY RAY CYRUS	**356** SHIRLEY HORN
178 MINISTRY	**248** BAD COMPANY	**304** VINCE GILL	**360** MILES DAVIS
180 SKINNY PUPPY	**252** DR. DRE	**304** JOHN ANDERSON	**360** BRANFORD MARSALIS
182 GWAR	**252** BOBBY BROWN	**308** WYNONA JUDD	**360** DON BYRON
184 KING MISSILE	**252** SHABBA RANKS	**308** TRISHA YEARWOOD	**364** THE DISPOSABLE HEROES OF HIPHOPRISY
186 THELONIOUS MONSTER	**256** MARY J. BLIGE	**308** REBA MCENTIRE	**364** "WEIRD AL" YANKOVIC
188 THE HEIGHTS	**256** TLC	**312** AARON TIPPIN	**364** GEORGE CARLIN
190 T BONE BURNETT	**256** EN VOGUE	**312** MARTY STUART	**368** MARIAH CAREY
192 DELBERT McCLINTON	**260** SWV	**312** TRAVIS TRITT	**368** R. KELLY & PUBLIC ANNOUNCEMENT
194 ARC ANGELS	**260** JADE	**316** PAM TILLIS	**368** SNAP!
196 THE NEVILLE BROTHERS	**260** EXPOSÉ	**316** CONFEDERATE RAILROAD	**369** N2DEEP
198 BUCKWHEAT ZYDECO	**264** WILSON PHILLIPS	**316** ALABAMA	**369** THE FIVE BLIND BOYS OF ALABAMA
200 ZACHARY RICHARD	**264** SHAKESPEARS SISTER	**320** GEORGE STRAIT	**369** GREY GHOST
202 DR. JOHN	**264** SWING OUT SISTER	**320** GEORGE JONES	**370** TONY BENNETT
204 ROBERT CRAY	**268** CHARLES & EDDIE	**320** DOUG STONE	**370** LEONARD COHEN
206 SANTANA	**268** SILK	**324** FIREHOUSE	**370** DEICIDE
208 LUKA BLOOM	**268** SHAI	**324** EXTREME	**371** PAVEMENT
210 CLANNAD	**272** DAS EFX	**324** SAIGON KICK	**371** SUBLIME
212 GREGSON & COLLISTER	**272** THE PHARCYDE	**328** JON SECADA	**371** THE LIGHTNING SEEDS
214 THE BEAUTIFUL SOUTH	**272** PETE ROCK & CL SMOOTH	**328** PETER CETERA	**372** IRIS DEMENT
216 PAT METHENY	**276** GRAND PUBA	**328** TOM COCHRANE	**372** BILL MORRISSEY
218 KENNY G	**276** POSITIVE K	**332** GO WEST	**372** HUGH & KATY MOFFATT
220 YANNI	**276** MC SERCH	**332** STACY EARL	**373** SAWYER BROWN
222 KITARO	**280** ERIK B. & RAKIM	**332** MIKI HOWARD	**373** REVEREND BILLY C. WIRTZ
224 WAILING SOULS	**280** EMPD	**336** RIGHT SAID FRED	**373** ALVIN & THE CHIPMUNKS
226 YOTHU YINDI	**280** REDMAN	**336** WEEN	
228 RINGO STARR	**284** GANG STARR	**336** THE WOLFGANG PRESS	**374** ACKNOWLEDGMENTS
230 NEIL DIAMOND	**284** WRECKX-N-EFFECT	**340** DAVID BYRNE	
232 ERIC CLAPTON	**284** DA LENCH MOB	**340** MORRISSEY	
232 ELTON JOHN	**288** JOE PUBLIC	**340** PETER MURPHY	
232 NEIL YOUNG	**288** HI-FIVE	**344** XTC	
236 WHITNEY HOUSTON	**288** LO-KEY?	**344** THE SUGARCUBES	
236 CELINE DION	**292** PANTERA	**344** THE SUNDAYS	
236 MADONNA	**292** DC TALK	**348** SONIC YOUTH	
240 SADE	**292** AMY GRANT	**348** MUDHONEY	
240 ANNIE LENNOX	**296** GARTH BROOKS	**348** SOCIAL DISTORTION	
240 SINÉAD O'CONNOR	**296** CHRIS LeDOUX	**352** LEMONHEADS	

PHOTOGRAPH BY STEPHEN COLLECTOR

ON RECORD | VOL.9 | 1992

I CROSSED paths with Cameron Crowe in 1992, when the filmmaker was promoting *Singles*, his paean to Seattle's grunge scene. That music formed an integral backbone for his script came as no surprise—he'd started his career as a contributor at *Rolling Stone* magazine. Eight years after *Singles*, he would write and direct *Almost Famous*, the story of his experiences as a 15-year-old journalist covering rock bands in the Seventies.

I used to be one of those, too. *Almost Famous* revealed a lot of what we lived, coming of age when the music business was less corporate and more of a community. I grew up Colorado, listening to the radio, blowing my allowance at the local record shop and reading *Creem* magazine. I played drums in garage bands, but it soon became obvious that Python Deity wasn't going to be selling out the Enormodome anytime soon. So I decided to channel my passion for music into writing about it. At age 15, I rode my bike down to the *Arvada Citizen*, a weekly suburban newspaper.

The editor, Mark Wolf, later an excellent reporter for the Denver dailies, was a 22-year-old fresh out of college. And he printed my first record review. A few clippings later, I got up the moxie to contact RCA Records regarding the Guess Who. I was a deeply invested fan, and the guys were touring in support of their classic *American Woman* album.

And I was told I could meet leader Burton Cummings before the Guess Who played at the Denver Coliseum—a prospect that thrilled and terrified me in equal measure. On that unfathomable day in July 1970, wanting to make a good impression just like my mom taught me, I put on my brown wool suit, an orange shirt and matching tie. I took my place backstage, pen in one sweaty hand, spiral notebook in the other, and introduced myself.

I'm sure Cummings must have pulled the road manager aside and said, 'Who sent this geek?' But to his credit, he came back into the dressing room, curled up in a chair and answered my questions. Had he blown me off, I'd have been devastated. But he didn't—and I was smitten. With the zeal of the newly converted, I wanted to interview every rock band that I could.

I wound up going to journalism school, and I've intersected with thousands of musicians. But things changed—eventually, publicists arrived to keep interviews short and shallow, sometimes becoming pure promotional events. So *Almost Famous* reflected what got me started in the first place—a genuine love of music that could withstand the industry's cynicism and greed. And I continue to thank Burton Cummings, who kept this introverted teenager on his path when I wasn't entirely sure my heart was in it for the long haul.

1992 marked many notable events in music. Nirvana's *Nevermind* went to No. 1 on the album charts, establishing grunge's widespread popularity. Sinéad O'Connor stirred up controversy when she ripped up a picture of the Pope on television's *Saturday Night Live*. *The Bodyguard*, from Whitney Houston's debut film, would become the best-selling soundtrack of all time. And I attended all the concerts and got all the new releases and attendant press kits. I was and am a very lucky boy. Please allow me to share. — **G. Brown**

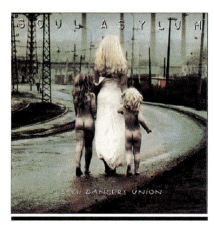

Billboard 200: *Grave Dancers Union* (#11)
Billboard Hot 100: "Runaway Train" (#5)

With a music video showing actual missing children, "Runaway Train" propelled Soul Asylum to the big leagues.

IN THE mid-Eighties, when Minneapolis was heralded as the next great rock stomping ground, the best of the city's bands—the Replacements, Hüsker Dü—started to move from small record labels and the hardcore club circuit to higher, major-label stakes. Soul Asylum was the scene's great unwashed hope, and the band's biggest strength was reliably spectacular, frenetic live performances—the energy, teamwork and wit bolstered the perfect sort of garage-band rock for making air-guitar faces.

But Soul Asylum's criminally underrated albums never quite delivered that promise. Finally, in 1992, eight years after the foursome's first release and the implosion of its Minneapolis peers, Soul Asylum got its commercial due with *Grave Dancers Union*, a better album than anyone had a right to expect so late in a band's career.

"In the old days, you'd hear about how nutty the show was, or how drunk we were, or how it was a big deal that we didn't have stage clothes—you didn't hear much about the musicianship," good-natured guitarist Dan Murphy said.

"When we were getting *Grave Dancers Union* together, we said, 'What if we didn't have the loudest guitar that you've ever heard on every song?' I could never hear any of the lyrics—Dave (Pirner, vocalist) would be screaming in our rehearsal space. We started writing on acoustic guitars, and it was a revelation, an important time in my life. For the first time ever, I knew what the songs were about before I went to the studio. We slowly learned how to play better together.

"We did the business, shopped to seven or eight record companies. I didn't think we'd end up on a big corporate label, but what used to be alternative music is viable now."

Indeed, Soul Asylum had a post-Nirvana industry buzz as the next big thing. *Grave Dancers Union* was easily the band's most diverse collection, with a more controlled sound and several melodic, hard-hitting songs—the sorrowful "Runaway Train" (which won the Grammy for Best Rock Song), the hooky "Black Gold," the rocking "Somebody to Shove"—that endeared the band to a whole new generation of fans. Some of the old moshing constituency was upset by their heroes' evolution, labeling it as a sellout.

"A good way to not be suspicious of success is to not have any for about 10 years," Murphy mused. "You put strings on a song and it's 'Soul Asylum has mellowed,' but whether we want to or not, we're maturing a little bit. No one goes through life in a constant punk-rock stage of mind—there are quiet, reflective days. We've never tried to classify ourselves, and maybe it's hurt us. But maybe it's helped us. We're nothing but guys trying to write and play good songs." ■

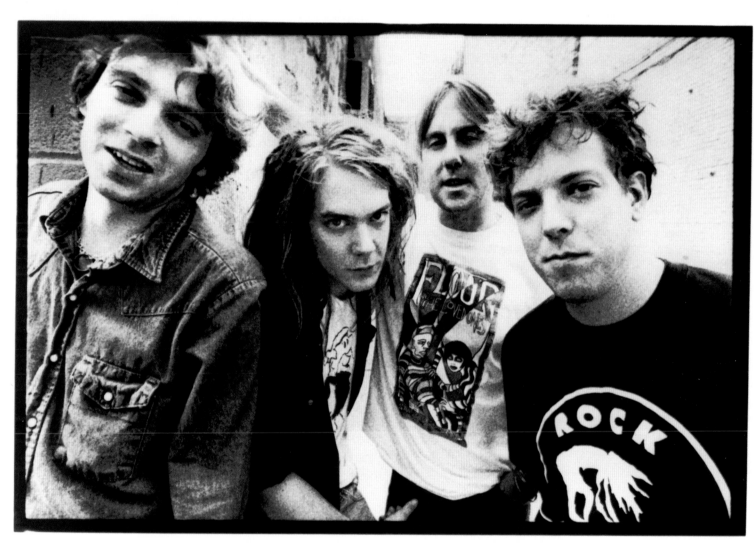

From left: KARL MUELLER, DAVE PIRNER, DAN MURPHY, and GRANT YOUNG.

Management:
Addis/Wechsler & Associates
Los Angeles, CA
Phone: 213.954.9000
FAX: 213.954.9023

SOUL ASYLUM

COLUMBIA
9208

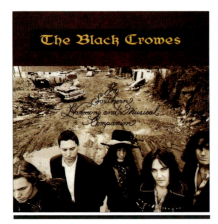

Billboard 200: *The Southern Harmony and Musical Companion* (No. 1)
Billboard Hot 100: "Remedy" (#48); "Thorn in My Pride" (#80)

The Black Crowes dug further into a spirited brand of Southern-fried, hard-edged rock on their second album.

STORMING OUT of Atlanta in 1990, the Black Crowes vaulted up the charts behind a crunching cover of Otis Redding's "Hard to Handle" and the ballad "She Talks to Angels." Nearly 5 million copies of *Shake Your Money Maker*, a knockout debut album, were sold worldwide.

People dogging the Black Crowes usually accused them of shamelessly appropriating the classic raunch of the Rolling Stones, Aerosmith, the Faces and Humble Pie. The Crowes didn't get it—they got away with their plundering because they did it so well, freshening and energizing the old sounds.

"That dismissal makes us upset," guitarist Rich Robinson admitted. "I'm like, 'Man, you guys aren't listening to what we're trying to do. We're young—why don't you shut up and see where we are in five years?'"

Touring presented the interplay between Robinson' slinky guitar bravado and his lanky brother Chris' alley-cat singing. They looked like dopehead rednecks, all bleary-eyed soulful vibe and retro-rebel attitude. They smoked pot publicly, and the band was kicked off the ZZ Top tour for mocking corporate sponsorship.

The Black Crowes took eight days to record their second album, *The Southern Harmony and Musical Companion*. The abrasive battles between Rich and Chris Robinson got reported, but the siblings' creativity and high standards came from their common musical heritage and the grind of life in a touring rock band.

"I've never really worked with anyone else," Rich said. "Obviously, there's certain things I play and he knows what I'm going to do, and vice versa. A lot of people, when they come around us, they don't know what we're saying, because a nod means so much, or a half-sentence can speak volumes. There's a shorthand between me and Chris."

The Southern Harmony and Musical Companion reached the top spot of the album charts, propelled by "Remedy," "Sting Me," "Thorn in My Pride" and "Hotel Illness"—all No. 1 tracks at rock radio.

"It's a little weird," Robinson said. "We came out when heavy metal was huge, and we had nothing to do with heavy metal. And now Nirvana's come out, and the industry has drawn a line in the sand, basically stating that anything before that was metal. And we're not really in competition with anyone. But we'll keep putting out records. That's how we'll do it." ■

Chris Robinson Steve Gorman Rich Robinson Johnny Colt Marc Ford

The Black Crowes

Photo credit: Mark Seliger

©1992 Def American Recordings/Permission to reproduce limited to editorial use in newspapers and other regularly published periodicals and television news programming.

ON RECORD | 1992 | [GIN BLOSSOMS]

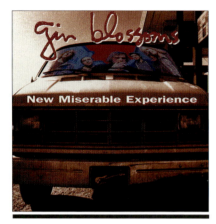

On *New Miserable Experience*, Tempe, Arizona's **Gin Blossoms** forged thoughtful, accessible guitar-based rock.

Billboard 200: *New Miserable Experience* (#30)
Billboard Hot 100: "Hey Jealousy" (#25); "Found Out About You" (#25)

THE DECIDEDLY American sound of Gin Blossoms aspired to the timelessness of heroes like the Byrds, Tom Petty and the Replacements—sweet harmonies and gorgeous, chiming guitars. Original? No, but the quintet was carrying on a great tradition.

"Yeah, we're 'jangly'—except I don't know what that means," guitarist Jesse Valenzuela allowed. "But if jangling is 'arpeggiating' that chord, there's a certain amount of that—all of my favorite bands do it."

New Miserable Experience, the band's first full-length major-label album, didn't take off commercially for nearly a year after its release, but the band's relentless touring turned it into a hit.

"There haven't been any shortcuts," Valenzuela noted. "We didn't get a lot of airplay or video exposure, so it was a matter of hitting the same bars over and over and meeting people, making friends at radio and newspapers—a classic grassroots thing. We've done the country five times. Everyone would rather be home watching CNN, but we're happy—a lot of guys don't get this shot. When the tour started, we said, 'Well, we'll be out at least three months.' And we're out for a year."

When *New Miserable Experience* gained momentum, it did so with a vengeance. "Hey Jealousy," "Found Out About You," "Allison Road," "Mrs. Rita" and "Until I Fall Away" were all radio favorites. But it remained to be seen whether Gin Blossoms could create another album as affecting. Half of the best songs were composed by band founder Doug Hopkins, who was fired the previous year; he subsequently committed suicide just as *New Miserable Experience* was becoming a success.

"There's always more songs," Valenzuela assured. "I try not to wait for the muse because it's a mystery—I get scared, confused and unhappy if it doesn't show up. So I try to write every day." ■

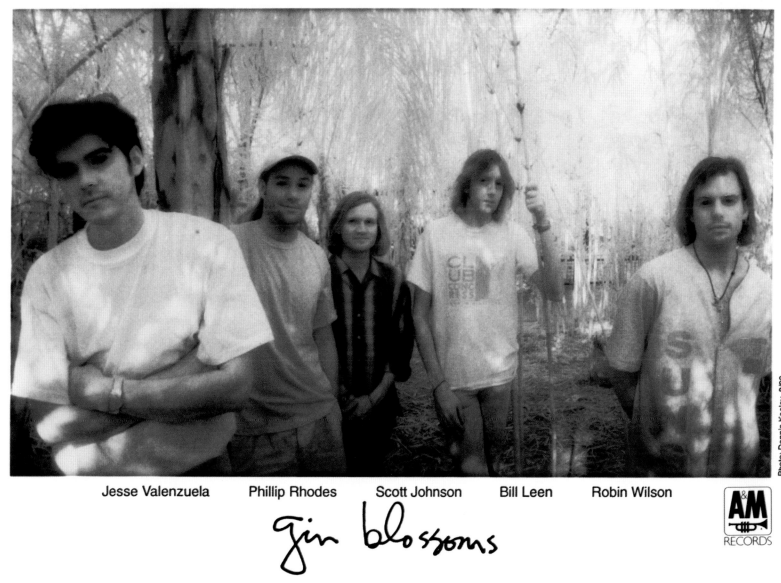

Jesse Valenzuela Phillip Rhodes Scott Johnson Bill Leen Robin Wilson

gin blossoms

A&M RECORDS

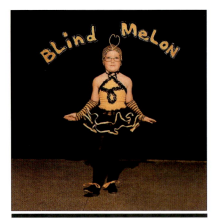

Billboard 200: *Blind Melon* (#3)
Billboard Hot 100: "No Rain" (#20)

Its accompanying video receiving heavy airplay on MTV, Blind Melon skyrocketed up the charts with "No Rain."

BLIND MELON was just another new group with a funny name, small-town rock 'n' roll dreamers who met by chance in Los Angeles. There was a buzz when singer Shannon Hoon popped up in a Guns N' Roses video, becoming the mysterious "other man" as he sang backup vocals on the song "Don't Cry" with fellow Hoosier Axl Rose. The group landed a record deal in a few months—and then left Los Angeles for North Carolina, completing its self-titled debut.

For nine months, *Blind Melon* sat in stores. And then MTV began airing "No Rain," a video inspired by the "bee girl" character on the album cover art—a free-spirited, chubby young tap dancer in large glasses, unappreciated by the majority, found a group that accepted her as she was. The role touched a chord in many hearts—*Blind Melon* re-entered the charts and rocketed to #3 in only seven weeks.

The members of Blind Melon were exhilarated by their breakthrough, albeit a little terrified by overnight success. "It just shows you the power of MTV," happy-go-lucky guitarist Christopher Thorn said. "For a while, we said cruel things about the bee girl in interviews, but she's just an innocent kid. We had no idea that this was gonna happen. We got annoyed when people thought we sat around with suits on and came up with a great marketing ploy. The whole thing exploded on us."

Blind Melon recalled the feel-good vibe and bluesy semi-acoustic sound of late Sixties and early Seventies bands. Allman-esque Southern rock and the old-fashioned style upheld by the Black Crowes had clearly made a mark on some songs, prompting some to dub the band "nouveau hippie." "It's hard to stomach, because I don't think we're any one thing," Thorn said. "'No Rain' had that Sixties retro feel, but other songs don't. We were very influenced by bands of the Eighties, too—Jane's Addiction and U2."

Entertainment Weekly put a slight damper on the celebration after a telephone survey found that 68 percent of people had never heard of Blind Melon. Of those who did know the name, 44 percent believed the band would be a flash in the pan and 25 percent had no prediction on the group's future.

So the guys were eager to get off the road, but they had to continue touring until the record company milked the winning streak for all it was worth. Hoon had been in trouble with the law—among other indiscretions, he was charged with attacking security guards and police officers at the American Music Awards show.

"Shannon feels awkward about a lot of the things that have happened," Thorn said. "But when you're on tour for so long, you're always on, always together—and you cut loose. The press wants to blow it up, but it's just a bunch of guys drinking too much." ■

BLind MeLoN

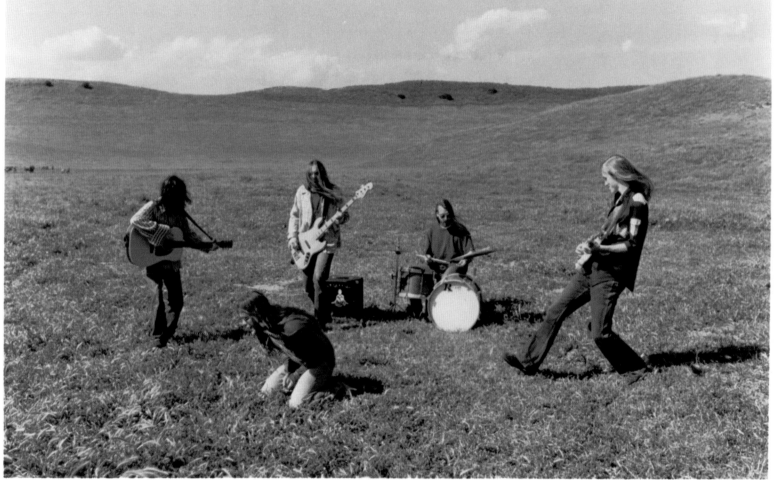

Christopher Thorn Shannon Hoon Brad Smith Glen Graham Rogers Stevens

Photo: Gene Kirkland

ON RECORD | 1992 | [ALICE IN CHAINS]

Billboard 200: *Dirt* (#6)

With the essential album *Dirt*, grunge dreadnought Alice in Chains was set on a path to inevitable grim fortune.

ALONG WITH other Seattle bands, Alice in Chains had risen to fame as part of the grunge explosion. The group's debut, *Facelift*, featured the hit "Man in the Box." The second album, *Dirt*, was one of the era's darkest and most riveting records, playing like the soundtrack to a long and winding bad trip, with unremittingly bleak images of heroin and death.

Guitarist Jerry Cantrell experimented with exquisite riffs of doom, drawing out with textures and time signatures to build walls of sonic corrosion, and Layne Staley's angry, gloomy vocals provided much of the dangerous sound. Fighting a nasty drug habit, he verbalized his own pain and insight, dealing with the urges through brooding tracks like "Angry Chair," "Sickman" and "Junkhead." The troubled, enigmatic singer was especially upset by comments that suggested the music advocated drug use.

"A reviewer called it a pro-heroin record, and it's 180 degrees opposite of that. But I have confidence in our fans who choose to listen and come to the shows—they're smart enough that they're going to get it."

Staley was riding a three-wheel all-terrain vehicle when he tried to use his foot as a brake before he crashed. The rear wheel ran over his foot, breaking it in three pieces. Doctors inserted pins during surgery. He still had some floating bones, but orthopedic surgeons agreed that he wouldn't need more operations.

A legitimate road warrior, Staley worked his disability into AIC's act, never missing a date as openers for Ozzy Osbourne's *No More Tours* tour. He performed some shows from a wheelchair, and he was on crutches for a bit. "I'm healing," he reported. "For gigs, I'm using lighting cables, ladders, anything I can lean on."

Dirt remained on the charts for nearly two years and spawned the alternative hits "Would?," "Rooster," "Them Bones," "Angry Chair" and "Down in a Hole." Bassist Mike Starr was replaced by Mike Inez, and Alice in Chains headed out on Lollapalooza '93, joining Fishbone, Primus, Tool, Rage Against the Machine, Dinosaur Jr., Arrested Development and Babes in Toyland. Near the end of the tour, Staley decided a new look was in order—he began wearing tailored suits and ties on stage. ∎

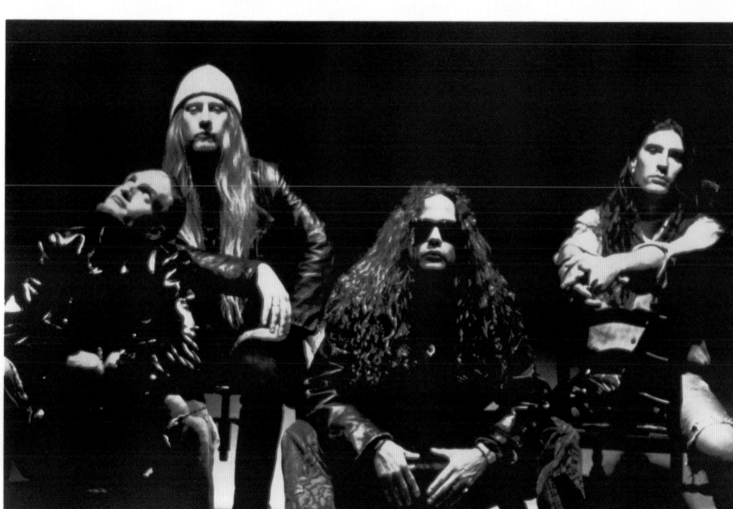

Left to Right: Layne Staley, Jerry Cantrell, Mike Starr, Sean Kinney

Management
Susan Silver 206/623-9268
Kelly Curtis 206/725-8927

Columbia

9208

Billboard 200: *Core* (#3)

With *Core*, Stone Temple Pilots promptly emerged as one of the era's most commercially successful rock bands.

IN EARLY 1991, Stone Temple Pilots got off the ground when lead singer Scott Weiland met bassist Robert DeLeo at a Black Flag concert in Long Beach, where they were both living at the time. "It was one of those weird things," Weiland explained. "You get into a heavy discussion with a total stranger, and you discover that both of you are seeing the same girl."

When their mutual girlfriend moved to Texas, DeLeo and Weiland sized the opportunity and moved into her apartment. They discovered a common artistic ground and formed Mighty Joe Young with drummer Eric Kretz and DeLeo's brother Dean on guitar. Feeling San Diego would provide a more conducive musical environment than Los Angeles, they developed their approach away from the glitz of the Sunset Strip.

"At the time, the attitude of bands in L.A. seemed to be, 'We're right in the middle of the music business here in Hollywood, so we've all got to try to sound like this band or that band that just got signed,'" Weiland explained. The quartet changed its name to Stone Temple Pilots and arose from obscurity, leaping to unexpected chart heights with *Core*. The debut release, featuring the hits "Sex Type Thing," "Creep" and "Plush," sold nearly 4 million copies.

Some perceived "Sex Type Thing" as sexist. "The song isn't about sex at all—it's about unoriginality and men who take too much pride in their dicks," Weiland insisted. "The scenario is similar to a date-rape situation—I'm putting myself in the mindset of the typical American macho jerk with a totally unoriginal attitude about women. It's basically about a character that I totally and utterly despise."

The uptempo, melodic "Plush" earned the band a Grammy in the category of Best Hard Rock Performance. "It's funny, we weren't even going to put 'Plush' on the album," Robert DeLeo revealed. "I remember sitting on a couch three years ago with an acoustic guitar—that's how it was written. Our producer figured we should do it electric, and it's amazing what happens when MTV plays something. But the whole band's sick of that song. We're ready to move on to the next one."

STP's triumph was accompanied by duress. The members found themselves accused of copying Pearl Jam, and they were the target of Seattle wannabe jokes by alternative-rock pundits who called the Californians "Stone Temple Toilets" and "Clone Temple Pilots." The persecution suffered at the hands of rock critics, other musicians and even MTV's animated culture critics Beavis and Butt-Head almost broke up the bandmates—morale sank so low they canceled a tour and didn't speak to each other for months. ■

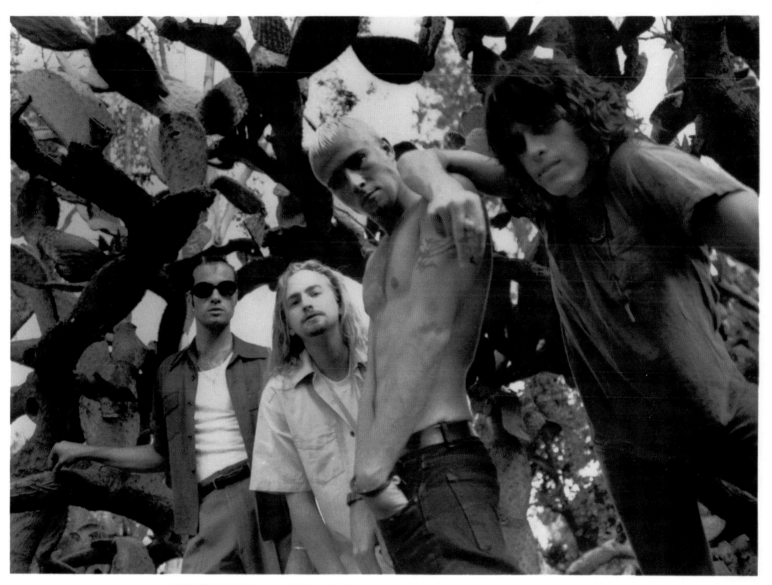

ROBERT DELEO ERIC KRETZ WEILAND DEAN DELEO

STONE TEMPLE PILOTS

Billboard 200: *Sweet Oblivion* (#141)

Sweet Oblivion and "Nearly Lost You" catapulted Screaming Trees to a heightened level of national awareness.

THE POST-PUNK indie rock of the American Northwest produced many strains of noise. Screaming Trees, a ramshackle quartet, originally called Ellensburg in central Washington home. Surrounded by hunting and fishing wilderness, the members were raised on Seventies classic rock, whatever punk records they could get, and plenty of beer and weed. Boredom was a catalyst for creativity.

"There's always been a lot of bands from the Northwest—Green River, the Wipers," guitarist Gary Lee Connor noted. "By the time the Seattle underground thing started, we'd already been to Europe a couple of times. Nobody considered us a local band."

But low-budget touring was a strain. "There were years where we had everyone sleeping in the same room, if we got a room at all—oftentimes we'd sleep in a van and wouldn't eat," singer Mark Lanegan said. "It wasn't a career or a hobby, it was more like prison. We're older now, so it's hard on us to live like that. But we try to enjoy the hell out of it—we're incapable of holding regular jobs."

The band had compulsively written and recorded music in the independent sector, producing some dozen releases including side projects. The Trees worked in a real 24-track studio for their major-label debut, 1991's *Uncle Anesthesia*, yet the garage-rooted sound had been preserved. Connor's massed guitars made for powerful, grungy noise, and Lanegan's surly vocals called to mind early Iggy Pop.

Screaming Trees finally got some nationwide attention for *Sweet Oblivion*. The band broke with tradition to make the album, recording in New York, using a professional producer and writing songs together. "We'd gotten used to making entire records in a day for a thousand bucks," Lanegan said. "But there just came a point where we needed to get paid for doing it."

Connor played raw, bellowing chords with simple drama, layering the sound with undeniable pop sensibilities and infectious hooks. The elements were condensed on the alternative radio hits "Nearly Lost You" (which also appeared on the soundtrack to the Cameron Crowe film *Singles*) and "Dollar Bill."

"We always intended to make this record, but we did think it might be the last one—everyone was getting burnt, and we didn't have a permanent drummer," Connor admitted. "And in the climate before Nirvana broke out, it would have been very difficult for us to get any kind of mega-success. But then we thought, 'Fuck it, we're going to make the best one we can.' We found a drummer and we were a band, a unit again. There's definitely a revitalization process going on." ■

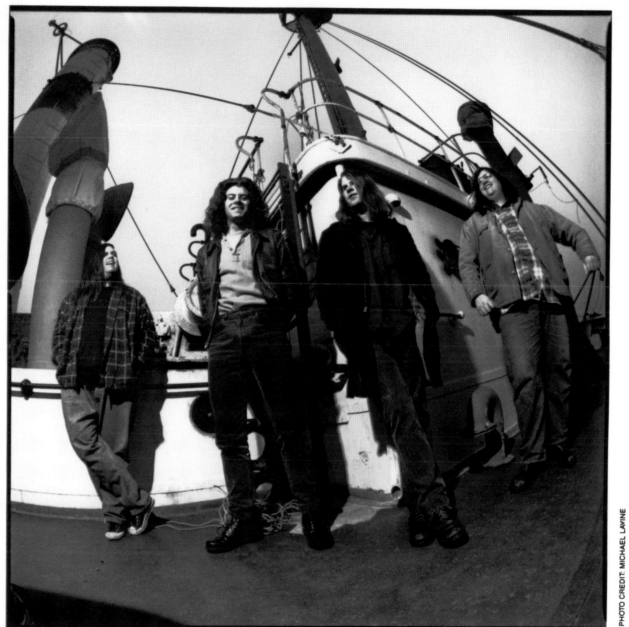

| GARY LEE CONNER | BARRETT MARTIN | MARK LANEGAN | VAN CONNER |
| (GUITAR) | (DRUMS) | (VOCALS) | (BASS) |

SCREAMING TREES

epic
9208

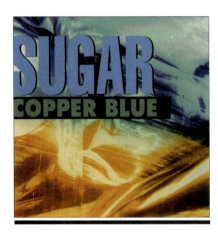

Establishing his new band **Sugar** and recording *Copper Blue* was like "starting again at zero" for Bob Mould.

BOB MOULD spent the better part of the Eighties as the guitarist and frontman for Hüsker Dü, a pioneering post-punk trio that perfected an exuberant collision of melody and noise. The Hüskers' from-the-gut attack was ahead of its time, but bands like Nirvana had risen to superstardom by referencing the eloquent grunge-pop fusion. With that crossover success, the marketplace was ready for Mould's new band, Sugar—the debut album *Copper Blue* reached No. 1 on college album charts.

"I never thought I'd work with a band again, so this is an odd premise," Mould said. "It's not an eat-breathe-and-sleep-together band. It's a love-for-playing-music-together band. I'm glad we're not together all the time."

When Hüsker Dü fell apart in late 1987, Mould did the expected and established a solo career. He released two records, *Workbook* (1989) and the loud, overwhelmingly bleak *Black Sheets of Rain* (1990). "I made those albums with the help of other musicians, hired guns," he explained. "And the lines were drawn—if you're gonna put your name on it, you can't expect other people to help you out. I got up onstage with them, and I hoped they'd be there in spirit. They weren't. A string of solo acoustic dates last year cleared my head. I was having fun again."

Copper Blue became Mould's most commercially successful project, bolstered by singles like "Helpless" and the irresistible "If I Can't Change Your Mind." Mould wouldn't deny that Sugar resembled Hüsker Dü's sonic assault, creating bracing power-pop surroundings for his careening, stacked-guitar blowouts.

"I'm no dummy. When *Copper Blue* was finished, I listened and said, 'This is what everybody has been waiting for.' It's a three-piece ensemble. I mixed the songs, the record sounds like the way I hear music. So I knew what people were gonna tap into. But what am I supposed to do, put six guys in the band and play Latin jazz? I could name a hundred bands that Hüsker Dü comparisons apply to. Unfortunately—or fortunately—I was in Hüsker Dü. I was at every show, I didn't miss one. So the parallels are a little more apparent."

Mould emphasized he was just one member of Sugar—the other two were ex-Mercyland bassist David Barbe and ex-Zulus drummer Malcolm Travis—but he was also the band's manager. He seemed quite calm. "It's difficult to juggle things, to stay on top of what's going on," he admitted. "I haven't had a day off in three years." ∎

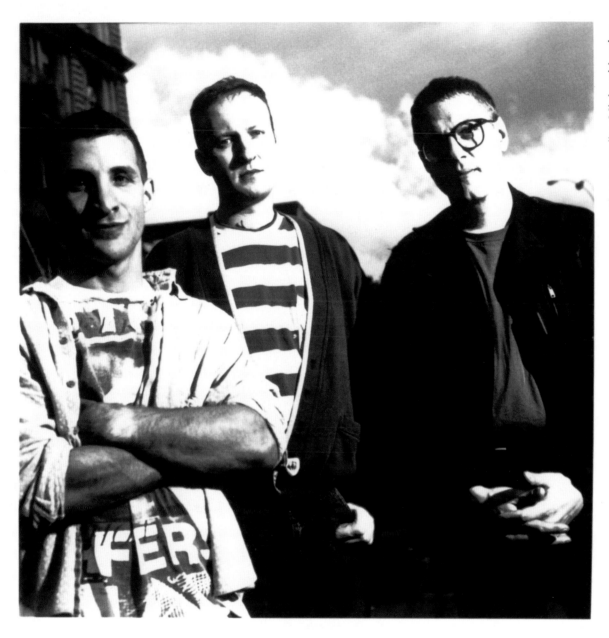

Photo credit: Michael Lavine

David Barbe, Bob Mould, Malcolm Travis

SUGAR

Billboard 200: *Danzig III: How the Gods Kill* (#24)

For a generation of metal devotees, *Danzig III: How the Gods Kill* was Danzig's greatest musical achievement.

LED BY former Samhain and Misfits singer Glenn Danzig, the band Danzig had reached the pinnacle of the heavy-metal scene. The boss was a pseudo-Satanic insurgent who stimulated a degree of controversy. Guitarist John Christ was somewhat quieter. "I'm a quasi-edge-of-suburbia kid from Baltimore," he allowed. "I want to put my money into a ranch up in the mountains of Colorado."

Christ—born John Knoll, his surname conferred by his discourteous bandmates—was a serious player who had pursued a music degree and dug sheet music. "I live this good-and-evil dichotomy on a daily basis," he explained. "The people that meet the mellow me don't know what to think—they're going, 'What do you get out of this?' Then they come to the show and see. I've got a dark stripe going down my back and into my soul. I get off performing in that heavy, intense environment. It's become natural for me to shift back and forth to 'Danzig mode.'"

It was obvious that Glenn Danzig and Christ had spent some time pumping iron in the gym, but there was a tension between them musically—Danzig wrote the songs alone and told Christ how to play them, and he took a co-production credit on *Danzig III: How the Gods Kill*. But the collaboration was undeniably fruitful, combining Christ's impressive monolithic riffs and the growling Danzig's charisma on "How the Gods Kill," "Dirty Black Summer" and the arresting "Sistinas."

"There's less freedom, but it doesn't bother me," Christ said. "If I do a good job, everybody's happy. I keep reminding myself that it's not my band." He was in the nascent stage of pursuing gigs writing TV promo music. "I'm just trying to expose myself to all the possibilities. It's cool—Glenn doesn't watch much network TV." ■

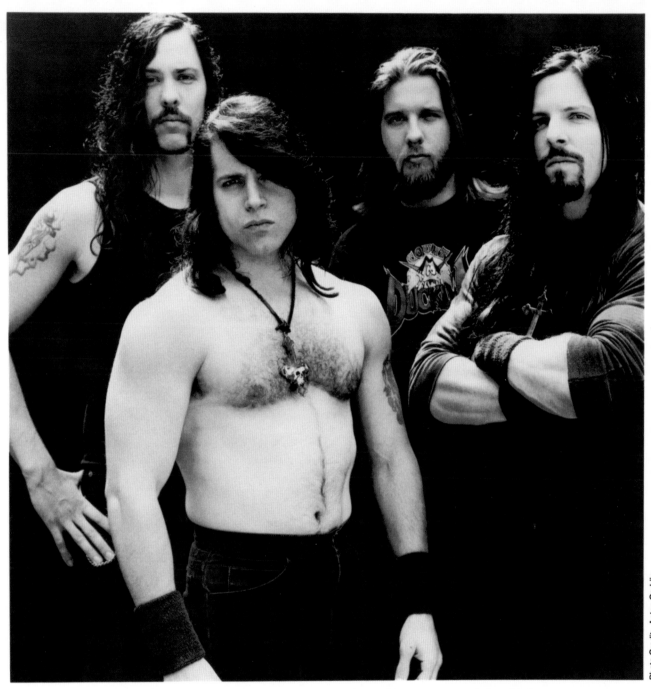

Eerie Von Glenn Danzig Chuck Biscuits John Christ

Photo Credit: Anton Corbijn

© 1992 Def American Recordings/Permission to reproduce limited to editorial use in newspapers and other regularly published periodicals and television news programming

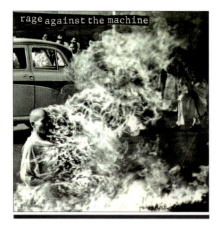

Billboard 200: *Rage Against the Machine* (#45)

Rage Against the Machine's first album gave prominence to explosive funk-metal and contumacious messages.

IT WASN'T necessary to make a distinction between Rage Against the Machine's energetic, passionate live performances and the rap-rock band's outspokenness. Rage advocated a leftist approach to racial justice and capitalism—issues that were usually avoided on the pop charts, removed from the lives of most American teens. Which might explain why its self-titled debut album of battle cries sold twice as well in Europe as in the US.

"It has to do with the anesthetization of youth that goes on here, through the education system and the bombardment of the advertising community to keep people alone and fixed in front of their televisions," guitarist Tom Morello said. "That's less prevalent overseas. Many Europeans whose eyes and ears are open share a view they see in our songs which many Americans are unable to see about their own country. But now there's a groundswell of alienation and indignation that Rage music is a soundtrack for."

Rage Against the Machine reached platinum status and spawned the alternative hits "Freedom" (a song in support of the AIM movement and Indian rights activist Leonard Peltier), "Bullet in the Head," "Bombtrack" and "Killing in the Name"—once the offending expletive was deleted from the song's relentless refrain: "Fuck you, I won't do what you tell me…"

Singer Zach de la Rocha was solely responsible for Rage's lashing lyrics, and Morello matched his seditious calls to arms and tirades against iniquity with a relentlessly militant in-your-face sound. Morello's imaginative repertory of improbable noises and sonics made the Harvard alumnus a guitar hero among modern rockers.

"When the band first formed in 1991, the rhythm section was playing funky hip-hop music," he explained. "I was basically the designated DJ—I had to find a way to complement the sound in a way that wasn't tired. I had two options. One was to do something that maybe sounded too reminiscent of the Red Hot Chili Peppers. The other was to try and approximate the sounds you'd hear on a Dr. Dre record or a Public Enemy record or a Run-D.M.C. record. I went that route."

All the raw, potent music was the product of guitars, bass and drums, and the highly charged language "might force you to consider the ideas that are put forward," Morello said. "When you grow up Black in Libertyville, Illinois, you don't have to crack a single book to start getting politicized—your introduction is when you start getting name-called on the playground in kindergarten. My mom was active in the civil rights movement and my father was active in Kenya's independence struggle, so there was a culture of radical politics at home which contrasted very sharply with the conservatism of where I grew up. That juxtaposition helped me ask a lot of questions early on. The Clash was so amazingly important to me. They did what we're trying to do—you don't treat the audience as empty vessels to fill with knowledge. It's a dialogue." ■

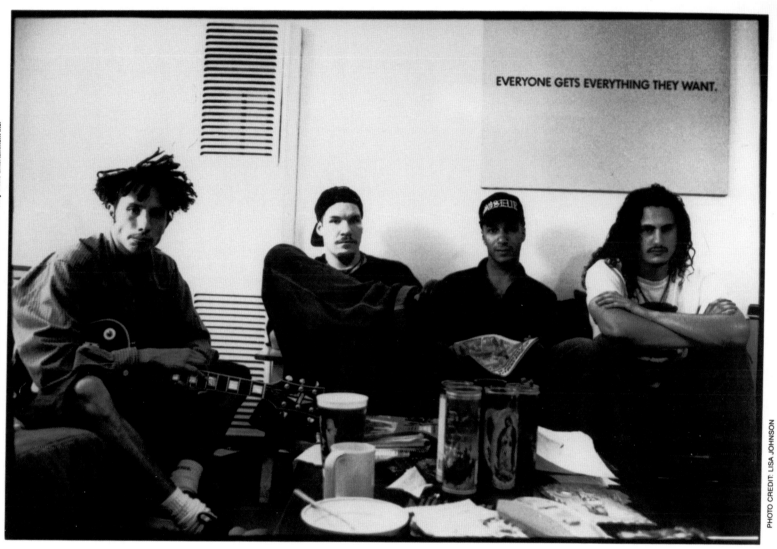

ZACK DE LA ROCHA
(VOCALS)

TIMMY C.
(BASS)

TOM MORELLO
(GUITAR)

BRAD WILK
(DRUMS)

rage against the machine

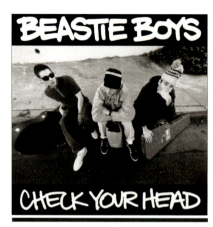

Billboard 200: *Check Your Head* (#10)
Billboard Hot 100: "So What'cha Want" (#93)

Hankering to be taken as serious players in the hip-hop community, Beastie Boys picked up their instruments.

WITH THE anthem "(You Gotta) Fight for Your Right (To Party!)," Beastie Boys exploded in a hail of beer guzzling and bong hits in 1987. The three white, upper-middle-class Jewish New Yorkers became the first rappers to have a No. 1 album, *Licensed to Ill*, by marrying the style with the heavy-metal aggression of white suburbia. The Beasties' incorporated their appealing rudeness into live performance—an arena tour featured caged, scantily clad go-go girls, a huge six-pack of Budweiser tallboys and a 20-foot tall phallic prop.

The band was defined as a novelty, but Beastie Boys had since pursued an artistic vision—and matured. The hectic sampling of 1989's *Paul's Boutique* brought the group new critical acclaim, but the album didn't produce a hit and they didn't tour to support it.

The ramshackle *Check Your Head* was recorded in the band's own studio rehearsal space (they were now living large in Los Angeles). The witty rhymes and alliteration were sprinkled with some politically correct platitudes for racial harmony. And the Beasties augmented the usual sampled sounds with their own guitar-bass-drums instrumentation.

"These days everyone wants the digital equipment," Adam "MCA" Yauch said. "But we outfitted our studio with really cheap second-hand equipment—wah-wah pedals, fuzz basses. It sounds dope."

The sprawling album included a variety of beat-heavy styles. There was straight-up hardcore—"So What'cha Want" shredded—and the Beasties flashed their old brattiness in "Pass the Mic," distorting their whiny vocals. "Jimmy James" had off-the-wall sampled tidbits blended in.

"We just put a load of two-inch tape on and jammed, and we turned those jams into songs," Michael "Mike D" Diamond said. "We recorded it live as a four-piece band (with producer Mario Caldato, Jr.) because we wanted this shit to be phat in both sound and attitude. We went for the whole nine yards of phatness and I think we tipped the scales."

Check Your Head debuted in the Top 10 upon its release, and Beastie Boys became dope again. ∎

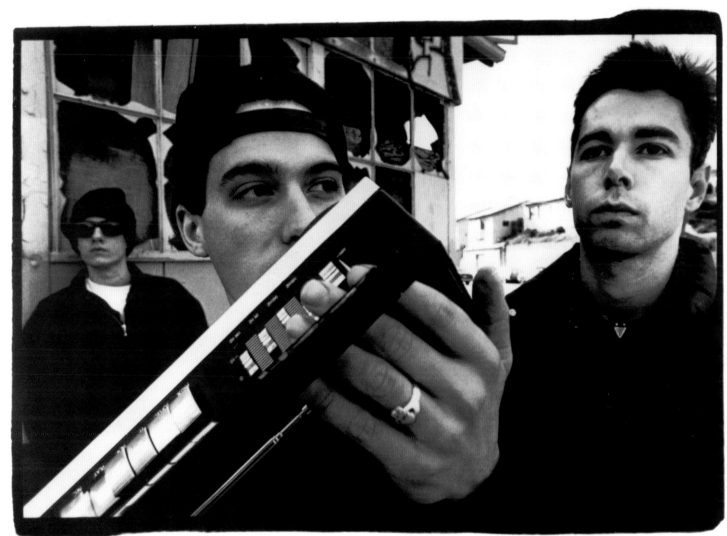

Mike D King Ad-Rock MCA

BEASTIE BOYS

Photo: Ari Marcopoulos / 1992

Billboard 200: *Bricks Are Heavy* (#160)

Hollywood-based **L7**, a female-led group, charged up its grungy glow with the formative *Bricks Are Heavy* album.

ACCORDING TO magazines like *Entertainment Weekly*, *Rolling Stone* and *Spin*, Los Angeles' favorite up-and-coming band was L7, made up of four women who could blow the minds and speakers of fans. An anonymous college DJ described L7's sound as "like the Go-Go's on a lot of bad crank cut with Drano."

"Being female is an important part of this band," bassist Jennifer Finch said. "But it's frustrating when I see headlines—'The Girls You Don't Want to Introduce to Mom.' That baffles me—I have a great relationship with every mom I know."

Formed in 1985, L7 was initially regarded as a curiosity around L.A. "Hardcore had fizzled out, and it left us with not much else to do but play bars," Finch explained. "But then the indie thing came around, and you could be natural."

Bricks Are Heavy, L7's major-label debut album, was produced by Butch Vig of Nirvana fame. The catchy songs, driven by thick, distorted guitars, managed to be amusing, from "Diet Pill" ("My diet pill is wearing off…Calgon can't take me away/From the things I did today…I think the swelling is going down") to the single "Pretend We're Dead," about apathy ("Just say no to individuality").

But with a long list of political grievances, L7 was informing as well as entertaining, attacking issues that would affect fans. The members had organized benefits for the Feminist Majority, and two of them had started Rock for Choice, staging concerts for reproductive-rights organizations.

"We're artists, but we're also citizens who care about what's going on in society right now," Finch said. "I see the Supreme Court's ruling on abortion as a defeat. I think the right to control biological destiny is within our constitutional rights, and they're slowly taking that away. Giving the states permission to pass restrictive laws makes women geographically unlucky." ■

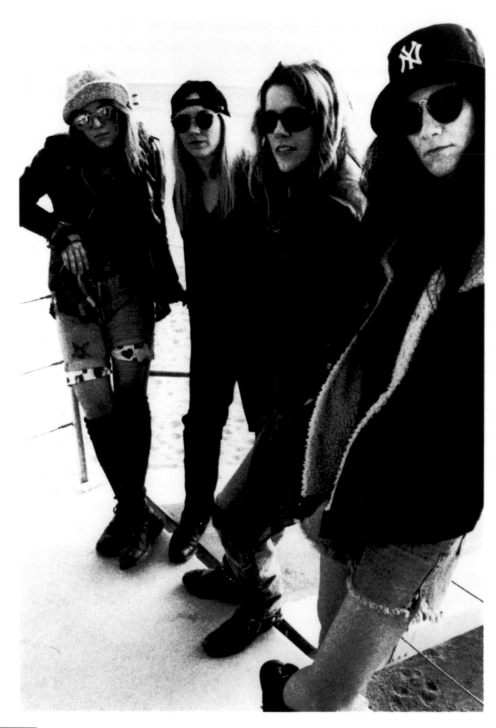

L7
JENNIFER FINCH SUZI GARDNER DONITA SPARKS DEE PLAKAS

Billboard 200: *The End of Silence* (#160)

Rollins Band's *The End of Silence* transformed Henry Rollins into a new breed of underground rock deity.

ON THE inaugural 1991 Lollapalooza tour—a lineup of left-of-the-radio-dial heroes—it was the opening act that blew everybody away. Henry Rollins, leading Rollins Band, performed with the tireless ferocity of an attacking pit bull. People stared at the guy with jarhead-short hair dressed in black gym shorts, tattoos spilling down his brick house body, veins popping out, spit spraying from his mouth. Rollins Band was soon signed to a mainstream label.

No stranger to pain in his adolescent life in Washington, D.C., Rollins seethed with justifiable rage. "My motivation? Having my first sexual experiences with strange men, being terrified of my dad, hating my mother's guts, feeling I was worthless for most of my young life," Rollins reflected. "I was raised to hurt and hate myself. I've just expanded my physical and mental threshold so I can take it."

Rollins had exorcised his demons through music and poetry. In 1981, he assumed the difficult task of fronting seminal hard-core band Black Flag at the height of the Los Angeles battalion's popularity—a perfect marriage until it dissolved five years later. Rollins had since maintained a frantically prolific pace. In addition to his work with the Rollins Band, he'd toured his "talking shows" around the country on the beatnik circuit in uncharacteristic displays of humility and sensitivity.

Rollins also owned a successful small publishing company, 2.13.61 (the date of his birth), which he began by publishing his own prose. His schedule was a virtual year-round blur fueled by black coffee. Rollins envisioned himself as a lonely outcast questing for self-knowledge and self-improvement—he lived every aspect of his life with a military strictness, saying he had no interest in drugs or alcohol.

"I was raised around people with staggering work ethics," he explained. "So what I do isn't art; it's poor man's therapy. I never did EST training or any of that stuff—I watched my mom do it and turn into a stupid hippie. I do it because I'm fucked up, a bluesman getting what's inside me outside of me. I do it in public because I don't have the guts to do it in private."

Musically, *The End of Silence*, Rollins Band's fifth release, was his most cohesive, well-recorded project, with more experimental structures, jazz-inflected musicianship and tricky, grinding tempo changes. The cathartic self-help rant "Low Self Opinion" was essentially autobiographical—"I see you standing by yourself, unable to express the pain of your distress/You draw deeper inside!"

"All of the songs came out of jamming," Rollins explained. "We never write. Our practices are one-two-three-ready-play. We're the ground for the current—it goes right through us. I'm not politically conscious, I don't watch TV. I can't be impressed by a big bank account or electric shoes or an ounce of coke. I'm a basket case. I'm only interested in one thing, the thing that makes me go 'Wow!'—music." ∎

ROLLINS

ROLLINS BAND

(ĭ·mä′gō)™

Billboard 200: *Body Count* (#26)

Led by Ice-T, **Body Count** got more media scrutiny for the hot-button "Cop Killer" than its mix of metal and rap.

HARDCORE RAPPER Ice-T was recruited to bring his beats and samples on the 1991 Lollapalooza tour, but he also commanded Body Count, a heavy-metal band. Audiences were simultaneously exhilarated and confused. Ice-T was convincing as a bellyaching, boasting bad guy, and his group made raw, riveting references to Black Sabbath and Led Zeppelin. He sang "There Goes the Neighborhood": "Who gave them fuckin' niggas/Those rock guitars?…Don't they know rock's just for whites/Don't they know the rules?"

"That's the advantage to playing rock over rap—I can tour," Ice-T said. "Body Count is straight-up rock—it just so happens that a rapper is singing. I always wanted to be in a rock band, and I formed Body Count to allow my friends to play on their terms."

Ice-T and Body Count guitarist Ernie-C were school chums. "I was the last diehard metalhead, but I couldn't be known as a rap guitarist," Ernie-C said. "I auditioned for bands in L.A. with no success—maybe it was a color thing, I dunno. They have a formula to play on Sunset Strip—6-foot-1, blond, blue-eyed."

Ernie-C fronted his own speed-metal band, and when Ice-T went on to become a gangsta rap star, he tapped Ernie-C whenever his music required howling guitar. "When people heard Ice-T was in Body Count, they said, 'Oh, they must use samples and run loops," Ernie-C said. "We were determined not to turn the album into a rap record."

On *Body Count,* Ernie-C's power chording was no more involved than *Wayne's World* air-guitar riffs, but the beats lined up easily for Ice-T's explicit lyrics, which were straight out of Compton. Ice-T took his brutal, rebellious and aggressive notions to extremes, such as the matricidal "Momma's Gotta Die Tonight." But Body Count was frustrated that Ice-T's rap audience hadn't picked up on the heavy-metal vibe.

"It's harder to sell metal to Black kids—it's not cool to listen to rock," Ernie-C explained. "I didn't know about Led Zeppelin until some white guy gave me a tape and said, 'Hey, you're a guitarist, you gotta check out Jimmy Page.' You grow up in the inner city, you need someone to get you hip to rock—you don't get MTV."

The track "Cop Killer" came under fire when a police group in Texas noticed it on the *Body Count* album and threatened a national boycott of Time Warner, the record's distributor. Ice-T soon found himself caught in a crossfire of outrage and protest. Members of Congress and even President Bush denounced what they saw as open advocacy of the murder of policemen. The artist explained that the song was just allegorical, portraying a psychotic seeking revenge on a murderous cop.

In the end, Ice-T voluntarily pulled the song from his album, but the uproar continued—gigs were canceled when off-duty cops refused to provide security. "We came up with a joke about it," Ice-T said. "What do you call 100 policemen standing outside in the cold protesting an Ice-T concert? Cop-sicles!" ■

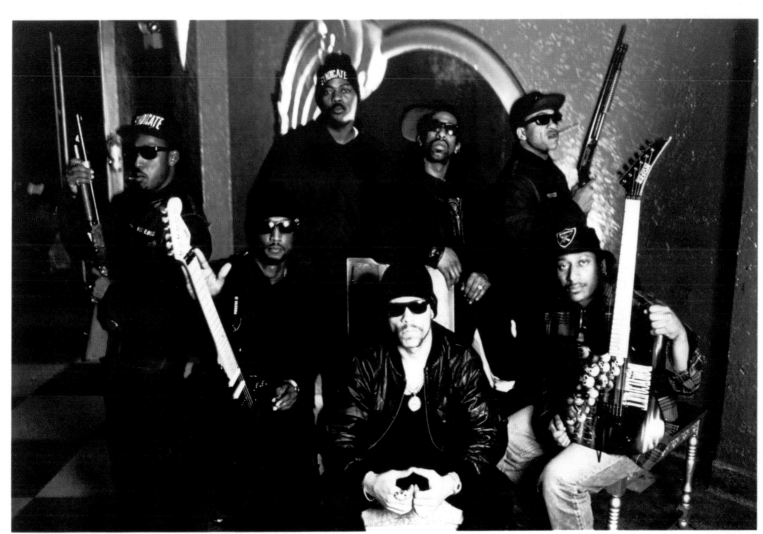

Body Count

© 1992 Sire Records Company/Permission to reproduce limited to editorial uses in newspapers and other regularly published periodicals and television news programming

Photo Credit: Kristin Callahan

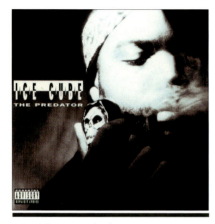

Billboard 200: *The Predator* (No. 1)
Billboard Hot 100: "Wicked" (#55);
"It Was a Good Day" (#15); "Check Yo Self" (#20)

Issued in the wake of the Los Angeles riots, Ice Cube's *The Predator* pushed cultural turmoil to the No. 1 slot.

CONTROVERSY HAD surrounded Ice Cube's career ever since he wrote a tune called "Boyz-N-The-Hood" for his homeboy Eazy-E, laying the foundation for the legacy of pioneering gangsta-rap group N.W.A. Ice Cube defined the alienation of inner-city youth, an angry kid resorting to lyrical rants of misogyny and minority bashing.

None of Ice Cube's inflammatory pronouncements had damaged either his standing in the hip-hop community or his sales. *The Predator*, his third solo release, made history by debuting at No. 1 on both *Billboard*'s pop music and R&B album charts. "I have people scared to come up and say 'What's up?' to me 'cause they think I'm the meanest motherfucker ever," Cube said. "I'm not mad 24 hours a day, but I'm thinking 24 hours a day."

The essence of Cube's rage on *The Predator* was directed at the Rodney King verdict and the sense of oppression that triggered the 1991 Los Angeles riots. On the fierce "We Had to Tear This Mothafucka Up," he pondered, "I told you it would happen and you heard it, read it/But all you could call me was anti-Semitic." He was unapologetic for his stabs at messianic politics.

"I know why people are upset—I'm telling the truth, but truth gotta be told," he said. "The problems I talk about ain't going nowhere until we solve them. They can call me everything, but they can't call me a liar. The kids see that—that's why they're down with Ice Cube."

The Predator was a provocative listen because he weaved in sound bites from leaders like Malcolm X and a dense web of Seventies funk samples (Parliament/Funkadelic, Sly Stone). "It Was a Good Day" was a pleasant surprise. "Most of my records is talking about how fucked-up shit is, but realistically, living day-to-day, some days are cool. Some days, don't shit go wrong, don't nobody fuck with me. I just wanted to do a record on a day where everything was cool and it wasn't no beef. But the next day, it goes back to the same ol' thing. That's why I put 'We Had to Tear This Mothafucka Up' right after that song."

The bouncy, noisy jam "Wicked" reminded that Cube was a mesmerizing MC. "I just wanted to get loose," he said, laughing. "I entertain, too. I make records and I can bust. That song describes the way I feel when I'm doing a show and the crowd's going crazy—I feel wicked."

Racially mixed crowds turned out for Cube's concerts. "But my objective is to talk to Black people because we need it so much," he mused. "Everybody else is just eavesdropping." ■

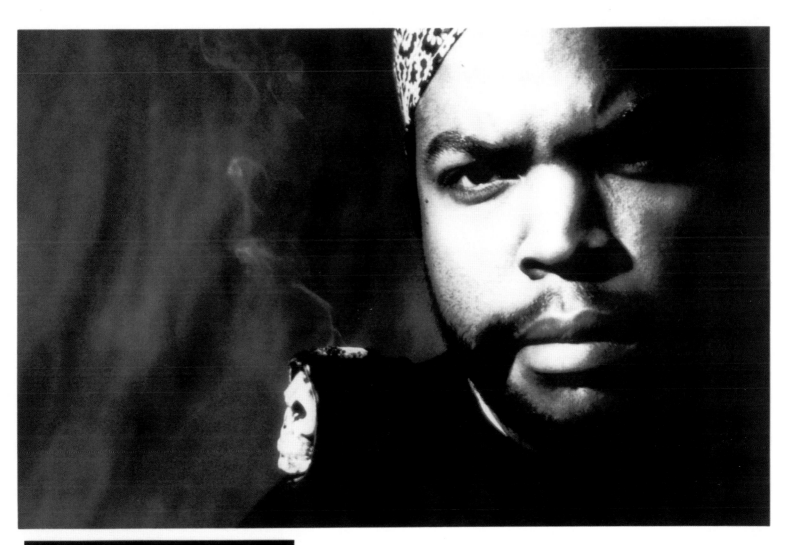

PRIORITY RECORDS

213.467.0151

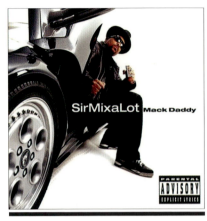

Billboard 200: *Mack Daddy* (#9)
Billboard Hot 100: "Baby Got Back" (No. 1)

With his butt-forward "Baby Got Back," **Sir Mix-A-Lot** spurred discord, parody and some genuine appreciation.

IT WAS a part of the female anatomy long celebrated by rappers, but Sir Mix-A-Lot became America's newest star for "beggin' for a piece of that bubble." His smash "Baby Got Back" (the first verse began, "I like big butts and I cannot lie") was a No. 1 hit, topping the *Billboard* singles chart for six weeks—even though most radio stations wouldn't touch it, calling it sexist and racist, and MTV, after briefly banning the video where Mix bounced on a giant mocha-colored backside, would only air it at night.

But Sir Mix-A-Lot knew there was a bottom line to the controversy surrounding his paean to pulchritudinous posteriors. "The song is funny as shit, but it ain't just about big asses," the Seattle-based rapper said. "I'm trying to destroy the beanpole image of what those white folks at *Cosmopolitan* and *Playboy* say is beauty. I'm sorry, but that's not beautiful to the average Black man."

Mix's inspiration came from models who complained to him that they were considered too fat for many jobs. In his rap, he dissed the media for promoting a skin-and-bones feminine ideal. "A lot of women have thanked me for it," he noted. "I'm telling Black women that Black men love them as they are—curvy is still in as far as I'm concerned."

Mack Daddy, his platinum album, stated his party agenda, but he also got into harder territory. "One Time's Got No Case" offered a more realistic and sensible alternative to Ice-T's "Cop Killer"—Mix's protagonist struck back within the system. In the video, he recounted being harassed and assaulted by the police, but instead of seeking blood vengeance, he took the cop to court and won. As Mix said at the surprise ending of the song, "I fought with my brains and not with my gat." He also thanked his lawyers. "I still believe that the American system works," he explained. "You pimp any crooked system by hitting them in the pocketbook."

Sir Mix-A-Lot cited Seattle's isolation from the rest of the hip-hop world as a source of his originality. His home was a stately 13-acre spread where he truly lived the life of a multiplatinum artist—two gyms, a state-of-the-art recording studio, a home arsenal and a fleet of luxury cars. "I got a new Lamborghini, a Rolls Royce," he allowed. "But I'm kinda tired of them. I'm into fishing and fixing up the house."

Some people thought Sir Mix-A-Lot, whose real name was Anthony Ray, sent a negative message to kids with his flashy image. But there was not a more personable and eloquent figure in the world of hardcore rap. "I understand when a lot of rappers say, 'Let's live low and get kids away from the material things.' I agree, but it ain't gonna happen in America. Commercials push the shit constantly. It's wrong for kids to look up to Big Daddy Dope Dealer with his flyed-out car and his gold Rolex, but they do. I'm letting kids know you can own what you want legitimately. Come up legit." ■

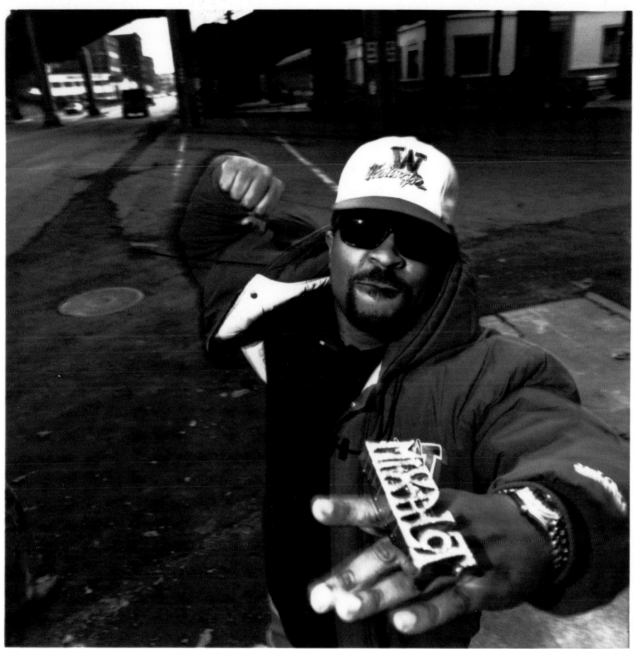

Photo Credit: Mark Hanauer

©1992 Def American Recordings/Permission to reproduce limited to editorial use in newspapers and other regularly published periodicals and television news programming.

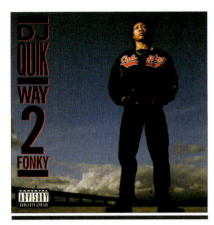

Billboard 200: *Way 2 Fonky* (#10)
Billboard Hot 100: "Jus Lyke Compton" (#62)

DJ Quik produced "Jus Lyke Compton," a record extolling West Coast rap as hip-hop's current gold standard.

RAPPER AND producer DJ Quik's *Way 2 Fonky* debuted in the Top 10 of Billboard's album charts, Top 10, and the single "Jus Lyke Compton" reflected his thoughts. The rhymes took on a resigned, almost dispassionate tone recounting his first tour—how the gangsta lifestyle of Compton had become endemic to urban life everywhere, how the scene in each city reminded him of home: "How could a bunch of suckers in a town like this/Have such a big influence on brothers so far away?"

The "Jus Lyke Compton" video was shot on the locations of cities in the song—Oakland, St. Louis, San Antonio and Denver—and briefly re-enacted a telling outbreak of violence. "In the song, I didn't mention Houston, Memphis or Phoenix—those were serious scenarios, too," Quik said.

DJ Quik had his share of doubters and critics—in Tim Dog's No. 1 rap single "Fuck Compton," the Bronx rapper said he would beat any Compton rappers. "Tim Dog was on that thing when it was hip, but I never had no serious animosity," Quik said. "It ain't personal because they don't know me—it's business. I actually like the music a little bit."

A love of instruments, as opposed to computers and sequencers, was at the root of everything else on *Way 2 Fonky*. Quik and his creative partner Rob "Fonksta" Bacon hunted down old hand-clap drum machines and keyboard to take his music back to post-disco funk, the full-bodied sound of George Clinton and Zapp. He was also lending his production skills to West Coast hip-hop artists such as Hi-C and the Penthouse Players Clique.

"And I'm doing 'Let Me Rip Tonight' (a tongue-in-cheek Seventies soul ballad) with a spinoff, Sexy Leroy & the Chocolate Lovelites," Quik enthused. "My stuff is party music—it's some funny, adult shit." ■

DJ QUIK

Billboard 200: *Totally Krossed Out* (No. 1)
Billboard Hot 100: "Jump" (No. 1);
"Warm It Up" (#13); "I Missed the Bus" (#63)

Kris Kross, a couple of cute kid rappers, leapt to double-platinum status with a monster hit single, "Jump."

HAVING KNOWN each other since the first grade, Chris "Daddy Mack" Smith and his partner Chris "Mack Daddy" Kelly soon became best friends. "We're twins who don't look like each other," Smith said. It was at the mall where Jermaine Dupri, an industrious 18-year-old Atlanta-based producer, spotted the two of them because of their baggy style of dressing. "They just had that look," Dupri said. "I knew they could be large, so I asked them if they could rap. They said, 'Yeah.'"

Kelly and Smith were only 12 and 13 years old when they recorded the catchy smash "Jump," a slap-rap sing-along track that displayed rhyming skills—"I'm bad, givin' you something that you never had/I'll make you bump, pump, wiggle and shake your rump." It became the fastest selling single in 15 years, and the debut album *Totally Krossed Out* reached No. 1.

The duo appeared cool and adorable on the record cover, but when they rhymed, they took it to the streets, not the playground. "We're as hard as little kids can get without using profanity," Kelly insisted. The pint-sized homies wore their clothes backwards, a style called "Krossed Out"—oversized overalls worn back-to-front, baseball caps twisted in reverse, front-to-back T-shirts and upside-down earrings. They got attention in the fashion press and were seen on the cover of every teen magazine.

"What kid wouldn't be happy?" Smith asked. "Have your own tutor and just do interviews every day and look at people and do shows and then have money—wouldn't you be happy?" ∎

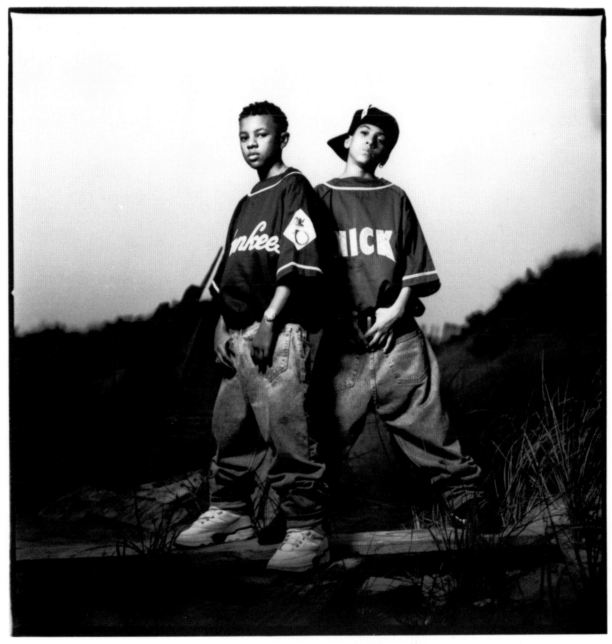

PHOTOGRAPH: MICHAEL BENSON

© 1991 Sony Music. Permission to reproduce this photography is limited to editorial uses in regular issues of newspapers and other regularly published periodicals and television news programming.

Columbia
9112

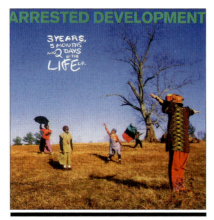

Billboard 200: *3 Years, 5 Months and 2 Days in the Life Of...* (#7)
Billboard Hot 100: "Tennessee" (#6); "People Everyday" (#8); "Mr. Wendal" (#6)

Arrested Development's intriguing amalgam of charisma and wisdom experienced near immediate appreciation.

MOST RAP used urban dysphoria as its platform, but the emerging new style in hip-hop was being labeled "alternative rap" by the music business. The smartest exponent of the movement was Arrested Development, a Georgia sextet with self-described "life music"—positive intentions and spiritual hopes carried by bright, imaginative musical signatures.

23-year-old Speech, Arrested Development's erudite leader, writer and producer, was beginning to realize that people were taking the outfit seriously. "This is all new to us," he noted. "We had a hard time getting a record deal because our music tries to change things. We're pro-Black and uplifting, and we talk about reality—community, hospitality, respect for your parents, listening to the wisdom of elders."

Speech (real name: Todd Thomas) had been an activist for several years—he wrote a column for his parents' newspaper in Milwaukee—but he'd channeled his energy into Arrested Development. He and his partner Headliner met in 1987 at an Atlanta art school and formed a gangsta-rap act, inspired by Public Enemy's militant music. "I was just starting to rhyme and I needed a deejay," he mused. "But I felt a need, there was a void. No one in hip-hop was expressing my values."

Arrested Development dropped the male-braggadocio approach and evolved into a tightly knit, more coherent and persuasive Afrocentric family. Speech's mission was to counteract what he saw as gangsta's negativity with a more unifying outlook, celebrating Mother Nature, Black life and rural blues. He steered clear of misogyny—the well-meaning collective was one of the few rap groups with strong female members.

The multimember band moved into a house in the countryside and released *3 Years, 5 Months and 2 Days in the Life Of...*, a cutting-edge debut album. "Tennessee," Arrested Development's first single and video, was a smash on the R&B and pop charts and on MTV. Speech wrote the captivating song—a wistful open prayer to God for enlightenment and peace of mind—after his grandmother and only brother died within a week of each other.

Speech addressed homelessness in "Mr. Wendal," and "People Everyday" (a rewrite of Sly & the Family Stone's "Everyday People") was about a street incident with Black men testing each other's manhood. "It's based on a lot of experiences," he explained. "You have that confrontation between what I call a nigger and an African. A nigger wallows in his oppression. An African is constantly struggling to get out of his oppression."

Arrested Development won two Grammys (the first rap act to win the Best New Artist award), and the group's appealing, unique artistry landed a headlining spot on the Lollapalooza tour. "We go onstage to celebrate life, death and the struggles of our ancestors," Speech declared. "Every night, that's what we want to accomplish." ∎

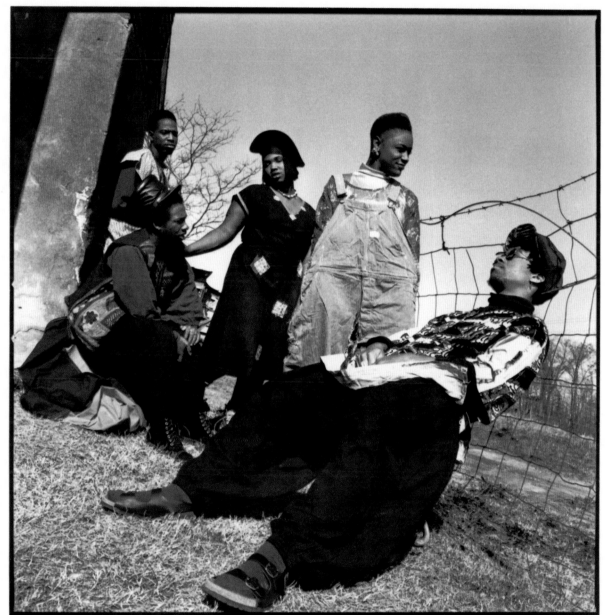

ARRESTED DEVELOPMENT

Photo: Jeffrey Scales '92

EMI Records Group
North America

Chrysalis®

Billboard Hot 100: "Sad New Day" (#83)

One signified **Me Phi Me** as a distinctive presence in rap music, using folk and pop as his chief cornerstones.

IT WAS almost impossible to generalize about rap music anymore—the inner-city art form had grown and evolved beyond hip-hop into bold new splinter groups that defied categorization. The newest development gaining ground on the charts was less self-promoting and a bit more literary and hopeful.

And in the vanguard of emerging Black performers was Me Phi Me, whose *One* album was a stunning debut. Me Phi Me penned wry, intelligent lyrics about world peace, self-respect and himself, adapted to street grooves. But to carry his cadenced rapping and singing, he preferred the organic sound of real instruments—like swells of acoustic guitars and harmonicas—to pre-recorded tracks.

"My music wasn't planned—my producer and I were trying to do something warm and earthy but still funky," Me Phi Me explained. "It's something we just stumbled upon. We lump together all good things to be found in almost everybody, from George Clinton to Bob Dylan. I think of everybody together—I look in my record collection and Public Enemy sits next to Paul Simon."

The former Laron Wilbur grew up in poverty-stricken Flint, Michigan, a town hit hard by the General Motors layoffs in the Eighties. "My neighborhood became a ghetto in the blink of an eye," he recalled. "It just fell apart." A self-styled one-man fraternity (he'd branded the Greek letter *phi* on his arm), Me Phi Me studied classic poetry and fused it to hip-hop, a style he termed "big-beat poetry." It was an unusual blend, but not an off-putting one—at once exotic, insinuative and danceable.

One covered a lot of musical ground, bringing together everything from Black fraternal concepts—booming beats and African vocal harmonies—to folksy influences (new age/jazz guitarist Michael Franks guested on the album). The track "Sad New Day" was a surprise entrant on the pop singles chart. "I took the hip from hop, the roll from rock, the rhythm from blues, and I added some folk for folks," he explained, "then carefully thought about what really needed to be said to make you think." ∎

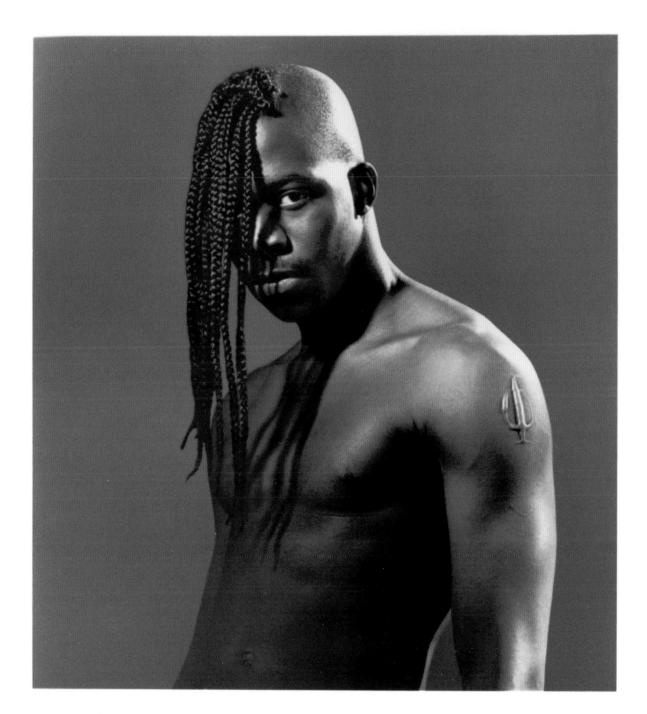

ON RECORD | 1992 | [DADA]

Billboard 200: *Puzzle* (#111)

Astute listeners were gaga over Dada's layered rock music, a mix of clever lyrics and inspired musicianship.

A WELCOME break from the guitar grunge dominating the charts, Dada's debut album, *Puzzle*, had just enough quirks to hold the ears of listeners used to more fast-loud-big-mean approaches.

"You know that scene—it happens a thousand times a day in America. Some guys get together with their favorite record and a photo and start a band," bassist Joie Calio said. "But we wanted to develop a harmony style, then a writing style. We wanted good lyrics and songs instead of vibe and attitude and clothes."

The Los Angeles trio created a buzz with the tuneful "Dizz Knee Land." The single took off on Disneyland's celebrated ad campaign, wherein a sports figure, having just won the Super Bowl or some big game, immediately proclaimed, "I'm going to Disneyland!" But instead of leaving the obligatory refrain to the usual assortment of clean-cut jock role models, Dada's song sardonically turned the tables, claiming the award for excellence and applying it to warped protagonists: "I just robbed a grocery store/I'm going to Dizz Knee Land…I just flipped off President George/I'm going to Dizz Knee Land…I crashed my car again/I'm going to Dizz Knee Land…"

The idea for the tune came to Calio in a dream at the time of the Persian Gulf War. "People think we went, 'Well, we'll use the word Disneyland and either get sued or get a big hit,'" he said. "Believe me, I wasn't thinking about it at all. It's not about Disneyland per se. The bottom line is just how crazy this world is, the information we receive in our day-to-day lives. We were making a record while the war was going on, a weird, uncomfortable feeling. We'd be glued to the TV getting bogged down with images of flying missiles and burning oilfields—and we'd flip the channel and see, 'I'm going to Disneyland!'

"I wanted to put that feeling together, the war and the commercials. I like the idea that it isn't the winner going to Disneyland, it's the loser. The song says we're not all winning right now—we're at war and people are getting shot."

Calio said he hadn't heard any feedback from the theme park, even though the Walt Disney Co. was notorious for dispatching lawsuits for trade-name infringement. The altered spelling of "Dizz Knee Land" was a goof.

"During a recording session, when you're in a room with five or six guys, you get 'studio fever'—you start making jokes to amuse yourself and pass the time," Calio explained. "On the schedule board, there was a list of the songs and what we'd gotten done. After a while, we started erasing the real names and putting in profane ones, different ones. I wanted to name that song something else, and that helped me. Disney doesn't need any help advertising."

The *Puzzle* tracks "Dim" and "Here Today, Gone Tomorrow," which took more of a direct approach, were modern rock hits as well. ■

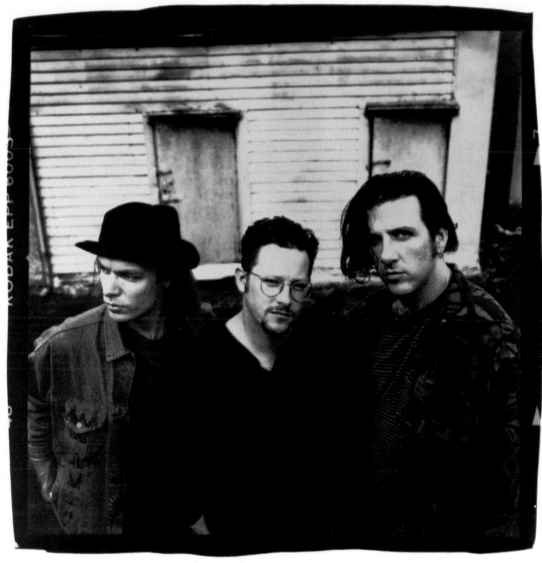

Michael Gurley Phil Leavitt Joie Calio

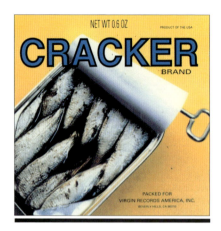

The puckish "Teen Angst (What the World Needs Now)" introduced **Cracker**, David Lowery's newborn band.

THE MEMBERS of Camper Van Beethoven, an iconoclastic combo of playfully eclectic surrealists from California, were the darlings of the Eighties rock underground. Leader David Lowery's unique aesthetic first emerged on his absurdist lyrics to "Take the Skinheads Bowling," a college radio hit. But the band broke up acrimoniously in 1990. Three Campers had forayed into jazzy ethnicity in a side project, Monks of Doom. Cracker was Lowery's new band.

"Camper was on a tour of Europe and those guys quit 10 days from the end—that was the stupid part," Lowery said. "The competition's weird lately. They've said nasty stuff, so my band rallied. I wish it was more controversial. I wrote songs to get ready for something else, but I waited a year. I thought they'd get over it and we'd start Camper again. I didn't betray Camper to do Cracker. I was proud of that experience—we did good work."

Lowery had known his Cracker bandmates since the Seventies—Johnny Hickman, a versatile guitar stylist, had done a stint in Bakersfield, California writing country songs. "It's a lot more physical—my vocals get to the shouting stage," Lowery enthused. "One of the things I'm trying to do with the band is get in touch with the stuff I liked in high school, the loud part of rock 'n' roll, playing fast."

The gems on the band's catchy self-titled debut album were less esoteric than Camper's. "Teen Angst (What the World Needs Now)," which emerged as a No.1 modern rock track, was "a venting." Lowery rambled about different things ("'Cause what the world needs now is another folk singer/Like I need a hole in my head") before realizing the subject.

"People ask, 'What do you have against folk singers?' I don't have anything against folk singers," Lowery said. "The speaker in the song is frustrated, so he's talking about things he's frustrated with, but he's really frustrated with something else, and by the third verse it comes out—it's lust. He can't get this girl in bed."

Another example was the lively "Happy Birthday to Me." "There are two kinds of songs—the ones that take you about six months to write, and the ones you write in an afternoon," Lowery explained. "'Happy Birthday to Me' is one I wrote in an afternoon. It's about being a fuckup, basically—friendships found through people who are also fuckups." ∎

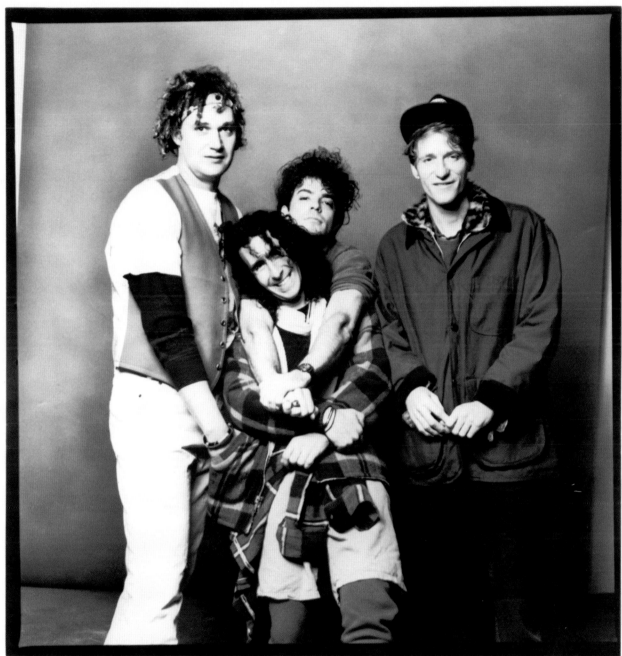

CRACKER

Billboard 200: *Mental Jewelry* (#73)

Making the leap from small-town origins to a neoteric success story, **Live** sprang forth with *Mental Jewelry*.

A YOUNG quartet from York, Pennsylvania, Live started out playing local dances and bars. The members won a high-school talent show and started thinking, "Hey, maybe we're on to something here." Live honed its musical vocabulary, and *Mental Jewelry*, a debut album produced by Talking Heads' Jerry Harrison, documented the struggles of four 21-and-under individuals with the outside world.

"We've been thrown into the ocean of the music business," frontman Ed Kowalczyk said. "We're the epitome of the cart before the horse—we got a record deal when I was at age 20, and we had a record in stores before I owned more than 10 records."

There was an unrepentant solemnity about Live, a willingness to tackle philosophical issues through the aesthetics of rock. Kowalczyk convincingly sang ambitious songs about pain, love and what it meant to be human. *Mental Jewelry* spawned a pair of alternative hits—"Operation Spirit (The Tyranny of Tradition)," a No. 1 track at college radio, invited people to release the burden of the past ruling them in the present, and "Pain Lies on the Riverside" encouraged an open spirit at different times in life. "I am 10,000 years old at least—we are all products of 10,000 years of recorded history," Kowalczyk said.

In concert, Kowalczyk did what the music demanded of him, performing with passionate intensity. "I'm not consciously trying to develop a persona," he said. "I think of myself as a weird love child of Michael Stipe, Bono and Peter Gabriel, people that I've been totally into growing up."

The band was named as one of 1992's "Hot Picks" in *Rolling Stone* magazine by Jeff Pollack—a commercial radio consultant responsible for turning the airwaves into a wasteland. "Well, we couldn't tell him not to say it," bassist Patrick Dahlheimer noted. ∎

+Live+

5/92

radioactive

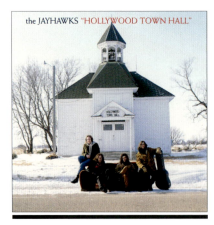

Billboard 200: *Hollywood Town Hall* (#192)

The Jayhawks emerged as critical favorites and cult heroes with their alt-country classic, *Hollywood Town Hall*.

INDEPENDENT RELEASES had brought the Jayhawks considerable attention—*The Village Voice* dubbed the group "the only country-rock band that matters." Singer-guitarists Gary Louris and Mark Olsen wrote exquisite songs in the rootsy, soulful spirit as pioneered by Gram Parsons.

Though it was still full of country flavor, Hollywood Town Hall, the Minneapolis-based quartet's major label debut, featured plenty of hooks to grab devoted pop-rock fans. With George Drakoulias producing (he was looking for a new project to follow up his success with the debut by the Black Crowes) and guest turns by Heartbreakers keyboardist Benmont Tench and Nicky Hopkins (the Rolling Stones), the record showcased the Olson/Louris songwriting team with a fuller, warmer sound.

"There's a Sixties country influence, but we certainly don't pretend to be a country band," Louris said. "I'm sorry for people who are looking for that. I sounded more like Parsons and the Flying Burrito Brothers at the beginning, but then you find your own thing. I'd like to make a lot of records—an acoustic record, a country record.

"But right now, we're in a rock band with fuzz guitar. It's hard to play country music well, and not a lot of people do. It takes a lot of restraint, playing very simply. I'm happy not to be associated with the style—it's a fad, it's in commercials. You know it's gonna go away, it's cyclical. Hopefully, we'll still be here doing what we do.

The single "Waiting for the Sun," which received MTV video play, had a Neil Young-ish flavor, and "Crowded in the Wings," "Settled Down Like Rain" and "Take Me with You (When You Go)" were also radio favorites. Trading vocal harmonies, Louris and Olsen evoked late-night friends having coffee at a diner counter.

"The symmetry happened right away, organically," Louris noted. "The writing became a mutual kind of productivity. We encouraged each other—there wasn't a lot of jostling for material. We both have our names on everything. A lot of times you have to get to a comfort level with the other person so you can play anything for them—and not get embarrassed by what might be your best or worst stuff." ∎

Mark Olson Gary Louris Ken Callahan Marc Perlman

THE JAYHAWKS

Photo Credit: Paul Natkin

©1992 Def American Recordings/Permission to reproduce limited to editorial use in newspapers and other regularly published periodicals and television news programming.

Billboard 200: *Change Everything* (#178)
Billboard Hot 100: "Always the Last to Know" (#30)

The hit "Always the Last to Know" consolidated **Del Amitri**'s melodic, guitar-driven brew of folk, rock and pop.

WITH 1990'S *Waking Hour*, Del Amitri had broken through—the album achieved platinum status in England and Australia, and the singles "Kiss This Thing Goodbye" and "Nothing Ever Happens" made inroads in the US market. But frontman Justin Currie begged off being pressured by the international success. "Anybody in a pop band who says they know what they're doing any given second is either lying or stupid," he said. "Generally, you fumble around and hope for the best."

Currie, who formed the original Del Amitri lineup in 1983 with guitarist Iain Harvie, regarded his band as toughened up by endless touring. "1990 was bizarre. It started with a big hit in the UK and we remained on the road for 18 months. You can only commit yourself to staying there until you get it done. When we got off, tired and drunk, we took stock."

The Scottish combo's *Change Everything* collected intelligent songs propelled by heartfelt lyrics and nifty musical hooks. "We wanted something warm, that would fit right alongside records from the Seventies," Currie explained. "Using modern technology and synthetic sounds can't really match hitting an old electric guitar and valve amp. Those things have the emotional appeal for us. We don't fit in with any specific bandwagon. Our music's cool, but the band is kind of un-hip."

There was no denying the smoky intensity of "Just Like a Man," and Currie's vocal on the gorgeous single "Always the Last to Know" was richly persuasive. "It's a classic infidelity song," he said with a shrug. "It's not a country song, but the lyrics are in that vein—'You've been unfaithful…why am I back?... I don't know.'" ∎

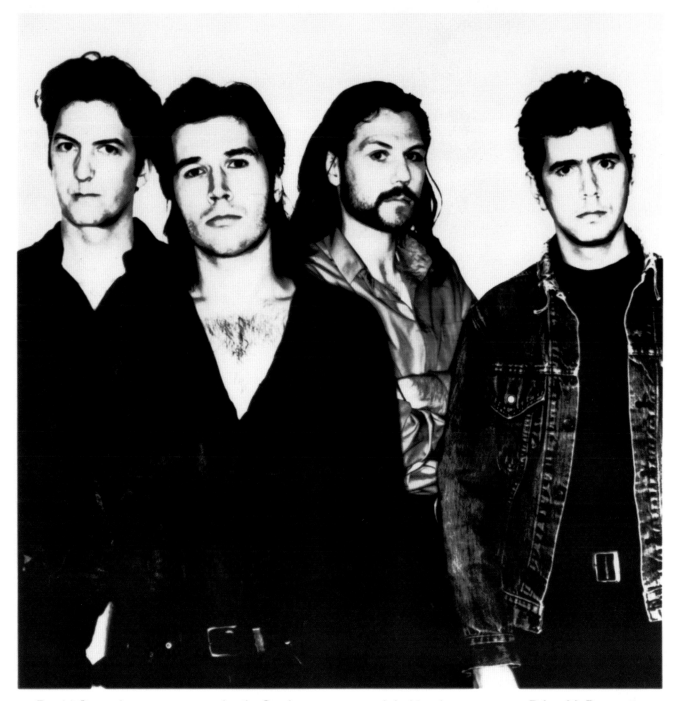

David Cummings　　Justin Currie　　Iain Harvie　　Brian McDermott
DEL AMITRI

A&M RECORDS

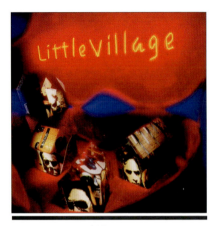

Billboard 200: *Little Village* (#66)

Ry Cooder, Nick Lowe, Jim Keltner and John Hiatt came together as the roots-rock supergroup **Little Village**.

TAKING A cue from the Traveling Wilburys, Little Village was an all-star lineup—but the four musicians were critically acclaimed, not legendary. John Hiatt, Ry Cooder and Nick Lowe all enjoyed renown for their roots-conscious solo ventures, and Jim Keltner boasted a long and impressive drumming résumé (the Wilburys, John Lennon). As Little Village, they achieved a higher level of popularity.

"There was a time when I couldn't even get a parking space at my record company," guitarist Cooder noted. "Now I park easy—same lot attendant, but it's different. The day that he knew my name and said, 'Please park here' after 20 years, I thought, 'I'll be damned—little victories for Little Village.'"

Little Village was a half-decade in the making—the distinguished cohorts first gathered to back Hiatt on his 1987 comeback album *Bring the Family*, a "magical" four days of sessions.

"All great bands have a complementary thing, going into the unknown and playing instead of just doing parts," Cooder mused. "I'd been with Keltner for 20 years—there isn't anything I do he doesn't play on. There was Hiatt with his oblique guitar playing and his terrific voice and songwriting. I didn't know Nick Lowe, but his presence held things together—the bass is the instrumental glue. We played so good, but I didn't think anything about it at the time—we were all busy doing something else."

Talk of a new collaboration was stifled by their different managers and record companies, but the four men eventually returned to the studio, taking the name Little Village from an old Sonny Boy Williamson studio discussion with a producer (the argument was sampled on the album's final track, "Don't Bug Me When I'm Working"). The material on *Little Village* was group-written, and despite Cooder's fiery and intelligent guitar work, skeptics said the songs weren't as good as on past individual projects.

But commerciality wasn't the band's driving force. The veteran players wanted to flaunt their mutual tastes rather than their writing chops, romping through playful, contemporary soul-pop grooves with titles such as "Solar Sex Panel" and "Don't Think About Her When You're Trying to Drive." "I've had a pretty good run, but it would complete the picture to sell some records—naturally, we want to connect in that sense," Cooder admitted.

All of the guys copped to having volatile artistic temperaments, which made the supporting tour delicate—rumors swirled that they were fighting like crazy. "We've progressed exponentially every night we've played, or at least gotten more focused—a band takes shape in performance, not in the studio," Cooder said. "Taking it a step at a time is about all anybody can do." The group called it a day later in the year. ■

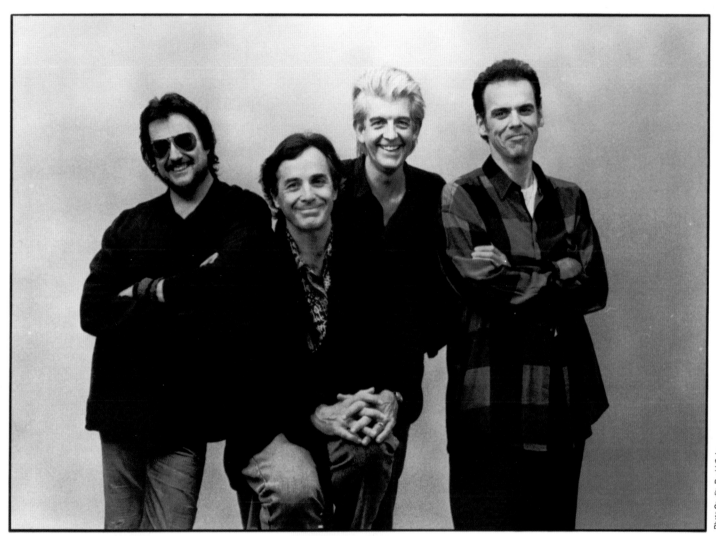

Jim Keltner Ry Cooder Nick Lowe John Hiatt

Little Village

reprise

© 1992 Reprise Records. Permission to reproduce limited to editorial uses in newspapers and other regularly published periodicals and television news programming.

Photo Credit: David Gahr

Billboard 200: *Human Touch* (#2)
Billboard Hot 100: "Human Touch" (#16);
"57 Channels (And Nothin' On)" (#68)

Bruce Springsteen issued *Human Touch* and *Lucky Town* concurrently amid accusations of "going Hollywood."

SINCE HE recorded 1987's *Tunnel of Love*, Bruce Springsteen had dramatically altered the circumstances of his life. The rocker broke up with his first wife, actress Julianne Phillips, and married a singer in his band, Patti Scialfa. They had two young children. He had also called it quits with the members of his popular E Street Band. After he moved from home state New Jersey to a $14 million Beverly Hills mansion, some cynics complained that he had lost touch with his blue-collar audience.

But Springsteen had clearly had his fill of the idol/role-model gig, and he no longer wanted to promote the illusion that youth lasts forever, the love-on-the-highway mythology his music described at the peak of his popularity in the mid-Eighties. At age 43 with a family, he and his outlook had matured.

"In a lot of your fans' lives, you're an imaginary character," the rock star said. "I've created one out of myself, and it's sort of like, 'Hey, what Elvis stamp do you want? Do you want the young Elvis or the old Elvis?' And that's for people to sort out themselves. I've done the work and it's there, and how you relate to it is for you to sort out."

There was no magic to his message, Springsteen said. "You see a lot of things expressed in rock music, but there's still not a lot of people who feel comfortable just expressing a pure kind of happiness—they think other people will mistrust it."

Springsteen released two albums, *Human Touch* and *Lucky Town*, on the same day. *Human Touch* was the more popular of the two, and each went platinum, but they quickly dropped toward the basement of *Billboard*'s chart, and extended sales were disappointing. His intense "get real" passion was too much for a general audience during the nation's prolonged malaise

"It's funny, because on one hand, people use pop music to be immediately of the moment, trendy," he said. "And then on the other hand, people use popular music to stop time for them in some fashion, like when you go back to your high-school reunion and they're playing all the songs from 19-whenever.

"My job isn't to come out and to continue putting people into cars because it feels like, 'Yay, the open road!' My idea was to find some place for me to go, which is what everybody is looking for. You just try to come up with something to make sense of a world that's increasingly chaotic, frightening and difficult to find any place to stand." ∎

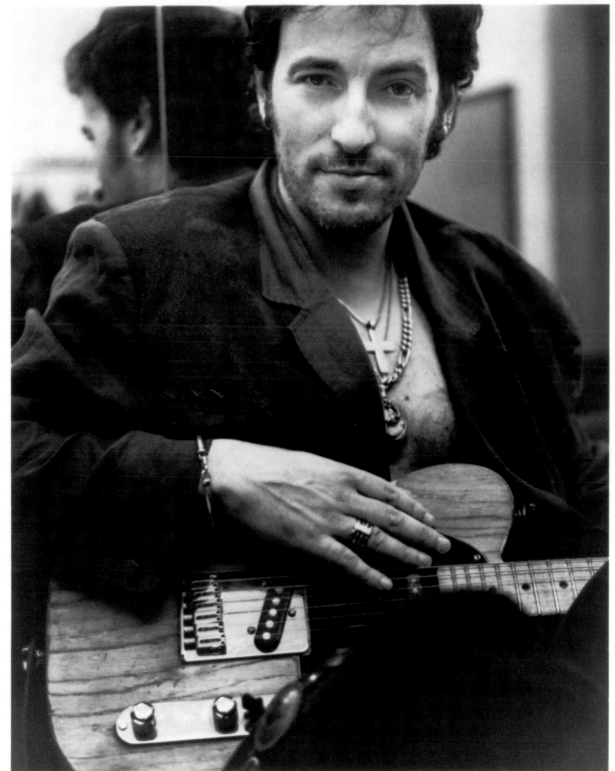

BRUCE SPRINGSTEEN

Columbia
9203

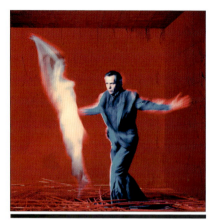

Billboard 200: *Us* (#2)
Billboard Hot 100: "Digging in the Dirt" (#52); "Steam" (#32)

Already established as an adventurous, intuitive artist, **Peter Gabriel** broadened his lyrical province with *Us*.

SINCE FIRST coming to attention as Genesis' eccentric frontman in the late Sixties, Peter Gabriel had excelled as one of rock music's most original thinkers, always ready to experiment with new polycultural ideas. But Gabriel himself was unimpressed.

"I take it all with a pinch of salt—I've been hot and cold, written off many times over," the musician said. "So even though I want and seek success, I try to keep my attention focused on good work. In the long run, that's what counts to people."

Gabriel's signature sound hadn't changed much since his Eighties heyday, when he composed "Shock the Monkey" and his 1986 No. 1 hit "Sledgehammer." *Us* synthesized all the world music influences that he did so much to bring to western ears—only one track didn't feature an exotic instrument. Gabriel also weaved a variety of computer-generated textures. "Steam" had the same snappy feel as "Sledgehammer," and "Digging in the Dirt" and "Kiss That Frog" were equally engaging.

But *Us* was Gabriel's most confessional and intimate work to date, tracing the complicated fault lines of his relationships. In the six years since his last pop album, Gabriel had endured a divorce from his wife of 16 years and a failed love affair with actress Rosanne Arquette. Gabriel dedicated *Us* to those who had taught him "about the intricacies of loving and being loved." The songs weren't exactly boy-meets-girl/boy-loses girl, but they documented his romantic obsessions.

Gabriel recognized that the world didn't need another musician pouring his heart out. "But there aren't many people who are prepared to confront some of their vulnerable aspects," he noted. "A lot of people are quite happy to talk about broken hearts, but the other half of that is excluded—their role in the situation, in the sense of owning up to the bits that aren't flattering."

Gabriel hadn't always been prone to introspective lyrics. Over the course of his career, he'd tended to write in more narrative form, often peopling his stories with make-believe characters. But "creation as therapy" was how he described the process of making *Us*.

"In song, your feelings are trapped in a form—there's a safer environment, it freezes," he explained. "But I've been doing a lot of group therapy work, and that's more challenging in a way—people struggle against accepting what they are, especially the negative, dangerous things. If you get comfortable coming out with that, it leaves you lighter and freer. I think I'm more adult. I use John Lennon as a reference and inspiration, someone who grew up jealous and angry and dealt with it in his music." ■

PETER GABRIEL

GEFFEN

© 1992 The David Geffen Company / Permission to reproduce limited to editorial uses in newspapers and other regularly published periodicals and television news programming.

Photo Credit: Alan Beukers

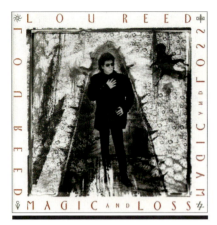

Billboard 200: *Magic and Loss* (#80)

With *Magic and Loss*, **Lou Reed** tackled weighty themes of mortality and the rehabilitation of the human spirit.

LOU REED could be a pretty frightening guy. Since his early days fronting the defiantly avant-garde Velvet Underground and throughout most of his solo career, the scowling rock poet had sung about heroin users, transvestites, social misfits and murderers, sadomasochism, attempted suicide and nihilism. A studied outsider with a taste for the seamier side of traditional rock values, he was known for his outrageously decadent image as much as his music.

But over the years, cultural connoisseurs had come to recognize Reed as a serious artist. He pushed himself into creating meaningful, contemporary adult-rock records for committed fans willing to give him the benefit of a doubt, the nimbus of unassailable integrity enveloping him. "Experience is good for quite a few things," he said. "You learn to watch where you walk, to look down first. You don't always fall down a staircase that way."

Reed had sought simply to chronicle existence with a trilogy of concept albums. After exploring the lives of public figures in 1989's *New York* and the life of an artist (Velvet Underground patron Andy Warhol) with former bandmate John Cale in *Songs for Drella,* Reed recorded *Magic and Loss*, his 16th solo album, as a reflection on the illnesses and eventual deaths of two close friends from cancer.

"It was very difficult to write this album, about how the magic of life transforms this loss into something else," Reed said. "But in the end, it seems to be a positive experience—the feelings you have internally are transferred to the album and then they're not in you anymore. It's a strange give and take, which I'm not exactly sure I understand. It's an adult album, but it's something that people can relate to with AIDS and cancer, things that happen to relatives and friends. I'm actually surprised that there aren't more albums about these subjects out there."

The track "What's Good" reached No. 1 on the modern rock charts. "I think *Magic and Loss* is a very 'up' album—it makes you feel better, because what I gained from what happened to my friends is really very inspirational," Reed said. "And I wanted to communicate this 'other' way of looking at something. There's a line in 'What's Good' that means a lot to me—'You loved a life others throw away nightly.' That's one of the things I got from these people—how much they really would fight for a life."

Onstage, where Reed performed a beautiful version of "Magic and Loss," the somber reflection on death was occasionally marred by fans shrieking "Lo-oo-ou!"

"It takes all kinds," Reed said. "It's a special kind of show—maybe I shouldn't be playing it in front of people, maybe it requires a little too much attention. But I'm on a mission. I've had signs up at some theaters saying, 'If you dislike this material, ask for your money back before the intermission.' And very rarely are there any takers. So, after all these years, I've reached this conclusion—I don't understand anything about anybody!" ∎

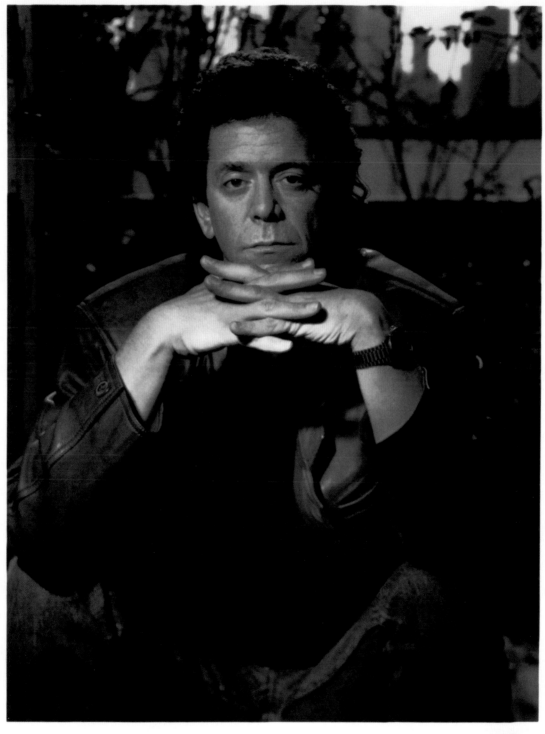

L O U R E E D

Photo Credit: Diego Uchitel

© 1991 Sire Records Company/Permission to reproduce limited to editorial uses in newspapers and other regularly published periodicals and television news programming.

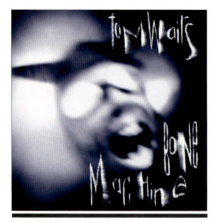

Billboard 200: Bone Machine (#176)

The calamitous *Bone Machine* rated as the most verbally and sonically abstract album **Tom Waits** had ever done.

TOM WAITS had been making music for 18 years, his early works telling jazzy and ballad Tin Pan Alley-style stories in sung verse. But that songwriting approach had given way to impressionistic aural architecture. "I've always been odd man out or the fifth wheel or something," Waits mused. "But maybe that's because I don't necessarily identify with groups."

Waits had changed to a rough, stripped-down, percussion-heavy manner of recording—gnarled, dense short films featuring more unusual recording techniques and odd instrumental textures. *Bone Machine* was his first album of new songs in five years, and his first ever to net a Grammy (Best Alternative Album).

"If there's too much subtext or baggage, it inhibits your spontaneity," Waits explained. "So I hire people for bravery, who are naturally curious and non-judgmental. You bring something in the studio and they stick it in the middle of the room and circle it like a moon rock and figure out some way to get a sound out of it. It makes you have to redefine yourself—what is music? Words themselves are music—their shapes, their ingredients. I like to get down to that."

On *Bone Machine*, Waits co-wrote a dozen songs with his screenwriter wife of 11 years, Kathleen Brennan. They worked together with a rented piano in a local hotel room. "Well, they say the way that you do anything is the way you do everything," Waits said of the collaboration. "It's songwriting, not brain surgery. You're essentially gluing pieces of macaroni onto a piece of cardboard and painting them gold. She's broadened my view of the world—of course, she's a broad. She's my seeing eye. We're compatible on many levels."

He recorded some of *Bone Machine* on portable cassettes at home and played percussion—he built a sound sculpture he dubbed the conundrum—or drums on almost every track. A couple of songs dealt with societal and political ugliness, "a new category for me." Waits the family guy had quit drinking and smoking, but his trademark crazed howling and bluesy barking remained. Guest musicians included David Hidalgo (Los Lobos) and Keith Richards.

Waits' emphatic "I Don't Wanna Grow Up" would be covered by Ramones and others. "It's good to do other people songs," Waits allowed. "The trouble is, we don't really know the same songs now—there's so much demographic isolation, they've got us all pegged as little groups so that they can sell stuff to us. I could make a waffle iron. I can make a lamp or a pair of boots, you know what I mean? But I can also make stuff that nobody knows what the hell to do with, which is also fulfilling for myself. But it's good to know that you can put two grooves into it and someone can use it for an ashtray." ■

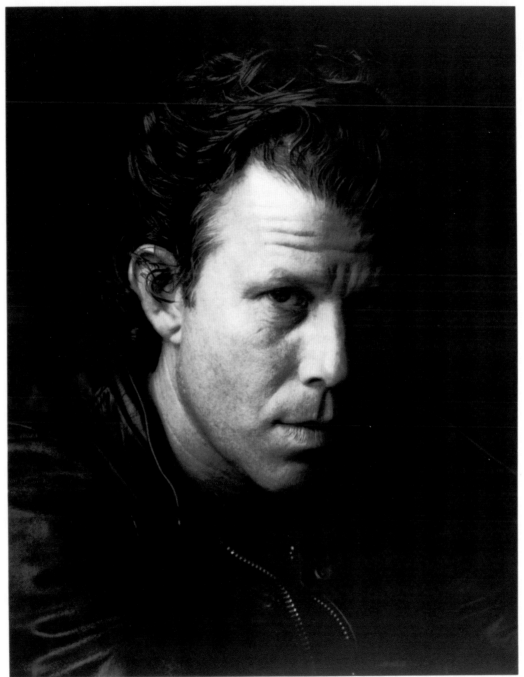

TOM WAITS

Billboard 200: *Kiko* (#143)

Los Lobos took a risk with *Kiko*, a venturesome undertaking of tuneful observations and impressive creativity.

1987's CHART-TOPPING version of "La Bamba" brought Los Lobos fame and fortune, but the remake's popularity remained at odds with the band's depth and direction. The East Los Angeles quintet could have easily followed with another album in the same mainstream vein. "But we didn't want to sell Doritos for the next 25 years," drummer Louie Pérez said.

Instead, Los Lobos opted to stake out new artistic terrain, warping regular song structures in favor of funky, highly textured sound collages. Drastically diminishing the sense of roots-oriented rock 'n' roll, the band retained Mexican-folk influences and a boogie-driven barrio approach, but found new directions by adding touches of swing and psychedelia, going deeper in a jazzier, mellower mood.

"The marching orders were to experiment, push harder and see what's there," saxophonist Steve Berlin said. "What would happen if we took styles and expanded them farther than we thought we could? What constitutes a pop song if we affected this and that?

Kiko had more colors than any previous Los Lobos project. "Wicked Rain" was an ominous Otis Rush blues with spacey sound effects, the evocative "Dream in Blue" had a New Orleans second-line beat and the traditional "Rio de Tenampa" was a big-band waltz. The eclectic textures and rhythms of the elliptical songs (subdued tales of hope and despair written by guitarist David Hildago and Pérez) were held together by Mitchell Froom's production—he pulled together the band's varied talents into a challenging yet listenable package.

"When you do a record like this, you're searching," Berlin explained. "You need willing participants, engineers and producers who make it okay to go after a broad variety of sounds instead of giving up when it sounds cheesy."

The press was tempted to describe *Kiko* as Los Lobos' equivalent of *Graceland* or *Achtung Baby*. "What the fuck does this have to do with *Graceland*? We hate Paul Simon with a passion," Berlin seethed. "He literally stole a song from us for that album ('All Around the World or the Myth of Fingerprints') as if he'd come up to us on the street with a gun on our backs in broad daylight. But I'll accept the U2 statement with pleasure. I'm not a big fan, but they reinvented themselves, hammered away at their own image as self-righteous gods. We both took a giant step and made courageous records.

"There are other people doing similar things, making career statements in terms of 'This is what I am'—k.d. lang, Lyle Lovett. The thread is a wave at what passes for rock radio—no one is concerned about it. That steels you, because we'll have to find another way to sell this record. But we made it the way we wanted to." ∎

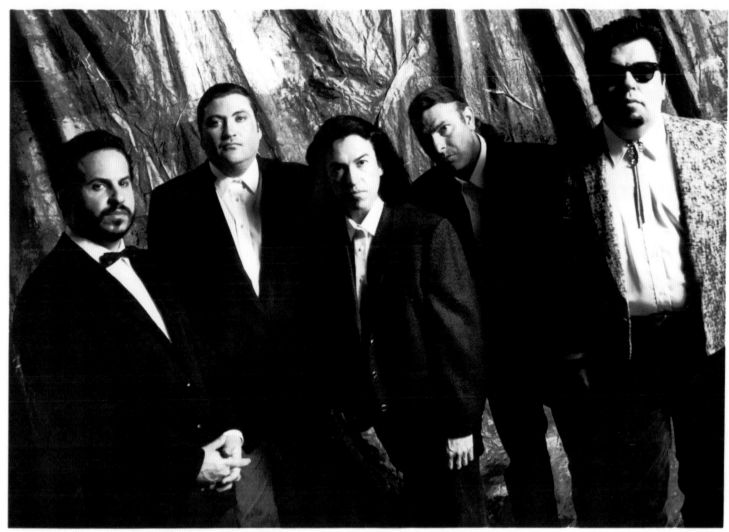

Steve Berlin David Hidalgo Louis Perez Conrad Lozano Cesar Rosas

Los Lobos

© 1992 Warner Bros. Records. Permission to reproduce limited to editorial uses in newspapers and other regularly published periodicals and television news programming.

Billboard 200: *Joshua Judges Ruth* (#57)

Lyle Lovett playfully designated *Joshua Judges Ruth* as "conversations with God about death, food and women."

ON HER "I Feel Lucky" single, Mary-Chapin Carpenter fantasized that "Lyle Lovett's right beside me with his hand upon my thigh." "I was disappointed she didn't tell the whole story," Lovett deadpanned. "But now people back home are hearing my name on the radio—they think I've really arrived."

Most hip folks knew Lovett was one of the best performing singer-songwriters to come out of the mid-Eighties. He was labeled country after three albums in Nashville and winning a country music Grammy in 1990. But country hardliners criticized the clever Texan. They felt that, from his unique haircut on down, the guy wasn't Nashville spawn, and they accused him of misogyny because of his wry, dark insights into "the man-woman thing." "It's sort of fun to pick on people, see how much of an irritant you can become," the genuinely soft-spoken and polite Lovett admitted. "But I don't feel like I do that."

Lovett's base of operations had moved to Los Angeles—his record company was hyping *Joshua Judges Ruth* to the rock and pop market. The album was recorded with some studio musicians in addition to members of his own band. Guest artists included Rickie Lee Jones, Emmylou Harris and Leo Kottke.

Joshua Judges Ruth (named after three consecutive books of the Old Testament) was an extraordinary mix of gospel, blues and ballads, but Lovett hadn't lost his skewed sense of humor. "You've Been So Good Up to Now" wasn't a "cheating on" song. "Rather, it's a 'cheating with' song," he said. "There's a story behind it, and, of course, I can't tell it." "Church" dealt with a long-winded preacher who sermonized past the choir's lunchtime, getting ever more frenzied until he eats a passing dove.

Lovett's apparent evolution from country toward a bluesier sound had less to do with songwriting than with song selection. "The whole thing of making records has been a continual process—it's all the same rather than segmented to me," he said. "I'm always writing songs, working on stuff, going out and playing every couple of months."

Lovett had another L.A. connection—he had made his acting debut as a dour detective in Robert Altman's film *The Player*. But he hadn't gone Hollywood—he was at home in the Houston area, where he was born and raised and where his family had lived since the 1840s. He graduated from Texas A&M in 1980 with a journalism degree.

"I was a perpetual student because going to school was legitimate—playing music isn't a real job where I come from," he mused. "Nashville was a revelation. You could go to a bank if you were a songwriter and get a house loan. But I don't think I had what it takes to be a journalist. For one thing, you have to tell the truth." ∎

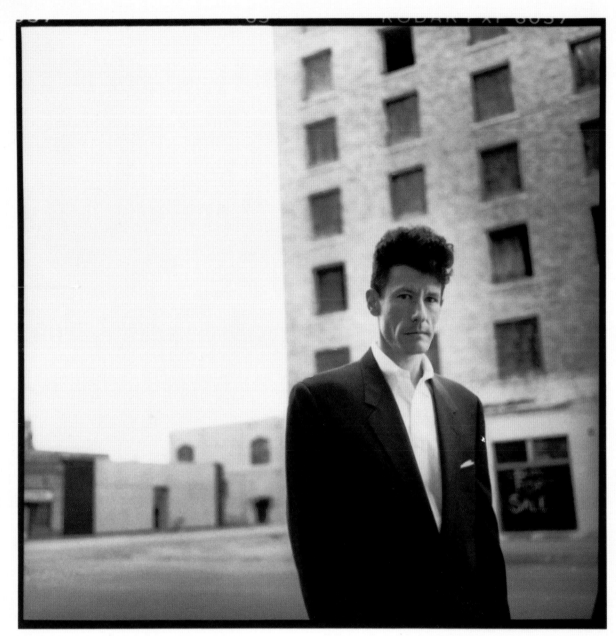

Photo credit: Peter Nash

LYLE LOVETT

3/92

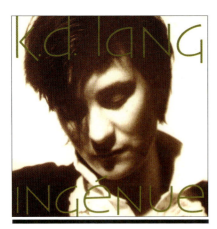

Billboard 200: *Ingénue* (#18)
Billboard Hot 100: "Constant Craving" (#38)

An intrepid reinvention, *Ingénue* boasted k.d. lang's matchless voice and the breakout hit "Constant Craving."

EARLY IN her career, k.d. lang was a performance artist. The western Canada native then released a series of unorthodox, giddy cowpunk-from-hell albums that won a legion of fans, but the traditional country music establishment eschewed her somewhat kitschy manner, androgynous short-haired appearance and outspoken animal-rights activism.

The mainstream success that had escaped lang finally arrived with her fifth album, *Ingénue*, a rapturous reflection on unrequited love that showed relatively little country inclination, redefining her as a torchy singer for a new generation. In an interview before the release of *Ingénue*, lang disclosed that she was a lesbian.

"I really thought that the circumstances of me deciding to come out, and putting out a morose, melancholic record like *Ingénue* after moving on from country, could have been the death of me," lang said. "It turned out to be the other way around, so it's completely unpredictable. When you have a hit record, that's how people identify you. I guess they're forgetting about the first seven years, which were completely ridiculous—they used to think I was a novelty act, not take me seriously."

The adult-oriented pop of the Grammy-winning "Constant Craving" manifested lang's self-assurance and brio. "When it came time to record, we had to change the tunings, and that brought it up higher and more poppy," she noted. "It wasn't a direct attempt to make a pop song. That's just the way that it grew up, like the black sheep of the family. Coming at the end of the album, it's sort of the light at the end of the tunnel."

Created with longtime collaborator Ben Mink, *Ingénue* promulgated lang's splendid artistry to the widest and most appreciative audience of her career. "I consider myself part of a musical elite," she stated. "I want my music to be like a gourmet dining experience." ∎

k.d. lang

Photo Credit: Albert Sanchez

© 1992 Sire Records Company/Permission to reproduce limited to editorial uses in newspapers and other regularly published periodicals and television news programming

Billboard 200: *Little Earthquakes* (#54)

An extraordinary emotional intensity and vulnerability made Tori Amos a memorable performer to hear and see.

MUSIC SERVED as the best form of therapy for Tori Amos. The introspective ballads on *Little Earthquakes*, her first solo album, attempted to reconcile, or at least recognize, the disparities in her life. Amos was arguably the hottest new artist in the country, with MTV taking a bow for her spurt.

"But sometimes I'm in a bit of shock," Amos said. "A few very intelligent people who think they're too cool for the room are not into personal expression, period. If you are, you're just being self-indulgent. When some cynic says, 'I think this is a load of rubbish,' I can't wrap my head around the concept—because I've done a load of rubbish."

Little Earthquakes completed a phase of spiritual oppression and self-emancipation for Amos, who was born in North Carolina. At five, she entered the Peabody Conservatory in Baltimore on a music scholarship, only to be expelled six years later for "playing by ear." In her teens, she performed standards in clubs before moving to Los Angeles and vowing never to play the piano again. She sent tapes out to record companies and accumulated a mountain of rejection notices.

"After so many years of listening to my own opinion, I figured that I didn't know anything," she explained. "I started believing other people—'Do dance music,' 'You should get a band.'"

Amos continued to reinvent her musical persona, and *Y Kant Tori Read*, a 1988 album by a group of the same name, was a bid for a hard-rock following. Cast as a frontwoman—a sexy siren in a push-up bra—Amos began to question her artistic aspirations as the record slipped into obscurity. She then moved to London, began to noodle on the piano and rediscovered her natural voice.

"I had gone from being a failed child prodigy at 11 to being called a bimbo in *Billboard* at 22. I had been at both ends of the spectrum, and neither one of them was what I wanted to be about. I could have tried to re-patch the armor a bit, find out if Metallica wanted a keyboard player. But that *Y Kant Tori Read* record was a gift. It was one of the final doors closing around me. I had to pull myself off the kitchen floor and figure out why I wanted to do music."

Little Earthquakes traced that strengthening process—she held nothing back on spare, intimate songs that alternated between simple piano-voice arrangements and complex, melodramatic orchestral interludes. The longing, tormented "Crucify" "knocks my sexual repression on the head," she explained. The beautiful yet baleful "Silent All These Years" chronicled a woman's struggle to find her own thoughts, and "Me and a Gun" was a harrowing a cappella account of a rape experience.

"It's been a long, difficult road to where I am today," Amos said. "But I'm enjoying the moment, all the attention I'm receiving. I've come to believe that every place you land in life has a lesson and a reason." ∎

Billboard 200: *Solace* (#167)

On *Solace*, Canadian singer-songwriter **Sarah McLachlan** assigned her transcendent voice to the poetry of life.

TO MAKE up for what she'd described as a lonely childhood, Sarah McLachlan studied classical music, investing six years in piano, 12 in guitar and five in vocal training. "My parents believed that the longer you're in something, the longer you'll become it," the singer-songwriter noted. "But I didn't have any passion. It was way too strict for me—I would play a piece and improvise. And I could always sing, so I don't think vocal training did me any good. It probably hurt me—they taught me to stand rigidly."

Yet a lifetime of lessons wouldn't have endangered McLachlan's talent. Her life in Nova Scotia was turned around when she saw Peter Gabriel in concert. She started hanging with a "bad influence," singing for a semi-punk band. "I begged my mother for two months to let me practice with them," she recounted. "After four rehearsals, we played a gig, and a manager wanted to sign me on the spot. But I was only 17, living at home with my parents."

A year later, McLachlan crossed Canada to Vancouver, played in bands and was signed to a recording contract—although she'd never written a song. She released her first album at the age of 20. *Touch*, made up of her moody, evocative compositions, made her a star in her native country and built a small cult following in the US.

On *Solace*, McLachlan's tales of tangled relationships were given to intensely romantic, vaguely surreal outpourings. "The only time I write is when something inspires me, and that's an emotional outburst, positive or negative—it has to come out," she mused. "The first album was vague and ambiguous—I was searching for an identity, a lot of abstract stuff went on. On *Solace*, I figured out who I was as a person. Questions would be asked, and I'd have to find the answers in my own life. The writing was therapy."

Producer Pierre Marchand, best known for his work with Kate & Anna McGarrigle, gave McLachlan lyrical encouragement. "If I couldn't justify a couple of lines, he'd throw me in the bathroom and tell me to keep going! 'Did it come from the heart or is this just bullshit you wrote down?' He forced me to be honest—my feelings would be hurt and I'd come up with something good just to spite him."

McLachlan's striking, flexible voice gave an atmospheric edge to everything she sang, and she was often compared to Sinead O'Connor and Kate Bush. The single "Into the Fire" lit up the alternative charts, and "The Path of Thorns (Terms)" was a classic love song.

"Musically, this album was easier," she said, comparing it to *Touch*. "I had a much stronger idea of what I wanted to achieve. Mentally, it was a lot harder—I put a lot more pressure on myself. *Touch* was fun because I had no idea what I was doing, but I realized what could happen if the people who bought that record liked my music. I thought, 'Wow, the next record has to be 10 times as good.'" ∎

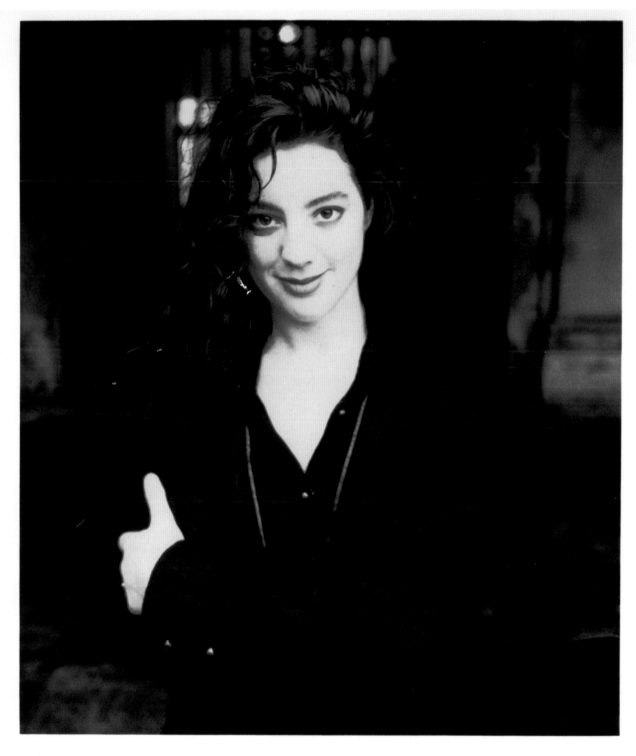

Loreena McKennitt, Canada's beloved siren, tried her luck in America, delivering the ethereal sound of *The Visit*.

A LADY with a beautiful soprano who played an ancient instrument, harpist Loreena McKennitt included the words of William Shakespeare and Alfred, Lord Tennyson in her songs. "It isn't quite hit-single material," she noted. But McKennitt had captured the ear and imagination of Canada, where she was already a big name. Hailing from a farming community in Manitoba, she developed a passion for traditional music after joining a Winnipeg folk society. She fell in love with the harp, but she didn't take it up as her main instrument until 1983. She performed on keyboards, tin whistle and Irish drum as well.

McKennitt also ran her own record label and had financed and produced her own recordings for years. Until the release of *The Visit*, her fourth and best album, she was likely the most successful independent recording artist in Canada. That and the reaction to her concerts prompted her to take the next step—an international distribution arrangement for *The Visit*.

"I hope my music will reach a new level of exposure," she said. "I knew it wasn't reaching as many people as were interested, and it's crazy to spend the day supervising the business side when I could be out exploring."

McKennitt moved toward a distinctive, richly textured fusion that smartly spanned centuries-deep Celtic folk elements and contemporary composition—in a way, the yin to Enya's Gaelic yang. In Canada, *The Visit* went platinum and spawned a hit, "All Souls Night." In America, McKennitt made a splash in literary circles—*The Visit* included "The Lady of Shalott" (an 11-minute ballad based on the famed Tennyson poem written in 1842), "Cymbeline" (based on a lyric from Shakespeare's romance play) and a version of "Greensleeves" (with lyrics, so the legend went, by the much-married King Henry VIII).

"It's bizarre—I get letters from elementary school teachers to university professors, and parents who say 'The Lady of Shalott' is their children's favorite song to play before bedtime," McKennitt said. "My music is simply not everybody's cup of tea. The challenge is to find out what that market is. There are lots of people who enjoy new-age music who enjoy my music, but it doesn't necessarily follow that my music is new-age. I refuse to let it be dismissed like that. I want notice, but only on my terms." ■

LOREENA McKENNITT

© 1992 Warner Bros. Records/Permission to reproduce limited to editorial uses in newspapers and other regularly published periodicals and television news programming.

Photo Credit: Melodie Gimple

ON RECORD | 1992 | [INDIGO GIRLS]

Billboard 200: *Rites of Passage* (#21)
Billboard Hot 100: "Galileo" (#89)

The satisfying *Rites of Passage* showcased Indigo Girls' maturity of spirit and a new risk-taking sensibility.

CULTIVATING A reputation for poignant confessions, honest self-examination and educated, politically aware material, Indigo Girls—singer-songwriters Emily Saliers and Amy Ray—had achieved status as independent, creative women. "There are certain things that have affected me profoundly, that make me want to write a song," Saliers explained. "That's why you get the pain, way below the surface. You're trying to draw into something that's more mysterious."

The folk duo's records had been marked by a familiar foundation of stirring vocals and acoustic guitar. On *Rites of Passage*, Saliers and Ray didn't abandon their pop song structures or trademark harmonies, yet they'd taken their material to a more sophisticated level. "You're protective of your first records—you don't want any control taken from your music," Saliers noted. "But that can limit you. We were ready to expand ourselves, broaden our horizons past that spare quality."

Rites of Passage was produced by Peter Collins, who seemed like a long shot—he was known primarily as a metal and hard-rock band specialist. "You can't listen to Queensrÿche and say he's the guy for us," Saliers admitted. "But we met and had the same set of ideas. He's not aggressive or heavy-handed—he combines professionalism and a willingness to experiment."

Collins was interested in using more exotic instrumentation and adventurous rhythmic undercurrents—arrangements were embellished with Celtic, Native American, Latin and African textures. And Saliers and Ray used an eclectic supporting cast, including drummer Budgie of Siouxsie & the Banshees, fiddler Lisa Germano and drummer Kenny Aronoff (of John Mellencamp's band) and bassist Sara Lee. The Roches assisted on vocals.

David Crosby and Jackson Browne also joined in, contributing harmony vocals on Saliers' "Galileo," a Top 10 modern rock hit about reincarnation and karmic debt: "Now I'm serving time for mistakes/ Made by another in another lifetime…How long 'til my soul gets it right."

"Galileo's name popped into my head, it had a ring to it—he must have been an illuminating soul," Saliers mused. "I felt the song coming on—the topic of reincarnation had come up a lot in my life in the last year. The initial approach was to be lighthearted— like, 'If this is really true, I've got a lot of baggage from my past lives!'" ■

indigo girls

9208

PHOTO CREDIT: LAURA LEVINE

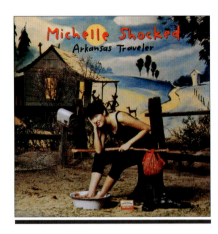

Every track on Michelle Shocked's *Arkansas Traveler* was recorded in a different city with a different cast.

ONE OF the most gifted and outspoken artists to emerge from the late Eighties singer-songwriter movement, Michelle Shocked's personality fused down-home country affection and in-your-face ideological commitment. A self-described rebel with a subversive streak, she moved happily from one genre to the next, exemplifying her appreciation for all forms of the American music landscape, from folk and funk to fiddle tunes and hymns.

Determined not to be constrained by narrow attitudes of the music industry, Shocked had an idea to do a trilogy of albums for each of her influences—"to trace my steps, to lay out a road map," she said. "My instincts told me that my medium, pop music, needs to be bold and simple. It can't deal with complex strokes. So instead of mixing up the elements on each album, I separated them. Now that I'm at the end of the trilogy, I can finally say, 'You've seen the whole picture, now you can make up your own mind.'"

The country-folk of 1988's *Short Sharp Shocked* reflected her fondness for Texas songwriters like Guy Clark. The big-band sound of 1989's *Captain Swing* displayed her swing-blues bent. The closing installment was *Arkansas Traveler,* mostly a country and rural-blues record. The album captured the "homemade jam" years Shocked spent growing up playing mandolin and guitar with her father—they duetted on the finale, "Woody's Rag," which she said was the first tune she ever learned.

The backup players were no ordinary session cats. Legends like bluegrass pickers Doc Watson and Norman & Nancy Blake, singer Pops Staples, ex-Band members Levon Helm and Rick Danko and blues pioneer Clarence "Gatemouth" Brown got on board, along with modern-day bands including Ireland's Hothouse Flowers, Australia's Messengers (minus leader Paul Kelly) and Missouri's Uncle Tupelo. Recording locales ranged from a barn to an antique store to a Mississippi riverboat to Memphis' Sun Studios.

Shocked had wanted to appear in blackface on the cover of *Arkansas Traveler*, but her label rejected her desire. The unpredictable singer-songwriter said she wanted to do more concept albums. "I'm looking for where the blackface minstrel tradition that I come from, and the gospel tradition where they come from, meets. There's been a racist revision of cultural history, and a lot of people have gotten ripped off." ■

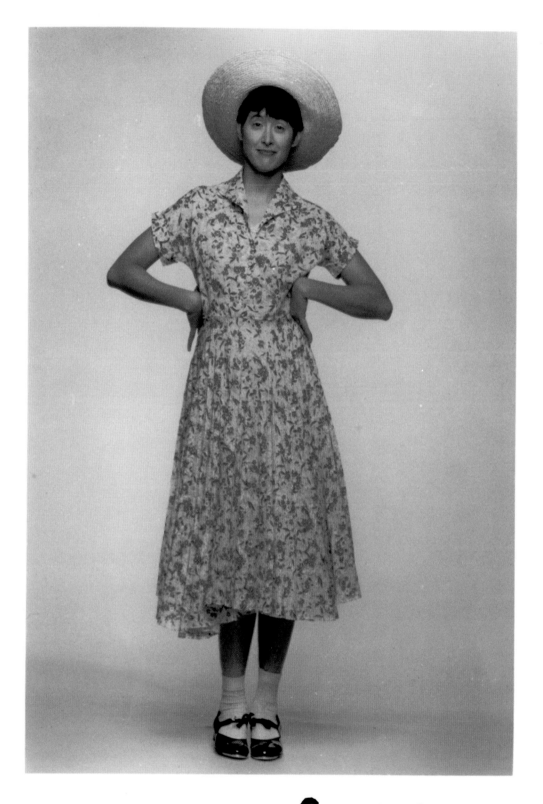

mercury Michelle Shocked Alive

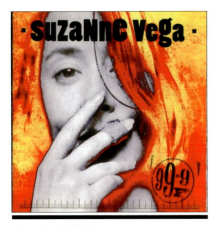

Billboard 200: *99.9F°* (#86)

The electronic, experimental *99.9F°* characterized **Suzanne Vega** as an artist who sought unexpected paths.

THERE WASN'T a more consistently challenging and exciting musical chameleon than Suzanne Vega. With each album, the once-waifish singer-songwriter defied expectations and ventured into new territory. Early on, Vega's neo-beatnik folk roots and earnestly poetic lyrics brought comparisons with Joni Mitchell and Bob Dylan.

"I went out in 1976 to get my first gig in the Village," she recalled. "I took four years to get it. But if one or two people would be interested, I'd send them fliers and let them know when I was playing. It was difficult. I was told it was not going to go anywhere—'Gee, honey, you have a really nice voice but a really bad attitude,' 'If it were 10 years ago, you'd be a big star, but it's not coming back, so hang it up.' But I was stubborn."

In 1987, a Top 10 hit about child abuse made Vega a temporary pop heroine—"Luka" helped usher in a new wave of folkish females like Tracy Chapman, Michelle Shocked and Indigo Girls. On *99.9F°*, Vega broke almost completely away from the folk form. She paired with Mitchell Froom, a studio wizard famous for producing Elvis Costello, Los Lobos, Richard Thompson and Crowded House. "We met under very high record-company circumstances—it was based completely on his work," she said.

They retooled her sound into a bold experiment, with Vega's haunting images pegged to electronic percussion and warped-sounding keyboards. It was a synth-folk album, as impressive for its odd noises and instrumental juxtapositions as for Vega's tunes. The single "Blood Makes Noise" reached No. 1 on *Billboard*'s Modern Rock Tracks chart.

"Some journalists have a hard time describing what the direction is like. 'Industrial' was the first thing to come out of *Rolling Stone*, and that's what has stuck, but it's only on a few songs. It's the quickest album I've ever made. It seemed very natural to me." Vega later married Froom. ■

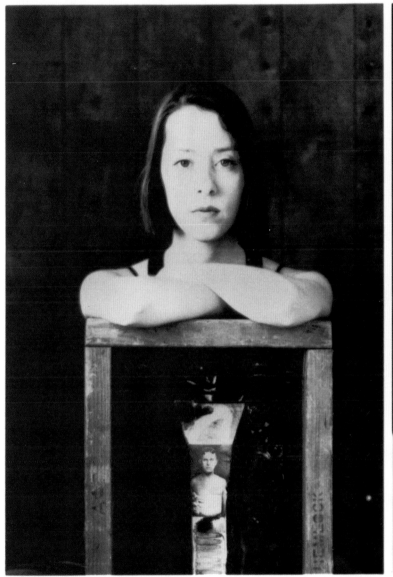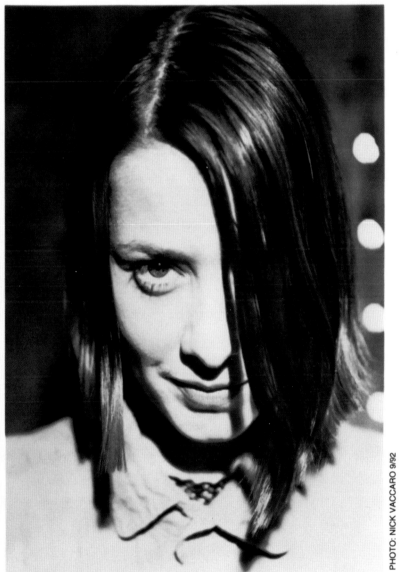

SUZANNE VEGA

ENTERTAINMENT LTD.
Phone: (212) 366-6633
Fax: (212) 366-0465

RECORDS

PHOTO: NICK VACCARO 9/92

Billboard 200: *Never Enough* (#21)

Kansas native **Melissa Etheridge** ventured in a new direction vis-à-vis the public's perception of her music and image.

MOVING TO Los Angeles in the mid-Eighties, Melissa Etheridge was discovered storybook-style—a record company president signed her on the spot after seeing her perform in a Long Beach bar. On her first two albums, Etheridge cut into the heartland-rock mold, writing and singing painfully honest yet intensely private songs reminiscent of her nearest male counterparts, Bruce Springsteen and John Mellencamp. Combined, 1988's *Melissa Etheridge* and 1989's *Brave and Crazy* sold more than 4 million copies.

Now success had changed the soul-baring process. "The songs are going to be different because I'm different. I'm not a 25-year-old struggling and playing in bars five nights a week," the confident, self-effacing Etheridge said. "Turning 30 had a big effect on me. To achieve what happened in my life the last couple of years was my moving force—and then I finally reached those goals. And I had to go, 'Uh-oh, this is great, but now what? I have a lot of stuff in front of me and a lot of energy left.'"

Never Enough, Etheridge's third release, marked a turning point. Produced with her longtime collaborator, bassist Kevin McCormick, the album showed off an expanded range of styles. The opening "Ain't It Heavy" came on full throttle, a rootsy rocker with a throaty vocal. "It's my declaration of purpose, about not being able to find that satisfaction or happiness from someone else. You've got to turn to yourself."

"2001" marked a real departure for Etheridge, The tale of future shock featured a percolating dance track that added a few modern hip-hop accents. "I said, 'Okay, let's go all the way, farther than we ever would think of going with the song,'" she said. "And we did." On the luminously textured "Dance without Sleeping," Etheridge gave her finest vocal performance—she laid back with surprisingly tender restraint. "It's my favorite thing I've ever recorded. I try to re-create it live, but it was just a strong, clear moment one night in the studio."

Curiously, the angry, betrayed, deprived Etheridge that often came across in song was far from the happy-go-lucky, perpetually smiling Etheridge that came across in person. On the provocative album cover of *Never Enough*, she was pictured from the back, naked from the waist up with a new blond haircut and a guitar slung over her shoulder. Etheridge didn't think the photo would turn off her fans, who ranged from hedonistic Deadheads to liberal feminists.

"Feminist isn't anti-feminine—you can tell it's not tasteless," she noted. "But I just found out the mayor of Wilkes-Barre, Pennsylvania, has been taking down the concert posters." ∎

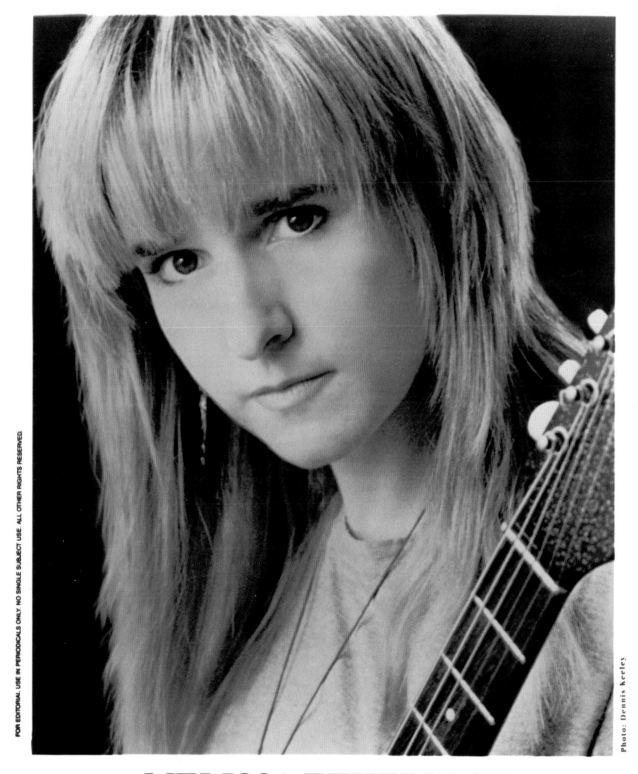

MELISSA ETHERIDGE

MONTEREY PENINSULA ARTISTS ISLAND W.F. LEOPOLD MANAGEMENT

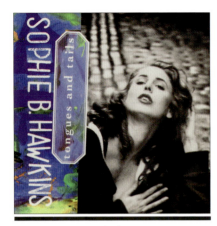

Billboard 200: *Tongues and Tails* (#51)
Billboard Hot 100: "Damn I Wish I Was Your Lover" (#5)

Sophie B. Hawkins sprang out of the New York music scene with the Top 5 hit "Damn I Wish I Was Your Lover."

WITH A restless intensity and candor, Sophie B. Hawkins came across like a woman deeply focused on her music. In many ways, she was the archetypal New Yorker—bold, smart, savvy and entertaining. "I feel the rhythm in New York," the singer-songwriter admitted. "I know that pavement, the air, the neighborhood. I'm like a train on track. My work, my art, is so important to me. It's not that I'm egotistically bound up in it, but nobody else is going to fight for it."

As a teenager, Hawkins studied percussion under Nigerian artist Babatunde Olatunji. She wrote her own songs, sang, played keyboards and drums and recorded at her home studio. On her first release, *Tongues and Tails*, she tempered her introspective lyrics with snatches of African rhythms and grooves. The album went gold and earned her a Grammy nomination for Best New Artist.

In the world of catchy dance pop, Hawkins' attention-getting debut single "Damn I Wish I Was Your Lover" was hard to resist. But her talent got deflected when the press painted a picture of a sultry diva obsessed with sex and desire, "the new Madonna." "People mean it as a compliment in many ways, but it shows that they don't listen," she said. "Both Madonna and I are aggressive about getting what we want. Yet I wouldn't call myself arrogant. I find people are drawn to my confidence. I do know what I want and what I don't want in my career." ■

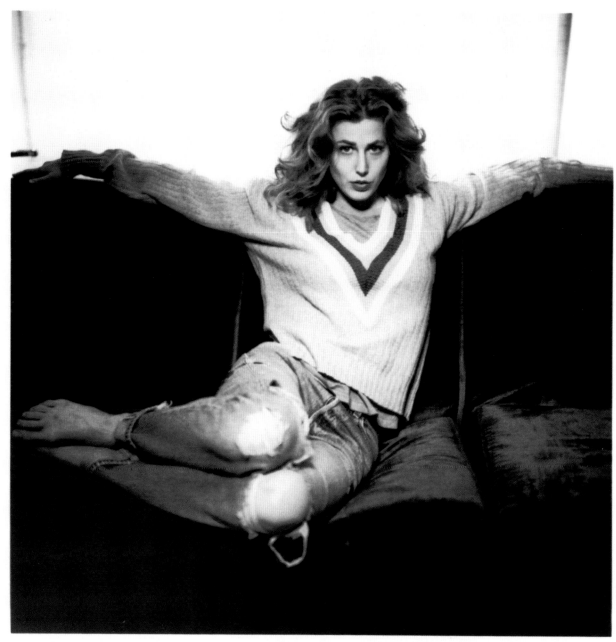

©1992 Sony Music Permission to reproduce this photography is limited to editorial uses in regular issues of newspapers and other regularly published periodicals and television news programming.

SOPHIE B. HAWKINS

COLUMBIA
9206

PHOTOGRAPH: CHRIS NOFZIGER

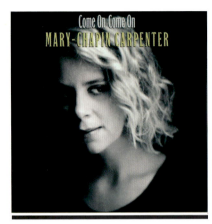

Billboard 200: *Come On Come On* (#31)
Billboard Hot 100: "Passionate Kisses" (#57)

Mary-Chapin Carpenter fashioned the incisive *Come On Come On* for folk, rock and country audiences alike.

MARY-CHAPIN CARPENTER had embarked on a musical journey, first beginning to achieve commercial recognition with the release of her 1989 album, *State of the Heart*, and the singles "Never Had It So Good" and "Quittin' Time." The singer-songwriter then enlisted the support of members of the seminal Cajun group Beausoleil for an ebullient, stomping *fais do-do*—"Down at the Twist and Shout" became a career-making hit for Carpenter, including a Grammy and the end of any "too folkie" designation.

Come On Come On, Carpenter's fourth album, continued her ascent into the ranks of leading songwriters and performers. An astonishing seven hit singles resulted. "He Thinks He'll Keep Her" became her first song to reach the top of the country charts. She won her second Grammy for Best Female Country Vocal Performance for the assured "I Feel Lucky." Widening her artistic scope, she covered Lucinda Williams' "Passionate Kisses," and the song's gorgeous guitar arrangement earned her a third Grammy.

"I walk around a lot of the time with my head in my hands going, 'Ah-h-h-h-gh!,'" Carpenter admitted with a laugh. "Writing, for me, is the ultimate catharsis—it's great exercise for my mind and my imagination, too. The struggle is so hard sometimes, but then something happens and everything falls into place if you let it. I think singing sad songs sets you up to see the light clearly and follow it."

Come On Come On featured guest appearance by Shawn Colvin, Benmont Tench, Indigo Girls and Rosanne Cash. It landed on the year-end best lists of *Rolling Stone*, *Billboard*, *Spin*, *The New York Times*, *Entertainment Weekly*, *Time* and *People*, among others, and earned Carpenter a CMA award for Female Vocalist of the Year.

"You go out and you sell records based upon a whole album, not a single—I just try to take advantage of every opportunity and let people know it's out there," the Brown University graduate said. "I absolutely believe music can change the world. I grew up being moved, provoked, inspired and completely transported by music, by art, by books. Without them, we have no culture. Without culture, we have no civilization." ■

MARY-CHAPIN CARPENTER

COLUMBIA

9205

photo: Frank Ockenfels 3

©1992 Sony Music Permission to reproduce this photography is limited to editorial uses in regular issues of newspapers and other regularly published periodicals and television news programming.

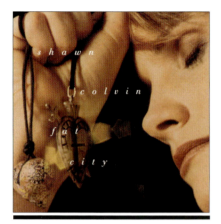

Billboard 200: *Fat City* (#142)

"I Don't Know Why" and "Round of Blues" were adult-contemporary hits for "new folk" heroine **Shawn Colvin**.

A GRAND group of female singer-songwriters had been tearing down the fences separating folk and pop. Shawn Colvin's *Steady On* album didn't shoot to the top of the charts, but it won the 1990 Grammy award for Best Contemporary Folk Recording. Yet Colvin had a problem with how her music was being classified.

"A younger audience wants to listen to R.E.M. and Belly and Toad the Wet Sprocket—bands with a folk-rock sound in their music—but they turn away from me because the marketing people hit them, saying I'm for an older, baby-boom audience," Colvin, 36, said. "It can be frustrating. I give my record company the benefit of a doubt—they've gotta get my career started somehow—but you find yourself taking meetings that you never thought would have anything to do with your music. Too many people still think of folk's negative side, that we're 'sensitive singer-songwriters' singing 'Kumbaya.'"

Since the release of *Steady On*, Colvin had kept fast company and not been overwhelmed. The bulk of her *Fat City* album was produced by Larry Klein, known for his work with his wife and Colvin's idol, Joni Mitchell. Colvin met and recorded with her biggest influence at Klein's home studio in Los Angeles (in the album credits, she wrote: "…and to Joni Mitchell—me wimp, you master"). The album's supporting cast also featured Mary-Chapin Carpenter, Béla Fleck, Little Feat's Richie Hayward and Bill Payne, Bruce Hornsby, David Lindley, the Subdudes, Booker T. Jones, Richard Thompson, Chris Whitley and Steuart Smith. But Colvin held her own among the guest musicians.

"Hooking up with performers you have long admired is one of the biggest pleasures of being a professional," she acknowledged. "You find equal creative ground when you find the mutual desire to make some music together. The feeling in your heart still might smack of inferiority to the person you're with, but if there's an agreement between you, you've gotta figure they have some respect for you. You find that everybody has a built-in insecurity factor, is in awe of some other musician. It's endearing, really."

The closing "I Don't Know Why" emerged as the album's tour de force. "It was the first song I wrote, when I moved to New York in 1980—it's a lullaby, and I wrote it on a subway ride," Colvin said. "It took me a while to work up the courage to play it for people, so I've always been sort of protective of it."

Critics agreed that Colvin deserved to be a household name. "It seems like success costs you a certain amount of freedom—there are misunderstandings about what you do," she mused. "You're hemmed in by labels, or you're defined by a hit that you don't feel comfortable with. Then again, I would be thrilled if it happened. I feel good about where I am, but there's room for me to have a better career. The more well-known you are, the more opportunities you get." ■

PHOTOGRAPH: E.J. CAMP

©1992 Sony Music Permission to reproduce this photography is limited to editorial uses in regular issues of newspapers and other regularly published periodicals and television news programming.

ENTERTAINMENT LTD.
Phone: (212) 366-6633
Fax: (212) 366-0465

SHAWN COLVIN

COLUMBIA
9209

New Jersey native **John Gorka** juxtaposed consequential and intimate matters on his *Temporary Road* album.

WHILE FEMALE singer-songwriters such as Shawn Colvin, Mary-Chapin Carpenter and Nanci Griffith were taking the "new folk" movement by storm, a male hero of the personal, highly emotive genre emerged—John Gorka, and with good reason. He had a gorgeous baritone, sensitive and insightful lyrics, and a warm wit that took the edge off his brooding reflections.

The rumpled, stocky wordsmith waxed philosophical about his chosen profession. "I think this is a singer-songwriter revival more than a folk-music revival," he said. "There's not a lot of traditional music getting out. What I've been hearing on the radio is music that people are singing with feeling, from the heart—songs that make me feel the way music used to make me feel."

Gorka was quiet and shy whenever his name got bandied about as a much-acclaimed new voice. "It was going on in the early Eighties—there were all of these really good songwriters coming up, writing these distinctive songs, but there was no interest at all from the record companies," he explained. "Suzanne Vega was the first one out of that scene. The record companies began to realize it was music they could sell, which is the only thing that motivates them to sign people. It was an interesting, exciting time for me, seeing a scene created before anybody paid attention."

Each of Gorka's albums had set a different tone and expanded his scope. His first showcased his stunning voice and sharp, subtle humor, and his second brought cracked-heart romanticism to grand heights. 1991's *Jack's Crows* centered on a tender yet honest view from American factory towns, and its followup, *Temporary Road*, was the work of an artist at ease with his craft, led by the droll "When She Kisses Me" ("If she loved me for the car I drive/Our love would surely stall").

"I tend to write about what I feel strongly about, what I'm interested in, what's coming through," he mused. "All I've ever wanted was for my songs to get a chance to be heard. And they are. And that's all you can ask for." ■

High Street Records™ Recording Artist

JOHN GORKA

High Street Records Publicity Office, 3500 West Olive Avenue, Suite 1430, Burbank, CA 91505 (818) 972-4242

History, **Loudon Wainwright III**'s inspired album about difficult family relationships, showcased his serious side.

IN 1970, Loudon Wainwright III made his first album and immediately became one of many folk singer-songwriters touted as "the new Bob Dylan." Because the sobriquet was so indiscriminately applied, it quickly turned into a rock critic joke. But in a genre overrun with soul-searching poets, Wainwright had always played the witty cynic.

He was at his best when he wrote about himself, a divorced dad still trying to figure out the meaning and meanness of life. The thinking person's troubadour had released 13 albums of spare vignettes personifying honest bewilderment and literate lunacy. He'd never become a full-fledged pop star ("Dead Skunk," a twangy ode to roadkill, stunk up the Top 20 in 1973), but for those in the know, he was one of America's greatest raconteurs, poking fun at his private paranoia, neuroses and doubts.

"I have a stoicism about it," Wainwright said of his perpetual mid-level career. "For a while, I had a reputation as a comedy songwriter. And then people thought I was this intense semi-suicidal nut case. Now I'm hearing them say, 'Singer-songwriters are really coming back this year.'"

Wainwright was at his artistic peak on the exceedingly personal *History*, one of the strongest records in his career. The hysterical "Talking New Bob Dylan" was a 50th-birthday tribute to his original muse, but the core of the album was fearless, revealing examination of his family history. The painfully honest "Hitting You" shared his remorse about a long-ago spanking incident that scarred his relationship with his resentful grown-up daughter. "She came to live with me for a year in New York—that was quite an experience," he shared. In the grieving "Sometimes I Forget," he longed for his dead father, the famous *Life* magazine columnist and editor. "When one of your parents dies, something really changes. I don't know if that had anything to do with the retrospective feel of the record—it's a mystery to me."

"So Many Songs (About You)" offered a heartfelt apology to ex-wife Kate McGarrigle of the McGarrigle Sisters and former girlfriend Suzzy Roche of the Roches for using them as unnamed targets in his bitter love songs. "The Picture" was a small masterpiece about his close relationship with his sister Teddy. And the somber "4 X 10" delineated his parents' unimpressible hearts.

Had Wainwright evolved from a smart aleck into a wise guy? "I don't know if anything's been resolved—you're thankful when the songs come through, but there's a lot of craft in finishing them off," he mused. "*History* is meant to be a heavy record for me, but I've never had a blast in the studio. My real job is writing songs and then playing them live for people—in clubs mostly, in bars a lot and concert halls occasionally." ■

LOUDON WAINWRIGHT III

PHOTO CREDIT: IRENE YOUNG

Billboard 200: *Free-for-All* (#160)

On *Free-for-All*, singer and guitarist **Michael Penn** did battle with his personal demons and some benign spirits.

FOR HIS debut album, *March*, and the ardent "No Myth"—his breakthrough hit with the "What if I were Romeo in black jeans" chorus—Michael Penn scored MTV's Best New Artist award in 1990. The irony? Prior to *March*, the "new" artist had been working around Los Angeles for 10 years, writing and recording and waiting for the right break.

"It surprised the hell out of me that *March* did as well as it did—I thought I was making this almost anachronistic kind of song-oriented rock music," Penn said. "It reached some people, so I was very happy. But to me, you've got to have a sense of humor about it and realize it's a popularity contest. I mean, it took me so long to get a record deal, and I became so cynical about the business, it was just such a relief to actually have this multinational corporation paying me to go into a studio, to have fun. Everything else has been icing on the cake. I've just been jazzed about the fact that I got to make another record."

The big brother of bad-boy actor Sean Penn wrote intriguing songs that never sounded cluttered. Working on four-track demos for so many years had forced him into a discipline—he kept the production lean, retaining only the elements necessary for his Beatlesque sort of charming, courtly pop.

Yet following "No Myth" was a problem. The delays in the release of his second album came partially from being on the road, since he found it impossible to write while touring. *Free-for-All* was an involved, often wry study in relationship dynamics jammed with neat melodies and instrumental touches. The album rocked out a little more than *March*, and while it didn't produce any big hit singles, two songs reached the Top 20 on the modern rock charts.

The heady tumble of "Seen the Doctor" combined ability and attitude. The song "starts out as your standard love song, this person's open heart is literally an open heart on the operating table." Penn swerved from literal to metaphoric and back again, the Möbius-strip narrative zeroing in on his emotional state: "I'm breathing/But it's become a chore/Now that I've seen the doctor/You're just a fucking bore/Like Dorothy Lamour/Dolled up in Singapore/To meet the Commodores/Don't call me anymore."

"Long Way Down (Look What the Cat Dragged In)" coolly refined a personal vision—"the anger you get when you're scared and feel you're about to resign to something," Penn said. "I think subversion is the only way—that's always the most powerful writing. I can only write in my terms of reference. The struggle is always not to bend my terms of reference to be more universal—I'd rob it of its emotional content." ■

MICHAEL PENN

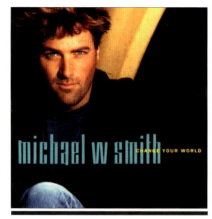

Billboard 200: *Change Your World* (#86)
Billboard Hot 100: "I Will Be Here for You" (#27); "Somebody Love Me" (#71)

A lauded crossover artist, **Michael W. Smith** climbed both the Christian and pop charts with *Change Your World*.

WHEN TEENAGE admirers burbled how much they loved 1991's "A Place in This World," Michael W. Smith's first Top 10 pop hit, the musician had to wince. Most of his new fans didn't realize that he was a contemporary Christian artist who had already released six albums and won six Dove Awards. Secular success hadn't shifted Smith's emphasis away from his original goals.

"I've had a big hit, but I'm not a superstar yet," he said. "It's hard not to get into a frame of mind that you've got to deliver a hit song, write something better for pop radio. You need to slap yourself, remember how you got here—be yourself."

On *Change Your World*, Smith linked up with songwriting partners such as David Foster, his longtime friend Amy Grant and—for the comforting No. 1 adult contemporary track "I Will Be There for You"—hitmaker Diane Warren.

"I had been looking at some songs by her, but the stuff she sent wasn't quite right for me," Smith revealed. "The day after the American Music Awards, we just sat down at the piano to see if we could pull something off. She hummed a little line and I had the rest of the melody within five minutes. She sent me the completed lyrics three days later."

Smith also scored with the single "Somebody Love Me." "I don't know what it is about my wife Deb and me, but we know a lot of single women. I think they sometimes wonder, 'Is it ever going to happen for me?' The lyrics are for all those women, but everybody's felt that way at some point." ∎

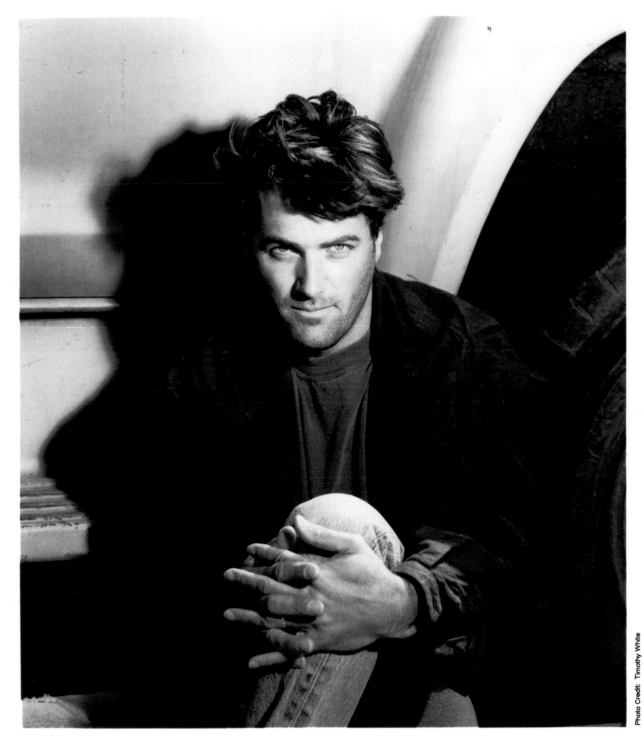

michael w smith

GEFFEN

REUNION RECORDS, INC.

Photo Credit: Timothy White

© 1992 The David Geffen Company / Permission to reproduce limited to editorial uses in newspapers and other regularly published periodicals and television news programming.

ON RECORD | 1992 | [PATTY SMYTH]

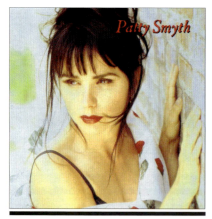

Billboard 200: *Patty Smyth* (#47)
Billboard Hot 100: "Sometimes Love Just Ain't Enough" (#2); "No Mistakes" (#33); "I Should Be Laughing" (#86)

With "Sometimes Love Just Ain't Enough," a pairing with Don Henley, Patty Smyth gained tons of radio airplay.

PATTY SMYTH had plenty of preparation for her performance sense and musical ability—learned literally at the feet of any number of Sixties musicians.

"I grew up knowing that music was the only way I wanted to say what I felt," Smyth said. "My mother was involved in club management in Greenwich Village. Backstage was home, a little kid hanging around while the Lovin' Spoonful to the Blues Magoos had their say. I was really terrible—I could get my mother to let me do anything. If you look at my school records, you could see that I didn't make it to school much the next day."

After a brief stint leading her own trio, Smyth continued her career fronting Scandal. A five-song 1982 EP yielded two hits, "Goodbye to You" and "Love's Got a Line on You," and with the million-selling album *The Warrior*, she was recognized as a potentially major rock voice. "I finally realized with the success of Scandal came a great responsibility, from choosing songs and players to deciding on staging and lights," Smyth said. "I knew I was smart enough to run my own show—besides, it was my future on the line."

Never Enough, her first solo album, generated a pair of hits, the title track and a cover of Tom Waits' "Downtown Train." After five years, she returned and put out another solo record, *Patty Smyth*, and reached the Top 10 with the smash single "Sometimes Love Just Ain't Enough," an everybody-knows-the-feeling duet with Don Henley of the Eagles. "I came out of rock 'n' roll, but I write a sensitive song exposing myself—and of course, it's my biggest hit," she mused. "I'm proud of it, but I haven't turned into June Cleaver." ■

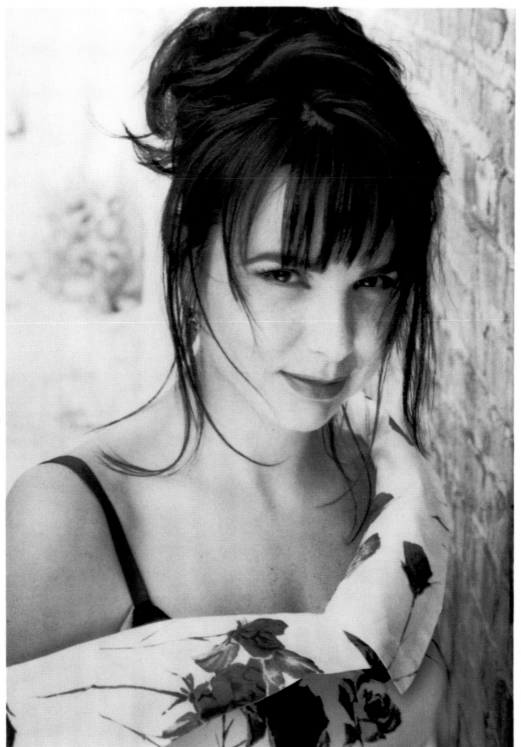

Patty Smyth

Billboard 200: *Our Time in Eden* (#28)
Billboard Hot 100: "These Are Days" (#66); "Candy Everybody Wants" (#67); "Few and Far Between" (#95)

10,000 Maniacs put out *Our Time in Eden*, their last studio effort with lyricist and vocalist Natalie Merchant.

NATALIE MERCHANT, the politically aware singer and primary songwriter of 10,000 Maniacs, had naturally taken the lead role in the band. Her face graced videos and the covers of magazines, and the guys who wrapped her lush voice with alluring folk-pop melodies—"the Four Stooges," they called themselves in jest—were cool about it.

"We resolved that early on—the lead singer is always the focus of a group," keyboardist Dennis Drew said. "My family appreciates it when people know there's five of us. But our kick is the music, really, and that's a collaboration."

10,000 Maniacs, formed a decade earlier in upstate New York, had occasional hits in the Eighties ("Like the Weather," "Eat for Two"), but the group won respect from many fans for tackling sticky social issues. Merchant's occasionally stern self-seriousness was a jarring complement to the gently ephonious feel provided by Drew, guitarist Robert Buck, bassist Steven Gustafson and drummer Jerome Augustyniak.

After 1989's *Blind Man's Zoo*, the members took a break and attended to their private lives—when not touring, they still lived in rural Jamestown, New York, except for Merchant. Upon reconvening, Drew noted, "Natalie played all through the sessions, and it brought her deeper into the actual songs. She had more to do with the music, and still had everything to do with the lyrics. Instead of being a little folk-rock band with her words on top, it was a better mesh, more interaction."

The platinum *Our Time in Eden* re-established 10,000 Maniacs. The subtle, trancelike aura of the music was orderly and well-tempered. Much of the album concerned the intricacies of personal relationships, but Merchant didn't abandon uneasy topics, from child abuse to nuclear fallout to frontier women.

"I don't assemble or approach songwriting in terms of theme—it seems too methodical—but I have noticed that many songs on this album are our most optimistic," Merchant said. "The songs seem to reflect the seasons during which they were written—the promise of spring, the freedom of summer, the introspection of fall and isolation of winter."

The atypically optimistic "These Are Days" hit No. 1 on *Billboard*'s Modern Rock Tracks chart, and James Brown's horn section sat in on the radio-friendly "Candy Everybody Wants" (an observation of a generation anesthetized by vacuous or lurid entertainment) and "Few and Far Between." But *Our Time in Eden* turned out to be a swan song. After the fine album finished its run on the charts, Merchant announced she was departing the band for a solo career. ∎

DENNIS DREW NATALIE MERCHANT STEVEN GUSTAFSON
JEROME AUGUSTYNIAK ROB BUCK

PHOTO CREDIT: MICHAEL HALSBAND

10,000 Maniacs

Elektra Entertainment

Billboard 200: *Black Eyed Man* (#76)

Cowboy Junkies continued to evolve their spare style on their fourth studio undertaking, *Black Eyed Man*.

COWBOY JUNKIES broke through in 1988 with the stark beauty and simplicity of *The Trinity Sessions* and a smart cover of Lou Reed's "Sweet Jane." The Canadian quartet's hallmarks were Margo Timmins' haunting, detached vocals and her brother Michael Timmins' languid yet tasteful guitar playing.

On *Black Eyed Man*, Cowboy Junkies arrived at a country sound. "We wanted to work a lot of diverse musicians into the project," Michael explained. The group's riveting original material remained a family affair—Michael crafted Margo's lyrics and sibling Peter played the drums—and had earned a reputation for lean, evocative narrative settings.

"I really just write for myself," Michael noted. "Margo is an interpretive singer. That's her job and her talent, to bend something so it becomes her own."

"I often know what to bring to the songs Michael writes, and he knows what songs to write for me, what I need as a singer," Margo added. "We communicate well. We share."

"Murder, Tonight, in the Trailer Park" had an energetic darkness, but other hopeful aspects made *Black Eyed Man* more a celebration than a nerve-wracked look at matters of the heart. Michael's love songs were sometimes addressed to a man, sometimes to a woman, and there was no apparent confusion in that. Legendary singer-songwriter John Prine duetted with Margo on the intriguing "If You Were the Woman and I Was the Man." ∎

Alan Anton Margo Timmins Michael Timmins Peter Timmins

COWBOY JUNKIES

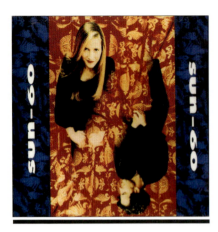

Prompting each other's musical and lyrical instincts, Joan Jones and David Russo banded together as **Sun-60**.

WHEN SHE closed her eyes and leaned back to sing, Joan Jones went for it all, making more renowned singers look like figurines. The powerful vocalist also played pocket trumpet, although it was doubtful Don Cherry lost any sleep. Performing as Far Cry, Jones and fellow singer-songwriter David Russo had built a modest following, but when they released their debut album, they perplexed fans by calling themselves Sun-60.

"We had finished the record, we had the artwork ready to go, and a heavy-metal hair band from Florida came running out of nowhere," Jones explained. "They had Far Cry registered for a year, but we'd been using the name for four. We could have beaten them in court, but we didn't have the money."

Sun-60, an inventive blend of Jones' vocal passion and trumpet solos with Russo's guitar, keyboards and harmonies, featured the songs "Landslide" and "Runaway Jane," labeled upbeat "alternative folk." "But I have a problem with being marketed as alternative, using today's modifiers," Jones said. "We're alternative because there's nothing else out there that sounds like us right now. Everybody's alternative—we all don't live the same lives."

The Los Angeles natives got signed to a record deal on the basis of their live show, not a demo tape. "We played a lot of underground clubs in L.A. that would be open for one night—they didn't have appropriate liquor licenses," Jones said. "They were several rooms with different kinds of music, and that led to playing with people from other bands. It was really fun.

"Over the last two-and-a-half years, I've lived out my life in this band through my writing. David and I both had day jobs, and oftentimes we'd be running to the show within 20 minutes of work. I attribute what I do onstage a real catharsis. I don't have any parameters on it—I just let go, I don't worry about what I'm wearing or what I look like. It's a nice place to be."

Sun-60 was original and imaginative, but there was a sense of heightened neurosis that could only come from citizens of Los Angeles. "We're put in a position of being ambassadors to our city, defending it," Russo said. "I grew up in an area that got increasingly hardcore as I got older. Yet I love it—there's a beauty here and I can't bail on it. It remains a place where people go to realize their dreams. But a third-world country is growing in L.A.—the situation that caused our riots isn't going away. It's gonna take natural forces. The place will be blown up before it gets better." ∎

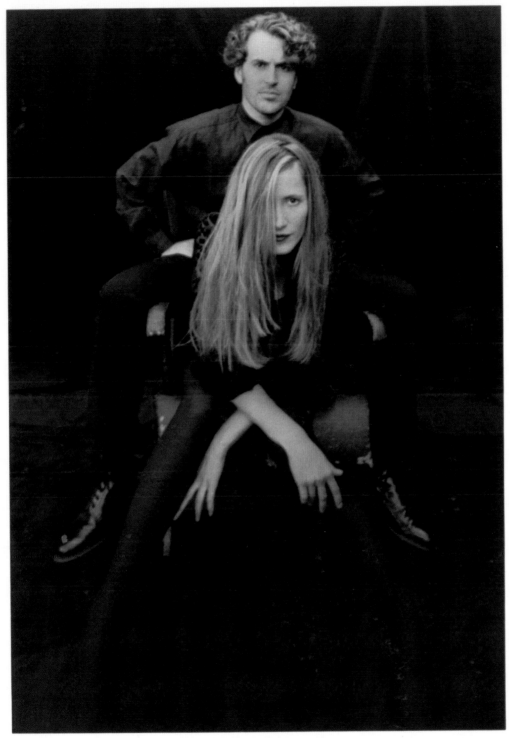

Joan Jones and David Russo

SUN-60

©1991 Sony Music. Permission to reproduce this photography is limited to editorial uses in regular issues of newspapers and other regularly published periodicals and television news programming

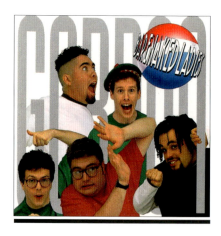

"Be My Yoko Ono" and "If I Had $1000000" began **Barenaked Ladies'** incumbency as Canada's princes of pop.

WRY, WISTFUL, wacky adult rock usually appointed a band to eternal cult status. But *Gordon*, the first album by Barenaked Ladies—a Toronto-based quintet of fully clothed guys—was greeted with history-making acclaim in Canada, selling nearly a million copies.

Vocalists and guitarists Stephen Page and Ed Robertson formed the band and started touring intensively, selling a five-song demo tape off the stage. Thanks to the emergence of the skewered love song "Be My Yoko Ono" on radio, Barenaked Ladies went on to outsell heavy hitters like Michael Jackson, U2 and Nirvana.

"It went gold, the first time that had happened to an indie single in Canada," Page explained. "So there was huge anticipation for *Gordon*. We were further identified by the hit 'If I Had $1000000.' That was written in five minutes, just like it's on the record—me and Ed bouncing back and forth, he'd sing one line and I'd sing back, and we tailored it down."

What made a Barenaked Ladies gig so full of fun was the way Robertson and Page heated up a crowd—the two frontmen, backed by keyboardist and percussionist Andy Creeggan, drummer Tyler Stewart and bassist Jim Creeggan, fed off each other's quirky jokes, monologues and wordplay.

"It's in the spirit of improv, somewhere between comedy and jazz, I guess," Page said. "In some ways we look at it as blowing solos. It's funny, some people get their backs up about it—'Well, I don't need to see a bunch of white guys pretending to rap.' That's not really the point. It's the spontaneity, the energy and the singularity of that moment that will never happen again. That's what gets us charged up, and that's what gets the audience a different show every time."

The mock seductiveness of Page's dancing stood as a reminder that a stocky guy could bust a move. "I realize that my body is one of the best sight gags I have, so you work with what you got," Page said. "I try to be natural but larger-than-life at the same time. I think people get a kick out of it, too, because it's something you're not used to seeing in rock music, that's for sure."

Concertgoers had started pelting Barenaked Ladies with boxes of macaroni and cheese. The lyrics to "If I Had $1000000" referred to the projectiles—"If I had $1000000 we wouldn't have to eat Kraft dinner, but we would, we'd just eat more…" "It's getting out of hand, and we've been discouraging it after a couple of stray boxes," Robertson lamented. "There are some nights when we have hundreds of boxes flying at the stage. And it's dangerous! Each one of those things is two pounds and pointy." ■

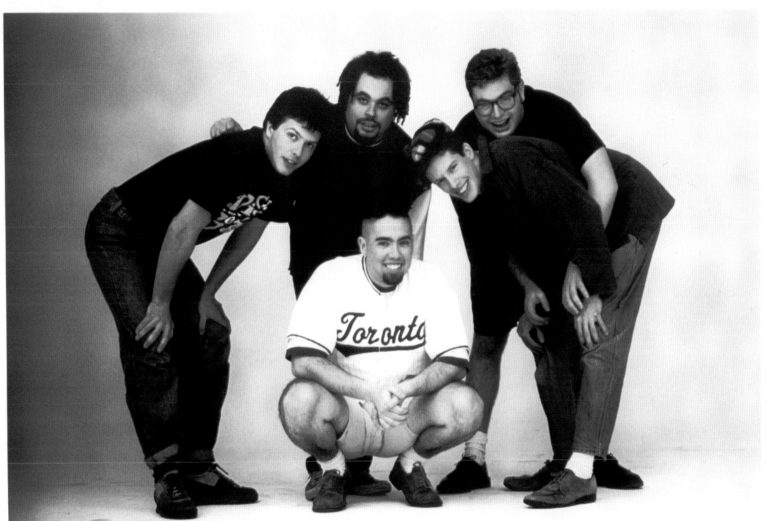

BARENAKED LADIES

Photo Credit: Neil Prime-Coot

© 1992 Reprise Records / Permission to reproduce limited to editorial uses in newspapers and other regularly published periodicals and television news programming

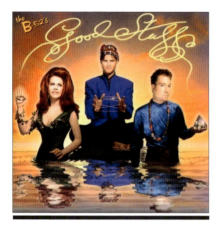

Billboard 200: *Good Stuff* (#16)
Billboard Hot 100: "Good Stuff" (#28)

The B-52's pressed on as a triad and brought out *Good Stuff*, the zany group's most overtly topical album.

IN THEIR cheeky, goofball past, the members of the B-52's looked silly-neat in their vintage glitzy outfits and namesake bouffant hairdos. But underneath the garish thrift-shop garb beat the hearts of social activists.

"People dwell on the party aspect of our music, but we like to write positive songs—that's also an important part of us," singer Fred Schneider said. "Interviewers have wanted to hear about the hair and wild dances. If we talked about politics, they wouldn't mention it. But we've always cared about people, what it takes to survive. It would be pretty empty to just get up onstage and make money. How could we enjoy that when there's so much to be done?"

The B-52's were the elder statesmen of the Athens, Georgia, music scene. From their beginnings in 1978 as a low-rent new-wave lark, they mixed futuristic effects with experimental guitar tones, retro melodies and unearthly harmonies. Only the rock underground truly appreciated the freewheeling camp classics "Rock Lobster" and "Private Idaho."

But the B-52's were also durable, and with 1989's *Cosmic Thing*, the group's alternative pop sensibility came to fruition, spawning its biggest hit, "Love Shack." The dance-rock party record ended the band's days as an irredeemably bizarre cult act without significantly altering its eccentric musical style.

The huge success was an unduplicatable high, but the B-52's still entertained on *Good Stuff*. The saucy, bouncy title cut smirked and shimmied to a wacky extreme. And like *Cosmic Thing*, the album reflected the band's emerging advocacy, urging listeners to respect the environment ("Revolution Earth") and their own individualism. The members had been activists and fundraisers for ecological and animal rights causes, and the group had a long-standing commitment to the fight against AIDS, which claimed original guitarist Ricky Wilson in 1985 (*Good Stuff* was dedicated to "all of our brothers and sisters who are living with AIDS"). "But we never want to preach," Schneider said. "It has to be presented in a way that the message gets absorbed and doesn't just slap you in the face."

The B-52's recorded *Good Stuff* without vocalist Cindy Wilson, Ricky's sister, who along with Kate Pierson delivered the band's trademark post-girl-group harmonies. She amicably took a sabbatical from the band to get married and start a family. "I gave them a year's notice," she said. "It was scary, crazy to do." ∎

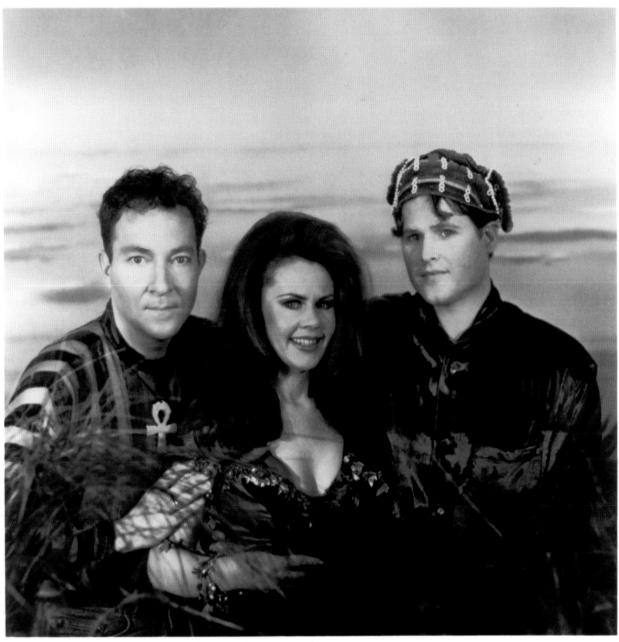

Fred Schneider Kate Pierson Keith Strickland

the B-52's

© 1992 Reprise Records. Permission to reproduce limited to editorial uses in newspapers and other regularly published periodicals and television news programming

Photo Credit: Josef Astor

Col. Bruce Hampton & the Aquarium Rescue Unit took a plunge into description-defying modern improvisation.

AN ATLANTA native, Bruce Hampton first distinguished himself by assembling the Hampton Grease Band in 1966 as a vehicle for his songwriting aspirations. The group's sole album, *Music to Eat*, released three years later, drew puzzled head-scratching—Columbia Records, Hampton observed, "didn't know what bin to put us in."

It was on the concert stage that the eccentric "good colonel" thrived on rock's lunatic fringe. He and the various musical crews that supported him established a reputation for musical obfuscation for the better part of three decades, redefining what music could be when it didn't matter what it was called. In the late Eighties, Hampton's musical expeditions led to the Aquarium Rescue Unit, a group of gifted young phenoms from the burgeoning Atlanta scene—Oteil Burbridge, Matt Mundy, Jimmy Herring and the mercurial Apt. Q258.

"When I hired these guys, I looked for three things—disposition, intention and release," Hampton said. "I wanted sensitive players who could listen. We never rehearse. And, while we have a format, I'm not sure what it is."

The band and label agreed that the best recording strategy would be to capture their live show. *Col. Bruce Hampton & the Aquarium Rescue Unit*, featuring guest keyboardist Chuck Leavell (formerly of the Allman Brothers Band), documented a date at Athens' Georgia Theatre in September 1991. ∎

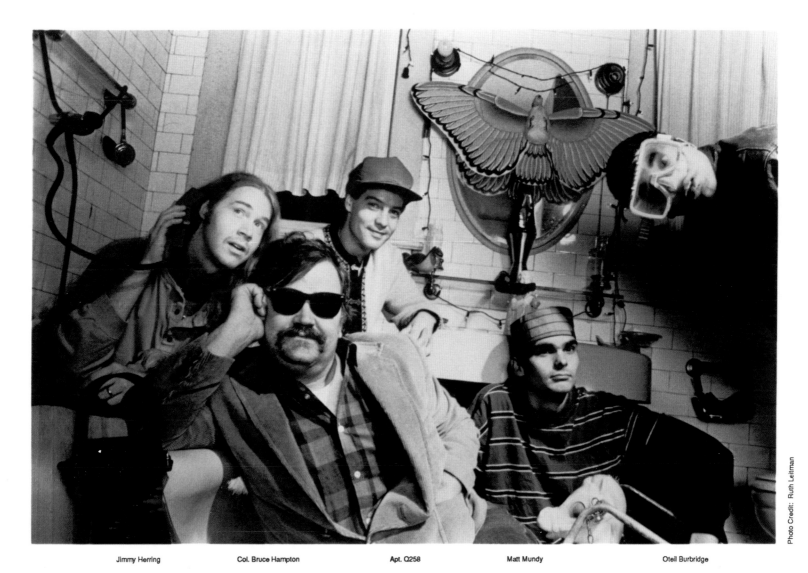

Jimmy Herring Col. Bruce Hampton Apt. Q258 Matt Mundy Oteil Burbridge

COL BRUCE HAMPTON &
THE AQUARIUM RESCUE UNIT

© 1992 Warner Bros. Records / Permission to reproduce limited to editorial uses in newspapers and other regularly published periodicals and television news programming.

Photo Credit: Ruth Leitman

A Picture of Nectar captured **Phish**'s virtuoso blend of improvisation, structure and some galvanized goofiness.

WHAT TO say to college-age free spirits looking for a band with a maddeningly eclectic range of styles, served up with chops galore and a wacky sense of humor? Go Phish. Through exhaustive touring, the Vermont quartet had built a faithful following nationwide, mostly a tie-dyed crowd. But Phish wasn't a "Deadhead band"—not when guitarist Trey Anastasio and bassist Mike Gordon bounced on trampolines and drummer Jon Fishman took a vacuum cleaner solo.

Phish's home base in Burlington was something of a mini-commune. During the weeks off the road, the bandmates resided with their crew and sound man, and they jammed three hours daily. "It's where we work out the arrangements and learn the compositions," keyboardist Page McConnell said. "The rest is skeletal."

Phish's collision of tight, earnest musicianship and resolutely non-commercial hippie abandon was unusual, but a major label came running to release *A Picture of Nectar*. "We weren't signed when we recorded it—we financed it ourselves, so we did it in a couple of weeks," McConnell admitted. "That's an awfully short time for a release in the majors."

A Picture of Nectar (named in honor of Nectar's, a bar that supported the band's early efforts) was all over the musical map, veering from art rock to bluegrass to reggae. On the jazzy "Tweezer," the members dabbled in an improvisational jam, taking prolonged solos à la Thelonious Monk. The single "Chalk Dust Torture" was straightforward, catchy rock 'n' roll.

"That's a new experience, what having a song on the radio can do—it takes on its own personality now," McConnell said. "We had a real handle, a control thing, on everything that's happened up to this point. If we didn't want a song to be heard anymore, we wouldn't play it. The worst thing would be to have a hit single. When people come see us, they get a better feel for what we're about. We don't take ourselves too seriously, like a lot of technical musicians. It's important that we remain human, that we like what we do." ■

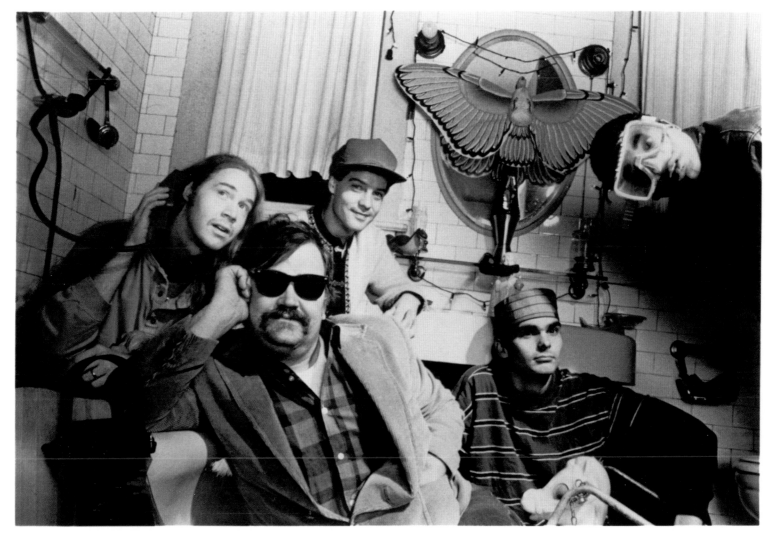

Jimmy Herring Col. Bruce Hampton Apt. Q258 Matt Mundy Oteill Burbridge

COL BRUCE HAMPTON &
THE AQUARIUM RESCUE UNIT

© 1992 Warner Bros. Records / Permission to reproduce limited to editorial uses in newspapers and other regularly published periodicals and television news programming.

A Picture of Nectar captured **Phish**'s virtuoso blend of improvisation, structure and some galvanized goofiness.

WHAT TO say to college-age free spirits looking for a band with a maddeningly eclectic range of styles, served up with chops galore and a wacky sense of humor? Go Phish. Through exhaustive touring, the Vermont quartet had built a faithful following nationwide, mostly a tie-dyed crowd. But Phish wasn't a "Deadhead band"—not when guitarist Trey Anastasio and bassist Mike Gordon bounced on trampolines and drummer Jon Fishman took a vacuum cleaner solo.

Phish's home base in Burlington was something of a mini-commune. During the weeks off the road, the bandmates resided with their crew and sound man, and they jammed three hours daily. "It's where we work out the arrangements and learn the compositions," keyboardist Page McConnell said. "The rest is skeletal."

Phish's collision of tight, earnest musicianship and resolutely non-commercial hippie abandon was unusual, but a major label came running to release *A Picture of Nectar*. "We weren't signed when we recorded it—we financed it ourselves, so we did it in a couple of weeks," McConnell admitted. "That's an awfully short time for a release in the majors."

A Picture of Nectar (named in honor of Nectar's, a bar that supported the band's early efforts) was all over the musical map, veering from art rock to bluegrass to reggae. On the jazzy "Tweezer," the members dabbled in an improvisational jam, taking prolonged solos à la Thelonious Monk. The single "Chalk Dust Torture" was straightforward, catchy rock 'n' roll.

"That's a new experience, what having a song on the radio can do—it takes on its own personality now," McConnell said. "We had a real handle, a control thing, on everything that's happened up to this point. If we didn't want a song to be heard anymore, we wouldn't play it. The worst thing would be to have a hit single. When people come see us, they get a better feel for what we're about. We don't take ourselves too seriously, like a lot of technical musicians. It's important that we remain human, that we like what we do." ■

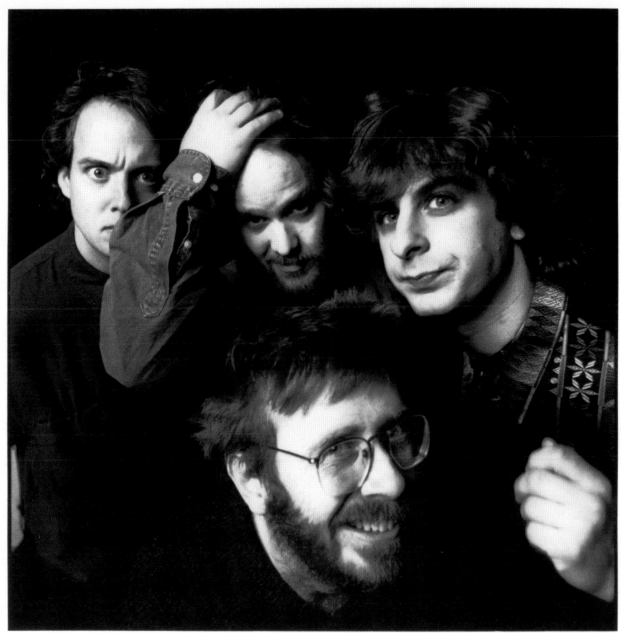

CLOCKWISE FROM BOTTOM: TREY ANASTASIO, PAGE McCONNELL, JON FISHMAN, MIKE GORDON

PHI5H

Elektra Entertainment

They Might Be Giants toured with a full band in support of *Apollo 18*, fortifying the brainy, quirky duo's fandom.

Billboard 200: *Apollo 18* (#99)

A HIGHLY developed sense of absurdist humor branded They Might Be Giants, a Brooklyn-based duo. John Linnell and his partner John Flansburgh had been likened to science-class nerds who grew up listening to *Super Hits of the '70s*. They initially developed a following on the New York club circuit by pursuing a low-budget musical eclecticism.

Many fans discovered They Might Be Giants' eccentric pop rock through the pair's Dial-A-Song answering machine service (718-387-6962), offering songs recorded especially for their phone line, the only charge that of a regular call to Brooklyn. "It's a difficult medium of expression," Linnell said. "A lot of sounds just can't be heard over the phone, and of course if you hit that sustained note which sounds like a beep, the machine ends the song right there."

"Fingertips," from the *Apollo 18* album, comprised a series of 21 separate refrains, most under 30 seconds long—when played in a CD player's shuffle mode, the song became a random, ever-changing musical collage. Linnell revealed he and Flansburgh had written it "before CDs hit the scene, the idea of little chopped-up choruses. It's a kind of music that you only get to hear on those late-night TV ads where they're selling compilations of songs and they only play the hooks."

Other *Apollo 18* songs teemed with unusual topics, such as "I Palindrome I"—the palindrome in the lyrics was "Egad a base tone denotes a bad age." The album received mostly positive notices, but reviewers conveyed reproval for its lack of a singular lead single, as "Birdhouse in Your Soul" had been an alt-rock hit in 1990. "It was positive in a crass way—we really got a lot more attention," Linnell said of "Birdhouse..." "Which is fine, but it also raised people's expectations in the industry. We don't see our function as making hit singles."

When their notoriety first skyrocketed, Linnell and Flansburgh began national tours as a two-man show, playing accordion, keyboards and guitar, frequently accompanied by a drum machine. For *Apollo 18*, TMBG performed with a three-piece backing band (sax, bass, drums). "For nine years, everybody kept saying, 'When are you gonna get a band?,'" Linnell mused. "Now that we have one, it's 'Why did you get a band?'" ∎

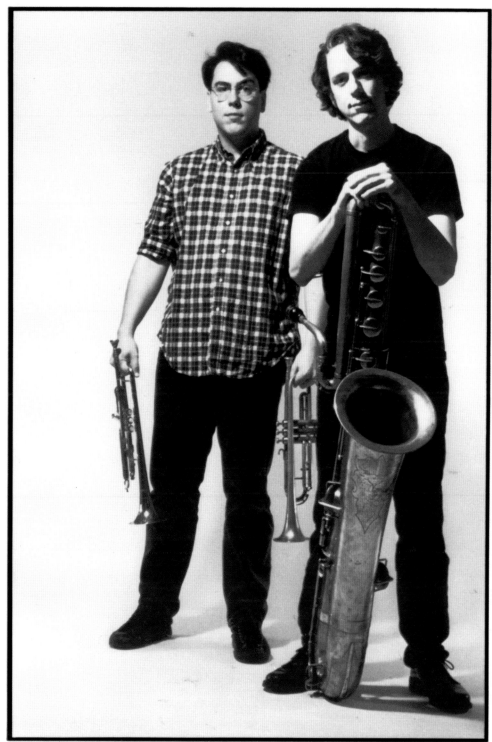

JOHN FLANSBURGH JOHN LINNELL

They Might Be Giants

Elektra Entertainment

PHOTO CREDIT: MICHAEL LAVINE

A stylish and original unit by way of the Twin Cities, **Walt Mink** made a glowing debut with *Miss Happiness*.

TWO HIGH-SCHOOL chums, drummer Joey Waronker and guitarist-singer-songwriter John Kimbrough, reunited at Macalester College after three years apart. "Joey and I created a concept-rock two-piece, playing parties and gallery openings while we auditioned bass players," Kimbrough remembered. With Candice Belanoff in place, the clean-cut band was named after a popular psychology professor. Walt Mink began attracting admirers soon after its first Minneapolis gigs in February 1989.

The loud, ferocious—but not bombastic—power trio was roundly praised in new music circles, and a couple of well-received indie 7-inch singles and lots of gigs later, Walt Mink released a debut album, *Miss Happiness*.

"As a teenager, I had a big hardcore collection," Kimbrough said. "I was always addicted to the speed and energy rush of that kind of playing, and I still feel happiest with that totally in-your-face, no-subtlety music. But I was also listening to *Revolver*-era Beatles, and there was no way of reconciling those two things. So, it pulled my writing off in another direction."

Walt Mink recorded *Miss Happiness* at Butch Vig's Smart Studios in Madison, Wisconsin. In order to provide the proper coziness, the band brought in rugs, lamps and various furniture from their home living rooms. At Waronker's request, a balloon-animal kit arrived, and he began to craft hundreds of brightly colored creatures which would eventually adorn every surface of the studio (featured on the album cover art).

The band's accomplished musicianship shined on the summery "Chowdertown" and an upbeat interpretation of Nick Drake's "Pink Moon." "It's about taking pop songs where you don't expect them to go," Kimbrough noted, "making the lyrics and hooks kick-ass and pretty all at the same time." ∎

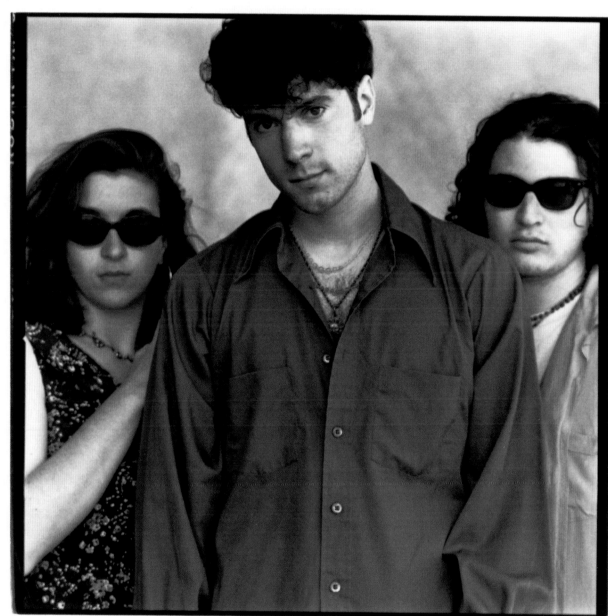

WALT MINK

CAROLINE
EAST COAST CAROLINE RECORDS, INC., 114 WEST 26TH STREET, NEW YORK, NY 10001
WEST COAST CAROLINE RECORDS CALIFORNIA, INC., 9838 GLENOAKS BLVD., SUN VALLEY, CA 91352

From left to right: Candice Belanoff, John Kimbrough, Joey Waronker

Photo credit: Chris Cuffaro

The Samples released *No Room* independently after an unacceptable experience with a major record company.

THE SAMPLES weren't widely known on radio and MTV, but they were in touch with their fans. The key to the Colorado quartet's hard-earned success was a strong word-of-mouth reputation through constant touring. Vocalist and guitarist Sean Kelly didn't even have a permanent home—he lived in a hotel. "I tell our manager, 'Keep us starving—it's good for the art,'" Kelly said. "We're on a weird career path, I know. But I believe in fate."

Kelly and bassist Andy Sheldon lived off supermarket samples when they moved to Boulder from Vermont in 1987—hence they started the Samples, including Al Laughlin on keyboards and Jeep MacNichol on drums. They played their first concert that Easter Sunday and released their first album a year later. Attracted to Kelly's plaintive voice and the band's reggae-rock sound, a major label soon picked up *The Samples*.

But the band members, having developed a devoted fan base on tour, discerned the label's meddling and decided to escape. "We'd be long gone by now if a recording deal was all we had," Kelly said. "Some bands get signed after their fifth gig and think someone is going to turn them into something amazing. They go in the studio and money is spent, they're not seeing it—and the record comes out and they're history because they didn't keep on touring. They don't have anything else to fall back on. We did."

To take control of their career, the Samples moved to What Are Records?, a burgeoning New York-based independent outfit. W.A.R.? signed the band as its charter act and offered grass-roots marketing suited to reaching the band's audience, distributing directly to stores that fell through the cracks of the dominant channels.

No Room, the second album, came out, and the eco-friendly "When It's Raining," "Did You Ever Look So Nice" and "Taking Us Home" showed the band's continuing growth. Record sales reached a high point, but the young and unpretentious Samples kept their focus on what they enjoyed most—the road. Eighteen months of touring followed the release of *No Room*.

"Actually, I hate MTV," Kelly admitted. "Their awards show disgusted me so much. Those people's attitudes—they're all idiots. It's like a glorified *Star Search*—I don't want to be any part of that. I tell local bands not to focus on getting signed, don't get caught up in that stuff. Play music, tour, build an audience—it will give you better leverage when the day comes." ∎

W.A.R.?

What Are Records?
(212)964-3703

GMG

The Management Group
111 East 4th Street, #215
New York, NY 10003
(212)254-0038

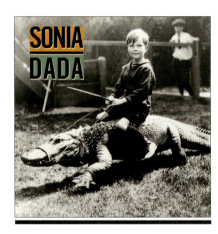

"You Don't Treat Me No Good" won Chicago-based Sonia Dada fans around the US—and in faraway Australia.

DANIEL PRITZKER had a favorite holiday memory. "I remember being a little kid and watching one of those Christmas television specials, and my dad saying what a great songwriter someone was—and then I hear him and go, 'God, this guy can't sing for shit,'" the Sonia Dada guitarist said. Fast-forward to the spring of 1990. "I'd written a lot of songs, and I couldn't sing them to save my life," Pritzker said. "I was playing around Chicago, always looking for singers."

As the story went, Pritzker stumbled out of a subway car in Chicago's Loop on the way to a Cubs baseball game and encountered three vocalists—Michael Scott, Paris Delane and Sam Hogan—harmonizing up a storm. Wowed by their gospel-drenched a cappella singing, he added some fellow rock-scene veterans, including drummer Hank Guaglianone and keyboardist Chris "Hambone" Cameron, for their loose, improvisational work.

Together they shaped a unique hybrid of rock, soul and R&B grooves. Infectious songs like "You Don't Treat Me No Good" and "You Ain't Thinking (About Me)" established the biracial octet at Triple A (adult album alternative) radio stations across the country. The debut album *Sonia Dada* soared to the top of the charts in Australia.

"It's lucky in terms of the way the personalities work," Pritzker, the scion of a prominent Chicago family, said. "Everybody does something that somebody else doesn't do well. I think we've got a little bit of a communist organization going on here—to each according to his needs, and from each according to his ability." ∎

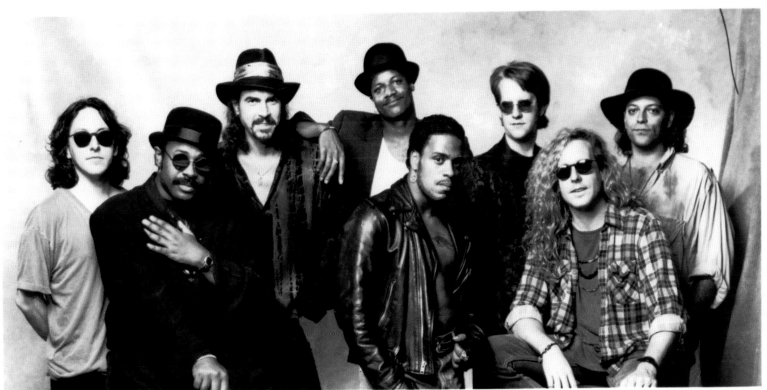

SONIA DADA

Photo Credit: Charles Cherney

© 1992 Chameleon Records

Billboard 200: *Wish* (#2)
Billboard Hot 100: "High" (#42); "Friday I'm in Love" (#18)

The Cure fine-tuned its moody, uneasy dirges and served up a pair of hits, "Friday I'm In Love" and "High."

AT THE beginning of the Cure's career, the band played the type of swirling goth-pop favored in Britain in the late Seventies. Robert Smith, a morose auteur dressed in black, specialized in brooding, frightening melodramatics, and the band's live and video performances emphasized Smith's ghoulish appearance—smudged red lipstick and an inky, bird's-nest hairdo. His self-absorbed moaning about love and death and loneliness managed to catapult the Cure into the top rank of cult artists.

The group continually evolved from Smith's original mope-rock presentation of doomy dirges into more textured soundscapes, and the Cure crossed over into the mainstream in the US. *Kiss Me, Kiss Me, Kiss Me* spawned the outfit's first Top 40 hit, "Just Like Heaven," and 1989's *Disintegration* went Top 20, with the single "Lovesong" becoming a smash. The success transformed a band that was founded to make stadium acts outmoded into a band that played stadiums.

"Things ballooned up when we broke in America," Smith admitted. "My life was a little blurry around that time—I believed that I was a pop star. But the rest of the group helped me. From that point on, I've kept being in the public eye very separate from how I act around friends. There have been several different Cures—the band has changed with my outlook. Unfortunately, we seem to be the only band in the world that's not allowed to be whatever we want. This 'doom and gloom' label is still put on us."

But the singer and guitarist knew that his dark, obsessive image had led the Cure down that career path, and brawls and outbursts of extreme behavior had always been common to the group. "There's a lot of baggage," Smith admitted. "But I'm proud of what we've done. I don't do it for the same reasons as other people. I'm not driven to be successful, just to play music and write songs. I'm being slightly disingenuous because they've gone hand in hand, but all I ever wanted was a means of self-expression."

Wish, the Cure's 12th US album, was one of 1992's biggest modern rock releases, entering onto the *Billboard* charts at #2. The album's moody atmospherics—ponderous, swirling guitars topped with Smith's diffident moaning—were the result of a cheerful chemistry among the five band members after original member Lol Tolhurst's acrimonious departure.

"High" reached No. 1 on the modern rock charts, and the giddy "Friday I'm in Love" was Smith's happiest song ever—and a worldwide hit. "The original version was pretty doomy, but it got sped up and I realized we had a really dumb pop song," Smith said. "It took me about three weeks to work up the courage to sing the words." ■

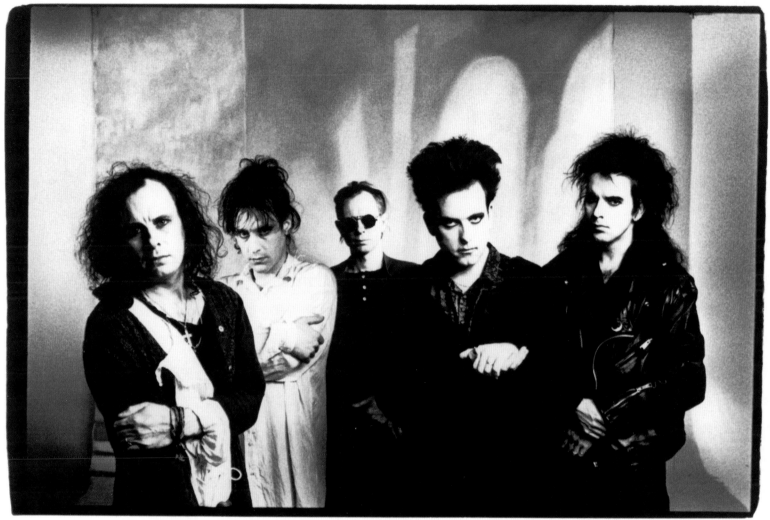

PORL THOMPSON　　PERRY BAMONTE　　BORIS WILLIAMS　　ROBERT SMITH　　SIMON GALLUP

PHOTO CREDIT: PAUL COX

FICTION

Elektra Entertainment

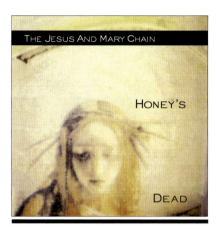

Billboard 200: *Honey's Dead* (#158)

The Jesus and Mary Chain attained some distinction in the Nineties by masterminding the *Honey's Dead* album.

THE SEMINAL debut album by the Jesus and Mary Chain, *Psychocandy* influenced a whole new group of bands in 1985. The Scottish-born brothers Jim and William Reid "patented" an invigorating mix of power-pop melodies, druggy lyrics and brutal wall-of-distortion guitar progressions. "We had the idea that nobody had ever made a really extreme guitar record," William said. "Other people used feedback, but nobody had ever pushed it to the limit."

Set up by a shift in music towards the sound they had developed seven years prior, the band resurfaced with a new work, *Honey's Dead*, meriting a slot on the main stage of the Lollapalooza '92 tour. The single "Reverence," awash with noise and a pumping rhythm, had already been banned from Britain's *Top of the Pops* because the BBC considered the lyrics—an opening line of "I wanna die just like Jesus Christ…I wanna die just like JFK"—inappropriate for young viewers.

But the Reids were obviously jerking society's chain. The single peaked in the Top 10 on the UK charts and received airplay on US alternative stations. "We hadn't worried about it—we never get played on mainstream radio, anyway," William said. "'Reverence' is a 'wannabe' song—people wanna be Madonna and live that kind of life, and there's a glamor in dying as well. Jesus Christ and John F. Kennedy experienced two of the most glamorous deaths in the history of the world." ■

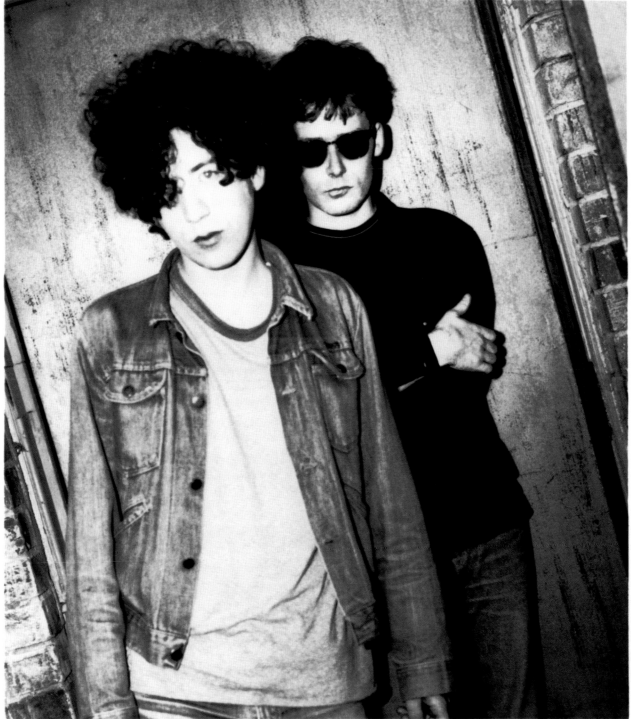

William Reid Jim Reid

THE JESUS AND MARY CHAIN

Photo Credit: Colin Bell

©1992 Def American Recordings/Permission to reproduce limited to editorial use in newspapers and other regularly published periodicals and television news programming.

Britain's **Curve** accumulated many positive reviews for *Doppelgänger*, a clamorous sonic assault on the senses.

The UK music press drooled over Curve, one of British alternative rock's most intriguing acts. The debut album *Doppelgänger* served as an aural manifesto—co-captain Dean Garcia layered ferocious, densely overloaded guitars, buzzing synthesizers and thrashy drums while frontwoman Toni Halliday's surging, high-pitched vocals gave the harsh, atmospheric style an icy edge. "We had an idea," Halliday said. "We experimented with how far we could take an abrasive Phil Spector wall-of-sound, how much we could get on a record."

Both Halliday and Garcia were veterans of the record industry's machinations. In the mid-Eighties, the duo worked in an ill-fated band called State of Mind. Prior to that, Halliday had a solo career that went nowhere, and Garcia was a session musician for Eurythmics. "Now we only do what we enjoy," Halliday said. "I want to have a life with exciting things going on. We derive our main pleasure from music, and when you get the opportunity to do something where you don't have to go through all the processes, then it's good fun."

"Faît Accompli" and "Horror Head" grazed the US alternative charts, and Curve toured extensively, supported onstage by additional musicians. People seated in the front rows found Halliday glaring at them—"No one sits down at our shows," she seethed.

"We put the music across the way my psyche hears it—louder than anything else. In London, they printed on the ticket, 'Bearers may be exposed to continuous sound levels that may cause damage.' It could be seen as a safety net for the band. It's comfortable to work at a certain volume, but it's not crucial. Yet fundamentally, it's what we want to do. You can't please everybody. But the majority love it. When I went to a gig at that age, it was disappointing if you could talk over the music." ■

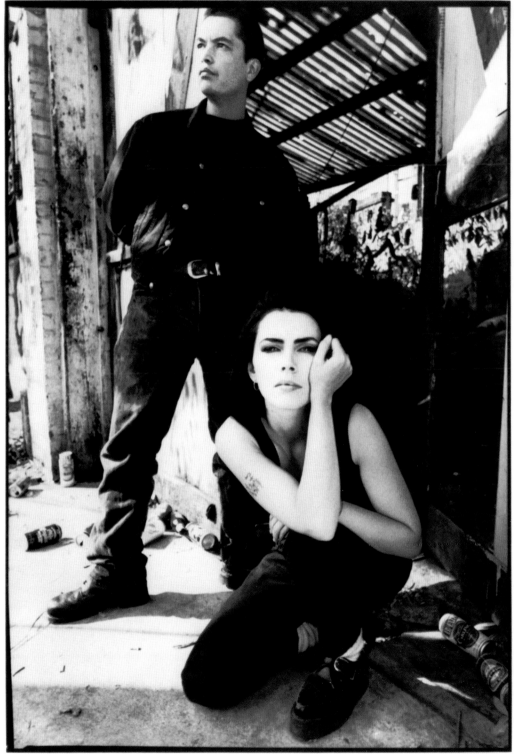

Photo Credit: Derek Ridgers 10/91

charisma

CURVE

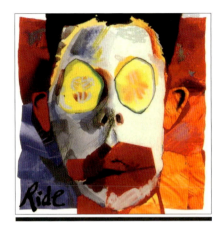

The members of **Ride** distanced themselves from the UK's shoegaze genre with the album *Going Blank Again*.

THE NEWEST English bands all seemed to feature introspective middle-class college boys who cared more about ethereal sonic textures than song structure and lyrics. Yet some were making exciting guitar-oriented rock 'n' roll. Ride, one of the feistiest groups, was part of the UK's "scene that celebrates itself," a term coined for the supportive setting. But the British music press, inspired by the serene, virginal inertia onstage, referred to it as "the scene that contemplates its shoes."

Ride resented the "shoegaze" labeling. "I'm gazing at someone else's shoes," guitarist Andrew Bell retorted. "The British media get so overexcited—they anticipate something six months before it happens, and then they get impatient and write it off two months before it happens. They've been good to us—but we'd rather not pay attention."

There was also enthusiasm in America about the next British wave. "Even though we grew up in the synth age, there was a big guitar heritage—Echo & the Bunnymen, the Smiths," Bell explained. "We got together through friendship, and we could play guitar, bass and drums."

The Oxford quartet's second album, *Going Blank Again*, had a seductive, layered pop sound. "Leave Them All Behind," a thunderous eight-minute jam, reaped radio airplay on modern rock stations. "We started jamming the riff a year ago when we were touring Europe—we played it at soundchecks all the time," Bell said. "In the studio, the engineer started playing it on a sequencer just to show us what hitting a guitar sound on a keyboard would sound like."

The sunny "Twisterella" was "the one we wanted to make really poppy, airy, light," Bell noted. "Mark (Gardener, vocalist) wrote it about going to London and getting off his head, that's the vibe. I did this good harmonica track, but Ride being a democracy, everybody voted against it." ∎

Ned's Atomic Dustbin offered the pithy "Not Sleeping Around," which turned into the UK band's biggest US hit.

INNOCENT ENTHUSIASM set Ned's Atomic Dustbin apart from other bright, tough youths on the British rock scene. The Neds had taken artistic license with the standard two-guitars-bass-and-drums aesthetic, altering it to feature dueling basses. "(Bassist) Mat and I wanted to be in the same band," bassist Alex explained. "We know our places. He plays the low part, rhythm with the bass drum. I play melodies on the high end of the bass."

The sound also included an invigorating guitar crunch and unabashedly catchy melodies, and the band's first single, the gleefully warped "Kill Your Television," was a steady alternative seller. In America, the maniacal young rockers were on college radio and making "dustbin" a household word in a country where people didn't know what a dustbin was. "We just tell them it's a trash can," Alex said.

Layering a post-psychedelic Bo Diddley beat with distorted guitars and a ranting vocal, "Not Sleeping Around" from the *Are You Normal?* album climbed into the Top 5 of *Billboard*'s modern rock chart. Alex and Mat, singer Jonn, guitarist Rat and drummer Dan (no last names, please) collaborated on the songwriting. "We've all got equal parts—it's our key to preserving the band," Alex noted. "But it makes producing songs a pretty slow process."

The Neds had imported a fad from their native England—creating custom-made T-shirts in dozens of editions and raising them to the level of collector's items. "Originally it was a cheap way of advertising the band," Alex explained. "Our fans are a rabidly devoted lot. In England, we've got people following us around. In America, they're very loyal and precious—we're *their* band." ∎

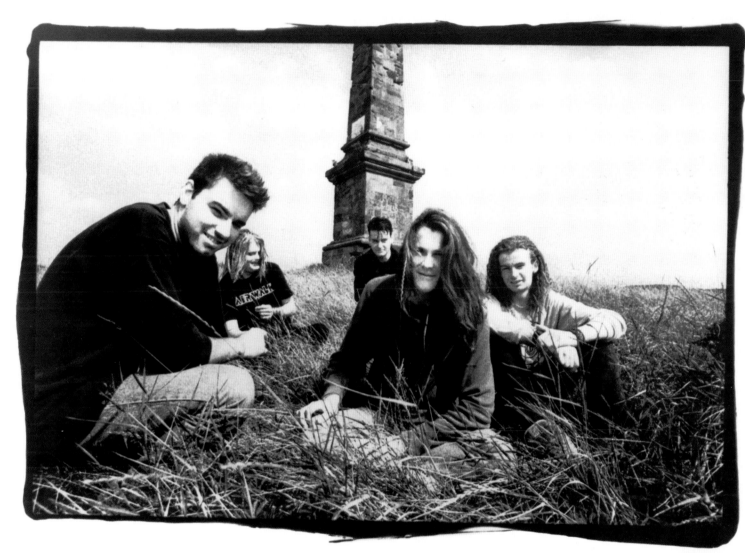

From left: DAN, RAT, MAT, JONN, and ALEX.

REM MANAGEMENT
14561 Greenleaf Street
Sherman Oaks, CA 91403
Phone: 818.501.4873
FAX: 818.907.8350

NED'S ATOMIC DUSTBIN

CHAOS
9209

Billboard 200: Hotwired (#97)
Billboard Hot 100: "Divine Thing" (#35); "Pleasure" (#69)

The Soup Dragons' "Divine Thing" manifested itself as a US Top 40 hit for the Scottish alternative-rock outfit.

WHEN THE Soup Dragons formed in 1985, the Glasgow-based group garnered interest because of a striking musical resemblance to punk-pop pioneers Buzzcocks. But the foursome mutated into an international name in the summer of 1990, dominating the college and alternative charts with the laid-back psychedelia of the Rolling Stones' "I'm Free." The Hotwired album further captured the Soup Dragons' marriage of grinding rock guitars and funky tribal rhythms. The energetic "Divine Thing" reached #3 on Billboard's Modern Rock Tracks chart.

"The album was recorded in an old converted Methodist church," guitarist Jim McCulloch explained. "People kept coming up to the door asking to speak to the minister. We'd say, 'Nobody here but us pop singers,' but they insisted on looking for a 'divine thing.'" ∎

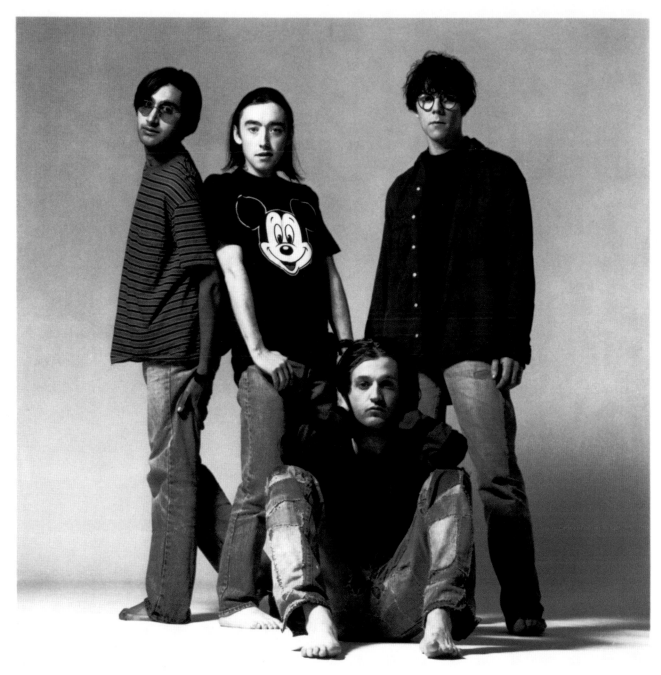

SUSHIL DADE JIM McCULLOCH SEAN DICKSON PAUL QUINN

THE SOUP DRAGONS

Billboard 200: *Welcome to Wherever You Are* (#16)
Billboard Hot 100: "Not Enough Time" (#28); "Beautiful Girl" (#46)

Adding new elements to *Welcome to Wherever You Are*, **INXS** shook up its accustomed sound and production.

WITH AN intelligent composite of mainstream rock and dance beats, such classic albums as *Listen Like Thieves* and *Kick* shot INXS into the pop stratosphere in the late Eighties—the international superstar act sold more than 20 million records, played thousands of shows and reaped numerous music awards. Keyboardist Andrew Farriss co-wrote most of INXS' material with frontman Michael Hutchence. Along with two Farriss brothers—guitarist Tim and brother Jon—rhythm guitarist Kirk Pengilly and bassist Garry Beers, they'd been playing together since 1977 in their native Australia.

"As the Eighties closed, a whole new generation of bands had picked up guitars and turned up amplifiers and discovered that it's okay to dance and have a good time," Andrew Farriss said. "We were like, 'Yeah, well, what's changed?' Having started out in the late Seventies, we think it's funny that punk music and disco are so hip and groovy now. That's what we've always been."

The Aussie sextet then explored fresh territory on 1990's *X* and the adventurous sonic textures of *Welcome to Wherever You Are*, spending more time together in the studio than expected. "We felt the need to continue writing and recording—we want to stick to the studio and get out of the usual album/tour-for-two-years cycle," Farris explained. "In Europe, they understand what we're doing. Not touring creates more interest in our records. Whereas in America, corporations don't like that. They hold it against you if you don't follow the program."

Accordingly, *Welcome to Wherever You Are* was positively received in the UK and Europe, but INXS' popularity started to wane on the American pop charts. "In the next century, I think you might be surprised to find that there's not so much emphasis on being popular in America," Farriss said. "No one can ever take away from America that it invented show business. But other people have been into music and other artforms before America existed, and will continue to be. In Europe, I've noticed that it's easier to move around and there's a subtle pride. In Asia, there are more people, industry is expanding and they don't have the same kind of rules about what you can do. It's trying for them to get along and become great nations—they're big places. But if they can actually do it, who knows? Maybe the mecca of places to be will be where no one expects." ∎

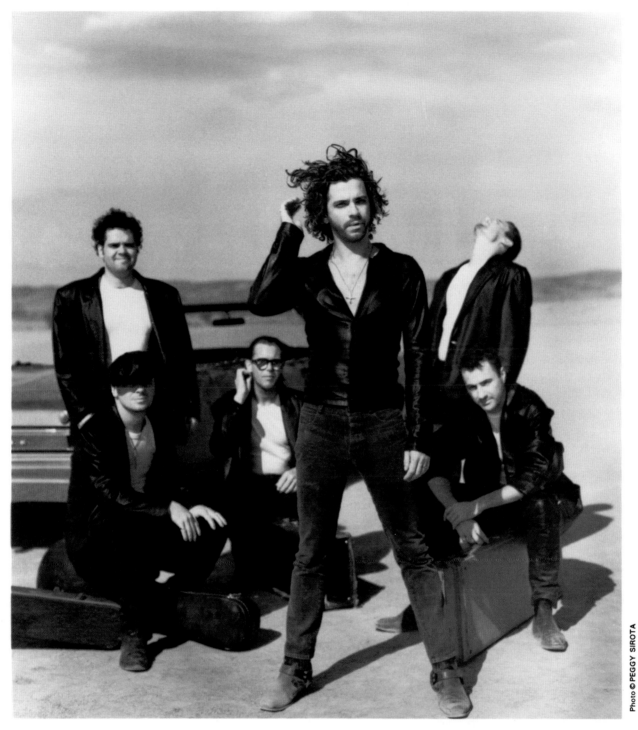

ANDREW FARRISS
TIM FARRISS KIRK PENGILLY
MICHAEL HUTCHENCE
JON FARRISS
GARRY GARY BEERS

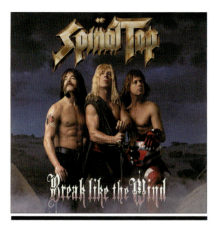

Billboard 200: *Break Like the Wind* (#61)

Spinal Tap became a real band—a parody heavy-metal band—issuing a studio album and embarking on a tour.

IN 1984, the "rockumentary" film *This Is Spinal Tap* captured a variety of wicked mishaps that befell fictional British heavy-metal has-beens who never were, created by comedians and musicians Michael McKean, Christopher Guest and Harry Shearer. Bassist Derek Smalls (portrayed by Shearer) was apprehended when the foil-wrapped cucumber he secured in his trousers set off an airport security device. The band ordered a gigantic Stonehenge stage set, only to be given scenery that stood 18 inches high, not 18 feet. Drummers died by spontaneous combustion, and the girlfriend of guitarist and lead singer David St. Hubbins (McKean) tried to take over management guided by astrological charts. With the band mistakenly booked at an Air Force base, guitarist Nigel Tufnel (Guest) stormed off the stage when his radio-miked guitar picked up air-traffic-control messages. Tufnel had a desperate moment with backstage catering when the meat for his sandwiches was round but the tiny bread slices were square.

The music from the soundtrack was passable fare with bright, imaginative lyrics ("Sex Farm," "Big Bottom"), and *This Is Spinal Tap* became an inside joke for anyone who had ever spent a few minutes backstage at a rock concert.

Spinal Tap reemerged and was seemingly playing for keeps. The conceit? After turning their collective backs on rock stardom in the wake of the disastrous "Smell the Glove" tour documented on *This Is Spinal Tap*, the members of the band decided to reunite. A new album, *Break Like the Wind* (promoted as the group's 13th), featured original songs and guest appearances by Jeff Beck, Joe Satriani and Slash from Guns N' Roses. The aural satire tackled standard rock themes like the agony of touring ("Stinkin' Up the Great Outdoors") and the obligatory sappy ballad (Cher sang on "Just Begin Again").

Some pundits had commented that the single "Bitch School" was sexist. "It's about dog obedience," Tufnel said. "The three of us love dogs. Read the lyrics—'You're so fetching when you're on all fours.' How can you misconstrue that?" "The Majesty of Rock" was a bloated manifesto: "That's the majesty of rock/The mystery of roll/The darning of the sock/The scoring of the goal/The farmer takes a wife/The barber takes a pole/We're in this together."

Spinal Tap assaulted the media—the poker-faced band cropped up giving comical interviews to every magazine and talk show in sight. The rockers went on a national tour, appeared at the AIDS benefit at London's Wembley Stadium and made their animated debut on *The Simpsons*. And so Spinal Tap filtered into the rock consciousness, blending scarily into the metal scenery. It was still a sendup, but the presentation invited the audience in a little more.

"We are hoping to play to audiences who bring their own youthful exuberance with them—so that we don't have to supply it along with the electricity and all that," St. Hubbins pontificated.. "We *are* working up here, kids!" ∎

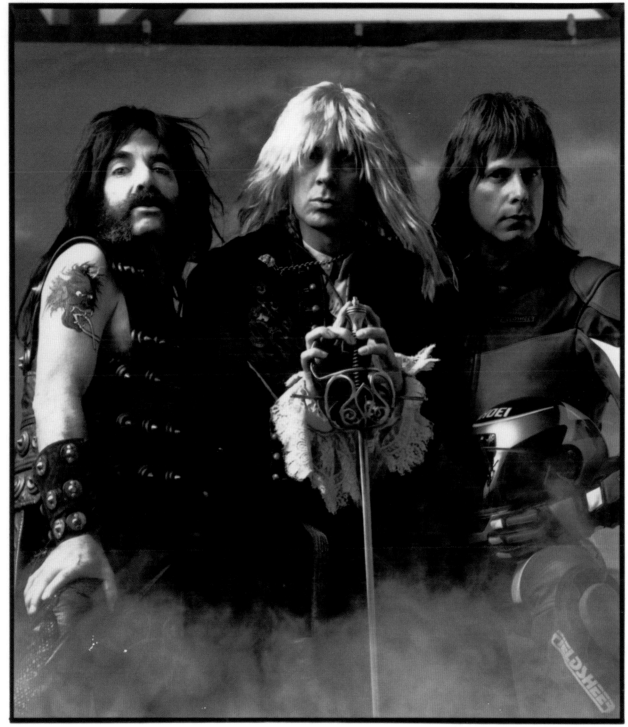

Photo credit: Peter Darley Miller

DEREK SMALLS DAVID ST HUBBINS NIGEL TUFNEL

2/92

Billboard 200: *Revenge* (#6)

One more stab at chasing greatness, **Kiss**' *Revenge* debuted in the Top 10 but soon faded from the charts.

TWO DECADES after aspiring New York rockers Gene Simmons and Paul Stanley decided to form a band, Kiss still had not grown up. "Kiss is like a party—you stay as long as you're having a good time," Simmons explained. The guys had given up the trademark Seventies makeup long ago, but Kiss had become one of the most long-lived acts in hard-rock history, an enduring symbol of three chords drenched in sex and smart-ass rebellion. At any given career moment, Kiss had penetrated the consciousness of pubescent males preoccupied with acne, report cards and their virgin status.

But during the past decade, Kiss had slipped into pallid pop-metal—the band was seen as a spent force, headed for the rock landfill. And Simmons, once a great showman (a blood-spewing, fire-breathing demon), was rerouting his sizable drive into other corporate corridors. He played villains in movies, produced metal bands, founded Simmons Records and managed Liza Minnelli. His outside business interests seemed like a time bomb waiting to destroy the band.

"It was totally my fault—once the makeup came off, I was lost in the ozone," Simmons admitted. "I was raped and seduced by the American dream. I listened to what record companies wanted me to do, what the girl I was in bed with the night before wanted me to do—'Why don't you do more ballads, Gene? You have a nice voice.' Ultimately, you've got to listen to your own heart—what really makes you happy. The thing that made me happiest was creating this thing called Kiss, which went way beyond what any critics thought and is still moving on happy as can be and breaking all the rules. So I've put that other stuff in mothballs."

It seemed the killer instinct had returned on *Revenge*, the band's 16th studio album. The songs were more aggressive, catchy yet heavy, from the killer riff of "Unholy" to the stirring ballad "Every Time I Look at You." "I Just Wanna" turned the words "forget you" into a dirty expression. *Revenge* went gold, though it failed to reestablish a mainstream audience.

While Kiss began work on *Revenge*, drummer Eric Carr was diagnosed with cancer. After open-heart surgery, he died from complications. Eric Singer, whose credits included work with Gary Moore, Black Sabbath and Alice Cooper, was the new drummer. "The good thing is, he's had lots of experience with other bands and he comes in with a fresh point of view," Simmons mused. "When we start to grumble, he says, 'What are you complaining about? You're Kiss!' Sometimes it takes somebody new to tell you what you should already know." ∎

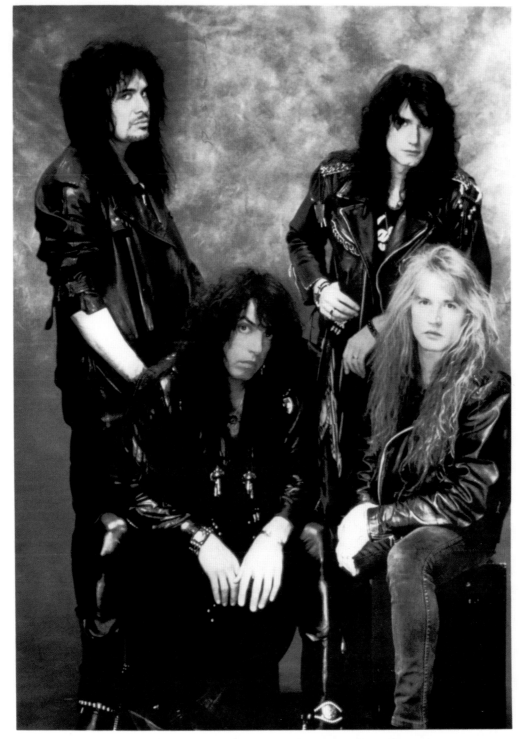

GENE SIMMONS PAUL STANLEY BRUCE KULICK ERIC SINGER

Billboard 200: *Adrenalize* (No. 1)
Billboard Hot 100: "Let's Get Rocked" (#15); "Make Love Like a Man" (#36); "Have You Ever Needed Someone So Bad" (#12); "Stand Up (Kick Love into Motion)" (#34); "Tonight" (#62)

Def Leppard's *Adrenalize* topped the album charts and launched the immediate smash hit "Let's Get Rocked."

THE INDOMITABLE pack's albums struck multiplatinum, but Def Leppard had been hounded by a notorious streak of cruel fate. In 1984, drummer Rick Allen lost his left arm after a New Year's Eve car crash. The latest tragedy—guitarist Steve Clark died in 1991 after years of chronic alcoholism. Nevertheless, the British rockers had bounced back loudly, recording as a quartet. *Adrenalize* entered the *Billboard* 200 at No. 1.

The songs were devoted to teen fantasies, simple shout-along catch phrases like "Let's Get Rocked." The pop-metal production pounded home the hormone-heavy stances, a glossy amalgamation of chanted vocal hooks and densely layered guitar snarls. Def Leppard would always be viewed by a few critics as just another group of heavy-metal musical terrorists, the very embodiment of corporate rock. To singer and frontman Joe Elliott, the notion of the rock 'n' roll lifestyle being a fashion statement not only seemed inappropriate, but maybe a little dishonorable as well.

"We come from a working-class background, we grew up the hard way, we don't take anything for granted—and you don't lose that when you start selling a few records," he said in disgust. "When I'm at home, I drive my own car—I don't have a limousine, I don't have a chauffeur, and I've never had a bodyguard in my life. And for what it's worth, I take out my own trash."

Ah, yes, as in "Let's Get Rocked." In the hit single from *Adrenalize*, Elliott complained about being told to take out the trash, declaring, "I'm your average, ordinary, everyday kid/Happy to do nothing/In fact that's what I did." The carpers asked how a wealthy 31-year-old could still regress and convincingly convey that kind of adolescent frustration. Elliott, a walking encyclopedia of rock history, was matter-of-fact in analyzing the song's success.

"Does that mean that when Robert De Niro is handed a script to play a down-and-out bum, he shouldn't take it because he's a multimillionaire? You're playing a part—I was singing the song from the point of view of a 16-year-old, someone half my age. When I wrote the lyrics to 'Let's Get Rocked,' I was basically doing an entire rewrite on 'Summertime Blues' by Eddie Cochran. I changed the boss/employee thing to father/son, boyfriend/girlfriend—the argument factor.

"It's stupid—it's *supposed* to be stupid. It's the alternative to serious, mature, angry rockers like Peter Gabriel or Sting or Leonard Cohen. They understand the need for bands like us. There's nothing wrong with escapism." ■

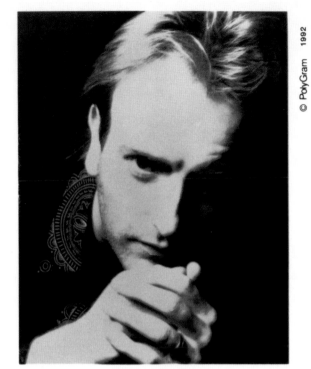

JOE ELLIOTT

PHIL COLLEN

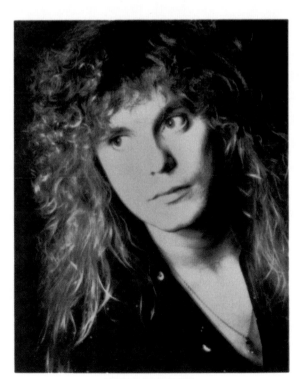
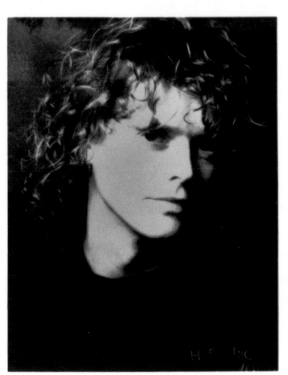

RICK SAVAGE

RICK ALLEN

© PolyGram 1992

Photos: Pamela Springsteen

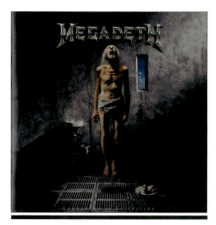

Billboard 200: *Countdown to Extinction* (#2)
Billboard Hot 100: "Symphony of Destruction" (#71)

Helming *Countdown to Extinction*, Dave Mustaine credited Megadeth's newfound focus to his cleaned-up act.

PRETTY MUCH everything Megadeth touched had turned to gold in a five-album career, and *Countdown to Extinction* represented the thrash-metal outfit's most successful effort ever. But the group continued to major in frequent upheaval—it regularly changed its lineup, and Dave Mustaine, the outspoken leader, guitarist and singer, spent a few tumultuous years largely in a drug and alcohol haze.

"The abuse never affected my playing; it affected my relationships," he mused. "I didn't want to have anything to do with human beings but playing music for them. I was my acronym for 'pig'—personal instant gratification, whatever I could get out of other people. I was coming from a real bankrupt place emotionally. I couldn't find happiness anywhere, so I numbed the pain. But I got married, built a house, had a kid, got a dog. And now it's, 'What else can go right?' Success is what I wanted, happiness is what I needed. And I got what I needed—success made me happy."

In 1991, speed-metal cult heroes Metallica crossed over to the pop mainstream and turned into a commercial juggernaut. Megadeth had taken the megabuck route, too, making *Countdown to Extinction* more accessible to the masses. But it was a touchy subject—nearly a decade prior, a then-unheralded Metallica ousted Mustaine.

"James (Hetfield) kicked my dog and I smacked him and I got fired," Mustaine said. "I survived, but I was very hurt. I didn't get a warning or a second chance. I was disappointed that they let me go, and part of it was the jealousy of seeing them go on to wondrous heights. But I had a spiritual awakening—wishing bad on them was wishing bad on me. Trying to come off better than other people and preying on their misfortunes was gonna hold me back. It's gotten a lot better—I don't think twice about it."

Countdown to Extinction was doubtlessly too tame for the hardcore fans who would always prefer Megadeth in the old thrash mode. "Teddy Roosevelt said that only the people in the trenches matter," Mustaine said. "I challenge anyone to try and do what we do. We win just by taking the chance. For every fan we've lost, we've gained a thousand. I wish we'd lose a few more! From the beginning, I had it in me to play anything I wanted—there's nothing we can't do. We're showing people that thrash isn't just about speed, it's a lot of different, creative things."

Besides Mustaine, Megadeth was composed of bassist Dave Ellefson, drummer Nick Menza and guitarist Marty Friedman. Mustaine's lyrics had long been political, and this time he took up conventional gripes like world powers ("Symphony of Destruction") as well as the problems of life in general for metalheads. "We're not getting caught up in success—it's the next step to being a rock-star pig," Mustaine vowed. "I look into the crowds at these sweaty, pimply faces, and they're going, 'He's my hero.' I wish I could wave my hand and give them all a part of my happiness, but I can't. But being a bringer of pleasure is enough." ∎

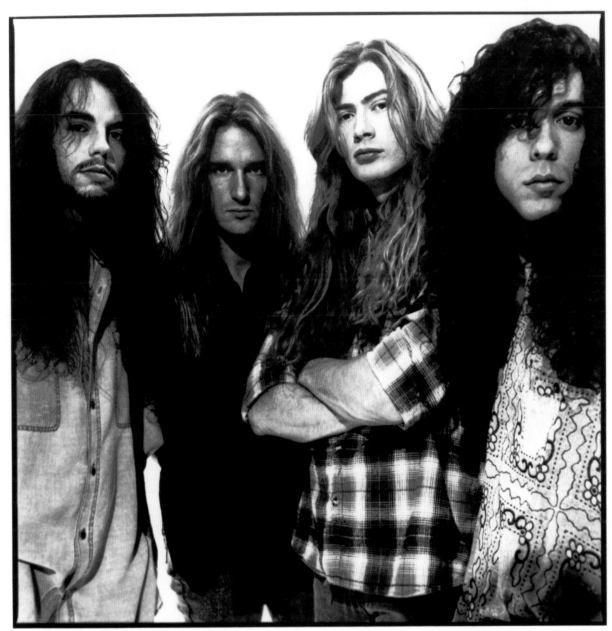

NICK MENZA DAVID ELLEFSON DAVE MUSTAINE MARTY FRIEDMAN

Photo: Michael Halsband / 1992

Billboard 200: *Fear of the Dark* (#12)

Fear of the Dark's title track became an anthem for Iron Maiden, one of metal's appreciable success stories.

MAKING THEIR way from the seamy working-class pub scene of London's East End, the members of Iron Maiden released a debut album in 1980. By the mid-Eighties, the group's thundering musical style and live performances had gained an international following that extended not only across the Atlantic and Pacific oceans, but into Iron Curtain nations like Poland, Yugoslavia and Hungary. By the end of the decade, the band claimed worldwide sales of more than 25 million records and more than a thousand gigs.

Yet the last couple of albums were caricatures. Iron Maiden lost the menacing vibe of earlier recordings like 1982's *The Number of the Beast* with releases featuring overblown cinematic titles and protracted epics, and on 1988's *Seventh Son of a Seventh Son*, the band experimented and used more synthesizers. They fended off breakup rumors when lead singer Bruce Dickenson released his first solo record, and then guitarist Adrian Smith quit. But Smith's replacement, Janick Gers, gave the band a kick in the rear—1990's *No Prayer for the Dying* was the heaviest Iron Maiden effort in years, blending fiery guitars and Dickenson's go-for-the-jugular screaming.

Fear of the Dark, recorded in founder and bass guitarist Steve Harris' barn studio, found Iron Maiden doing songs in the varied, progressive settings of *Seventh Son* again. It was the band's third UK No. 1 album. "People can't dictate to us what we want to do," Harris mused. "We have to be happy and worry about it afterwards. *Seventh Son* was our biggest album in England, but in America the fans bad-rapped it because of the keyboards. This time people seem to be reacting differently."

In the past, Iron Maiden lyrics had drawn upon mythology, history and films for inspiration. But like many of the songs on *Fear of the Dark*, "Be Quick or Be Dead" dealt with a topic straight from the day's headlines, the big business scandals plaguing "the establishment." "We can't ignore what's been going on the last couple of years," Harris said. "We emphasize fear quite a few times."

Ten years earlier, Iron Maiden was the prototypical thrash act, the reason many young speed kings started bands. "A lot of them say they're influenced by us, but I can't hear it—they don't sound anything like Iron Maiden," Harris allowed. "All I hear is the aggressive side. We've got so much melody in our songs, whereas a lot of those bands concentrate on the anger." ∎

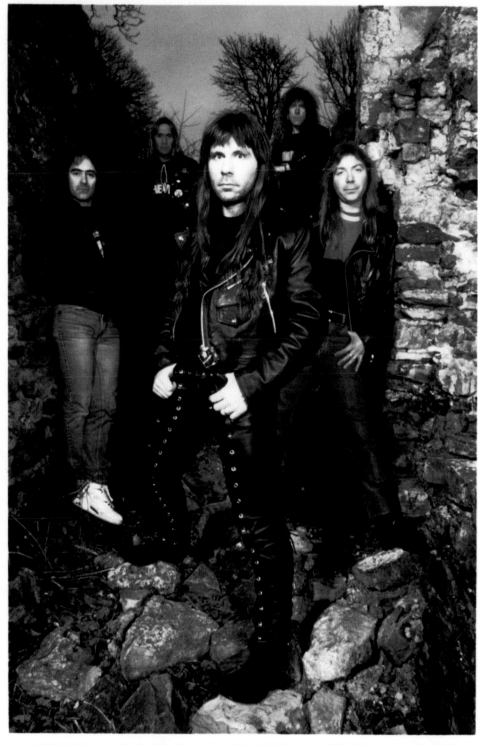

STEVE HARRIS NICKO McBRAIN BRUCE DICKINSON JANICK GERS DAVE MURRAY

9205

Billboard 200: *The Ritual* (#55)

Testament's *The Ritual* was marked by a new approach to recording, followed by a major lineup change.

IN THE mid-Eighties, Testament was part of the Bay Area's thriving thrash-metal sphere. Growing up listening to Judas Priest, Scorpions, Raven and Iron Maiden, the members gradually began writing their own maniacally fast, repetitive songs. Live shows captivated fans, but Testament took it in the shorts from peers as a so-called Metallica rip-off.

"It's frustrating from a personal standpoint—I don't listen to Metallica, I don't own an album of theirs," guitarist Alex Skolnick said. "We're hoping the comparisons will change with the album."

The Ritual featured Metallica-sized riffs—heavy, loud and forceful—but the material was more sophisticated and melodic, with decelerated, subtle arrangements. "Return to Serenity," a wistful meditation on loneliness, managed to receive mainstream rock radio airplay. "Electric Crown," about a person on death row awaiting the electric chair, was driven by Skolnick's deft soloing.

Skolnick, a marvel who had partnered in the past with progressive-rock guitarist Stuart Hamm, had fretted of the creative limitations imposed by Testament's style. Was he challenged by metal music? "If I can make something that sounds creative and unexpected in this context, that's not boring," he said. "With any band that's a democracy, there's compromise involved. When we make an album, it's important that everyone in Testament is satisfied." Skolnick left Testament soon after *The Ritual*'s release. ∎

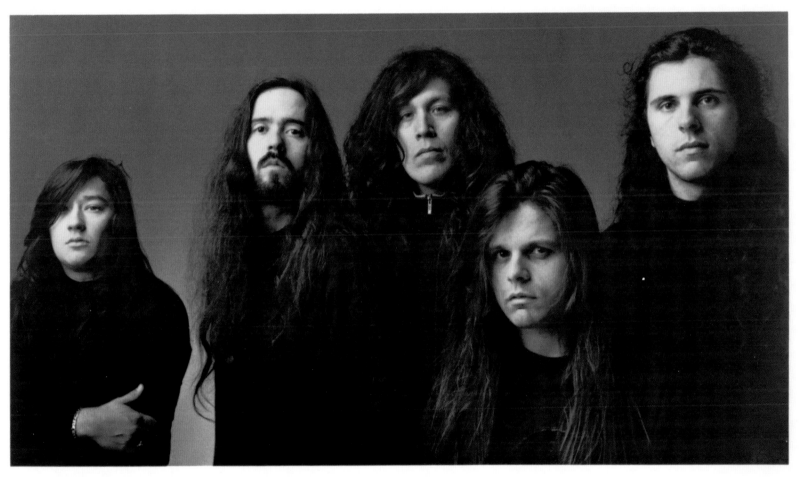

ERIC PETERSON GREG CHRISTIAN CHUCK BILLY LOUIE CLEMENTE ALEX SKOLNICK

ON RECORD | 1992 | [BON JOVI]

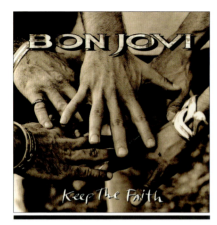

Billboard 200: *Keep the Faith* (#5)
Billboard Hot 100: "Keep the Faith" (#29); "Bed of Roses" (#10); "In These Arms" (#27); "I'll Sleep When I'm Dead" (#97)

Keep the Faith was proof positive **Bon Jovi**'s brand of unabashedly melodic hard rock was far from obsolete.

BON JOVI had been out of the spotlight since 1988's quintuple-platinum *New Jersey* album, but Jon Bon Jovi was sticking to his musical guns. Respond to the grunge threat? He wasn't desperate enough to don flannel shirts, Doc Martens and wool caps. "If I did that, I would have lost my mind," the singer said. "It would really be wrong for me to chase after any kind of current fad or fashion."

In the Eighties, pump-your-fist hard-rock anthems and sensitive-guy power ballads about youthful frustration and desire made Bon Jovi one of the biggest acts in the business. The band marked global sales of more than 30 million albums and staged two massive world tours. But the pace drove all five members to take a vacation from each other after more than eight years of nonstop action.

"We'd gone to a level we'd never imagined," Bon Jovi explained. "We were shells of the men who started touring, delirious. We wanted to do other things, even if it was just going home to cut the lawn. I realized you didn't have to press '9' to get an outside line in your own house."

Bon Jovi cut his famous hair, turned 30, got married and had a daughter, split with his managers, agents and lawyers—but the original band lineup remained intact. "I didn't have a master plan to grow up," Bon Jovi laughed. "When you're a kid, you'll sell your soul for rock 'n' roll. I don't know if it was worth it. I started it all over, redefined it and wrote about it. It was a soul-cleansing well worth doing."

Keep the Faith included the hit "Bed of Roses," which Bon Jovi said was "as close to a confession as I can come." The genesis took place at a posh Los Angeles hotel, with a very tired, hungover and lonely superstar feeling sorry for himself. Borrowing a rollaway piano, he wrote the compelling song. "It was at a point of my life that I can only refer to now as 'the gray summer.' I don't remember a lot of it. It was a lot of questioning, a lot of time spent drinking or being miserable or making records for other people. That morning I wrote down the emotion, being loaded again and hating the feeling. And I eventually got to pull away from it all."

The title track concerned expecting the best outcome in the face of adversity. "People think 'Keep the Faith' is about the band, but that's too shallow. It means faith in the world around you. I didn't want to state the obvious, but you're got to believe in something, or you're heading down a real dark street. I dunno why, but I've been an optimist for a long time."

"I'll Sleep When I'm Dead," a hard-thumping defense for around-the-clock hedonism, "was taken from a Malcolm Forbes quote. He ran a multimillion-dollar empire on a daily basis, but at five o'clock he was back on his motorcycle and hanging out in rock 'n' roll bars and flying in balloons and dating Liz Taylor—just living life. I admired that. We've been a touring band all these years, and knowing that this tour could be as long as any other was like going back into the fire. I hope we'll pace it better—but what the hell!" ■

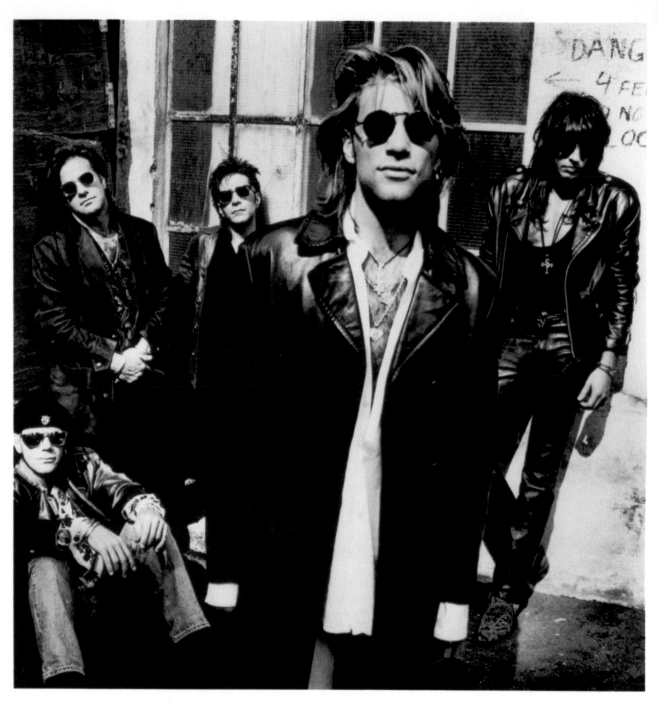

DAVID BRYAN　　TICO TORRES　　ALEC JON SUCH　　JON BON JOVI　　RICHIE SAMBORA

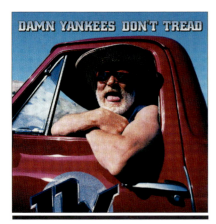

Billboard 200: *Don't Tread* (#22)
Billboard Hot 100: "Where You Goin' Now" (#20); "Silence Is Broken" (#62)

The hard-rocking **Damn Yankees** added to their hit-making résumé with another ballad, "Where You Goin' Now."

CYNICS SEEMED to think superstar band lineups were corporate schemes spawned with the intent of turning successful pasts into numbered Swiss bank accounts. So when Damn Yankees—Styx guitarist Tommy Shaw, Night Ranger bassist Jack Blades, legendary guitar slinger Ted Nugent and drummer Michael Cartellone—assembled for a 1990 self-titled debut album, the old-timers started writing their own bad reviews in advance.

"But we've since been vindicated by having fun," Shaw said. "We just had this chemistry. We found that without any of the effort it takes to keep a band together, we had a great band. It's no-frills, no sweat."

It had been a successful grouping—the arena-rock ballad "High Enough" topped the pop charts and pushed *Damn Yankees* past the double platinum mark. On *Don't Tread*, Damn Yankees' second album, the power ballad "Where You Goin' Now" was another Top 40 hit. "For dynamics on a record, you want to slow down and get quiet occasionally—at least I do," Shaw explained. "But when we get together, we just end up slammin'. So Jack and I wrote 'Where You Goin' Now' out of the blue to take to the band. Nugent is either hot or cold on that stuff, and he loved it."

Nugent had a wild-man image—hysterical showmanship and unrestrained boastfulness of his talents. "Ted's insane, but at the same time he's an encyclopedia of rock," Shaw allowed. "He knows the parameters, he's good at pointing out the little rules of a rock band. He's like the sheriff of Damn Yankees. I love watching and learning from him. He's not one of those guys who sat down and practiced. He's just the 'feel' guy from hell."

The majority of *Don't Tread* was a groove-heavy riff fest. Shaw and Blades alternated lead vocals and complemented each other on the high harmonies, and then Nugent got in people's faces with his boisterous guitar work. As always, the Nuge, a bow-hunting enthusiast, was happy to clarify in his colorful style.

"You're supposed to be sexually charged at the thought of playing your guitar," he insisted. "When I started, it was that Lonnie Mack-Duane Eddy-Chuck Berry-Elvis Presley stuff, that 'twang' factor, that thrust, that rhythm—rock 'n' rollers want it. But if you hammer at it around the clock, there's no way it'll have the same fire as if you're denied it. So I take it away from myself. I'm a hunter—when I hunt, I got none of that. And when I grab that guitar, I'm ready to hurt somebody. And when you hang around me, when I come up with a gargantuan, thumping riff, it's so contagious, it's so simple. And the reason that nobody else thought of it is that they *thought*. You're supposed to grab it—and shit happens. It's a very elusive quality." ∎

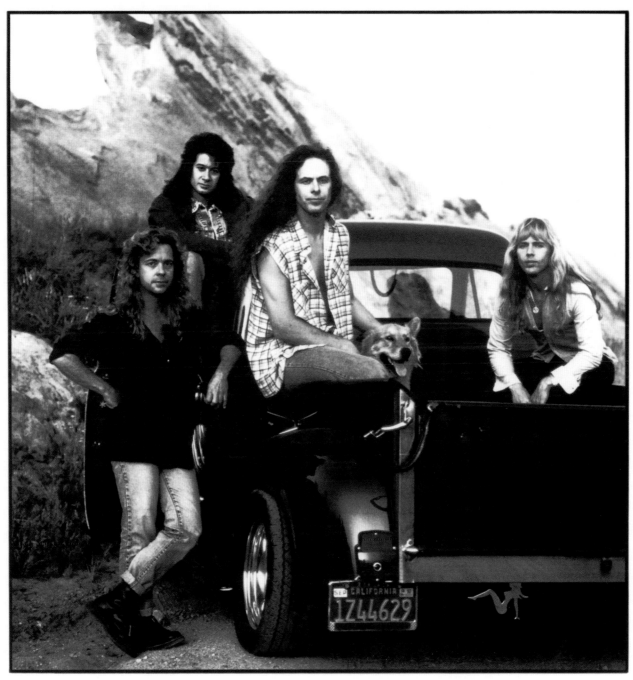

Jack Blades Michael Cartellone Ted Nugent Tommy Shaw

DAMN YANKEES

© 1992 Warner Bros. Records/Permission to reproduce limited to editorial uses in newspapers and other regularly published periodicals and television news programming

Billboard 200: *Jackyl* (#76)

Southern hell-raisers **Jackyl** deemed that rock music was meant to be unruly, uninhibited and uncensored.

CRITICS HEAPED abuse on Jackyl, but lead singer Jesse James Dupree got credit for knowing his audience—there were a lot of rock 'n' roll rednecks who just didn't get Nirvana and Pearl Jam. They wanted loud and lewd hard rock, even if it was reshuffled from the Seventies. And that's why *Jackyl*, the Atlanta-based band's debut album, was a platinum-selling record.

"It takes so much to stimulate people these days—when something fresh like the 'Seattle sound' comes out, they want more, more, more," Dupree drawled. "But by the time it seeps down to South Georgia, it's worn out. Bon Jovi is just hitting down there right now! All we know is real rock 'n' roll."

K-Mart refused to carry the album because of certain colorful lyrics (the tune "She Loves My Cock"), so Jackyl drove a flatbed truck onto the local Atlanta-area store's parking lot and gave an impromptu concert; footage comprised the music video for the track "I Stand Alone." Jackyl spent more than a year touring, opening shows for Aerosmith and Damn Yankees. And Dupree fed the rumor mill—the incorrigible frontman's performances were enveloped in such shenanigans as mooning the audience and doffing his duds when the mood hit him.

Mayhem ruled on "The Lumberjack," an ordinary song with a strong visual hook—Dupree played a chainsaw, revving the power tool in time with the music. "I consider it a vital musical instrument, but I'll cut up just about anything we get our hands on," he noted. "I've signed an endorsement deal with Jonsered chainsaws—they keep me in blades and bars and blocks, and I go through them. It's rock 'n' roll—there is no mercy. MTV asked me to chop through the national anthem before a charity baseball game, but a sponsor thought it was in poor taste. And one night I cut my knee, seven stitches worth—I'm bleeding trying to get through the last couple of songs. There were these two guys pressed up against the barricade with their concert T-shirts on, and I could just imagine them in Beavis & Butt-Head's voices—'Huh-huh! That's cool! Blood's cool! I wonder if he bleeds every night?'"

Dupree knew that if Jackyl released a sodden follow-up, the self-described "redneck punks" would be heard as the dying, last gasp of rebel-without-a-clue metal. "We draw from everyday experience, so we went down to Tijuana and came back with a whole album's worth of stuff," he said. "Get ready for *The Donkey Album*." ∎

Tom Bettini Jeff Worley Jesse James Dupree Chris Worley Jimmy Stiff

Photo Credit: Alison Dyer

© 1992 The David Geffen Company / Permission to reproduce limited to editorial uses in newspapers and other regularly published periodicals and television news programming.

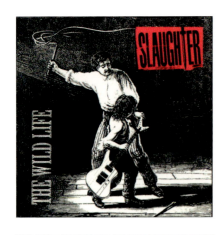

To share *The Wild Life*, **Slaughter**'s grand design of welcoming devoted fans into the fold paid off handsomely.

Billboard 200: *The Wild Life* (#8)
Billboard Hot 100: "Real Love" (#69)

ONE OF the big hard-rock success stories of 1990-91, Slaughter went from obscurity to stardom following the release of *Stick It to Ya*. The debut album spawned radio-friendly hits ("Fly to the Angels," "Up All Night" and "Spend My Life") and flashy, high-spirited videos (four top phone-in clips on MTV). The photogenic foursome had pictures plastered everywhere—and other bands grumbling about beginner's luck.

The members said part of the reason for their popularity was their close connection with their audience—they always tried to meet them and sign autographs before and after all their shows (more than 300 in less than a year to support the album). They had accepted rides to their gigs in devotees' cars, taken a supporter up on his offer to stay in his parents' Philadelphia residence and performed an acoustic concert at a fan's home.

Slaughter took a sophomore swing with *The Wild Life*. Refreshingly, the group maintained making records wasn't brain surgery. "The harder edge reflects the buzz of coming off the road—we'd be idiots not to feel the momentum," bassist Dana Strum said. "We're all fans. We openly talk about where our music comes from, our influences—Queen, Cheap Trick, Kiss. To do otherwise is a ridiculous crock of bullshit."

For *The Wild Life*, Slaughter sent out a six-song demo tape to the 32,000 people on the band's fan club mailing list. "After we sold a couple million albums, everyone thought we'd become elite—everyone was looking to the Seattle bands, and they won't deal with the fans," Sturm noted. "I'd like to see where Nirvana is five years from now. I'd like to see how long Guns N' Roses fans are going to put up with them cancelling shows and not letting the fans get near them." ∎

© 1992 EMI Records Group. Permission to reproduce this photography is limited to editorial uses in regular issues of newspaper and other regularly published periodicals and television news programming

Photo: NEIL ZLOWZOWER

SLAUGHTER

EMI Records Group
North America

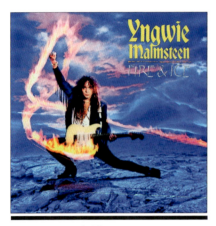

Billboard 200: *Fire & Ice* (#121)

Fire & Ice, **Yngwie Malmsteen**'s sixth studio album, corroborated his high-reaching, effortless guitar wizardry.

IN BASEMENTS and rec rooms across America, thousands of kids were practicing scales and dreaming of becoming a "guitar hero"—a title given to so many people it had almost become meaningless. But Yngwie Malmsteen had certainly earned the designation. Since emigrating to the US in 1983, the Swedish native continued to grow his worldwide presence, building his reputation on high-speed, classically influenced guitar playing.

Malmsteen received his first guitar at age five, but it was a 1970 Jimi Hendrix TV special that solidified his career plans. "It was a revelation—I really started playing the day Hendrix died," he recalled. "I saw him playing 'Wild Thing' and it fascinated me. I'd never seen anything like it." Malmsteen gathered critical accolades throughout his career as his work changed the standards of excellence in shred guitar technique.

Fire & Ice wasn't as polished as *Eclipse*, his previous album. "The music had become a little too slick," Malmsteen said. "This album has sophistication, but it's raw. And it covers a lot of ground." His approach to songwriting hadn't changed over the years. "I'm spontaneous—I just go for it, I pick up a guitar and play." On his albums, Malmsteen was responsible for everything from writing to arranging to production. "I get pretty specific—I know what I want to do," he said.

With the exception of the single "Teaser"—a hackneyed attempt at a radio-ready anthem—Fire & Ice was tied together by Malmsteen's inimitable guitar prowess. However, neoclassical metal and shredding no longer represented the pinnacle of hard rock in the US, where grunge flourished. Malmsteen remained a superstar in Japan, where *Fire & Ice* debuted at No. 1 on the album chart. ∎

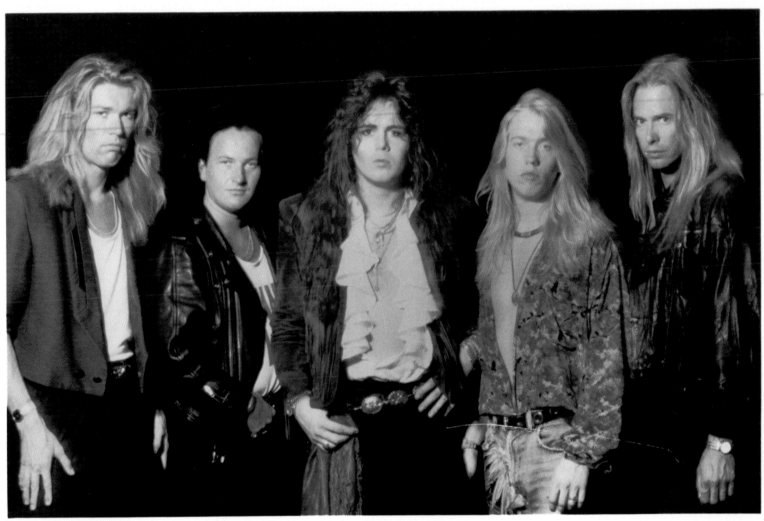

SVANTE HENRYSON MATS OLAUSSON YNGWIE MALMSTEEN BO WERNER GORAN EDMAN

Elektra Entertainment

PHOTO CREDIT: MICHAEL JOHANSSON

Billboard 200: *Izzy Stradlin & the Ju Ju Hounds* (#102)

When the guitarist in one of the world's biggest bands walked away, Izzy Stradlin & the Ju Ju Hounds launched.

FANS HAD to love a guy who told Axl Rose to stuff it. In late 1991, rhythm guitarist Izzy Stradlin separated from Guns N' Roses, the hard-rock band he'd helped found nearly a decade earlier when he drove his Chevy Impala from his hometown of Lafayette, Indiana, to Hollywood to hook up with his high-school buddy Rose. Stradlin's well-publicized exit at the height of the Guns N' Roses' fame fueled plenty of second-guessing, but he had become disillusioned with the traveling circus atmosphere, confronting singer Rose about his chronic lateness to shows.

Rose had made a point of telling anyone who would listen that Stradlin left Guns N' Roses because he wasn't taking an interest in the little things that came with being a world-class rock act, like touring and video production. Stradlin admitted he didn't have many fond memories of his final days with GN'R. "We were too fucked up to deal with anything," he shrugged. "I just couldn't seem to communicate my side of it. I've known Axl a long time and I still have a lot of feelings for those guys. But I had to leave to get sane and somewhat normal—to get back to reality, I guess you could say."

After some time away from the business, Stradlin assembled a new band comprised of Rick Richards (ex-Georgia Satellites) on lead and slide guitar, drummer Charlie Quintana (he'd backed Bob Dylan) and bassist Jimmy Ashhurst. The sound of *Izzy Stradlin & the Ju Ju Hounds* was in direct contrast to GN'R's high-fashion rock. Returning to his roots for vintage grooves and rhythms, Stradlin's neo-Keith Richards affectations (shaggy vocals, pictured with an ever-present cigarette) came off more as homage than rip-off. The tight band rocked hard on "Shuffle It All," "Somebody Knockin'" (both Top 20 rock radio hits) and a revved-up version of Toots & the Maytals' reggae classic "Pressure Drop."

In Guns N' Roses, Stradlin took a backseat to Rose and guitarist Slash, but he had toured much of the world since the break, and with the Ju Ju Hounds, he put to rest any speculation that he might have been riding anybody's coattails. "The best thing about this is, it's not a complicated thing," Stradlin said. "It's fun." ■

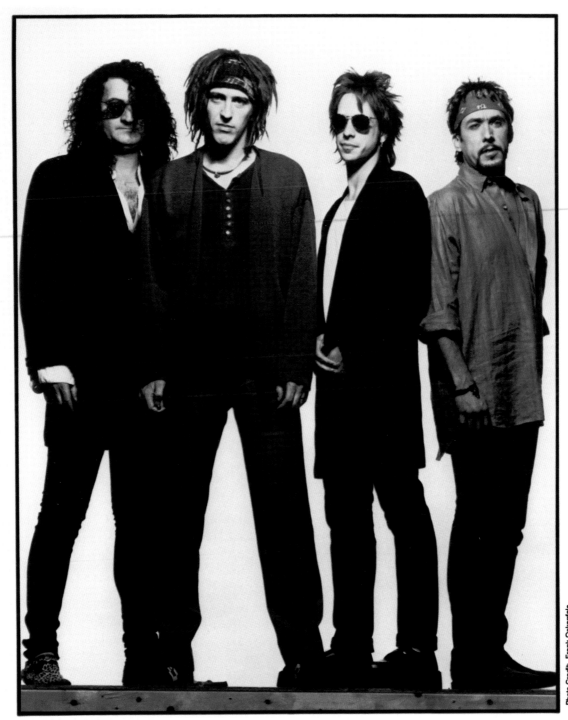

Rick Richards Izzy Stradlin Jimmy Ashhurst Charlie Quintana

Izzy Stradlin and the Ju Ju Hounds

GEFFEN

© 1992 The David Geffen Company / Permission to reproduce limited to editorial uses in newspapers and other regularly published periodicals and television news programming.

ON RECORD | 1992 | [UGLY KID JOE]

Billboard 200: *America's Least Wanted* (#27)
Billboard Hot 100: "Everything About You" (#9); "Cats in the Cradle" (#6)

Ugly Kid Joe covered "Cats in the Cradle," and the blithesome stoners found themselves with a major hit single.

A BUNCH of surf brats from Santa Barbara who got their kicks playing Black Sabbath cover tunes at college parties, Ugly Kid Joe started its career with the EP *As Ugly As They Wanna Be*, and the single "Everything About You" became a radio staple and part of the hugely successful *Wayne's World* film. *America's Least Wanted*, Ugly Kid Joe's first full-length album, knocked together frat-boy humor and garage metal. The record reprised "Everything About You," and "Neighbor" reflected the band's brash up-yours style.

The surprise was a Top 10 hit—a burly nonapostrophized version of "Cat's in the Cradle," folk-rocker Harry Chapin's 1974 No. 1 single about a father missing his son's childhood. "It was the first song I heard as a kid and could remember the lyrics, and it was one of the first songs the band learned to play," singer Whitfield Crane said. "I can relate to it because I haven't seen my dad for over 10 years."

Ugly Kid Joe felt the heat from music retailers for *America's Least Wanted*. The cover depicted a rendering of the band's cartoon character as the Statue of Liberty flipping the bird; certain retailers refused to stock the album unless alternate packaging was provided. The group's label responded with censored artwork of the cartoon kid bound and gagged with his offending middle finger amputated. ■

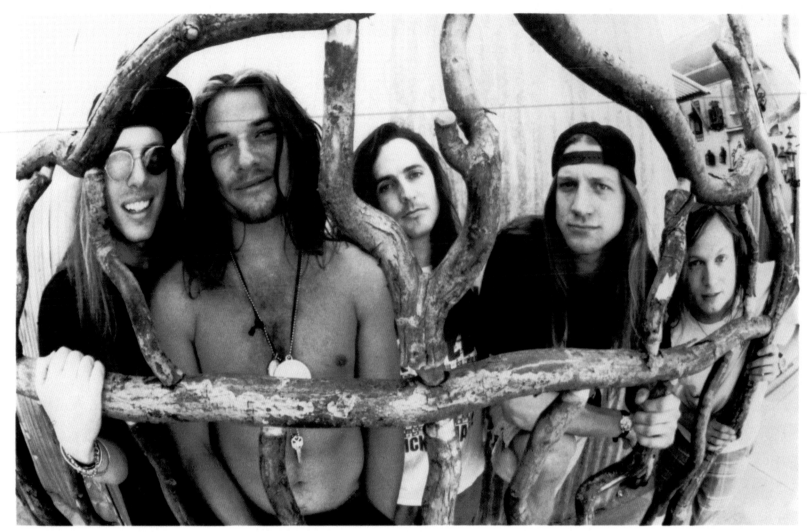

CORDELL CROCKETT WHITFIELD CRANE MARK DAVIS KLAUS EICHSTADT DAVE FORTMAN

Petra brought its success and acclaim in the Christian rock world to the mainstream with the album *Unseen Power*.

IN THE Christian hard-rock genre, Petra reigned. Influenced by classic Styx, Journey, Foreigner and Kansas, the band had churned out 15 albums and won a Grammy. Yet Petra remained largely unknown in the secular world. But with contemporary Christian musicians like Amy Grant and Michael W. Smith topping the pop charts, a major label took on the task of bringing Petra to the rock audience at large. Several tracks on *Unseen Power* ranked with anything played on album-rock radio stations.

It wouldn't have been a genuinely Christian undertaking without bouts of persecution. "It's a question of entertainment versus ministry," guitarist Bob Hartman said. "A lot of people think that a Christian act has to compromise to achieve something in the mainstream, watering down the message so that you can't tell any difference. We don't. We stand for something, and for us to hide that fact wouldn't be an honest representation. Accept us on that basis and on our music."

Hartman, Petra's sole remaining original member, could quote chapter and verse on the slings and arrows that came with the contemporary Christian music epithet. "There are fewer people who believe that you can't be a Christian and be in a real rock band. But five years ago, we were seeing flak from both sides. We didn't fit in anywhere, and it was a lonely place to be. If you're a secular musician, you go out and be the best you can. In Christian music, you do that—and then you have to get the church to believe in you, let them know who you are and where you're going so they'll get onboard." ∎

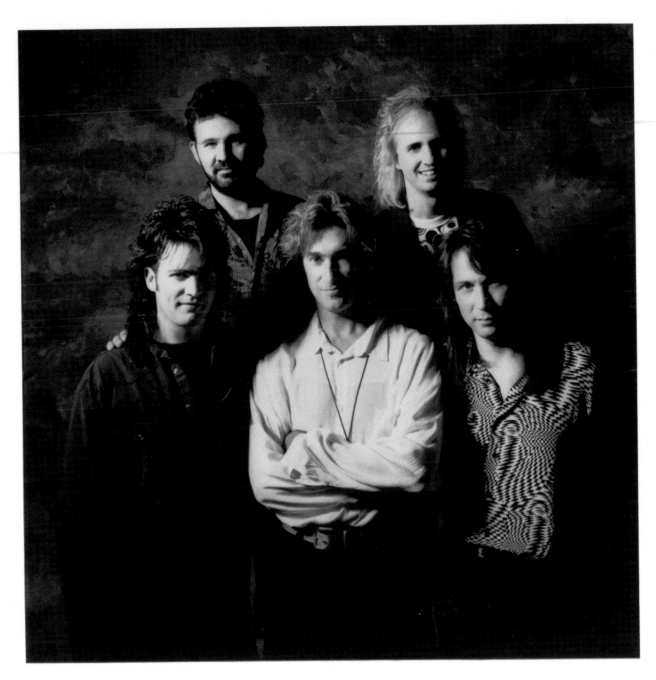

PETRA

WILLIAM MORRIS AGENCY, INC.
2325 CRESTMOOR ROAD · NASHVILLE, TENNESSEE 37215 · (615) 385-0310

epic WORD

For Tour Publicity:
ATKINS, MUSE & ASSOC.
1808 West End #1119
Nashville, TN 37203
615/327-3747

Billboard 200: *Images and Words* (#61)

Just when progressive rock was considered dead, up went the curtain on Dream Theater's *Images and Words*.

AMID THE unrelenting deluge of alternative-metal bands, Dream Theater stood out. Formed at Boston's prestigious Berklee College of Music in 1985, Dream Theater built a sound on stunningly complex riffs and technically proficient musicianship out of reverence for adventurous Seventies rockers such as Genesis, King Crimson, Gentle Giant, Kansas, the Dregs and Pink Floyd. But the five members also incorporated elements of contemporary heavy metal, Metallica-style bashing and bruising.

"To us, the attraction of all that old 'art rock' was the musical value, the arrangements and all the instrumental sections," drummer Mike Portnoy said. "Most bands who are serious about their chops probably appreciate that stuff the most. It was the perfect background to step out and challenge ourselves musically."

The lushly textured *Images and Words*, Dream Theater's first album with new vocalist James LaBrie, generated mostly positive and sometimes effusive reviews, with many applying the tag of "progressive metal." The fly in the sonic ointment? The top tracks ran in the seven- to 10-minute range, and radio programmers tended to scoff at a song of length unless it hailed from the classic rock era.

At first, the dramatic eight-minute single "Pull Me Under" received only marginal support from metal and rock radio outlets. But Dream Theater toured relentlessly, and "Pull Me Under" became an MTV success, partly because the station aired a more accessible five-minute edit. Similarly, radio stations received an edited version of "Take the Time," another eight-minute song.

"It's a tough call," Portnoy admitted. "As musicians, we obviously take some offense to editing our material. It's an insult to our artistic side. We worked hard on the time signatures and key changes—we've got a 20-minute piece ready for our next album. But we understand it has to be done. With an edit, at least we can get played on the radio and get some exposure. If we have to do it to get people to hear us, then fine. The album and concerts have the real versions." ■

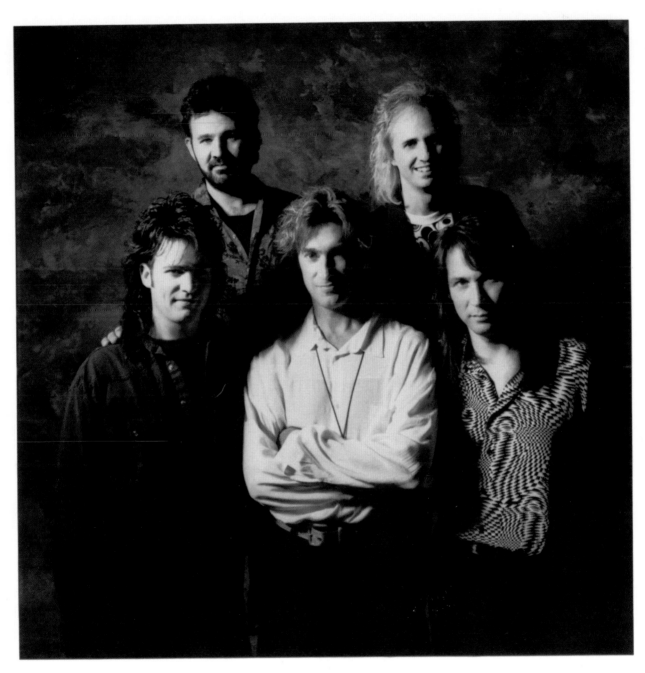

PETRA

WILLIAM MORRIS AGENCY

 epic WORD

For Tour Publicity:
ATKINS, MUSE & ASSOC.
1808 West End #1119
Nashville, TN 37203
615/327-3747

Billboard 200: *Images and Words* (#61)

Just when progressive rock was considered dead, up went the curtain on Dream Theater's *Images and Words*.

AMID THE unrelenting deluge of alternative-metal bands, Dream Theater stood out. Formed at Boston's prestigious Berklee College of Music in 1985, Dream Theater built a sound on stunningly complex riffs and technically proficient musicianship out of reverence for adventurous Seventies rockers such as Genesis, King Crimson, Gentle Giant, Kansas, the Dregs and Pink Floyd. But the five members also incorporated elements of contemporary heavy metal, Metallica-style bashing and bruising.

"To us, the attraction of all that old 'art rock' was the musical value, the arrangements and all the instrumental sections," drummer Mike Portnoy said. "Most bands who are serious about their chops probably appreciate that stuff the most. It was the perfect background to step out and challenge ourselves musically."

The lushly textured *Images and Words*, Dream Theater's first album with new vocalist James LaBrie, generated mostly positive and sometimes effusive reviews, with many applying the tag of "progressive metal." The fly in the sonic ointment? The top tracks ran in the seven- to 10-minute range, and radio programmers tended to scoff at a song of length unless it hailed from the classic rock era.

At first, the dramatic eight-minute single "Pull Me Under" received only marginal support from metal and rock radio outlets. But Dream Theater toured relentlessly, and "Pull Me Under" became an MTV success, partly because the station aired a more accessible five-minute edit. Similarly, radio stations received an edited version of "Take the Time," another eight-minute song.

"It's a tough call," Portnoy admitted. "As musicians, we obviously take some offense to editing our material. It's an insult to our artistic side. We worked hard on the time signatures and key changes—we've got a 20-minute piece ready for our next album. But we understand it has to be done. With an edit, at least we can get played on the radio and get some exposure. If we have to do it to get people to hear us, then fine. The album and concerts have the real versions." ∎

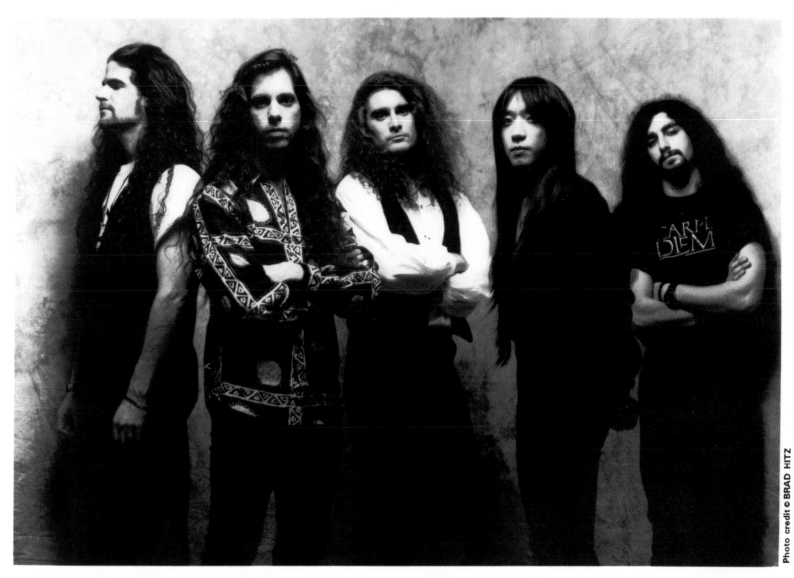

KEVIN MOORE JOHN PETRUCCI JAMES LaBRIE JOHN MYUNG MIKE PORTNOY

DREAM·THEATER

Billboard 200: *La Sexorcisto* (#26)

La Sexorcisto fixed **White Zombie**'s place in the pantheon of deranged but entertaining heavy-metal ensembles.

AS A joke, the members of White Zombie subtitled their major label debut album *La Sexorcisto: Devil Music Vol. 1*. They thought it was funny—until they turned up on televangelist Pat Robertson's TV show. After filming a White Zombie performance in Washington, DC, the fundamentalist Christian devoted an hour of *The 700 Club* to satanic music and how it was warping the minds of innocent young Americans.

"They weren't exactly honest—they pretended to be some cable rock 'n' roll show doing us a big favor," dread-headed vocalist Rob Zombie said. "On one hand, it was hilarious—whenever we knew a repeat of the program was airing, we'd order pizza and laugh our asses off. But then we got annoyed—they've got a lot of nerve and power to throw some faces on TV and badmouth them. And out of all the people in the club, they interviewed a couple of kids in the dressing room who were so drunk they couldn't even stand up. Robertson said they were possessed by Satan. They were possessed by Heineken."

White Zombie's music was a mutated juncture of junk culture—Kiss, Fifties monster movies, punk rock, comic books, prime Black Sabbath and all-night reruns on the boob tube. The band debuted circa 1986 in New York City, but never felt comfortable in the "downtown noise" scene. "The Sonic Youth school was still small back then, and it was so arty—bands with untuned instruments and stern faces," Zombie recalled. "We sucked, but the local critics would say we were making a heavy statement. It was stupid. As soon as we would get ready to play a show, the guitarist would quit—we'd be saying, 'Damn, now we gotta find another player.' Then we'd get a record out, and another guy would quit. We had different guitarists for six years until we got J (Jay Yuenger)—he was the first that could actually play. We told him, 'If you quit, we kill you.'"

After three independent record releases, White Zombie moved to Hollywood for inspiration. *La Sexorcisto* launched the band into mainstream recognition, as the TV show *Beavis & Butt-Head* began featuring the trashy music videos for "Thunder Kiss '65" and "Black Sunshine." The sound of the album was high-decibel, corrosive sludge-rock—but instead of adding flourish with guitar solos, the band sampled sound bites from radio, television and movie dialogue, creating dense, claustrophobic tableaux.

"The album was delayed because of legal problems," Zombie noted. "We had a wacky executive who was gone before the record came out—he said, 'Sample whatever you want, go crazy, don't worry about it.' We had to worry about it. There's a law that states you can't sample a person's voice without his consent if he's still alive. It turned out to be a nightmare, contacting people who haven't made a movie in 45 years and are now working for the post office somewhere. In the end, only Vincent Price and Robert Di Niro refused—the lawyers got clearance for everything else. If we were Guns N' Roses, it'd be one thing—but we were more trouble than we were worth." ∎

Ivan de Prume Rob Zombie J Sean Yseult

© 1992 The David Geffen Company / Permission to reproduce limited to editorial uses in
newspapers and other regularly published periodicals and television news programming.

Billboard 200: *The Art of Rebellion* (#52)

Punk-skate-thrash group Suicidal Tendencies looked to broaden its target audience with *The Art of Rebellion*.

RISING FROM L.A.'s underground club scene, Suicidal Tendencies developed musically from hardcore punk to thrash metal on early albums. *The Art of Rebellion* was the band's most textured and introspective work, leaping into alternative territory while maintaining founder and leader Mike Muir's aggressively nonconformist stance. The bandana-wearing frontman fueled the fire and commanded the sound that made ST a raging, snarling force.

"I'm not worried about being hip," Muir said. "Hip doesn't mean anything. It only means something to the person who doesn't feel very good about themselves."

The most adventurous cut on *The Art of Rebellion* was the psychedelic "Asleep at the Wheel." "I wrote the song eight years ago, actually," Muir divulged. "I definitely couldn't have recorded it then, but it proves that a lot of times you're limited by people's imaginations other than your own. We have no expectations of what they think we should be." The ballad "Nobody Hears" and "I'll Hate You Better" also charted on modern rock radio.

Suicidal Tendencies' commercial peak, *The Art of Rebellion* represented Muir's ongoing challenge to listeners to deal with reality head-on. "Living is not an experiment to see which way it falls—it's a responsibility to know what you're doing and why you're doing it," he said. "I think living is accomplishment, going out there knowing some things that mean something four days later and still mean something four years later. Where there's a purpose in the long run, not just killing time." ■

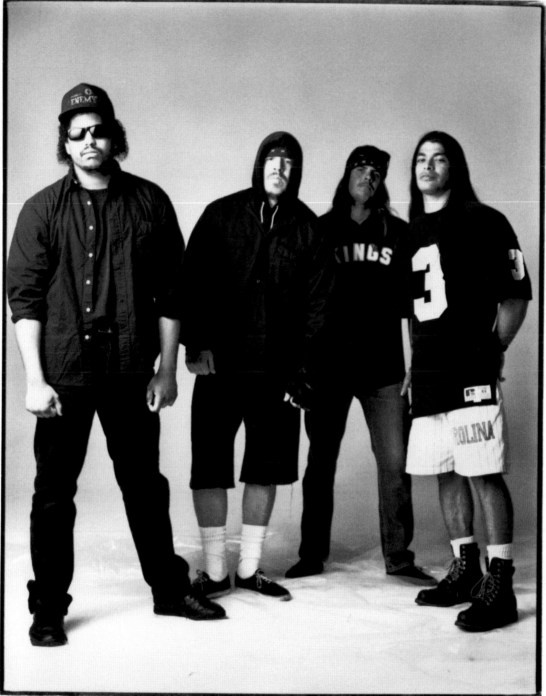

ROCKY GEORGE
(LEAD GUITAR)

MIKE MUIR
(VOCALS)

MIKE CLARK
(RHYTHM GUITAR)

ROBERT TRUJILLO
(BASS)

9206

Billboard 200: *Angel Dust* (#10)
Billboard Hot 100: "Easy" (#58)

Until adding a cover of "Easy," **Faith No More**'s eclectic *Angel Dust* was received with a resounding hush.

FORMED IN 1982 as a "hippie hate band," according to a self-penned bio, it took three albums and the replacement of the original vocalist with Mike Patton for Faith No More to break through. FNM achieved multiplatinum sales with 1989's *The Real Thing*, thanks to the MTV-driven success of the Top 10 hit "Epic." The slow-building track crammed together the vocal cadences of rap, the brute force of metal and the pompous keyboards of progressive rock.

Most bands would be satisfied with stability, but Faith No More thrived on remaining as annoying, charming and sick in the head as ever. For the rougher and less-pop-tinged *Angel Dust,* the group was determined not to become any more accessible, lest there be accusations of selling out. "I thought we sold out from the word go, before it was time to sell out," keyboardist Roddy Bottum laughed. "Now it doesn't seem like we did. We could have repeated ourselves, made it easier on us—the record company expected us to maintain our ways. But we did exactly the record we wanted."

Although the expression "commercial suicide" might have been an exaggeration, the album departed from the sound that introduced Faith No More to the music video generation. The powerful band belted through a stylistic mishmash—slow, scary songs, and not as much funk-metal thrash as the average fan would expect.

Patton, who had joined during the sessions for *The Real Thing*, was perfect for a group that couldn't keep a straight face or stick to a genre. His voice could go from stirringly muscular to utterly scabrous—rasping like a heavy-metal ghoul, emoting like a pop singer or sneering cartoonishly through his nose. Hyperactive, totally distracted and half-insane, he got his lyrics across more through attitude than literal meaning. "It's a much more honest representation of the band, just because Mike was there helping us and putting in his two cents," Bottum noted. "Mike's very musically together. When he hears something in his head, he's good at expressing it."

Angel Dust won great critical acclaim for its uncompromising attitude. Yet MTV provided little support despite several stunning videos, including a clip for "A Small Victory" with nightmarish, full-scale World War I combat scenes, grotesque human chess pieces and the unlikely sight of the band members dressed in black Armani suits.

In December 1992, Faith No More covered "Easy," a delightful dismantling of the Commodores' 1977 hit, drenching the featherweight song in funky sludge. Released as a single, it was included on later pressings of *Angel Dust* and became the band's biggest hit in the UK, Australia and other parts of the world. "We're pretty bratty for the most part," Bottum allowed. "I think we do things we'll resent later on." ∎

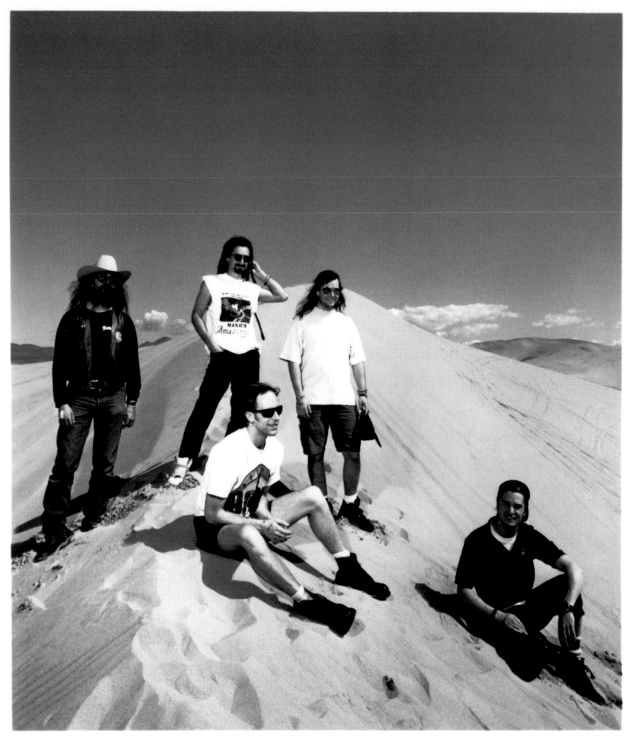

FAITH NO MORE

reprise

Photo Credit: Ross Halfin

© 1992 Reprise Records/Permission to reproduce limited to editorial uses in newspapers and other regularly published periodicals and television news programming

ON RECORD — 1992 — [HELMET]

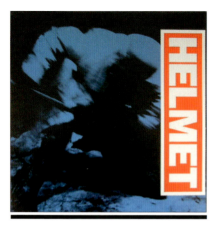

Billboard 200: *Meantime* (#68)

Volume kings Helmet melded surgically precise dropped-D riffs with irregular time signatures and harmonies.

BY CREATING hulking, stripped-down music, Helmet elevated above the triteness of the heaviest competition. Page Hamilton pummeled eyeball-rattling riffs out of his guitar, and the band's thundering, synchronized chord changes merged energy and cerebral savvy, elemental enough to appeal to both alt-rock fans and metal crowds. But Hamilton—who was formally trained in jazz guitar at the Manhattan School of Music—cited such avant-garde and jazz influences as Glenn Branca and John Coltrane. "In Helmet, if I can plug my guitar in and break down some walls, there's something indescribable about that," he explained.

After an indie recording, Helmet released *Meantime*. The breakthrough album benefited from heavy MTV rotation for the video of "Unsung" and managed to go gold because of impressive live shows and strong word of mouth. The staunch, no-frills musical ethos carried over to Helmet's look, more like an ROTC unit than a metal band.

"We get knocked for being short-haired, skinny-legged guys in baggy shorts, as if it was some sort of fashion statement, the 'asshole-aesthetic' look," Hamilton said. "Some people just absolutely hate that. Rock 'n' roll has always had a fashion element involved. I don't pay much attention to that as much as what is between the grooves

"When we started, it was a completely different scene. We didn't feel the opportunity to be on a major label would ever present itself. We just wanted to make the music we wanted without an image committee to sculpt us into rock gods."

Helmet had cashed in when major labels were starting to grab up alternative and punk bands, signing a favorable deal that promised unheard-of creative control and royalty rates. The New York neo-noise band felt media-imposed pressure. "We're in a van touring across the country, disconnecting the odometer so we'll have $300 after a month to pay our rent," Hamilton insisted. "You can be on an indie label and get treated like shit and not get paid, or you can be on a major label and get treated like shit and maybe get paid. People say half-joking that we're ruining the record business, but a lot of bands are getting more of a fair shake." ∎

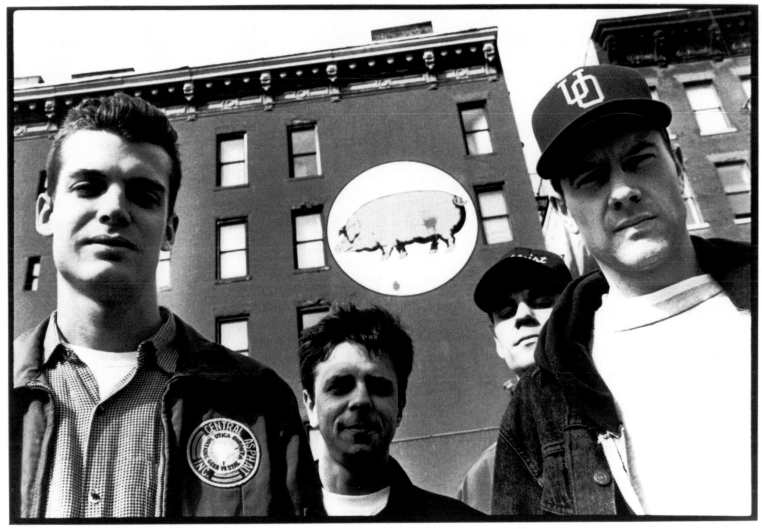

John Stanier Peter Mengede Henry Bogdan Page Hamilton

© 1992 Interscope Records, Inc. Permission to reproduce limited to editorial uses in newspapers and other regularly published periodicals and television news programming. All other rights reserved.

Photo Credit: Jesse Peretz / 1992

Billboard 200: *Psalm 69: The Way to Succeed and the Way to Suck Eggs* (#27)

Ministry's convulsive "Jesus Built My Hotrod" became a benchmark for nonconformist noise-rock aesthetics.

FOUNDED IN Chicago in 1981, Ministry had evolved into innovators of industrial noise. Partners Al Jourgensen and bassist-programmer Paul Barker combined the exactitude of incendiary riffs and samples with aggressive impulses and opinions. "I use industrial noises, but so what?" Jourgensen said. "I use whatever it takes to get the type of atmosphere I want on a song. I use guitars—that doesn't make me Led Zeppelin. We don't want to be part of an organized scene. That's as bad as being part of the Boy Scouts."

The over-the-top sonic assault evolved with Ministry's first album in three years, *Psalm 69: The Way to Succeed and the Way to Suck Eggs* (Jourgensen added the subtitle after planning just to use cryptic symbols). The duo's adrenalized beats, layered electronics and throat-damaged exhortations reached a new height in harsh histrionics. MTV was all over the hit "Jesus Built My Hotrod," featuring lead vocals by co-writer Gibby Haynes of Butthole Surfers, who "came down to say hello, and we got him drunk and handed him a microphone," Jourgensen recalled.

Ministry scored a slot on the bill of the second Lollapalooza tour, and Jourgensen embraced his reputation as a guy with a propensity for various pharmaceuticals and sexual fetishes. "I don't see this music being accepted on a national level," he said. "If it does happen, it'll be disappointing—it means it's not threatening enough people." ∎

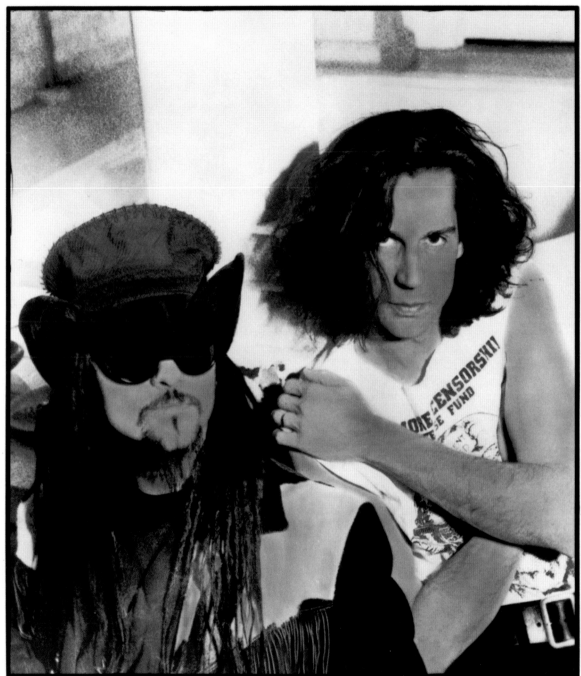

MINISTRY

© 1992 Sire Records Company/Permission to reproduce limited to editorial uses in newspapers and other regularly published periodicals and television news programming.

Billboard 200: *Last Rights* (#193)

Last Rights served as a hard punctuation on **Skinny Puppy**'s nine-year legacy as an industrial-music institution.

SINCE 1983, Skinny Puppy had churned out a disturbing brand of electronic music—distorted minor-key dirges, relentless techno-beats, otherworldly screams and growls. It was a sonic goosing that most of humanity would describe as malignant and nightmarish, but the punishing, distasteful body of work turned into a lucrative commodity—the Vancouver trio reached a far larger audience than was previously conceivable.

"When we started, we never wanted to get anywhere close to being a conventional rock band," keyboardist Dwayne Goettel said. "We wanted to create and sustain a mood by using lots of visual imagery. We called it 'audio sculpture.'"

Past live concerts had taken performance art to a morbid extreme with fake blood and gruesome props. With his head wrapped in a bondage mask, singer and lyricist Nivek Ogre pounded an ice pick into his head. Large video screens flashed rapid-fire edits of torture, accident victims, autopsies and severed limbs. Shows climaxed with Ogre's simulated onstage suicide. Goettel claimed the intent was to shock and disturb, to provoke a reaction from an audience using pain, disease and death to reinforce positive ideals.

"The three of us are the most afraid of any real violence—we're like little furry creatures," he professed. "We're just as weirded out by the emotions we've all got to deal with. What's expressed onstage is done with the intention of getting it out for us and our fans so we never have to get that way when it comes to skin on skin, when you get so mad that you have to hit somebody."

On the *Last Rights* album, notably the track "Inquisition," Goettel's creative use of electronics and sampling amplified the terrifying sound. "Every album is an experiment with what new technology is out there, but we've had our fill of the sounds that can come out of machines so easily if it's one-two-three-four. This time, 99 percent was done in a pressurized situation, writing in the studio. It's less song-oriented. It's allowed to go where it wants without having to pay attention to a chorus or a verse. It can be complete noise."

Goettel and multi-instrumentalist cEvin Key created the unforgiving music, and lyrical and visual assaults sprang from Ogre's imagination. "If you talked about having sex—'I'm going to walk over and gently caress your thigh, then move on to the elbow…'—that would ruin it. The pure sex act works out better," Goettel explained. "A lot of the band's conceptualization is like that. The three of us don't sit in a room and discuss it with each other. We use musical expressions to speak."

Skinny Puppy had influenced other bands who'd attempted to fit into industrial music's horror niche. "It's hard for us to think, 'Oh, the band is nine years old and it still hits people in the face'—this is our everyday thing," Goettel said. "We're seeing stranger acts have an impact. The norm is chasing us down. But this album proves what we can do and where we're heading. We're not going to sell out." ∎

photo: SIOBHAN O'KEEFE

 SKINNY PUPPY

Billboard 200: *America Must Be Destroyed* (#177)

America Must Be Destroyed by Gwar made the "Parental Advisory" warning label seem pitifully inadequate.

GWAR WAS the rock underground's latest Grand Guignol, hamming it up during outrageous, grotesque, theatrical live shows for audiences willing to be defiled and delighted. The members donned huge, bizarre papier-mâché masks and variations on suits of armor (the vocalist had a 3-foot false phallus). They staged mock sadistic executions, decapitations and mutilations, spurting gallons of fake blood from within a prop wrestling ring.

Gwar's lore was intended as a heavy-metal parody, part apocalyptic sci-fi, part Conan the Barbarian cartoon and part porno flick. The band claimed to be sword-swinging galactic savages, the spawn of aliens stranded in Antarctica who were set free from their icy detention thanks to holes in the Earth's ozone layer brought about by excessive use of hair spray by self-obsessed glam rockers. Going by names like Oderus Urungus and Beefcake the Mighty, they chose rock 'n' roll as their means of creative expression.

Disciples conveniently forgot the alternate history—that Gwar was a creative group of disguised art-school graduates from Virginia Commonwealth University in Richmond. The band's first two albums of bludgeoning speed metal had no musical merit—the production and playing were terrible, the vocals were yelled and toneless. But the lyrics were uproarious, shot through with scatological nonsense and obsessive posturing. *America Must Be Destroyed* was listenable enough to seduce a small portion of the record-buying population. The title reflected Gwar's ever-growing contempt for the human species.

"We didn't get this way ourselves—you hit a kid, he's gonna hit back," Urungus said. "We're going to destroy America, then Europe, then Mongolia, then back to America because you'll have come back by then." "When we were learning the language of mankind, we sat in front of MTV and pro wrestling," Beefcake added. "Everything we know about music came from people who know nothing about music."

Gwar's attention-nabbing shtick managed to churn up all sorts of trouble. The lyrical content of *America Must Be Destroyed* was partly inspired by an incident in Charlotte, North Carolina, in which Urungus (whose real name was Dave Brockie) was arrested on a felony charge of "intentionally disseminating obscenities." Police seized his prop, saying it was supposed to be a penis. Brockie claimed it was a fish, aka the Cuttlefish of Cthulhu.

The album was accompanied by *Phallus in Wonderland*, a long-form film described as "somewhere between Monty Python and Stephen King." And Sleazy P. Martini, Gwar's manager, announced that he would run for president in the 1992 election—pillars of his deliberately obnoxious radical camPAIN platform included "mandatory abortions for all ugly chicks" and "free suicide clinics for all those losers who can't afford health care." ■

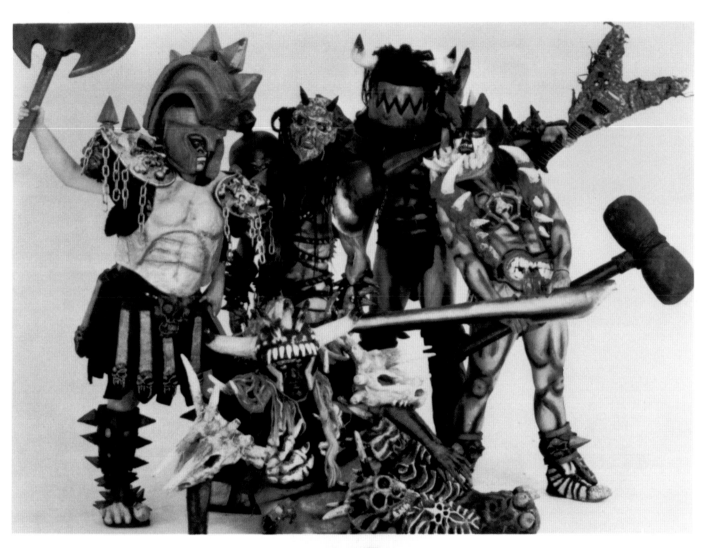

18653 VENTURA BLVD
SUITE 311 TARZANA
CA 91356 818 981-9050

Photo: Katherine Leatherwood

King Missile's exceedingly popular "Detachable Penis" ascended to No. 1 on the listings for college radio.

TO MESH his spoken-word performance art with rock 'n' roll, lyricist John S. Hall formed King Missile in 1986. "I wasn't a very good singer, and I wasn't too good at writing song lyrics, so as a rule, I didn't follow rhyming patterns or stick to exact meters," Hall mused. "Sometimes we're silly, sometimes we're funny, sometimes we're angry, sometimes we make nice songs, and sometimes we try to make a nice song and something goes wrong."

Three independently released albums took the New York alternative rock scene by storm, and wry alternative radio hits like "Take Stuff from Work," "Sensitive Artist," "Cheesecake Truck" and particularly "Jesus Was Way Cool" helped earn King Missile a shot with a major label.

"I want to spread my ideas, whether they're silly or profound—I can't really tell which ones are which," Hall noted. "King Missile itself isn't very macho, so there's a real contrast having this metalhead, phallus-worshipping name for a group that doesn't really get into the usual misogynistic, homophobic garbage. I've come to like metal over the years, but growing up, I associated it with the kids at school who listened to it and beat the shit out of me."

On *Happy Hour*, Hall's meandering narratives were tongue-in-cheek and faintly spiritual. His peculiar writing approach was fused with his bandmates' takes on punk, pop, noise, jazz or new age drone (guitarist Dave Rick was the MVP). The key tracks included "Martin Scorsese," a violent and vulgar tribute to the film director, and "Detachable Penis." Sporting lyrics that examined the nature of maleness and castration anxiety, the latter received tons of morning-show radio airplay—a mixed blessing.

"'Detachable' was only helpful in so far as it got some more people interested in the band," Hall averred. "For most of them, it was a novelty thing that they laughed at on the way to work. It never occurred to them that a working band had anything to do with it. We would purposely play the song early in our live set, so we wouldn't have people ignoring everything else we were doing while they waited for us to do it." ∎

DAVID RICK CHRIS XEFOS
JOHN S. HALL ROGER MURDOCK

KING MISSILE

Confronting an unsettled history, the regrouped **Thelonious Monster** came roaring back with *Beautiful Mess*.

IN THE Los Angeles underground music scene, there was no character more colorful than Bob Forrest. The singer and principal lyricist for Thelonious Monster had made a career out of being an unpredictable and volatile screwup. "I don't know why I've done all the stupid things I've done," Forrest said. "I always acted like I didn't give a shit, because I thought I'd look like a geek if I let anybody know that I really did care about my music."

Thelonious Monster grew out of the L.A. punk ferment of the early Eighties, cutting three albums that garnered rave reviews. Forrest's personal songs spoke about insecurities with truth and insight, drawing comparisons to Paul Westerberg's old band, the Replacements. "Sammy Hagar Weekend" was the Monster's best-known tune.

But while old sidekicks like the Red Hot Chili Peppers went on to stardom, Forrest's rep for self-destructive hijinks overshadowed his songwriting and zapped Thelonious Monster every time the group gained momentum. After a Forrest diatribe against his record company on a live radio show, the band was dropped and its records deleted from the catalog. Forrest signed a big-bucks solo contract and squandered his advance, renting a fancy house in the Hollywood hills and buying drugs in serious amounts. He began recording his album with pricey session pros, then reformed the band and rerecorded the songs in a more fitting style. His label washed its hands of the whole thing.

Considering Forrest's anarchic nature, it was amazing that anyone was willing to gamble on him, but Thelonious Monster was the first signing to the Signal Entertainment label. And *Beautiful Mess* was the Monster's most stirring, confident and disciplined record. The album featured "Blood Is Thicker Than Water"—"about my fucked-up family, frankly," Forrest said—"Body and Soul?" and a duet with Tom Waits, "Adios Lounge." The reaction at college radio was encouraging.

"There's a feeling that we've made it through all this shit, and now nothing's gonna fuck it up," Forrest allowed. "It can't get any worse than it was, and if we stick with it, something could happen. I made a great record (1989's *Stormy Weather*) and no one heard it because I was an idiot. I don't plan to be an idiot anymore." Forrest then sang the National Anthem at a Los Angeles Clippers basketball game and forgot some of the words—and was booed off the court. ■

Pete Weiss Dix Denney Bob Forrest Chris Handsome

Photo: Pamela Springsteen / 1992

ON RECORD | 1992 | [THE HEIGHTS]

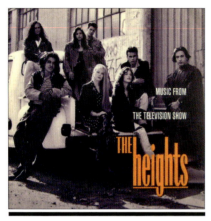

Billboard Hot 100: "How Do You Talk to an Angel" (No. 1)

The Heights, a television version of a band, had the No. 1 single in the US with "How Do You Talk to an Angel."

IN THE Sixties, people longed for the Monkees. In the Seventies, it was the Partridge Family. In November 1992, the biggest song in America was "How Do You Talk to an Angel" by the Heights, another made-for-TV band. "The song is huge, but we're not," Charlotte Ross, the actress who played guitarist Hope Linden, said. "We're the first television series with a hit song that isn't a hit in the ratings.

The Heights was a one-hour Fox drama about a group of blue-collar workers who formed a rock band—kind of like *Beverly Hills 90210* meets *The Commitments*. The week that "How Do You Talk to an Angel" was No. 1, *The Heights* was #89 out of 98 shows rated by Nielsen. And reviews had also been bad—the Associated Press called the show "first-class malarkey," and *Entertainment Weekly* gave it a D. But the series had spun off the slick, radio-friendly smash (it sounded like a Bryan Adams song).

"I helped them cast the show, and Jamie Walters auditioned," record producer Steve Tyrell explained. "I thought he could be Alex, a shy poet who was gonna present a song to the band at the end of the pilot episode and then join up. Alex couldn't put into words how he felt. I read the script and knew what it was gonna sound like—'How Do You Talk to an Angel.'"

The members of the band were professional actors, though some actually had musical experience. Ross said she sang and played on the song. Tyrell, an industry veteran who talked the talk, said it was a mix of the show's stars and outside musicians. "But that help is a process not unlike the way a lot of records get made today," he bristled. "It's a real unfair rap to take these kids who are actors, musicians, songwriters and performers and make light of their talent. It takes more talent than it does to be, say, a bass player in an Austin band. The Rolling Stones couldn't be the Heights—they couldn't shoot the show 12 hours a day, 20 shows a season, and still make a record. It's impossible.

"I think Jamie sounds pretty damn good on 'How Do You Talk to an Angel.' I think it's the beginning of a big career for him. He's got a great look. We played a gig in Philly, and kids were tearing his shirt off. He could be the next Elvis for all anybody knows." And the TV show? Fox canceled the series less than a week after the song fell from the No. 1 spot. ■

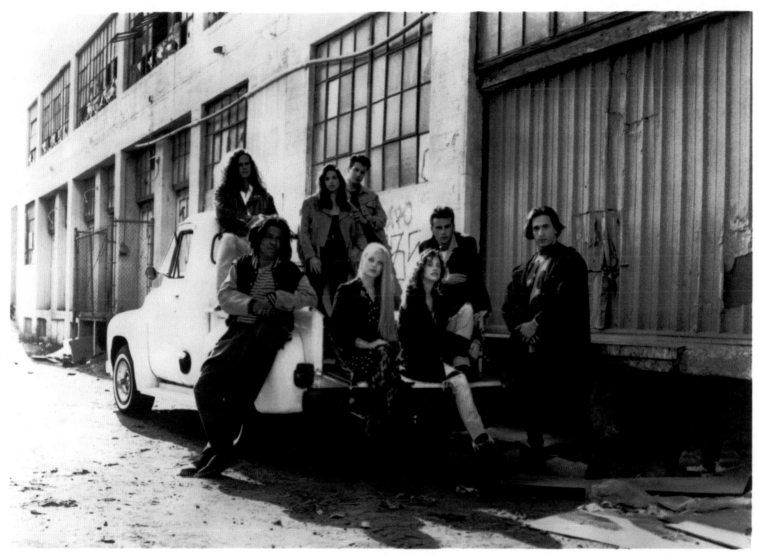

Exclusively for use in advertising and promotion relating to television exhibition through Fox Broadcasting Company. All other rights reserved.
© 1992 Fox Broadcasting Company

THE HEIGHTS

BACK ROW, L to R Shawn Thompson as J.T Banks, Tasia Valenza as Jodie Abramowitz, Ken Garito as Dizzy Mazelli, James Walters as Alex O'Brien. FRONT ROW L to R Alex Desert as Stan Lee, Charlotte Ross as Hope Linden, Cheryl Pollak as Rita, Zachary Throne as Lenny Schaeffer.

Photo Credit: Jeffrey Thurnher

A Grammy nominee for Best Contemporary Folk Album, **T Bone Burnett**'s *The Criminal Under My Own Hat* rang true.

IN A busy musical life that spanned nearly three decades, T Bone Burnett gained his first major exposure as a key but lesser-known member of Bob Dylan's 1976 Rolling Thunder Revue—the witty Texas songwriter played guitar (and was blamed by some for converting Dylan to right-wing Christianity). Best known as a studio mastermind who'd produced such noted artists as Los Lobos, BoDeans, Peter Case and Marshall Crenshaw, he'd also had a hand in the work of Elvis Costello, Roy Orbison and Sam Phillips, his wife. But he showcased his writing on his albums.

"After I started producing, it took over my life—I was making my records in my spare time," Burnett said. "After Costello's *Spike*, I went back to Texas for three years of soul-searching. I didn't watch TV or read anything. I just tried to return to ordinary life in the real world. Now I'm balancing things a little more, making sure I schedule six months a year for my own projects instead of one week."

Burnett took a largely acoustic approach on *The Criminal Under My Own Hat*. Invented characters delivered the songs—in the funny "Humans from Earth," a real estate agent told the inhabitants of a planet far away how lucky they were that earthlings would be moving in soon. "Randy Newman's 'Sail Away' had a profound effect on me, the use of irony in a narrative lyric," he noted.

Burnett's material rarely mentioned God, yet it always implied a hard-bitten sense of morality. Wrestling with crises of conscience, he was an absorbing example of how religion could be instilled in pop music. "If contemporary Christian artists want to sing about God, that's perfectly wonderful—but they shouldn't worry about how they're accepted," he mused. "God didn't tell us to go behind a wall and lob truisms over to an unsuspecting populace." ■

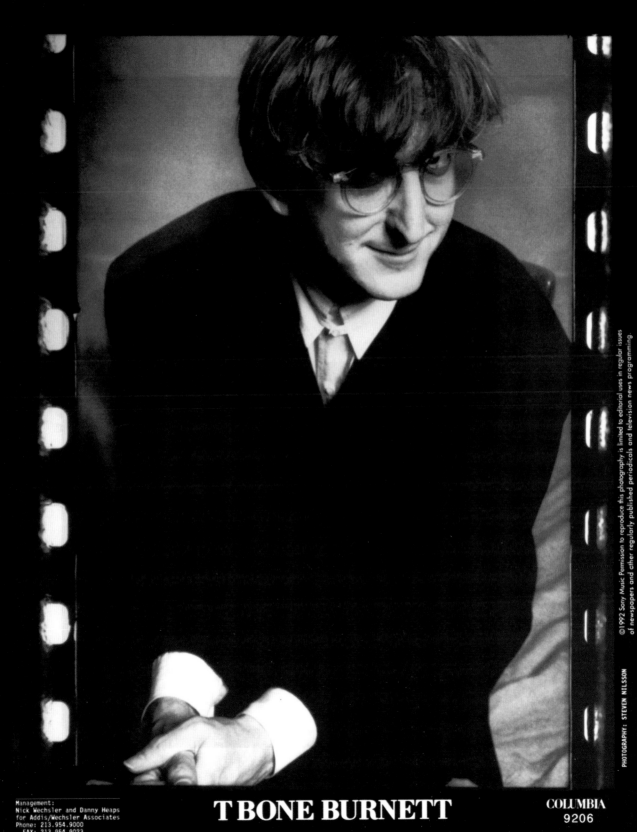

T BONE BURNETT

Billboard 200: *Never Been Rocked Enough* (#118)

Delbert McClinton spread the word about his soulful, roadhouse-bred music through *Never Been Rocked Enough*.

FOR PARTS of four decades, Delbert McClinton had been slogging away on the roadhouse circuit, purveying his special brand of Southern rock, country and honky-tonk blues in clubs, bars and late-night hangouts. He remained an unclassifiable jewel, and live performance still constituted the core of his love for music.

"When I was a little guy, I had uncles who would give me quarters to sing Lefty Frizzell songs," McClinton said. "Then I met somebody else who played music, and first thing you know we're trying to put a band together. I never said, 'This is what I'm going to do'—I just did it! I never, ever thought about anything else. Of course, I've had to have jobs, but they were always a means to an end. Anything to make it to where I could go and play music."

McClinton's recording career reached back to the early Sixties, when he played harmonica on Bruce Channel's No. 1 hit "Hey Baby" (he also taught John Lennon how to play the instrument, licks later heard on the Beatles' "Love Me Do") and led the Ron-Dels. Yet his solo success on the pop charts had been fitful. "Giving It Up for Your Love" made the Top 10 in 1980, but the veteran roots rocker had never gained a large audience until the success of "Good Man, Good Woman," his Grammy-winning duet with Bonnie Raitt, first released on her 1991 *Luck of the Draw* album.

McClinton, 51, proved rock 'n' roll was a factor of attitude, not age, and on *Never Been Rocked Enough*, he still sounded passionate and relevant. The Texas tornado had a lot of friends, and he was joined on the record by a cast of stellar musicians—Raitt, Melissa Etheridge and Tom Petty, to name a few. McClinton mixed rock, R&B and country for an incendiary, rough-edged sound, and he blew heartfelt, no-nonsense harp (*The Book of Rock Lists* ranked him among the world's 20 best harmonica players).

The infectious single "Everytime I Roll the Dice" received major airplay on rock radio, and McClinton's gospel-tinged cover of John Hiatt's "Have a Little Faith in Me" displayed his fervent vocals. The album also included "Good Man, Good Woman," which boosted his following further. "I've had a lot of people tell me that they became fans of mine because of the duet," he reported. "Winning a new fan is something that never gets old. It's nice to walk away feeling that you've made another convert. It'd be easy for me to say I'm not into making money, but I am—and the best way to do it is to have a hit record. I'm testimony to the fact that you don't come out with one every time, but this is a lot of fun." ∎

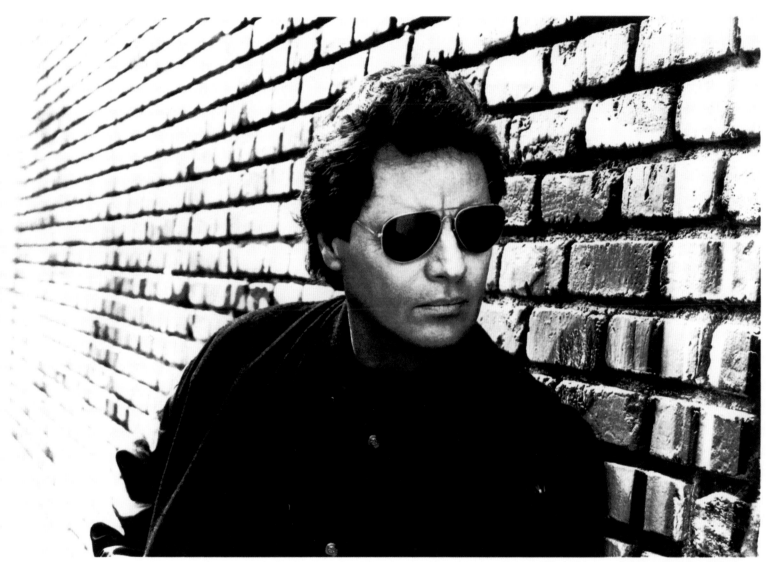

Billboard 200: *Arc Angels* (#127)

Arc Angels showed potential on their debut album, but the stage was where the Texas band's roots came alive.

ON PAPER, Arc Angels might have seemed like a manufactured supergroup. Doyle Bramhall II and Charlie Sexton were both 23-year-old guitar-slingers in the blues-based Austin tradition—Bramhall had played side by side with Jimmie Vaughan in the Fabulous Thunderbirds for two years, and Sexton, a former teen phenom, had already recorded two solo albums. Drummer Chris Layton and bassist Tommy Shannon comprised the rhythm section for the late Stevie Ray Vaughan's Double Trouble.

But the musicians emphatically maintained the partnership developed organically. During the summer of 1990, they woodshedded individually at the Austin Rehearsal Complex (the ARC of the Angels), and Layton initiated playing blues standards and shuffles together, just for fun. Goofing off led to jamming in clubs, and Arc Angels became the next big hope of Texas guitar-rock.

Bramhall struggled to come to terms with the August 1990 helicopter crash that took Stevie Ray Vaughan's life. He was pulled off the road to enter rehab. "I knew Stevie since I was born," he explained. "My dad was supposedly the first guy to tell Stevie how much he enjoyed his playing. He walked into the Vaughan house and said, 'Wow, that sounds great!' Stevie was 11." Bramhall's father, Doyle Sr., drummed in the Nightcrawlers with Vaughan and later became his favorite songwriting partner ("Tightrope," "Life by the Drop," "The House Is Rockin'").

"So it was hardest for me to say, 'Yeah, I'll be in this band,'" Bramhall explained. "I'm basically a blues guitar player from Texas playing rock, and if I played with Double Trouble, people would go, 'Oh, he's trying to ride on their coattails, trying to be Stevie Ray Vaughan.' I'd never want to do that—I got a lot from Stevie, but I'm my own person with my own songs. But that's the only reason I didn't want to do it. So I said, 'Fuck it, you only get to live once. Why let people stop me from playing with the people I love?'"

Arc Angels featured two tracks that caught fire on the rock charts. The opening "Living in a Dream," a midtempo raw-edged rocker, "sorta started the band—it's the first song Charlie and I wrote together," Bramhall noted. "I'd worked on the melody and music for years, but he took it and finished it overnight." Bramhall's husky-voiced ballad "Sent by Angels" was the only song written after coming into the studio. "I was feeling lonely one night, and I pretended I had a girlfriend to write. I didn't finish the song—we already had enough for the album—but (producer) Little Steven kept pushing me to do it. He was a great help. But the album is different from what we do live. You can't get the same vibes—we feed off people."

Within a year, the band was in shambles. By Bramhall's own admission, it was his substance abuse that broke up Arc Angels. ∎

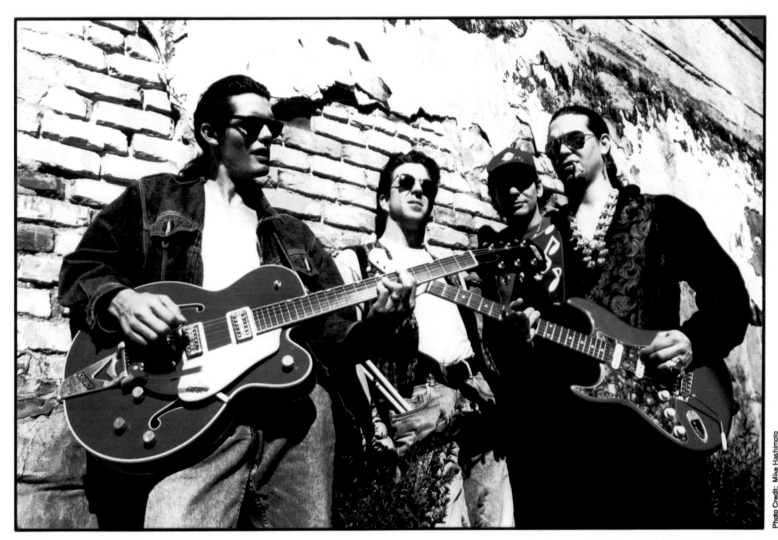

Charlie Sexton Chris Layton Tommy Shannon Doyle Bramhall II

ARC ANGELS

DAVID GEFFEN COMPANY

© 1992 The David Geffen Company/Permission to reproduce limited to editorial uses in newspapers and other regularly published periodicals and television news programming.

Photo Credit: Mike Hashimoto

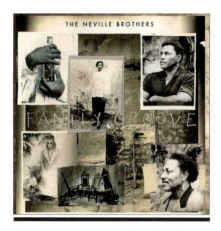

The Neville Brothers recorded their rendition of "Fly Like an Eagle" and made Steve Miller's song their own.

THE INDIVIDUAL Neville Brothers had rich histories. Art wrote "Mardi Gras Mambo," a staple of the celebration, in 1954. Aaron had a #2 smash in 1966 with "Tell It Like It Is." In the Seventies, Art formed the Meters, grand masters of the New Orleans "second-line" funk style. But as the Neville Brothers, none of their first few recordings sold well, and they tried to cross over many times with different strategies. The industry ostracized the band for years, afraid of the siblings' tough look and reputation. "We did certain things that weren't played or exposed, and the next thing we'd hear, somebody had copied us," Aaron mused. "But we knew it was good to begin with."

The Nevilles' legend grew as they overcame their unsavory image with a sense of hope and enlightenment. In 1987, they won a Grammy with *Yellow Moon*, and 1990's *Brother's Keeper* received critical acclaim. But the compelling records never ignited with the magic of the Nevilles' flamboyant live shows, which were nearly aerobic in intensity. Longtime fans of greasy, syncopated Crescent City music had been waiting for them to release a killer album.

Family Groove was an attempt to consolidate the commercial gains made by the Nevilles during the past few years. The album accentuated their gutsy funk and hearty R&B—hitting the rhythms hard, sounding at ease and natural—while getting across the band's deeply moral perspective, a preoccupation with injustice and racial intolerance. "We wanted to get a little more radio-oriented," Aaron admitted. "We don't like to repeat ourselves."

The album reintroduced Steve Miller's "Fly Like an Eagle" as a driving pop-funk workout, complete with the original's trippy space noises and backing vocals and guitar from Miller himself. Aaron said the 1976 hit remained an important social statement, and the Nevilles' version took them back to their roots. "We played it our first gig—when we first got together in 1977, that was one of the first things we worked up." ■

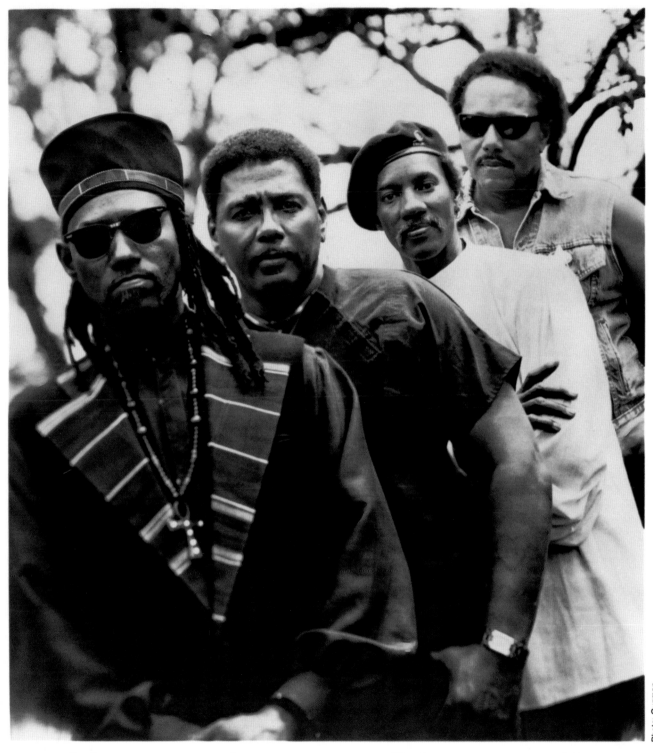

Cyril Aaron Charles Art

BILL GRAHAM MANAGEMENT
P.O. Box 1994, San Francisco, CA 94101 • 415/541-4900

Buckwheat Zydeco explored the possibilities of modern zydeco music and connected with the general public.

ONCE OBSCURE, zydeco—the exuberant, accordion-fired dance music of southwestern Louisiana's Black French-speaking Creoles—had found a cultural niche through its infectious spirit. And Stanley "Buckwheat" Dural, Jr., a versatile singer and multi-instrumentalist, had played a major role in zydeco's crossover, bringing it a rock 'n' roll edge with his band Buckwheat Zydeco.

Dural took up the piano and organ at age nine in his hometown of Lafayette, Louisiana. By the late Fifties, he was playing soul and R&B in area nightclubs while still in school, and he went on to become a sought-after sideman and led his own funk outfit. The major turning point came when he joined the "King of Zydeco," Clifton Chenier, as a keyboardist. Chenier re-acquainted Dural with his zydeco roots and was directly responsible for his decision to go out on his own and form Buckwheat Zydeco in 1979.

The *On Track* album assembled Dural's zydeco sensibilities—a blend of blues, R&B and rock with touches of traditional country, gospel and pop. "I've got so many ideas in my head, so many things I've wanted to express," Dural said. "In the past, I did a lot of good things in roots music, but I'm taking it to a different level with cover tunes to capture more of an audience."

An eight-minute-plus version of "Hey Joe" was unlike any other song in the zydeco idiom, featuring ferocious solos from three guitarists, transportive harmonica trills and tumultuous drum work. "Radio stations are limited to what they can play, and what I'm doing is very strange to them—I have to wait until they can't play anything else, then they'll play me," Dural said. "So to get their attention, I did 'Hey Joe'—I always loved the way Jimi Hendrix did that song, and I wanted to tip my hat to him. He took rock guitar to another dimension, and that's what I'd like to do with zydeco accordion. And I've made commercials—I've done Budweiser, Coke, Lee jeans, Mercury and Cheerios. The exposure is good for me and all of zydeco."

The release of *On Track* was supported by Buckwheat Zydeco's nonstop touring schedule. "I'm gonna continue doing the pop things, but it's a good idea to take the best zydeco out to people at this time," Dural said. "Zydeco will always be my roots—no matter what I do, I make it move like a zydeco song." ∎

BUCKWHEAT ZYDECO

 charisma

 Ted Fox Productions

Photo Credit: John Casado 1/92

Snake Bite Love by **Zachary Richard** went far beyond the traditional sound and language of "La Louisiane."

HIS FUSION of spicy Cajun music and American rock 'n' roll had earned Zachary Richard a reputation. "The Cajun Mick Jagger, the Cajun Elton John, the Cajun Bruce Springsteen, the Cajun John Mellencamp—I've heard them all," the singer-songwriter-accordionist said. "It's made me wince, but I don't resent it. I'm flattered because it's in rock music circles—it's better than being compared to Lawrence Welk. But ultimately, I'd like to be known as who I am."

The Louisiana native had been working on his trademark sound for two decades. He cited R&B, white soul, old Chicago blues, folk-rock and the British Invasion as early influences. "I was a typical American kid who was a Cajun on Sunday afternoons," he explained. "I knew I was one, but I wasn't aware of the heritage."

Richard majored in history at Tulane, receiving his degree in 1972. He made a Jackson Browne-type record that was shelved, but with the money left over from the label's advance, he bought an accordion. "I was curious," he explained. "I had no anticipation of what it would come to mean to me, but it opened a door to my personality that I was unaware of. I got militant about the preservation of South Louisiana culture. I began to incorporate Cajun elements into a rock 'n' roll format and was able to acquire fans in Louisiana dance halls."

That started a 10-year French-language career. Richard became a successful pop singer in France and in Canada, where he had two gold records. He was finally introduced to American audiences, mixing modern styles into his brand of Acadian music and performing like a man possessed.

"I've gotten flak from purists who would prefer to keep Cajun music in a museum the way it was being played years ago," he noted. "I've never pretended to be traditional, but with a name like Richard (pronounced 'Ree-SHARD,' *à la* Cajun), being from Louisiana and playing accordion, they're surprised and disappointed to hear rock 'n' roll from me. I love my Cajun roots, but it's only one element."

Richard's album *Snake Bite Love* was a crossover bid—he and producer Bill Wray incorporated his Cajun legacy into a glossy contemporary package. "There was more time and money for this project, and expectations were greater," Richard said. "The record company's agenda was to make a rock record that they could get on the radio, have hits and sell some copies. It wasn't easy—it was an artistic struggle in terms of style, how much Louisiana to incorporate. If this was my Faulkner record, the next one will be my Hemingway—I'll go past the regional settings." ∎

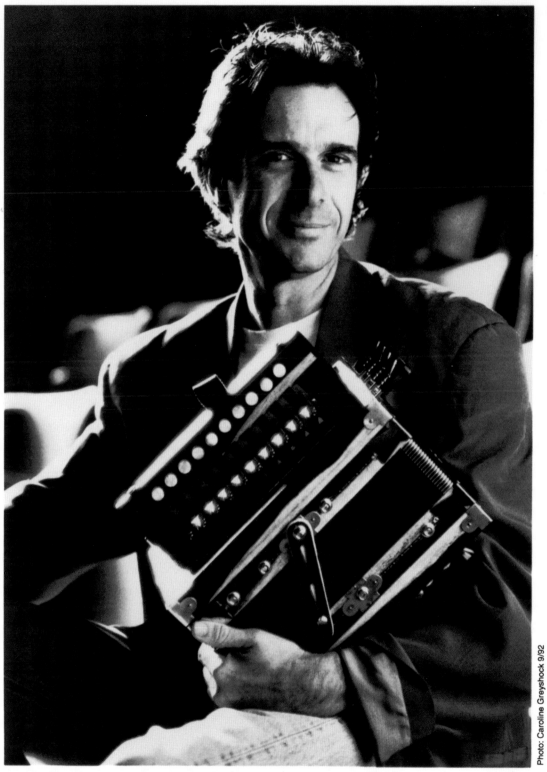

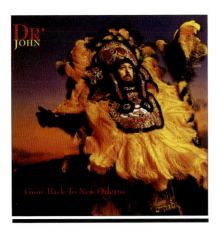

Dr. John, a.k.a. Mac Rebennack, made *Goin' Back to New Orleans* in the city that sired and inspired him.

MAC REBENNACK'S career had spanned the five decades of rock 'n' roll, but few people outside the music industry knew of him, though his whiskey-cured voice had graced pitches for everyone from Ivory soap to Pepsi-Cola to American Express. "I've made more money doing toilet-paper commercials than my last seven records did," he said.

The New Orleans native originally garnered respect as a prolific songwriter and arranger (he had more than 1,000 published songs to his credit). He was one of the most in-demand session players in pop-rock history—from his piano bench, he'd worked with such Crescent City legends as the Meters and Allen Toussaint, and then with the Rolling Stones, Aretha Franklin, Ray Charles, B.B. King and others.

And as Dr. John, he won enthusiastic worldwide acceptance. While working as a producer and A&R man in the late Sixties, Rebennack conceived a personage who sold sachets and potions in Creole neighborhoods. He recorded the concept himself and catapulted Dr. John into the spotlight. Performances by the mythical "gris-gris" man came complete with snake dancers, flamboyant bayou sorcerer attire (feathers, beads, robes and sequins), smoky evocations of backwoods magic and mysticism, and a bizarre musical blend of New Orleans funk, gospel and R&B.

The new role brought a loyal cult following, and Dr. John achieved some mainstream fame when "Right Place, Wrong Time" hit the pop charts in 1973. "I gave up my identity," he said of the voodoo trappings. "Suddenly I was an artist—and it became a monster. We were doing a traditional 'snake show,' and we became exactly what we all hated about psychedelia. But I always loved that music. It's a big part of Louisiana culture. I'm not a real religious person, but I thought it was worth trying to record.

Dr. John eventually settled into his adopted persona. He'd somewhat mellowed and was relieved to be free of the old star-making jive, having proven himself a master of distinctive ivory-stroking in the manner of Professor Longhair and Huey "Piano" Smith. His audiences realized that the syncopated rhythms and snatches of Mardi Gras French that spiced his music were cultural residue, not exotic posing.

In 1992, Dr. John recorded a Grammy winner—*Goin' Back to New Orleans*, his first-ever album produced there. He reworked the hillbilly standard "Careless Love" as a blues piece, and on a rafter-rattling version of "Blue Monday," he paid tribute to all the "Junker's Blues" piano players who preceded him, like Tuts Washington, Sullivan Rock and Kid Stormy Weather. He recalled reinforcing his musical education when he was little, tagging along to help out at his father's appliance store.

"It was located next to Dillard University, a very hip Black college. They bought what they called 'race records' at the shop, so I soaked up the full range of sounds—'barrelhouse boogie,' 'funky butt,' old-fashioned 'gut bucket,' R&B, Dixieland jazz, the Creole-voodoo culture and a whole lot of blues. This album is my approach to the history of New Orleans music." ■

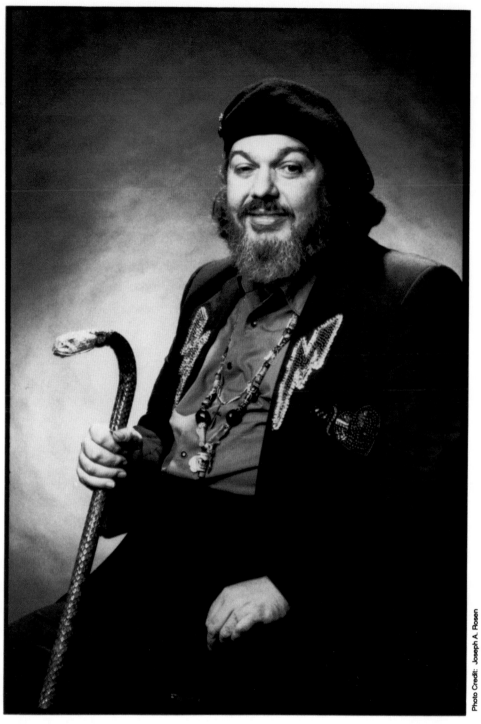

Photo Credit: Joseph A. Rosen

© 1992 Warner Bros. Records/Permission to reproduce limited to editorial uses in newspapers and other regularly published periodicals and television news programming.

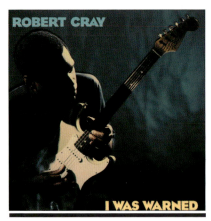

Billboard 200: *I Was Warned* (#103)

The *I Was Warned* album communicated the range of **Robert Cray**'s blues, soul, pop and ballad composite.

WHENEVER ANYBODY boasted of Robert Cray's sophisticated urban blues credentials, he told them to go back through all of his records. "Blues is a part of what we play, but not all of it," he explained. "We've always done a lot of different things, combining elements of rock, soul, gospel and jazz. What all those styles have in common is that you're dealing with situations in an honest, down-to-earth way. It's such a wide area of music to enjoy, we don't change things with each album or talk about what we want to do. We just get together and do it."

Eric Clapton had called Cray "the finest touch player in the world," and Cray described the title track of his *I Was Warned* album as "Howlin' Wolf goes south of the border." "The guitar solo was a surprise in the studio," he admitted. "I'm sitting in the booth singing and playing rhythm—and I just started playing a lead. They wouldn't let me do it again—it was so good that they just kept the first take."

The song "On the Road Down" followed a writing session with Steve Cropper, the legendary Stax axeman who penned "(Sittin' on the) Dock of the Bay," "In the Midnight Hour" and many other R&B classics. Cray had been featured on the worldwide-televised "Guitar Legends" concerts at the Expo in Seville, Spain. Only two six-string luminaries were asked to play both the rock and R&B nights—Cray and Cropper.

"Our paths had crossed several times before, but the 10 days of rehearsals and shows gave us a chance to talk," Cray said. "His playing style is so unique—not overdone, just to the point. That's what this band strives for, the passion of what's going down. Getting the feeling is more important than the perfection of the material. There may be some buzzing frets, some bent notes, but we don't go back and touch them up because it would erase the real heart of a song."

I Was Warned consolidated Cray's guitar wizardry with his strength and sensitivity as a vocalist. "The only thing we love to do is play music," he said. "I look at John Lee Hooker—he's in his 70s and doing it. So I don't concern myself with image so much. We're creating a body of work. We're here for the long term." ∎

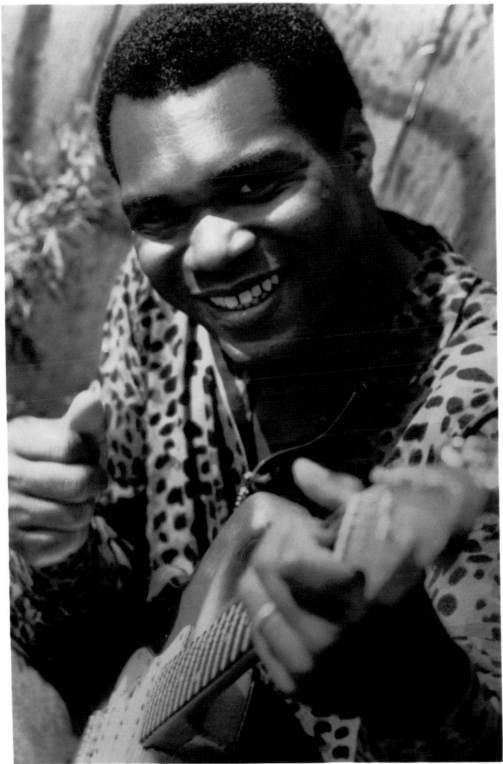

ROBERT CRAY

PHOTO CREDIT: ROBERT MATHEU

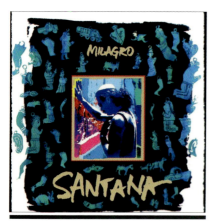

Billboard 200: *Milagro* (#102)

As *Milagro* affirmed, the music of **Santana** celebrated the leader's continued dedication to the human spirit.

SCORES OF guitar heroes had come and gone since Carlos Santana set the crowd ablaze at Woodstock in 1969 and released a number of classic rock hits including "Black Magic Woman," "Oye Como Va" and "Evil Ways." The veteran guitarist had proven he had more staying power than most luminaries of his generation—he had recorded 27 albums, 20 with the Santana band.

But many of them had leaned more toward new-age jazz than rock, and they'd received modest promotion and marketing. Yet the soft-spoken Santana was still making inventive, exciting music, and he continued to tour almost nonstop. He thrived on spiritual influence more than on earthly motivation, remaining humble and grateful for his audience.

"I'm still perfecting my art, trying to play music from the heart," the legendary player mused. "Life as a musician is no different from life as a minister or a professional wrestler—it's just a business. It's whether you go through that job with dignity or as a fool, if what you do leaves a long-lasting positive impression."

Milagro honored the memories of two friends who died during the release's conception—promoter Bill Graham and jazz trumpeter Miles Davis. "Even though you prepare yourself all your life that we all belong to God, it still takes a while to come up for some air when you lose someone close. While we were down there in that state of pain, we got to the studio—and it turned out to be a wonderful tribute. Music's a healing force, it reminds us that we're just passing through—'To live is to dream, to die is to awaken.'"

Milagro featured Santana's unmistakable guitar work on several instrumentals, mixtures of rock, blues, soul and salsa. "I don't like to sing—I get an opportunity to sing though my guitar," he said. "To me, the worst thing is a musician who hears none of the parts, only his own part."

After 22 years with CBS/Sony, *Milagro* was Santana's debut release for Polydor Records. The album failed to re-generate Santana's commercial fortunes, becoming his first release not to crack the upper half of the *Billboard* 200. ∎

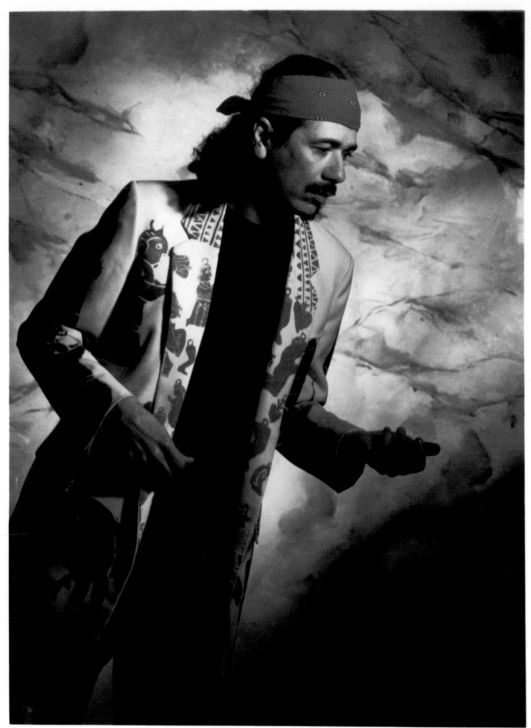

PolyGram Label Group

Luka Bloom reinvented himself on the folk-pop scene with a creative cover of rapper LL Cool J's "I Need Love."

THE FORMER Barry Moore, younger brother of famed Irish singer Christy Moore, was going nowhere fast with his musical career at age 32. So he moved to New York and changed his name with a joking nod to novelist James Joyce's fictional character Leopold Bloom and Suzanne Vega's best-selling song, "Luka." Using an alias unleashed Luka Bloom as a riveting performer, relying on his ingratiating, brogue-inflected singing and a vigorously played amplified acoustic guitar.

"I had been very self-conscious, but after I changed my name and discovered this guitar sound—I call it 'electro-acoustic'—it instantly transformed my songwriting," he said. "All of a sudden I had a powerful animal at my disposal. Sooner or later, people will latch onto the idea of this third guitar. It's not electric, it's not acoustic—it's an instrument with acoustic sounds that are arrived at electronically."

Bloom's 1990 *Riverside* album earned critical acclaim for his emotive charisma. He moved back to Dublin, where he wrote the songs for his second US album, *The Acoustic Motorbike*. The title song vividly recounted a long ride on his mountain bike across the Irish countryside. "Mary Watches Everything" was packed with references to the Emerald Isle. But Bloom also reflected on ideals and dreams—"I Believe in You" appealed for faith in a faithless world.

The album also showcased a strangely impassioned and affecting acoustic version of LL Cool J's "I Need Love." Bloom played the rap ballad straight. "Initially, it was a desire to tap into rap, because I'm very excited about it," he noted. "The mind-bending things that Shinehead and P.M. Dawn are doing with lyrics, rhythm and syncopation—they're breaking out with new ideas, crossing rap with reggae and soul. Rap is much more sophisticated than people imagine. This was the most complex song I've ever had to learn in my life—it took me a long time to get it together. I performed it for a year before I recorded it."

Bloom even invited Moore to play *bodhrán* (a traditional Irish drum) on "I Need Love." Moore wound up lending a Celtic twist on five songs. "Aside from the fact that Christy performed a couple of songs I'd written, we'd never worked together in the last 10 years—our tastes are very different," Bloom allowed. "I didn't ask him to do 'I Need Love' because he's my brother—I asked him to do it because he was the right man for the job. I wanted to give the song an Irish flavor and I tried a couple of percussionists, but they were too flashy. My brother came in with the perspective of a singer and nailed it." ∎

LUKA BLOOM

reprise

Photo Credit: Lynn Goldsmith

© 1992 Reprise Records. Permission to reproduce limited to editorial uses in newspapers and other regularly published periodicals and television news programming

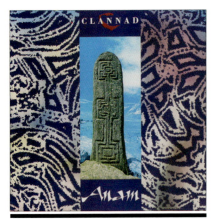

Billboard 200: *Anam* (#46)

Attention created by a Volkswagen TV spot gave rise to *Anam*, a US boon for the Irish folk group Clannad.

THE VEHICLE for Clannad's huge exposure in the US was literally that—an automobile. "Harry's Game," a 10-year-old piece by the Irish folk group, was included in the soundtrack for the film *Patriot Games*. Someone at an ad agency saw the espionage thriller and decided that Clannad's moody Celtic new-age tune (sung in Gaelic) would work in a major television advertising campaign for Volkswagen's top-of-the-line Passat.

When the commercials started airing, thousands of people called an 800 number given at the end to inquire where they could grab the nice music without the sales pitch. Clannad then got a credit at the end of the spots, like in an MTV video. The band and its record company stood to get a lot of mileage out of the VW connection, as the US edition of *Anam*, the parent album, sold over 250,000 copies.

"Harry's Game" originally was written for a British TV documentary on the conflict in Northern Ireland. "I thought a lament would be in order," Ciarán Brennan said. "I was on the bus to Dublin and had my grandfather's book of proverbs—he was a schoolmaster. And I just opened it to a page and this thing came screaming at me in Gaelic, the opening lines in 'Harry's Game'—'Everything that came before will go, all things will pass.' Then we sat around the house between lunch and dinner and wrote the song."

The success of "Harry's Game" was a reward for years of hard work. The tight-knit family from County Donegal included Ciarán, his sister and lead singer Máire Brennan and their twin uncles, Noel and Pádraig Duggan. His sister Enya, whose *Shepherd Moons* was the No. 1 new-age album, had sung with the band prior to the recording of "Harry's Game."

"It was straight out of school into Clannad—just playing cover versions in my father's pub, relieving him during our summer holidays," Máire said. "We started exploring old Gaelic sounds in the late Seventies. It was great fun doing a lot of folk festivals and tours in Europe. But it felt like we were only doing it for ourselves. It was only when we were asked to write 'Harry's Game' that we actually got a record deal."

Clannad's captivating sound blended elements of traditional Irish and contemporary pop music, and the band had scored a few hits in Europe (including 1986's "In a Lifetime," a duet with U2's Bono also included on *Anam*). But Clannad didn't expect so much to happen with "Harry's Game."

"Anything that gets people interested in your music is important," Ciarán said. "After two decades, we're still thrilled at any little thing that happens, and this is a big one. It's a complete joy to be in the States and feel the buzz of interest in our music." ■

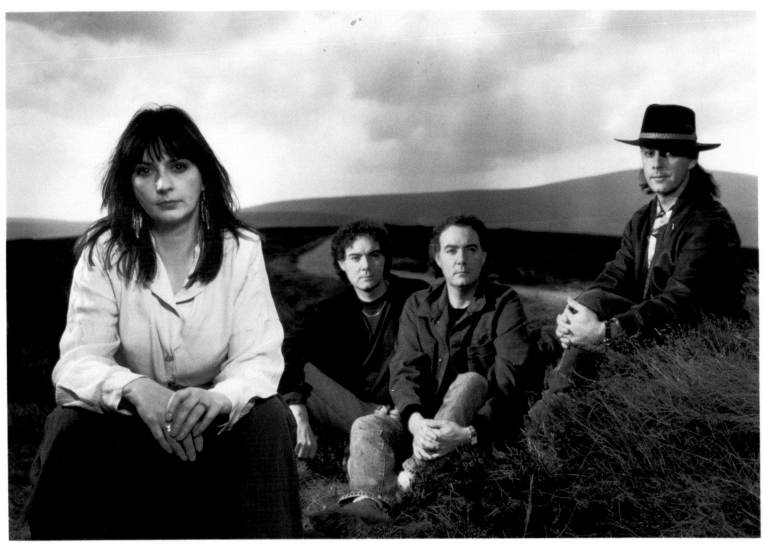

MÁIRE BRENNAN PADRAIG DUGGAN NOEL DUGGAN CIARÁN BRENNAN

CLANNAD

The UK duo **Gregson & Collister** ended their personal and professional association with grace on *The Last Word*.

CLIVE GREGSON, a seasoned songwriter—he once led Any Trouble, one of the first new-wave bands signed by Stiff Records—spotted Christine Collister singing at a club in Manchester, England. They formed a team, touring and recording as part of Richard Thompson's band. Then they began proving that they could stand alone as Gregson & Collister, though they were often misperceived as a British folk act.

"I'm a great fan of folk music, but it's just not what we do," Gregson noted. "My background in folk is very limited. What we do is acoustic pop, country and rock 'n' roll. Things took off for us—it seemed people were still interested in two voices and an acoustic guitar."

Gregson was an adroit and distinctive guitarist much like Thompson, equally adept at delicate melodies and piercing outbursts. Collister was a special, stunning songstress whose deep, throaty voice could belt and croon by turns. Gregson & Collister appeared to be a musical partnership made in heaven.

But they were calling it quits. The duo broke up romantically, and a farewell tour coincided with the release of *The Last Word*. "I think this is our best record—I'm proud of it, and we're going out on a high note," Gregson said. "But it's our fifth—we've reached the ceiling of what we can achieve. We've been going at it really hard for seven years."

The tender charm of *The Last Word* came in Gregson's striking, perceptive originals. The searing "I Don't Want to Lose You," "Last Man Alive" and "Here I Go Again" reflected the good and bad experiences of relationships, and the unpretentious allure was captivating.

"When Christine and I started working together, we made a conscious decision to do something very simple, purely for economic reasons at that point—it struck me that I ought to hone my playing a bit more, so I worked hard at it," Gregson said. "But as a singer, probably the worst person in the world you can stand next to is Christine. And as a guitarist, the worst person you could stand next to is Richard Thompson. I've done both of those things. So I don't think of myself as a guitar player or singer anymore. I'm a songwriter." ∎

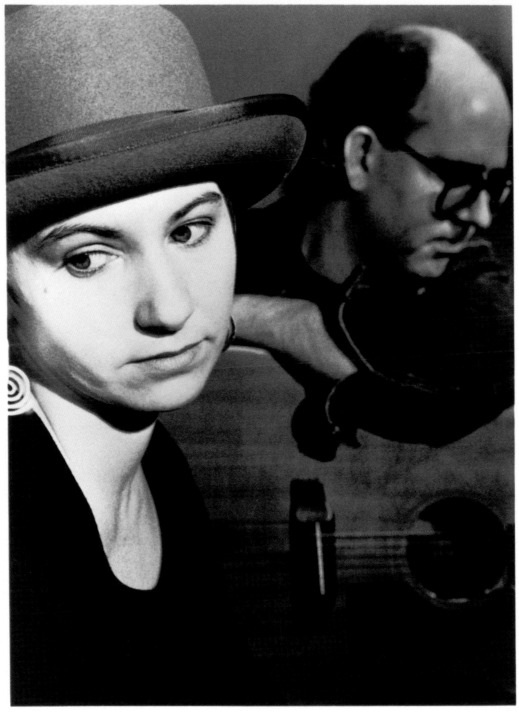

CLIVE
GREGSON
CHRISTINE
COLLISTER

JOHN MARTIN
For Eleventh Hour Management

A DIVISION OF RHINO RECORDS 2225 Colorado Ave. Santa Monica, CA 90404-3555 (310) 828-1980 Fax (310) 453-5529

The Beautiful South's "We Are Each Other" was the English band's prime hit on US alternative rock radio.

THE CRITICALLY acclaimed Housemartins were masters of acerbic, soul-influenced British pop prior to splitting in 1988. Featuring vocalists Paul Heaton and Dave Hemingway, the Beautiful South arose from the Housemartins' ashes as a more melody-oriented outfit, but one with similar charm and sarcasm. When told the *New York Post* described the band as "words by Charles Manson, music by Mary Poppins," frontman Heaton frowned. "I'm not sure about Mary Poppins," he demurred.

An ample pop sensibility animated the polished *0898* album. It featured Heaton's sweet vocals, frisky rhythms and bouncy arrangements. The jazzy, keyboard-driven sound was tinged with horn parts straight from the Burt Bacharach-Hal David songbook, distinguished by easy, loping grooves. But the seductive music was juxtaposed with the pure venom of Heaton's unrepentantly nasty lyrics. "We Are Each Other" became a minor hit in America, peaking at #10 on the *Billboard* Modern Rock Tracks chart.

"We write by improvising together with acoustic guitars, mutual jam sessions," guitarist David Rotheray said. "I always think it's too obvious if you match words and music—there's no contrast." "It's not something we go out of our way to do," bassist Sean Welch added. "The only songs we can write are ones with real tunes—we're not good at that grungy, metallic sound. We can also only write lyrics that have something to say. I think it's odd that other people *don't* do it this way." ∎

SEAN WELCH DAVE HEMINGWAY DAVID STEAD PAUL HEATON BRIANA CORRIGAN
DAVE ROTHERAY

BEAUTIFUL SOUTH

Elektra Entertainment

Billboard 200: *Secret Story* (#110)

Secret Story was virtuoso guitarist **Pat Metheny**'s most ambitious—and personal—musical statement yet.

OVER THE course of an 18-year recording career, Pat Metheny had been one of jazz's most familiar faces, always maintaining an immediately identifiable sound. But most of his popular acclaim had stemmed from his Pat Metheny Group records or his collaborations with keyboardist Lyle Mays, saxophonist Ornette Coleman and composer Steve Reich.

Secret Story was touted as Metheny's first solo project. The six-time Grammy Award-winning guitarist and composer bared his heart though he never opened his mouth on the album, a chronicle of his ill-fated affair with a Brazilian woman. "It's a culmination of a lot of things I've done stylistically—it's not jazz, even though it has some of my best jazz playing on it," he said. "The goal was to do a long record that told the story, the narrative shape of romance—the beginning, middle and end of things. I was going to do it by myself with a synthesizer—I completed a version like that—but I decided the emotional nature of the music would benefit from humanity."

On *Secret Story*, a shifting international cast of players created the lustrous textures and sprightly interactions of Metheny's compositions. His principal collaborator was the veteran British arranger-conductor Jeremy Lubbock, who invested deeply in grand orchestrations and melody. But the opus worked best when Metheny weaved in world-music influences—a Cambodian women's choir on "Above the Treetops" and an implied gypsy-jazz rhythm on "Antonia." "One of the great things about instrumental music—jazz, classical or whatever—is that the listeners can write their own stories," Metheny noted. "It's very personal for me, but it's so large in scale and scope. I have never gotten a response like this. It seems to be touching people."

Born in the wee Kansas City exurb of Lee's Summit, Missouri, Metheny's musical epiphany came at age 11 when his trumpet-playing brother, Mike, returned from college with Miles Davis' *Four and More* live album. "I put it on, and that was it. I hear people talk about how difficult jazz is to get interested in, but for me, it was in the first 30 seconds—it was the greatest thing I'd ever heard. For the next six years, I didn't want to hear anything but Miles, Ornette, (John) Coltrane, Jim Hall and Wes Montgomery. I mean, I was the biggest jazz snob in the universe," he recalled with a laugh.

Yet Metheny had since been known for his pluralistic view of jazz. His supple guitar riffs and fluid writing proved that jazz-pop fusion worked. "My aesthetic values are based on my own sensibilities," he mused. "If you try to let record companies or critics or radio programmers help you decide what is or isn't of value, you cross a line that you can't return from. Music is essentially the most personal thing you can do on Earth. And that has to come from inside, whether you're a listener or a musician." ∎

PAT METHENY

GEFFEN

© 1992 The David Geffen Company / Permission to reproduce limited to editorial uses in newspapers and other regularly published periodicals and television news programming.

Photo Credit: Timothy White

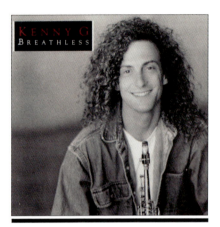

Billboard 200: *Breathless* (#2)
Billboard Hot 100: "Forever in Love" (#18); "By the Time This Night Is Over" (#25); "Sentimental" (#72)

With the phenomenal success of *Breathless*, Kenny G broke chart and sales records for an instrumentalist.

KENNY G'S breakthrough came in 1986 with the classic "Songbird"—the saxophonist's pop-jazz magic touched millions of fans around the world, launching a new era in instrumental music. Yet Kenny G had a reputation as a laid-back lightweight. Critics accused him of mesmerizing the masses with new-age noodling. Some detractors had called him "the cheese wiz." But he wasn't upset. In fact, he seemed in high spirits.

"Music is the one place in my life where I instinctively know the right way to go," Kenny G (for Gorelick) said. "So, if I get some derogatory remarks, it doesn't bother me at all because I feel confident about my music. I have lots of other doubts and fears, but fortunately that's not my professional life, so I don't get publicly criticized for it."

With his seventh album, Kenny G reached a new plateau. *Breathless* contained the instrumental hit "Forever in Love," which earned him a Grammy Award. He had worked with distinguished vocalists over the years—Aretha Franklin, Whitney Houston, Smokey Robinson, George Benson and many more—and with *Breathless*, he added Peabo Bryson to the list. Bryson starred on "By the Time This Night Is Over." "I met Peabo at last year's American Music Awards (where Bryson sang his No. 1 hit 'Beauty and the Beast' in duet with Celine Dion)," G shared. "He was very enthusiastic about wanting to record with me."

Breathless became the best-selling instrumental album in history, propelling Kenny G into the superstar universe. "When I started, there was no instrumental radio format—those 'quiet storm' easy-listening stations didn't exist. At one point the industry opened its door and let one instrumentalist in, which was me. I was lucky. But I never felt like I was fighting a battle, that there was an 'army' of instrumentalists that I wanted to join up with. I just do my thing and see what happens." ∎

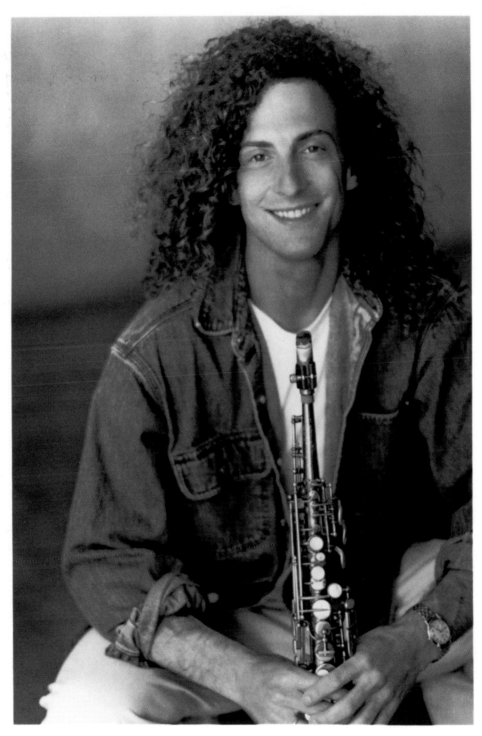

KENNY G

Dennis Turner
Turner Management Group
Central Park at Toluca Lake
3500 W. Olive Ave. Ste. 680
Burbank, CA 91505
(818) 955-6655

ARISTA

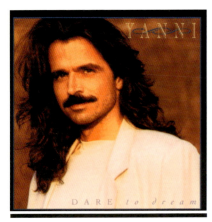

Billboard 200: *Dare to Dream* (#32)

With the lush, synthesizer-soaked sounds of his *Dare to Dream* album, composer **Yanni**'s success escalated.

CRITICS ABHORRED Yanni and his instrumental music. One called him "tofu-fingered." Another said his name was "pronounced 'Yawn-y.'" "I don't enjoy reading that, but I can't pay attention to it," the affable Greek composer and keyboardist, born Yiannis Chryssomallis, said. "It's the 'new age' title—essentially, it's a philosophical view rather than a musical one. New age is relaxed, meditative—which doesn't describe my music. There are soft and beautiful passages, but there's a lot of strength."

Yanni's passionate fans considered him profound—and sexy, with his soulful brown eyes and knockout smile. He'd been a well-kept secret to most Americans until late 1990, when he appeared with his lover, actress Linda Evans, on *The Oprah Winfrey Show*, and played the piano. Within a week, sales of his latest album, *Reflections of Passion*, tripled, giving him his first gold record.

While his romantic relationship played out in the public eye, spreading his fame further into the mainstream, Yanni recorded a Grammy-nominated album. Mixing acoustic and electric textures of his elemental piano work on tracks like the elegant "To the One Who Knows," dedicated to his father, *Dare to Dream* peaked at #2 on the new-age charts.

Oops, there was that term again. The new-age genre was associated with a sprouts-and-crystals image, but while romantic ballads had distinguished Yanni, majestic anthems were his signature. His compositions had been used extensively by television networks for a variety of sports programming.

"I want to break this 'new age' blanket around the field of contemporary instrumental music—that's why I'm bypassing the way things are done in the music industry," he said. "Instrumental music is virtually unsupported by radio in this country, so the masses don't know it exists. I always thought that if people could hear it, they would be ecstatic. I didn't have to change my music, I did it the way I always wanted to. I'm so lucky, because now that I'm coming into the public's consciousness, maybe I'll get to be one of the fortunate ones who gets to keep doing it for a while." ■

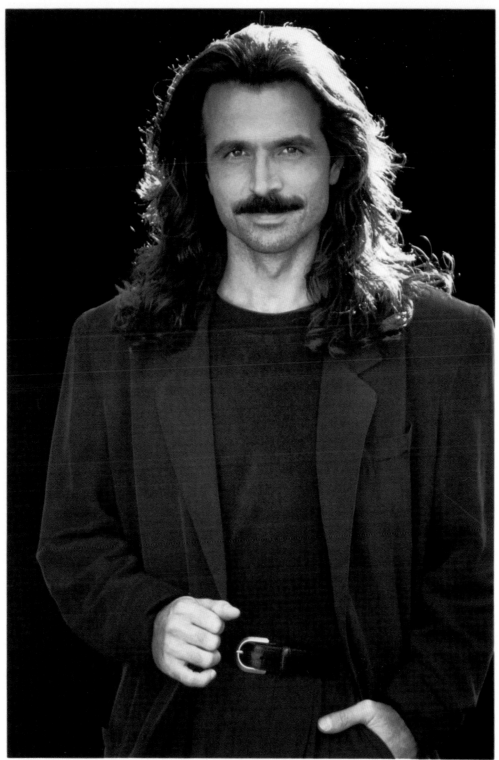

 YANNI

Private Music

Photo Credit: Lynn Goldsmith

Kitaro turned up his intensity on *Dream*, moving from Japan to his new headquarters in the Rocky Mountains.

KITARO NEVER used "new age" to describe himself or his music, preferring to use the word "spiritual," but the Grammy-nominated composer and synthesist helped pioneer the genre. In the Eighties, no other Japanese musician had cut as significantly across both musical and cultural boundaries as significantly.

Dream blended the essence of western instrumental forms with the percussive rhythms and melodies of Kitaro's native land. He had recorded the album mostly at the home studio and living quarters he had acquired in the mountains near Boulder, Colorado. "There is an old Japanese legend about a man who travels from his home to do something positive in another land. In turn, he will return to his home larger than life," Kitaro said. "Many Japanese musicians play good, but every day is the same to them—they don't understand that music is for the audience, not for themselves. My philosophy is that every day is different, you have to play more emotional for the audience. If they can enjoy it, then it's perfect. Japan is quiet—you never see standing ovations. But in the US and Europe, the reaction is more hotter. I like to feel that."

Kitaro was from a farming family in central Japan. He played electric guitar in high school, inspired by the R&B of Otis Redding. "American soul music actually started me musically—I was completely self-taught. Then I switched to keyboards and formed a progressive rock band." In 1972, Kitaro's musical vision changed during a visit to Germany, where he met Klaus Schultz of the innovative synthesizer group Tangerine Dream. At home, he became one of Japan's first synthesists, recording his first solo album in 1979.

Kitaro's international fame took a great leap forward in 1985, when he unified his work for worldwide distribution. Suddenly, the American market burst open for him. Combining a thoughtful compositional style with a refined execution, his innovative soundscapes crossed over classical, jazz and pop charts and sold in the millions. The electronic music icon had worked with an impressive range of skilled rock artists, from Grateful Dead percussionist Mickey Hart to avant-garde composer Philip Glass.

Dream paired Kitaro on three songs with Jon Anderson, the lyricist and vocalist of progressive rock giant Yes. "Our work on the project actually began at long distance—I would mail tapes or send faxes on ideas for the album from my Colorado home to where he was at the time," Kitaro said. "I don't know what happens in the future. But I want to visit and stay many places. I want to touch people." ■

KITARO

GEFFEN

Photo Credit: Dennis Keeley

© 1992 The David Geffen Company / Permission to reproduce limited to editorial uses in newspapers and other regularly published periodicals and television news programming.

The august reggae duo **Wailing Souls** entered a new era with an album created in Los Angeles, *All Over the World*.

WAILING SOULS had been stars in Jamaica stretching back to the Sixties. But basing in Los Angeles for four years, the Souls—Winston "Pipe" Matthews and Lloyd "Bread" MacDonald—had refined their roots reggae to a dense, textured dance jam. "I am a very flexible singer—I try to do all kinds of different songs like gospel, ballads, rhythm & blues," Pipe, the lead-singing half of the harmony duo, said. "I don't feel like I've reached a limit."

Growing up in the tough Trench Town district of Kingston, Pipe and Bread learned their craft on the frontline with Bob Marley, who shared their singing teacher, reggae pioneer Joe Higgs. Marley's group was the Wailing Rudeboys at first, and Pipe and Bread's group, originally a quartet, settled on the Wailing Souls. They made a name for themselves scoring such hits as "Harbor Shark" and "Backbiters" on Marley's Tuff Gong label. They also performed with Marley's Wailers on the classic "Trench Town Rock" and enjoyed a string of Jamaican hits throughout the late Seventies and Eighties ("Things and Time," "Bredda Gravalicious") before relocating to L.A.

"There was crisis in Jamaica—economic alarms, struggles," Pipe said. "Bob Marley set a certain standard of reggae music, and it was failing. Everybody was singing on the same track, every year. No creativity was happening, and I got stagnant. When I came to California, I looked around at all the different kinds of music happening. I got the idea about putting variations in our music like jazz and pop. People used to say they could not understand what the song was saying—in Jamaica, we speak a different patois. I said I was going to do straight English. Traditionally, reggae does not break on the radio in America, and I wanted to reach the majority of the people. I figure if I'm doing music, I should please everybody."

The genre-busting *All Over the World* earned Wailing Souls a Grammy nomination (Best Reggae Album), and the single "Shark Attack" enjoyed a surge of radio airplay. "We deal with keeping people's hopes up in our music, but in this world you have people who are taking and not putting anything back in, who are trying to grab and gain," Pipe explained. "We have a term in Jamaica—we call them 'sharks.' I got the idea to take a look and see what's really happening out there—there's a shark attack right now." ∎

Wailing Souls

With "Treaty," Yothu Yindi became the first Aboriginal band to earn an Australian hit and American approbation.

FOR MORE than two centuries, white Australia committed cultural genocide of the continent's indigenous people. But an important transition took shape in the Eighties—a generation of aboriginals (Yolngu) had escalated the fight for social equality and land rights. And Yothu Yindi, a popular agit-rock band from the remote coastal communities, was making a mark.

Mandawuy Yunupingu was the band's singer, founder and main songwriter. Yunupingu wrote his lyrics like a teacher—he had a degree in education (the first Yolngu to obtain one) and was headmaster of a school. He bonded the stories, language and imagery of his people and the universal language of pop music to press home his social agenda. "I grew up in a seminomadic life," he explained. "When the white man came, missionaries exposed me to gospel music—that's where contemporary music started for me. Then I followed country and western—it talked about the bush, the stockmen, the kangaroos."

Yunupingu fell under the spell of the Beatles—"It was a revolution for us, it changed everyone around the world, even in northeast Australia"—and a decade later, he considered the possibilities in Bob Marley's stimulating blend of music, politics and racial pride. "In my spiritual and academic acceptance, I was inspired to form Yothu Yindi, thinking about the skills and ideas I learned through studying and putting it to music."

Yothu Yindi (the name translated to "child and mother") began typical performances with three dancers clad in feathers and loincloths, and faces marked in the ocher-based makeup of their tribe. The music integrated contemporary western rock with traditional native instruments like *bilma* (clapsticks) and the ethereal, droning *yidaki* (the didgeridoo, nearly two meters long and fashioned from a termite-hollowed tree trunk that was played by breathing into one end).

For *Tribal Voice*, the band's first worldwide release, Yunupingu asked permission of clan elders to use the music of their ancient culture in a pop and rock setting. "Treaty," a call for a pact between Aboriginal and white Australia, was the first Top 40 hit in Australia for an Aboriginal act. In America, "Treaty" charted on *Billboard*'s Hot Dance Club Play singles chart, and *Tribal Voice* peaked at #3 on the Top World Music Albums chart. Yunupingu's motivation may have begun Down Under with the struggle between aborigines and colonizers, but his discourse was global.

"America is the land of opportunity," he said, "and the opportunity is there for us to crack the market." ■

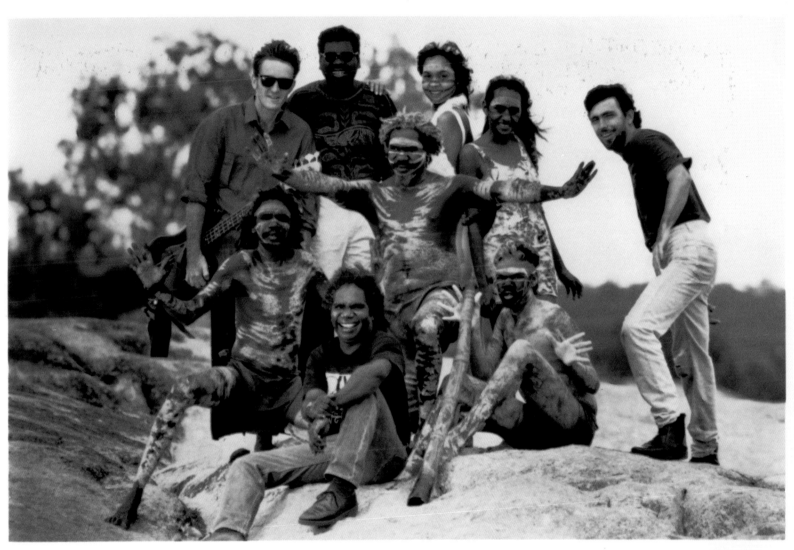

Ringo Starr resuscitated his solo career with *Time Takes Time*, his first studio album in more than a decade.

RINGO STARR had always lacked pretention, and *Time Takes Time* was the latest example of his comeback from years spent in what he described as "an alcohol- and drug-supported haze," a seemingly mandatory problem for all aging rock stars. In 1989, the former Beatle hit the concert trail with his All-Starr Band, expecting to get recording offers after the tour. But no company wanted to sign him, which he attributed to his bout with the bottle. Both he and his wife, actress Barbara Bach, had detoxed in 1988.

Time Takes Time found Starr back on the beat. For the project, he utilized the services of four top producers (Don Was, Jeff Lynne, Phil Ramone and Peter Asher) and compositions by everyone from Diane Warren to the Posies to Jellyfish. Musical guests on the record included veterans Tom Petty and Brian Wilson and a phalanx of notable West Coast session men. Yet *Time Takes Time* had a highly consistent sound, and Starr put across the modest and reflective material with his charming deadpan drawl.

"The album sounds cohesive now, but it wasn't very stable at the start," he admitted. "The strain of recording again was pretty terrifying for me. I lasted a week and had to go on holiday for another week. Hundreds of songs were submitted to the record company, and I got it down to 10 tracks that said what I liked—and they were in my key."

In "Weight of the World," Starr sang, "It all comes down to who you crucify/You either kiss the future or the past goodbye." He also recorded "Don't Go Where the Road Don't Go," one of three originals he co-wrote, a spunky rocker that conveyed his avuncular message about alcoholism and his recovery: "I don't remember many yesterdays, I left a lot of things undone/Now I'm back and I'm here to say, I'm looking after number one." "I'm not very good at preaching, but I wrote that song to put my situation in place," he mused.

The critically acclaimed *Time Takes Time* was easily Starr's most engaging solo collection since *Ringo*, his 1973 landmark. But he feared it faced an uphill battle, and the work met with public indifference. "I'm not a rapper, I don't play heavy metal and I'm not a teenager," Starr, 52, said. "But I'm back on the music trail. Because of my new way of living, I'm doing what I'm supposed to do—making records, performing, entertaining. Now there are many avenues for me to explore my relationships with my talented friends. I've been very lucky in this lifetime." ∎

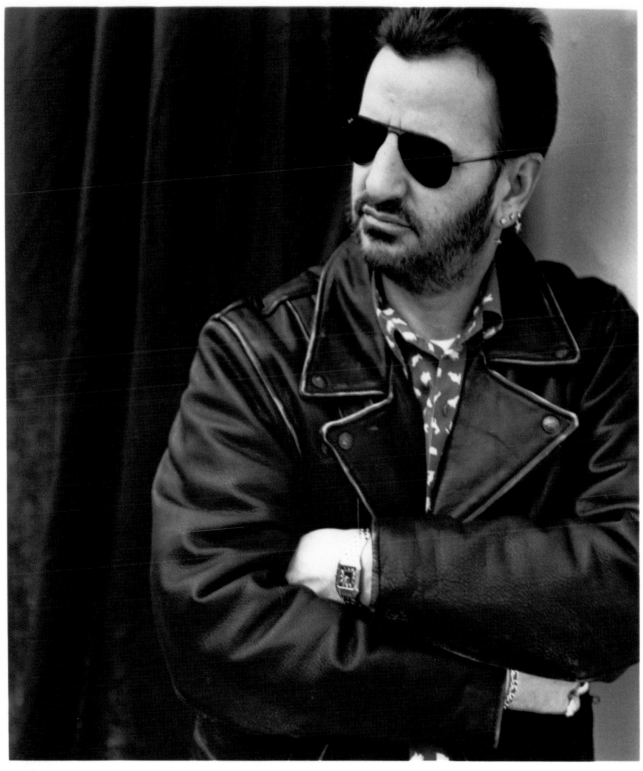

RINGO STARR

Private Music

Photo Credit: **Cantanzaro & Mahdessian**

Billboard 200: *The Christmas Album* (#8)

Remaining a major money-making live act, Neil Diamond promoted his first holiday record, *The Christmas Album*.

WHEN HE toured, Neil Diamond was regularly cited as the No. 1 box office attraction in America. But in his early days, before he started making his reputation, the charismatic live performer described himself as "nervous and uptight" onstage. "Basically, I was a songwriter—my first years of playing live were in clubs," the venerable star noted. "I didn't find myself as a performer until I wrote 'Brother Love's Traveling Salvation Show' in 1968. It was a great closing number, inspired by my visit to a backwoods revival in Memphis. It combined a gospel theme with a pop format, and it forced me to come out of myself."

The Greatest Hits 1966-1992, a 37-track set, took a long look back at Diamond's first singles—three-chord pop-rock gems such as "Solitary Man," "Cherry, Cherry," "Thank the Lord for the Night Time," "Kentucky Woman" and "I've Got the Feelin' (Oh No No)." The double-CD release formed a fairly comprehensive overview of his career, but many of his early standards—"Sweet Caroline, "Cracklin' Rosie," "Soolaimon," "I Am…I Said" and others—were newly recorded live on tour because his former label refused to license the master recordings. Nevertheless, the anthology eventually earned triple-platinum status.

Diamond then released *The Christmas Album,* his first-ever collection of holiday classics like "Silent Night," "White Christmas" and "Little Drummer Boy." He also included John Lennon's "Happy Christmas (War Is Over)" and an original song, "You Make It Feel Like Christmas." He taped an HBO special built around performances of the songs, and the album became a best-selling seasonal collection.

So how did a nice Jewish boy from Brooklyn come to record a Christmas record? "First of all, Christmas music is some of the most glorious music ever written," Diamond stated. "I fell in love with it during my high school days—every December we had a Christmas chorale. As a singer, I've always wanted to do a Christmas album. So I called around, checked with my mother—'Ma, I'm doing a Christmas album, a lot of holy songs on it.' She said, 'Christ was a nice Jewish boy, too—just do the best you can.'" ■

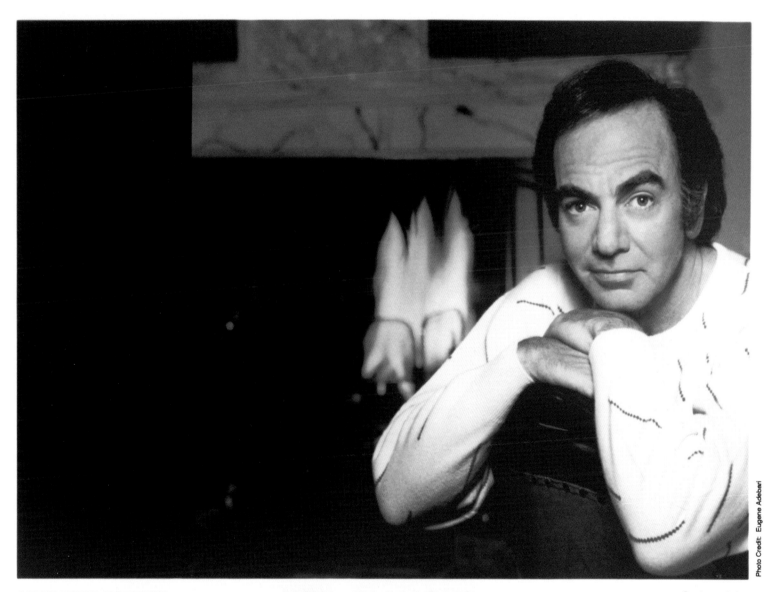

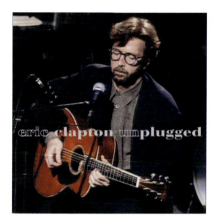

For his best-selling *Unplugged* album, **Eric Clapton** performed live in front of a small audience in England and included a new acoustic version of "Layla."

Billboard 200: *Unplugged* (No. 1)
Billboard Hot 100: "Layla" (#12)

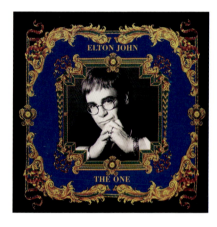

Reaching double-platinum sales with *The One*, a clean and sober **Elton John** had his biggest hit in 17 years and continued his career renaissance.

Billboard 200: *The One* (#8)
Billboard Hot 100: "The One" (#9);
"The Last Song" (#23); "Simple Life" (#30)

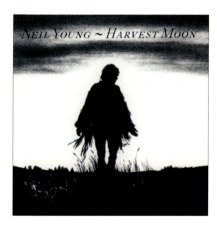

Via *Harvest Moon* and the graceful title track, the idiosyncratic **Neil Young** abruptly returned to the spirit and style of his landmark album, 1972's *Harvest*.

Billboard 200: *Harvest Moon* (#16)

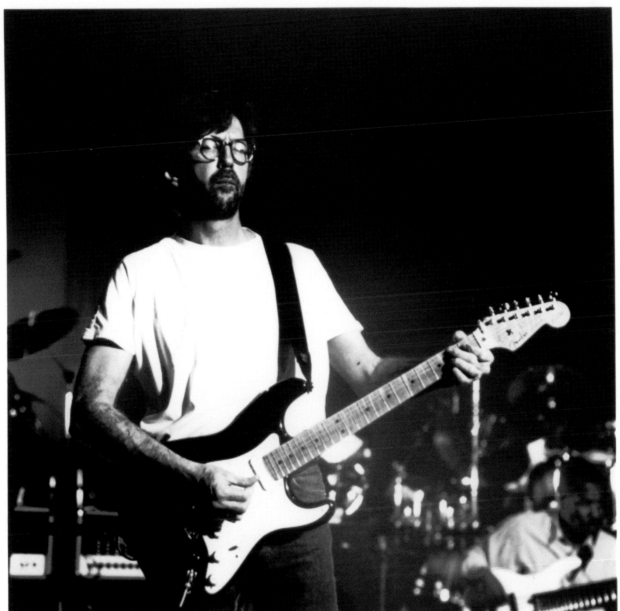

reprise

© 1992 Reprise Records/Permission to reproduce limited to editorial uses in newspapers and other regularly published periodicals and television news programming

Photo Credit: Terry O'Neill

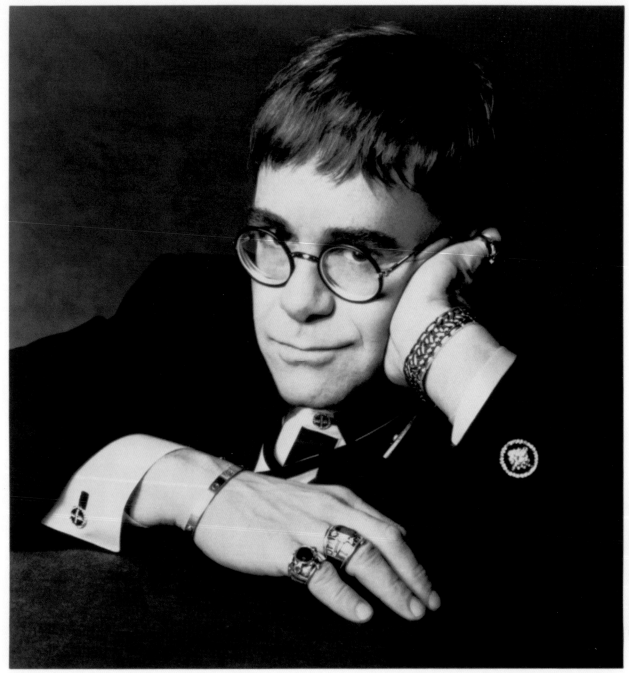

ELTON JOHN

MCA 6/92

Photo Credit: Patrick Demarchelier

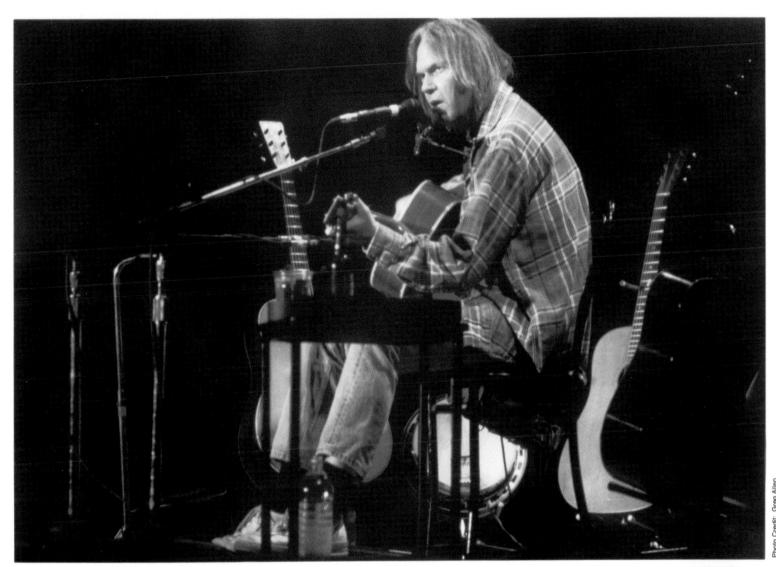

Neil Young

© 1992 Reprise Records/Permission to reproduce limited to editorial uses in newspapers and other regularly published periodicals and television news programming

ON RECORD | 1992 | [WHITNEY HOUSTON | CELINE DION | MADONNA]

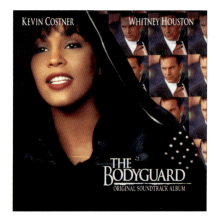

Superstar **Whitney Houston** recorded her chart-topping rendition of Dolly Parton's "I Will Always Love You" for *The Bodyguard*, her motion-picture debut.

Billboard 200: *The Bodyguard* (No. 1)
Billboard Hot 100: "I Will Always Love You" (No. 1);
"I'm Every Woman" (#4); "I Have Nothing" (#4); "Run to You" (#31)

The arrival of "Beauty and the Beast," a Grammy and Academy Award-winning duet with Peabo Bryson, propelled Canadian singer **Celine Dion** to fame.

Billboard 200: *Celine Dion* (#34)
Billboard Hot 100: "Beauty and the Beast" (#9);
"If You Asked Me To" (#4); "Nothing Broken but My Heart" (#29);
"Love Can Move Mountains" (#36)

The sultry *Erotica* didn't perform as well as **Madonna**'s previous albums, eclipsed by the negative reception heaved on her explicit coffee-table book, *Sex*.

Billboard 200: *Erotica* (#2)
Billboard Hot 100: "Erotica" (#3);
"Deeper and Deeper" (#7); "Bad Girl" (#36); "Rain" (#14)

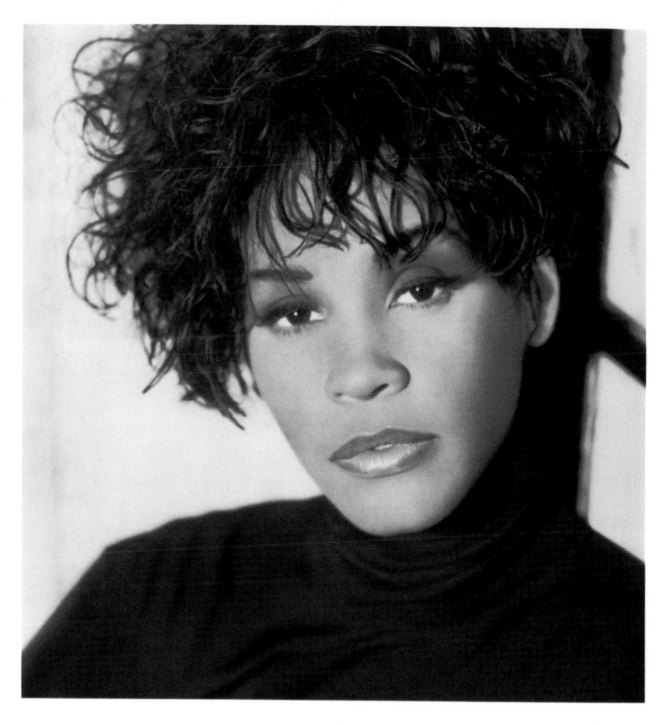

WHITNEY HOUSTON

Management
Nippy, Inc.
Grant Center
2160 North Central Road
Fort Lee, NJ 07024

celine dion

Photo Credit: Victoria Pearson

epic™
9203

©1992 Sony Music Permission to reproduce this photography is limited to editorial uses in regular issues of newspapers and other regularly published periodicals and television news programming.

Photo Credit: Siung Fat Tjia

© 1992 Warner Bros. Records/Permission to reproduce limited to editorial uses in newspapers and other regularly published periodicals and television news programming.

ON RECORD | 1992 | [SADE | ANNIE LENNOX | SINÉAD O'CONNOR]

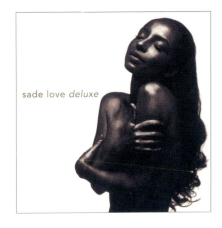

Sade's *Love Deluxe* won big critical and commercial kudos, and "No Ordinary Love" was featured prominently in the Robert Redford film *Indecent Proposal*.

Billboard 200: *Love Deluxe* (#3)
Billboard Hot 100: "No Ordinary Love" (#28); "Kiss of Life" (#78)

After the cessation of Eurythmics, **Annie Lennox** embarked on a solo career with the soul-stirring *Diva* and the hits "Why" and "Walking on Broken Glass."

Billboard 200: *Diva* (#23)
Billboard Hot 100: "Why" (#34);
"Walking on Broken Glass" (#14); "Little Bird" (#49)

"Success Has Made a Failure of Our Home," a cover of Loretta Lynn's "Success," anchored **Sinéad O'Connor**'s standards album *Am I Not Your Girl?*

Billboard 200: *Am I Not Your Girl?* (#27)

SADE

 epic

9208

Management:
Simon Fuller
19 Management Limited
Unit 32, Ransomes Dock
35-37 Parkgate Road
London, England
SW11 4NP

011 44 71 228-4000

Annie Lennox

ARISTA BMG

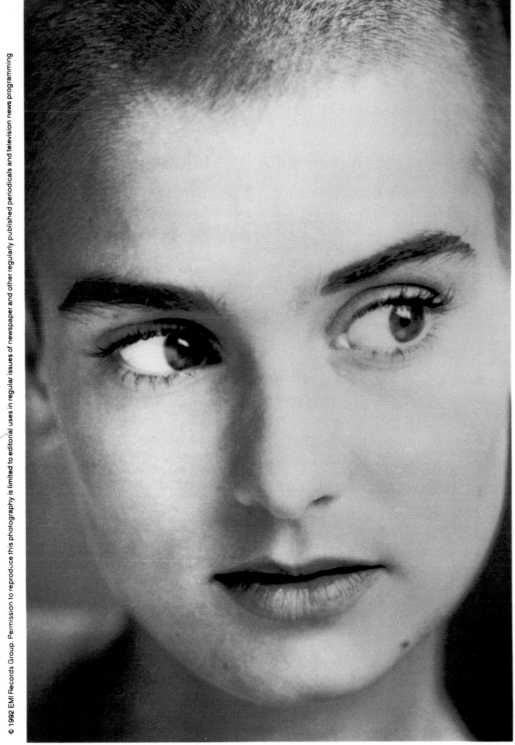

Sinéad O'Connor

EMI Records Group

ON RECORD | 1992 | [PRINCE & THE NEW POWER GENERATION | R.E.M. | DAN BAIRD]

Prince & the New Power Generation issued an album bearing an unpronounceable, cryptic glyph on the cover, which later was referred to as Love Symbol.

Billboard 200: *Love Symbol* (#5)
Billboard Hot 100: "Sexy MF" (#66); "My Name Is Prince" (#36); "7" (#7); "The Morning Papers" (#44)

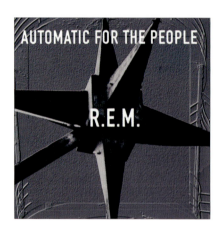

Conveying the gist of mortality, **R.E.M.**'s solemn *Automatic for the People* brought the Top 40 hits "Drive," "Man on the Moon" and "Everybody Hurts."

Billboard 200: *Automatic for the People* (#2)
Billboard Hot 100: "Drive" (#28); "Man on the Moon" (#30); "Everybody Hurts" (#28)

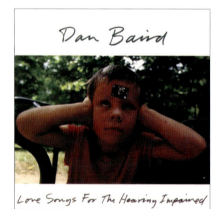

Former Georgia Satellites frontman **Dan Baird** began a solo career and inspired the proper use of punctuation with the rowdy radio hit "I Love You Period."

Billboard Hot 100: "I Love You Period" (#26)

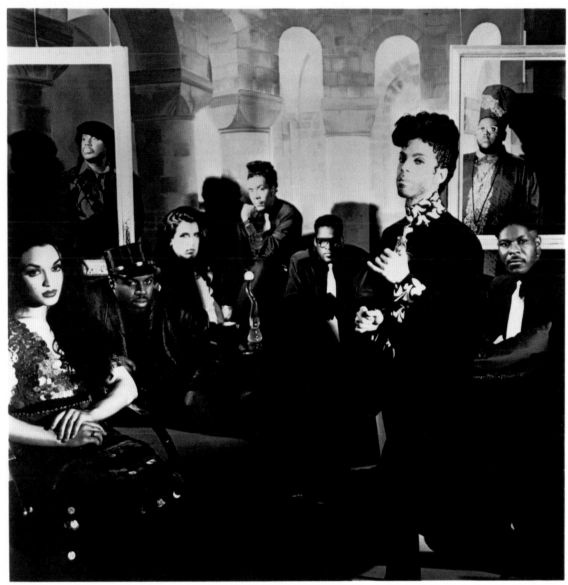

prince and the new power generation

Paisley Park

Photo Credit: Jeff Katz

© 1992 Warner Bros. Records/Permission to reproduce limited to editorial uses in newspapers and other regularly published periodicals and television news programming

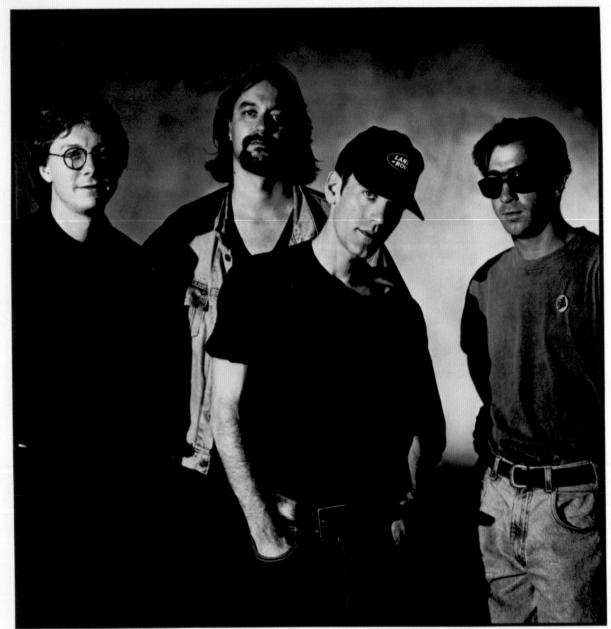

Mike Mills Peter Buck Michael Stipe Bill Berry

R.E.M.

© 1992 Warner Bros. Records/Permission to reproduce limited to editorial uses in newspapers and other regularly published periodicals and television news programming.

Photo Credit: Anton Corbijn

Dan Baird

Photo by: Michael Wilson

© 1992 Def American Recordings/Permission to reproduce limited to editorial use in newspapers and other regularly published periodicals and television news programming.

ON RECORD | **1992** | **[KEITH RICHARDS | ROGER WATERS | BAD COMPANY]**

Joined by the backing band he dubbed the X-Pensive Winos, **Keith Richards** brought forth his second solo album and the driving track "Wicked as It Seems."

Billboard 200: *Main Offender* (#99)

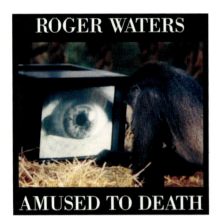

With the touted *Amused to Death*, **Roger Waters**, a founding member of Pink Floyd, furnished yet another example of album-as-cinematic-brainfood.

Billboard 200: *Amused to Death* (#21)

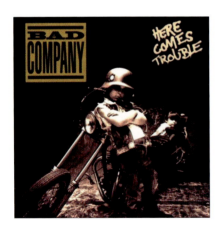

Here Comes Trouble, **Bad Company**'s final album with vocalist Brian Howe, earned the British classic-rock act another Top 40 hit with "How About That."

Billboard 200: *Here Comes Trouble* (#40)
Billboard Hot 100: "How About That" (#38);
"This Could Be the One" (#87)

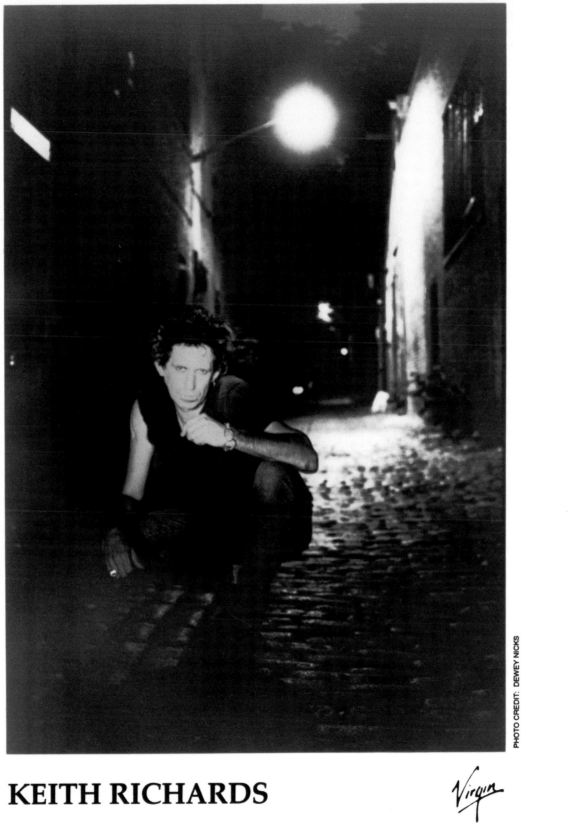

KEITH RICHARDS

PHOTO CREDIT: DEWEY NICKS

Virgin

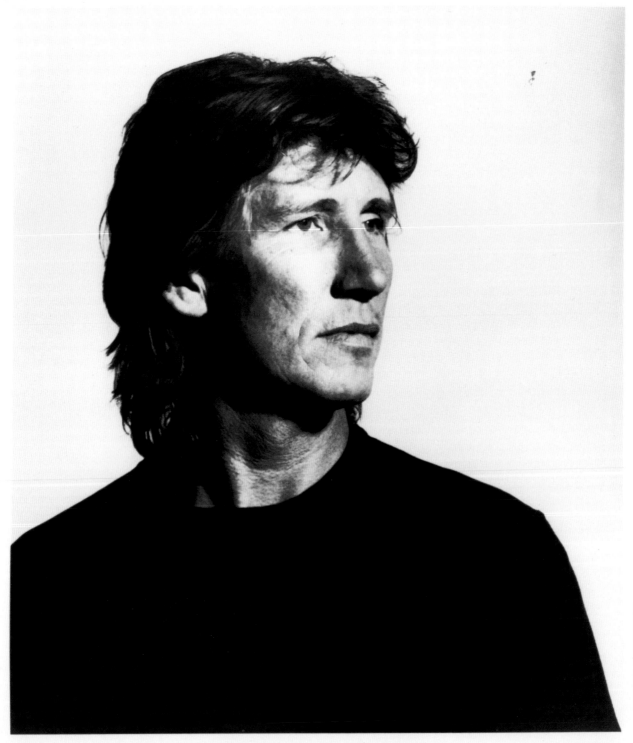

©1992 Sony Music Permission to reproduce this photography is limited to editorial uses in regular issues of newspapers and other regularly published periodicals and television news programming.

ROGER WATERS

PHOTOGRAPHY: RICHARD HAUGHTON

COLUMBIA
9207

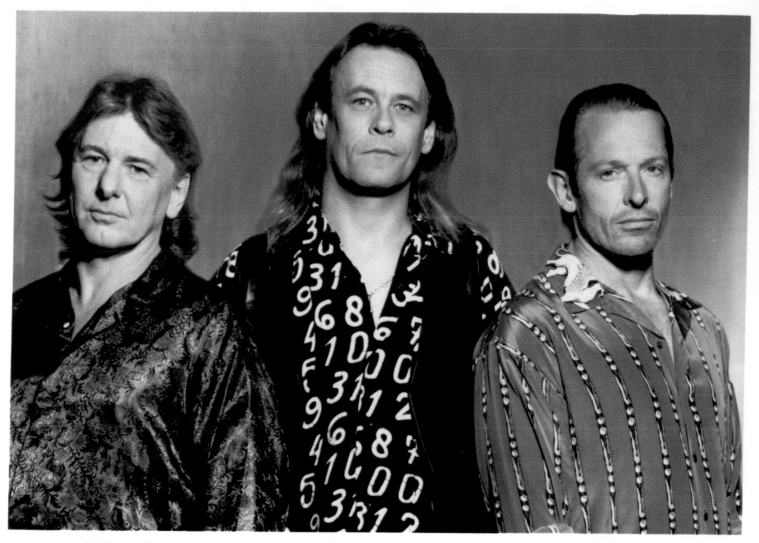

MICK RALPHS BRIAN HOWE SIMON KIRKE

After leaving N.W.A. at the peak of the group's celebrity, **Dr. Dre** changed the world of hip-hop, reaping accolades for his gifted production on *The Chronic*.

Billboard 200: *The Chronic* (#3)
Billboard Hot 100: "Nuthin' but a 'G' Thang" (#2); "Dre Day" (#8); "Let Me Ride" (#34)

Newly married to Whitney Houston, new jack swing pioneer **Bobby Brown** prepared *Bobby*, his long-awaited follow-up to the trailblazing *Don't Be Cruel*.

Billboard 200: *Bobby* (#2)
Billboard Hot 100: "Humpin' Around" (#3); "Good Enough" (#7); "Get Away" (#14); "That's the Way Love Is" (#57)

X-tra Naked earned **Shabba Ranks**' his second straight Grammy for Best Reggae Album and scored with "Slow and Sexy," a hit duet with Johnny Gill.

Billboard Hot 100: "Slow and Sexy" (#33)

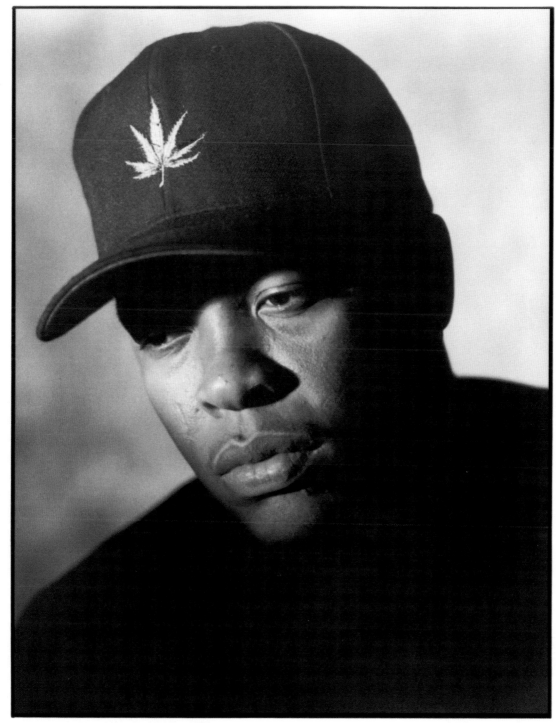

DR. DRE

© 1992 Interscope Records, Inc. Permission to reproduce limited to editorial uses in newspapers and other regularly published periodicals and television news programming. All other rights reserved.

Photo Credit: Daniel Jordan

BOBBY BROWN

PHOTO CREDIT: TODD GRAY

7/92

MCA.

ON RECORD | **1992** | [MARY J. BLIGE | TLC | EN VOGUE]

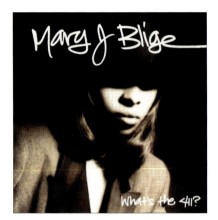

Her debut album *What's the 411?*, a model of jeep-beats and soulful, jazzy vocals, earned **Mary J. Blige** household-name status with the hip-hop nation.

Billboard 200: *What's the 411?* (#6)
Billboard Hot 100: "You Remind Me" (#29); "Real Love" (#7); "Reminisce" (#57); "Sweet Thing" (#28); "Love No Limit" (#44)

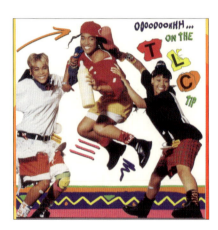

TLC rode the "new jill swing" style of *Oooooooohhh...On the TLC Tip* to fame, notching two platinum singles, "Ain't 2 Proud 2 Beg" and "Baby-Baby-Baby."

Billboard 200: *Oooooooohhh...On the TLC Tip* (#14)
Billboard Hot 100: "Ain't 2 Proud 2 Beg" (#6); "Baby-Baby-Baby" (#2); "What About Your Friends" (#7); "Hat 2 da Back" (#30)

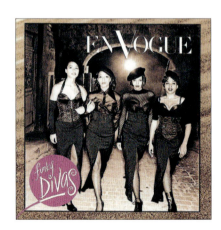

The sassy funk of "My Lovin' (You're Never Gonna Get It)" and the soulful ballad "Giving Him Something He Can Feel" spurred **En Vogue**'s *Funky Divas*.

Billboard 200: *Funky Divas* (#8)
Billboard Hot 100: "My Lovin' (You're Never Gonna Get It)" (#2); "Giving Him Something He Can Feel" (#6); "Free Your Mind" (#8); "Give It Up, Turn It Loose" (#15); "Love Don't Love You" (#36)

Mary J Blige MCA.

Photo Credit: Michael Benabib

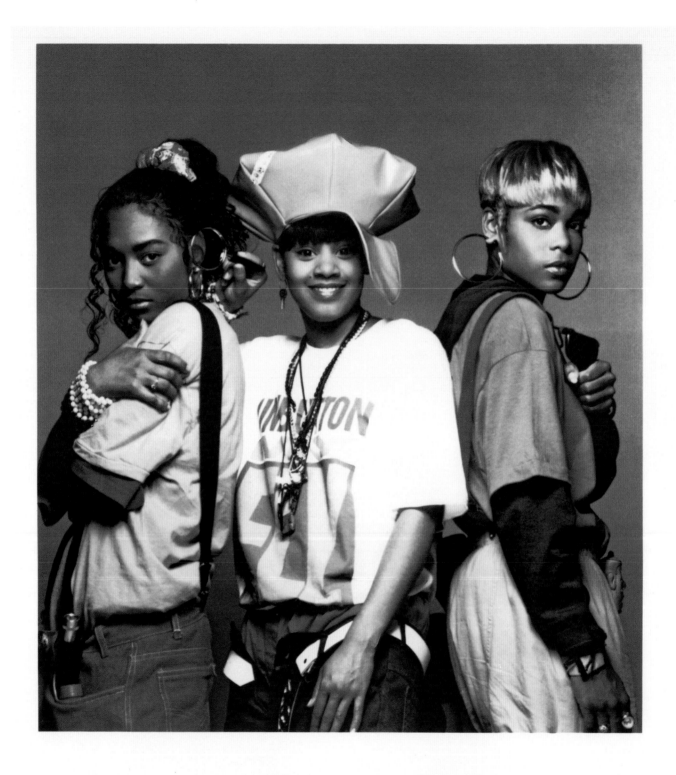

TLC MANAGEMENT
P.T. ENTERTAINMENT
3340 PEACHTREE ROAD, N.E.
SUITE 420
ATLANTA, GA 30326

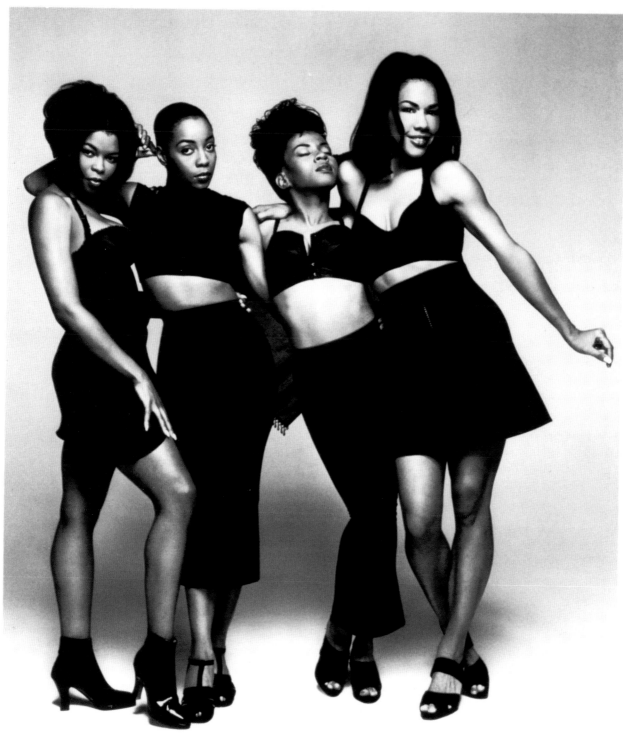

DAWN ROBINSON TERRY ELLIS MAXINE JONES CINDY HERRON

ON RECORD | 1992 | [SWV | JADE | EXPOSÉ]

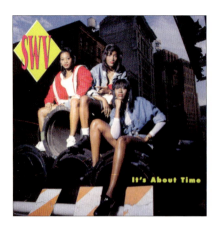

It's About Time, a debut by the trio **SWV** (Sisters with Voices), electrified the R&B world with the smash hits "Weak" and "Right Here (Human Nature)."

Billboard 200: *It's About Time* (#8)
Billboard Hot 100: "Right Here" (#92); "I'm So into You" (#6); "Weak" (No. 1); "Right Here (Human Nature)"/"Downtown" (#2); "You're Always on My Mind" (#54)

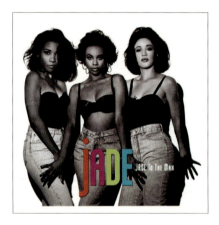

Jade delivered "Don't Walk Away," one of the year's biggest R&B singles, and the three sultry females traveled the world doing concerts and TV shows.

Billboard 200: *Jade to the Max* (#56)
Billboard Hot 100: "I Wanna Love You" (#16); "Don't Walk Away" (#4); "One Woman" (#22); "Looking for Mr. Do Right" (#69)

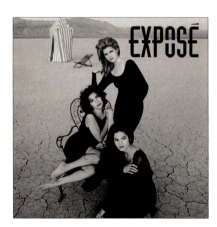

Less of a dance-pop album, **Exposé**'s third effort proved the vocal trio's mettle as song stylists on the ballad "I'll Never Get Over You Getting Over Me."

Billboard 200: *Exposé*
Billboard Hot 100: "I Wish the Phone Would Ring" (#28); "I'll Never Get Over You Getting Over Me" (#8); "As Long as I Can Dream" (#55); "In Walked Love" (#84)

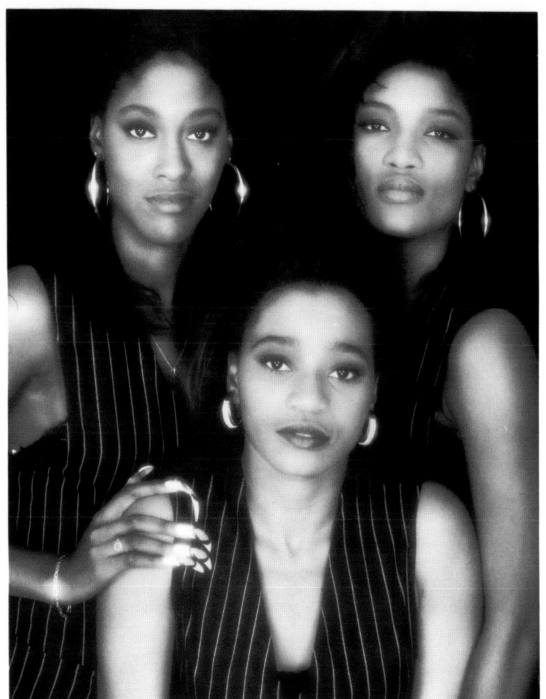

Photo Credit: Tony Cutajar

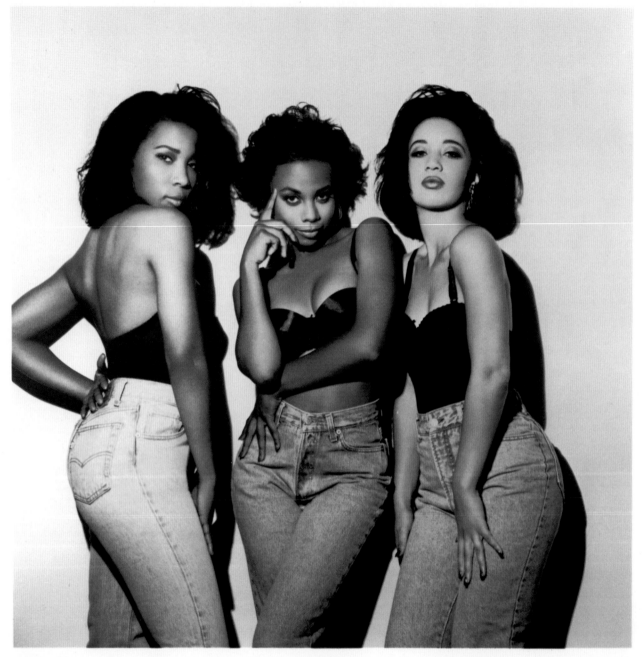

Di Reed Joi Marshall Tonya Kelly

 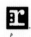

© 1992 Reprise Records/Permission to reproduce limited to editorial uses in newspapers and other regularly published periodicals and television news programming.

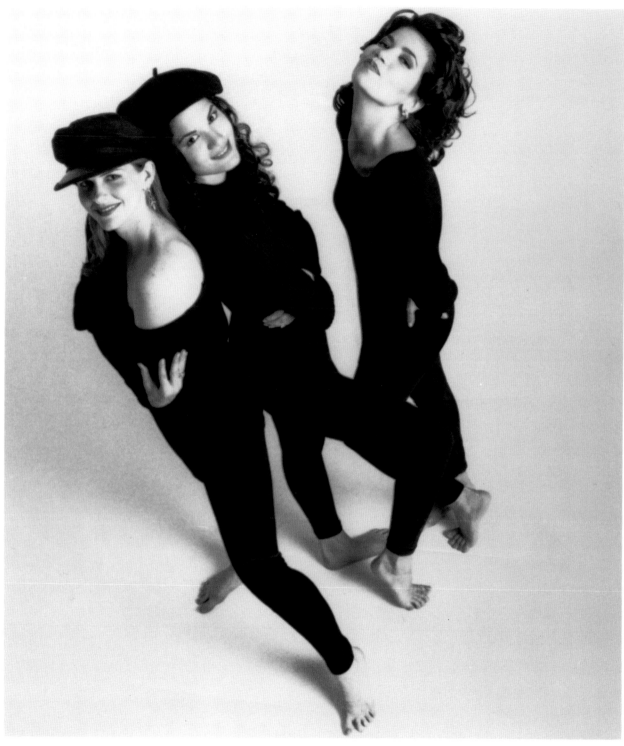

Following up a best-selling debut, **Wilson Phillips**' somber *Shadows and Light* was seen as a commercial misstep, and the trio dispersed by year's end.

Billboard 200: *Shadows and Light* (#4)
Billboard Hot 100: "You Won't See Me Cry" (#20); "Give It Up" (#30)

Shakespears Sister, a partnership of Siobhan Fahey and Marcella Detroit, delivered the gorgeous, melodramatic "Stay" and found global chart success.

Billboard 200: *Hormonally Yours* (#56)
Billboard Hot 100: "Stay" (#4); "I Don't Care" (#55)

The British pop group **Swing Out Sister** collected a No. 1 adult contemporary hit via a joyous cover of the 1968 Barbara Acklin song "Am I the Same Girl?"

Billboard 200: *Get in Touch with Yourself* (#113)
Billboard Hot 100: "Am I the Same Girl?" (#45)

wilson phillips

EMI Records Group

Photo: Herb Ritts 6/92

SHAKESPEARS SISTER

ANDY CONNELL　　CORINNE DREWERY

PHOTO CREDIT: KATE GARNER

swing out sister

ON RECORD | 1992 | [CHARLES & EDDIE | SILK | SHAI]

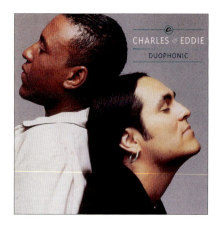

Pop-soul duo **Charles & Eddie**'s debut single "Would I Lie to You?" topped the charts in 16 countries, including France, England, Germany and South Africa.

Keith Sweat cut a deal to produce and write the bulk of **Silk**'s debut, *Lose Control*, and the sexually suggestive slow jam "Freak Me" reached No. 1.

Billboard 200: *Lose Control* (#7)
Billboard Hot 100: "Happy Days" (#86);
"Freak Me" (No. 1); "Lose Control"/"Girl U for Me" (#26)

Seemingly out of nowhere, the R&B vocal quartet **Shai** rose to the top of the charts, impressing with the gorgeous harmonies of "If I Ever Fall in Love."

Billboard 200: *...If I Ever Fall in Love* (#6)
Billboard Hot 100: "If I Ever Fall in Love" (#2);
"Comforter" (#10); "Baby I'm Yours" (#10); "Yours" (#63)

Charles Pettigrew Eddie Chacon
(standing)

CHARLES & EDDIE

Photo: Moshe Brakha / 1992

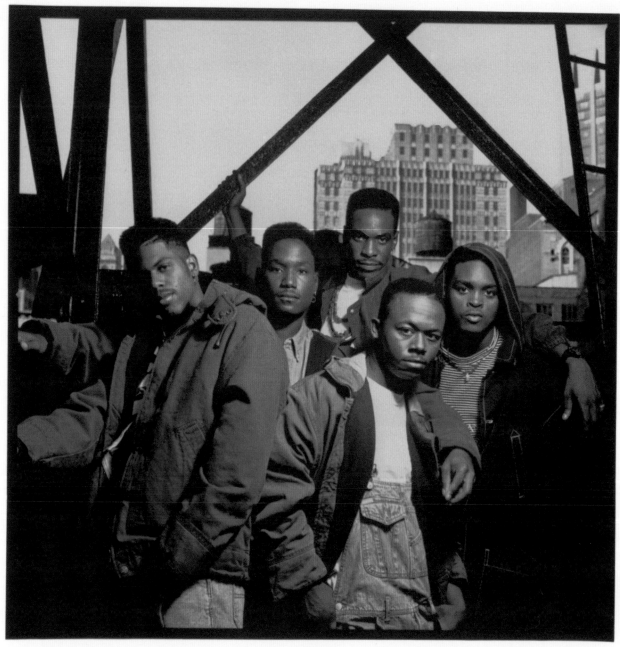

JONATHAN RASBORO JIMMY GATES, JR. TIMOTHY CAMERON GARY JENKINS (LIL G) GARY GLENN (BIG G)

PHOTO CREDIT: STEVE LEWIS

Elektra Entertainment

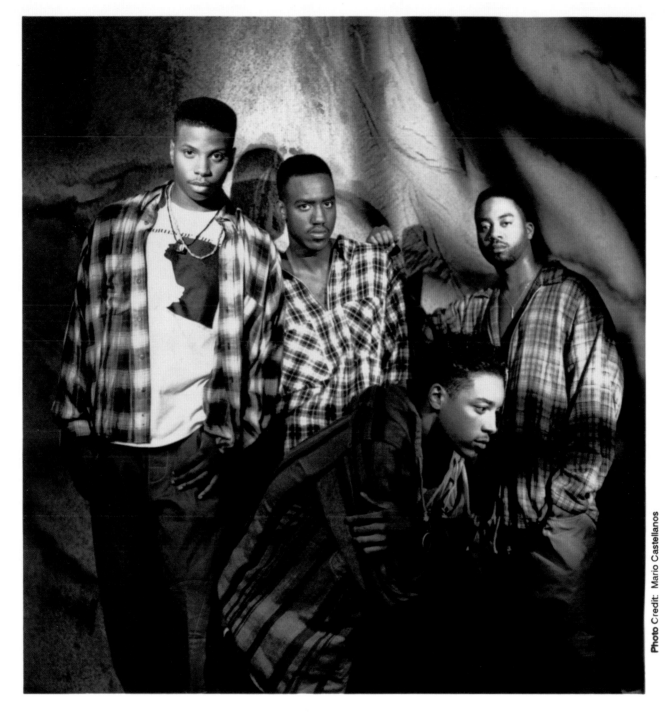

DARNELL VAN RENSALIER CARL "GROOVE" MARTIN GARFIELD BRIGHT MARC GAY

12/92

ON RECORD | 1992 | [DAS EFX | THE PHARCYDE | PETE ROCK & CL SMOOTH]

Das EFX made its mark with the debut album *Dead Serious* and the No. 1 rap track "They Want EFX," which stressed the duo's diggity-dope rhyming flow.

Billboard 200: *Dead Serious* (#16)
Billboard Hot 100: "They Want EFX" (#25):

The Pharcyde evinced a romantic side on the crossover hit "Passin' Me By," adding to the freaky humor of the South Central L.A. crew's debut album.

Billboard 200: *Bizarre Ride II the Pharcyde* (#75)
Billboard Hot 100: "Passin' Me By" (#55)

The hip-hop duo **Pete Rock & CL Smooth** emerged with an elegiac track in memory of a fallen childhood friend, "They Reminisce Over You (T.R.O.Y.)."

Billboard 200: *Mecca and the Soul Brother* (#43)
Billboard Hot 100: "They Reminisce Over You (T.R.O.Y.)" (#58)

BOOKS KRAZY DRAYZ

Photo © ROBERT MANELLA

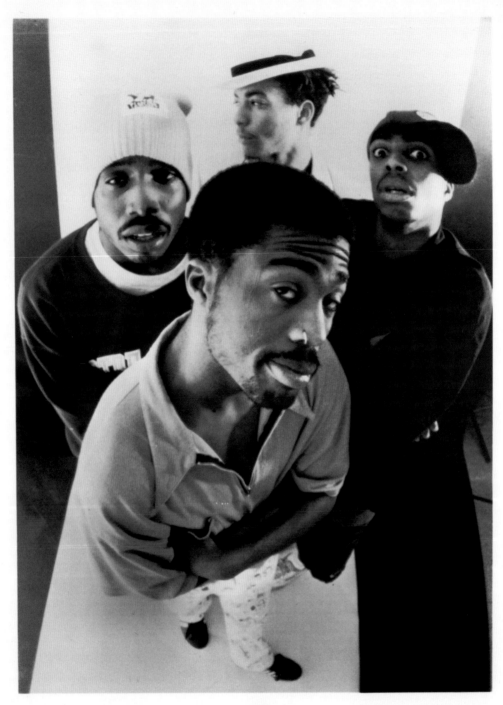

IMANI TRE FAT LIP
ROMYE

The Pharcyde

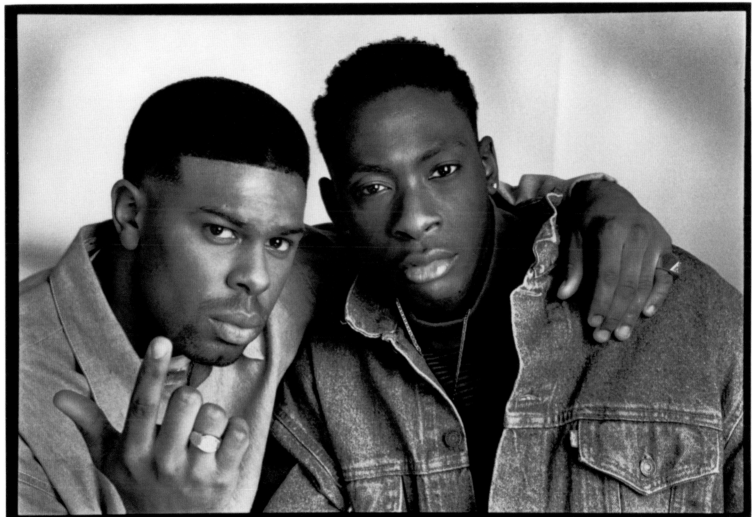

CL SMOOTH PETE ROCK

Elektra Entertainment

PHOTO CREDIT: DANNY CLINCH

ON RECORD | 1992 | [GRAND PUBA | POSITIVE K | MC SERCH]

After leaving Brand Nubian, Grand Puba debuted as a solo artist with *Reel to Reel*, which spawned the No. 1 rap single "360° (What Goes Around)."

Billboard 200: *Reel to Reel* (#28)
Billboard Hot 100: "360° (What Goes Around)" (#68)

From working in various capacities with seminal rap architects, Positive K became an active partaker in the music with the chart-topping "I Got a Man."

Billboard 200: *The Skills Dat Pay da Bills* (#168)
Billboard Hot 100: "I Got a Man" (#14)

After three releases with 3rd Bass, MC Serch worked solo on *Return of the Product* and scaled the rap charts with the slammin' track "Here It Comes."

Billboard 200: *Return of the Product* (#103)

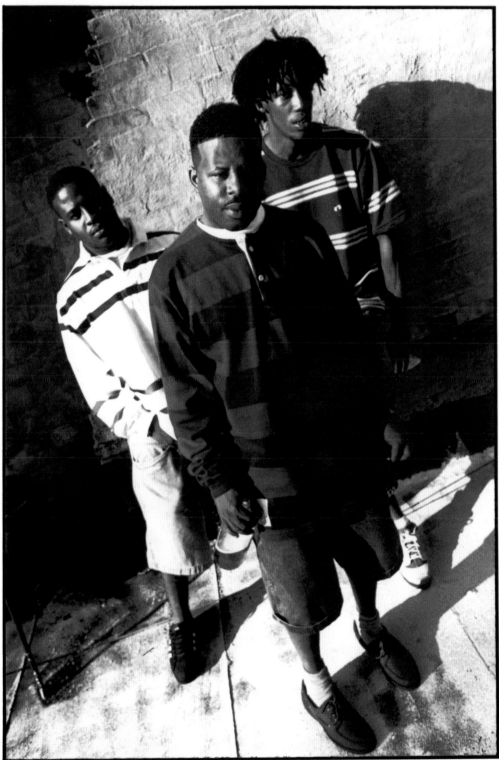

FRONT: GRAND PUBA; BACK (L TO R): STUD DUGEE, ALAMO

GRAND PUBA

PHOTO CREDIT: MICHAEL BENABIB

Elektra Entertainment

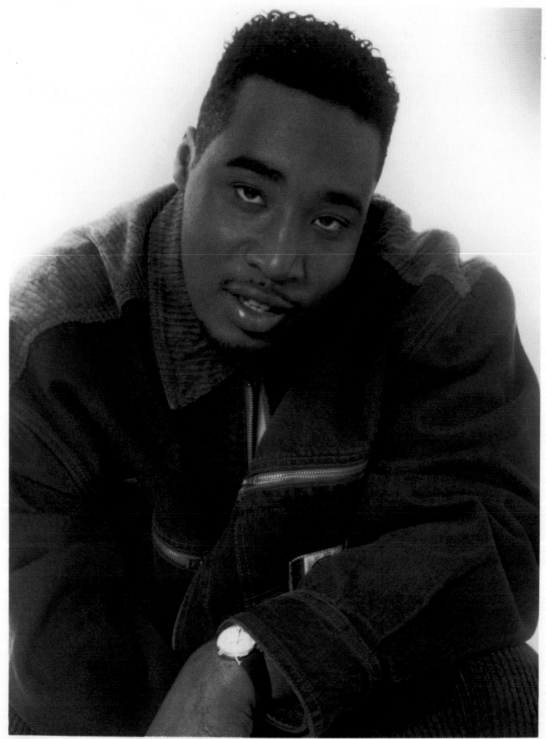

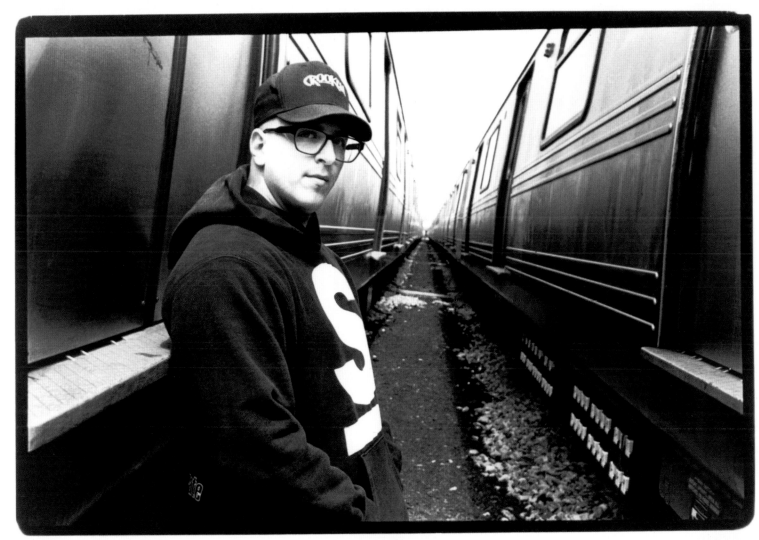

MC SERCH

Ensconced as veterans of the hip-hop industry, respected rappers Eric B. & Hakim broke up after their masterly fourth album, *Don't Sweat the Technique*.

Billboard 200: Don't Sweat the Technique (#22)
Billboard Hot 100: "Know the Ledge" (#96)

With "Crossover," EPMD opened a campaign against rappers who got large making cessions to mainstream tastes—and had its highest-charting pop hit.

Billboard 200: Business Never Personal (#14)
Billboard Hot 100: "Crossover" (#42)

Redman arrived with a debut album and the single "Blow Your Mind," focusing on funky work from mentors on the Hit Squad, EPMD's production team.

Billboard 200: Whut? Thee Album (#49)

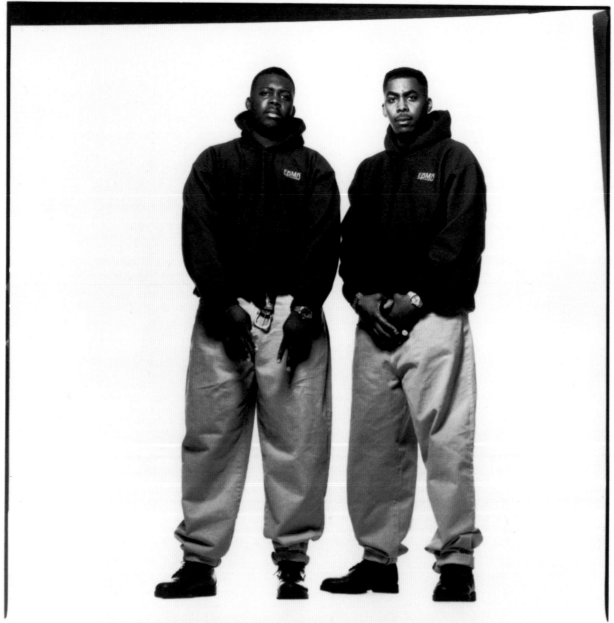

ERICK SERMON (left) and PARRISH SMITH (right).

 SHUMA MANAGEMENT EPMD

CHAOS
9206

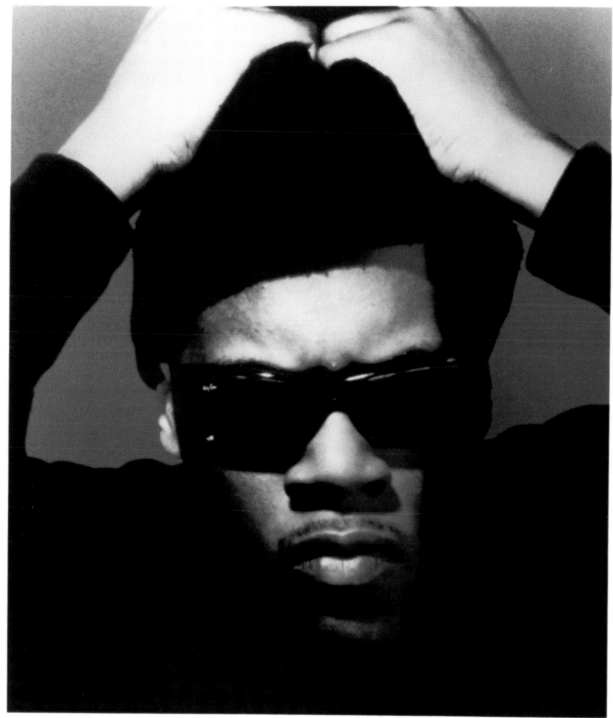

 REDMAN

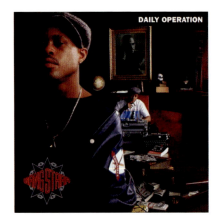

Leaders in the "jazz-rap" faction, Brooklyn's Gang Starr dropped a No. 1 rap hit, "Take It Personal," a caustic reaction to the treachery of friends.

Billboard 200: *Daily Operation* (#65)

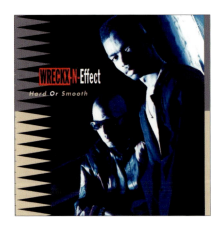

Produced by new jack swing pioneer Terry Riley, Wreckx-N-Effect's crossover hit "Rump Shaker" celebrated the spirit of women with callipygian curves.

Billboard 200: *Hard or Smooth* (#9)
Billboard Hot 100: "Rump Shaker" (#2); "Knock-N-Boots" (#72)

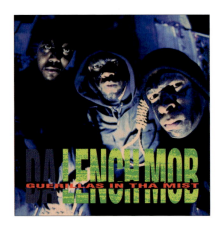

Da Lench Mob, Ice Cube's right-hand musical gang, struck out on its own, and the album *Guerillas in Tha Mist* affirmed the trio as a militant rap group.

Billboard 200: *Guerillas in tha Mist* (#24)

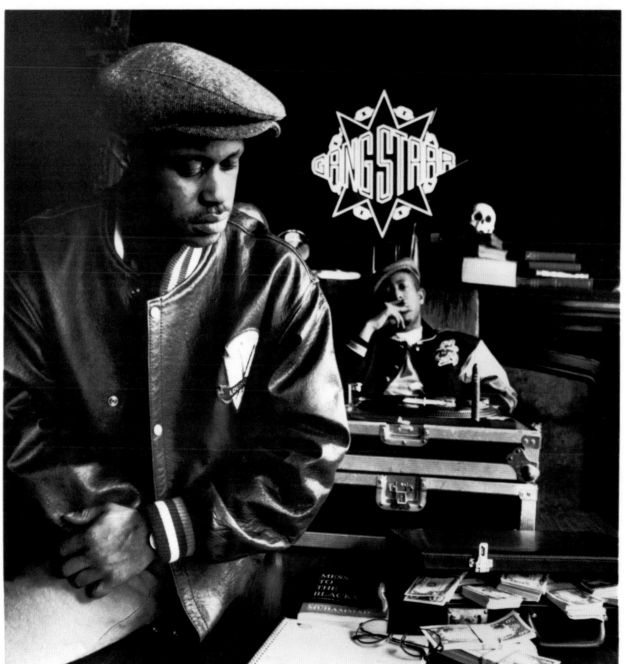

 EMI Records Group
Chrysalis

photo: Matt Gunther 4/92

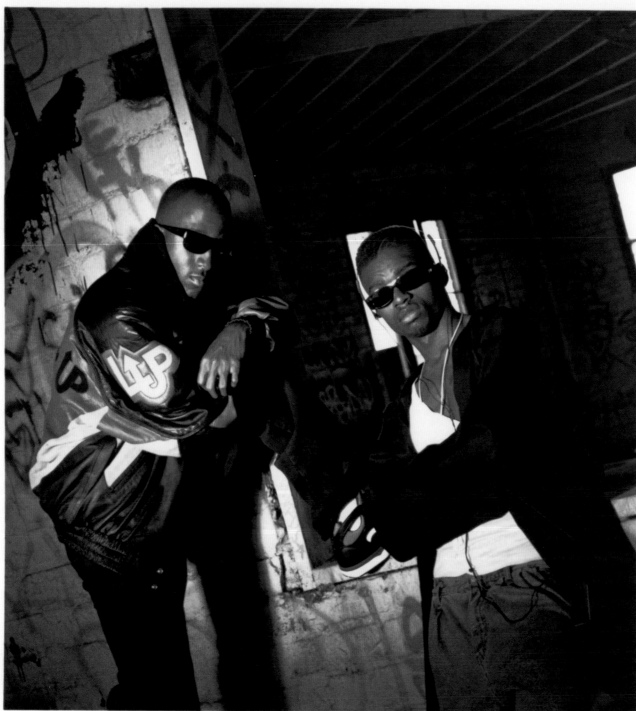

Photo Credit: Todd Gray

10/92

WRECKX-N-Effect

A TEDDY RILEY PRODUCTION

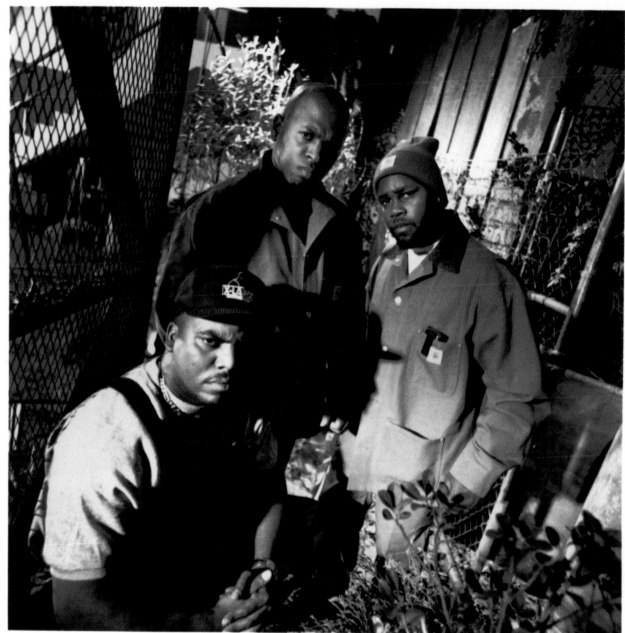

J-DEE SHORTY T-BONE

DA LENCH MOB

ON RECORD | 1992 | [JOE PUBLIC | HI-FIVE | LO-KEY?]

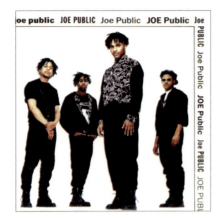

Joe Public's debut release boasted "Live and Learn," a rosy R&B and pop hit that made the new jack swing band a sought-after production team as well.

Billboard 200: *Joe Public* (#111)
Billboard Hot 100: "Live and Learn" (#4); "I Miss You" (#55); "Do You Everynite" (#98)

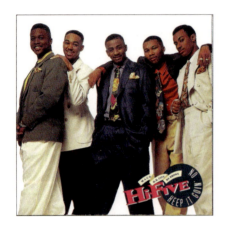

Keep It Goin' On, the second album from R&B quintet **Hi-Five**, featured the breezy "She's Playing Hard to Get" and the R. Kelly-penned "Quality Time."

Billboard 200: *Keep It Goin' On* (#82)
Billboard Hot 100: "She's Playing Hard to Get" (#5); "Quality Time" (#38)

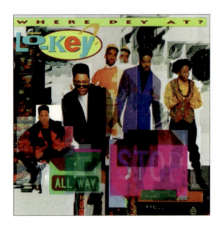

Lo-Key? turned to smooth balladry on the No. 1 R&B single "I Got a Thang 4 Ya!," featured on *Where Dey At?*, the Midwestern group's debut recording.

Billboard 200: *Where Dey At?* (#121)
Billboard Hot 100: "I Got a Thang 4 Ya!" (#27); "Sweet on U" (#91)

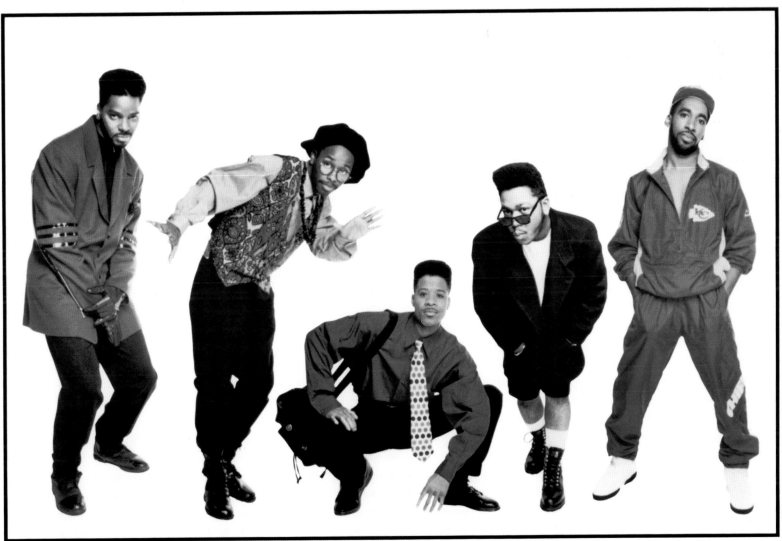

'Dre　　　prof t.　　　T-bone　　　Lance　　　'D'

PHOTO: EDDIE WOLFL 10/92

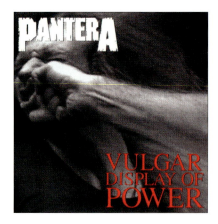

Pantera's *Vulgar Display of Power* piled the uber-heavy grooves of "Mouth for War" and "Walk" atop the relatively ballad-ish "This Love" and "Hollow."

Billboard 200: *Vulgar Display of Power* (#44)

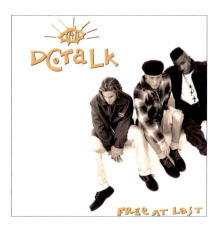

DC Talk's rap-rock mix brought contemporary Christian music to new heights with *Free at Last* and takes of "Jesus Is Just Alright" and "Lean on Me."

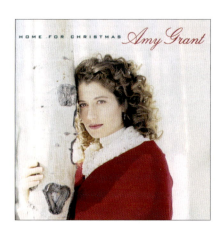

The best-selling *Home for Christmas*, Christian singer Amy Grant's second holiday album, contained her original song "Breath of Heaven (Mary's Song)."

Billboard 200: *Home for Christmas* (#2)

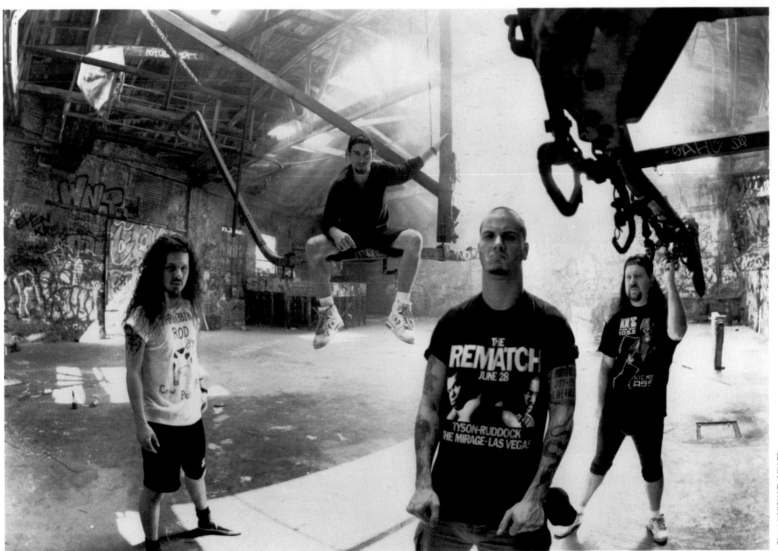

Diamond Darrell Rex Philip Anselmo Vinnie Paul

Management: **BROCK &**
Associates
615/370-4447

DC TALK

"DC TALK"
available on

(615)370-4447
FAX-(615)370-4446

EXCLUSIVE MANAGEMENT·
Blanton / Harrell
2910 Poston Ave.
Nashville, TN 37203
615-329-2611

AMY GRANT

Photo: Victoria Pearson 10/92

[ON RECORD | 1992 | GARTH BROOKS | CHRIS LeDOUX | JOHN MICHAEL MONTGOMERY]

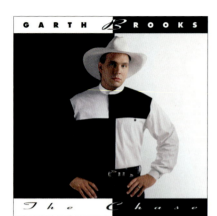

"We Shall Be Free," a gospel-tinged country production with a tenor of tolerance, was indicative of *The Chase*, **Garth Brooks**' ambitious fourth album.

Billboard 200: *The Chase* (No. 1)

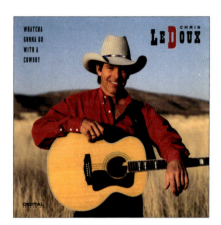

"Whatcha Gonna Do with a Cowboy," a duet with his friend and fan Garth Brooks, brought former rodeo star **Chris LeDoux** his first Top 10 country single.

Billboard 200: *Whatcha Gonna Do with a Cowboy* (#65)

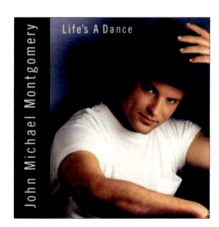

John Michael Montgomery, an old honky-tonk fave in his home state of Kentucky, produced his first No. 1 country hit, "I Love the Way You Love Me."

Billboard 200: *Life's a Dance* (#27)
Billboard Hot 100: "I Love the Way You Love Me" (#60)

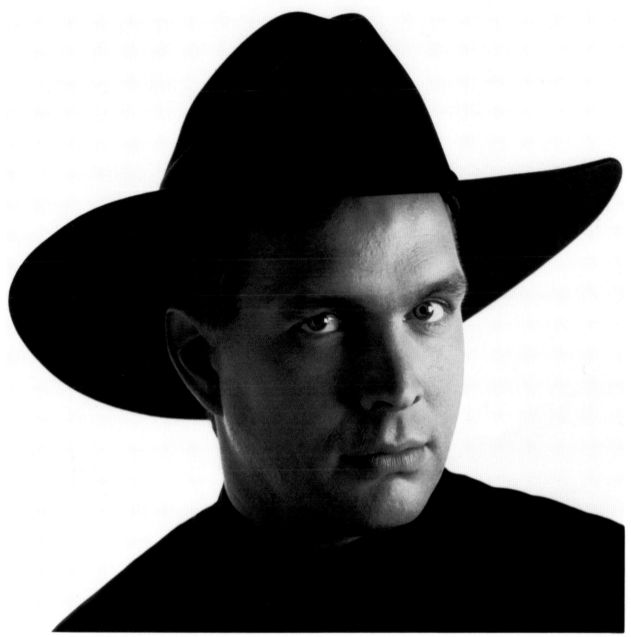

GARTH BROOKS

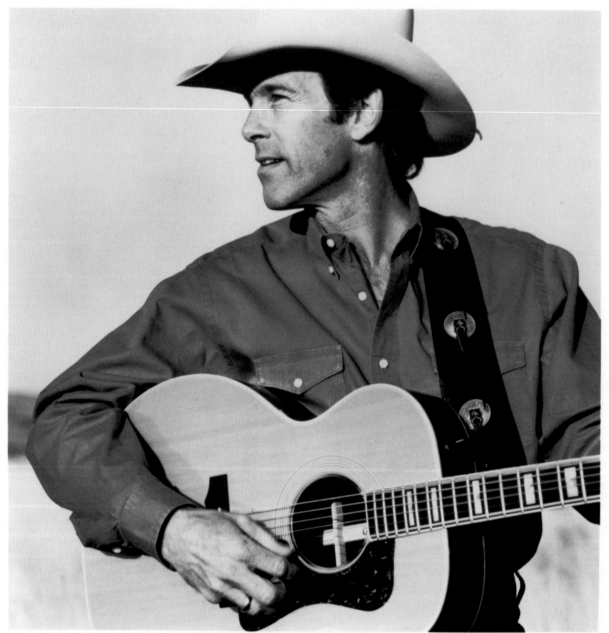

CHRIS LeDOUX

photo: Butch Adams

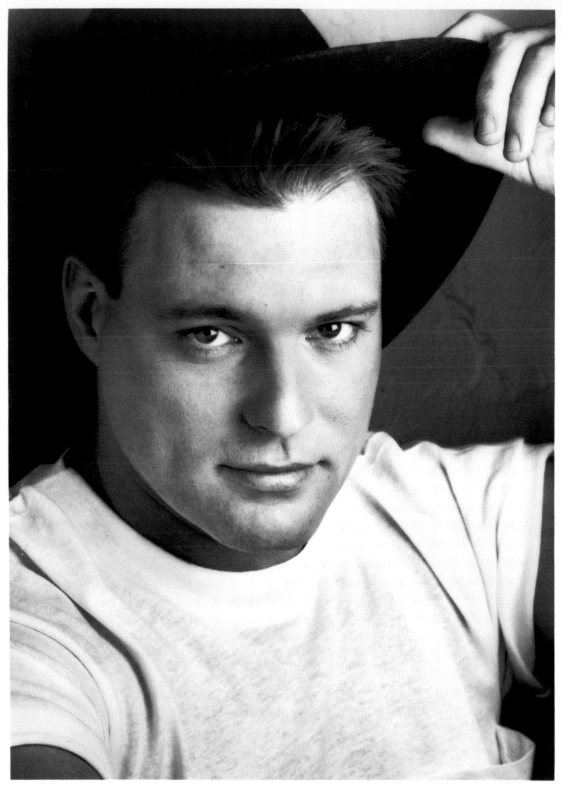

JOHN MICHAEL MONTGOMERY

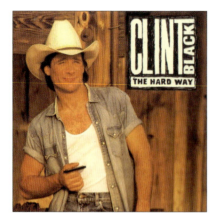

The Hard Way kept **Clint Black** in country music's vanguard with "Burn One Down," "We Tell Ourselves" and the No. 1 hit "When My Ship Comes In."

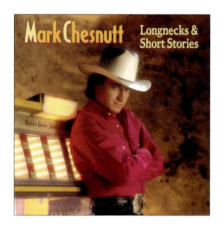

Mark Chesnutt's *Longnecks & Short Stories* spawned four Top 10 country singles, with his cover of "I'll Think of Something" becoming his second No. 1.

Billboard 200: *Longnecks & Short Stories* (#68)

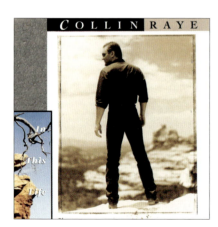

Collin Raye's poignant "In This Life" climbed to No. 1 on the country music charts, crossed over to adult contemporary and became a wedding standard.

Billboard 200: *In This Life* (#42)

CLINT BLACK

photo: Jim McGuire

RCA RECORDS (615)664-1200

MARK CHESNUTT

MCA NASHVILLE

photos: Mike Rutherford 0192

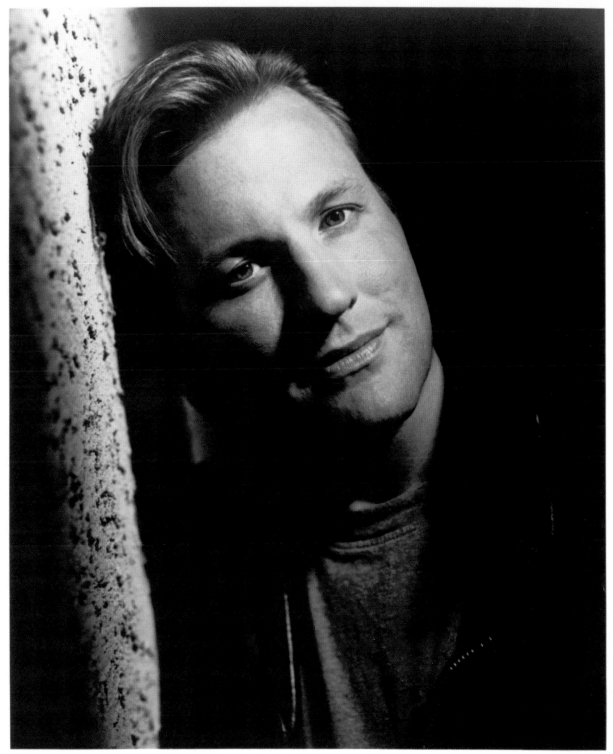

COLLIN RAYE

photo: Frank Ockenfels 3

9207

©1992 Sony Music Permission to reproduce this photography is limited to editorial uses in regular issues of newspapers and other regularly published periodicals and television news programming.

[ON RECORD | 1992 | BILLY RAY CYRUS | VINCE GILL | JOHN ANDERSON]

Thanks to the music video for "Achy Breaky Heart," **Billy Ray Cyrus**' No. 1 pop and country hit, line dancing rose in popularity and became a global craze.

Billboard 200: *Some Gave All* (No. 1)
Billboard Hot 100: "Achy Breaky Heart" (#4);
"Could've Been Me" (#72); "She's Not Cryin' Anymore" (#70):

Success smiled on **Vince Gill** as his double-platinum *I Still Believe in You* garnered four No. 1 hits on the country charts, revealing him as a creative force.

Billboard 200: *I Still Believe in You* (#10)
Billboard Hot 100: "Tryin' to Get Over You" (#88)

John Anderson's career resurged with *Seminole Wind*, scoring the No. 1 country hit "Straight Tequila Night" and the title track, an environmental lament.

Billboard 200: *Seminole Wind* (#35)

mercury
Nashville
a PolyGram company

Personal Management
JACK McFADDEN
818 Eighteenth Avenue South
Nashville, TN 37203
615/242-1500

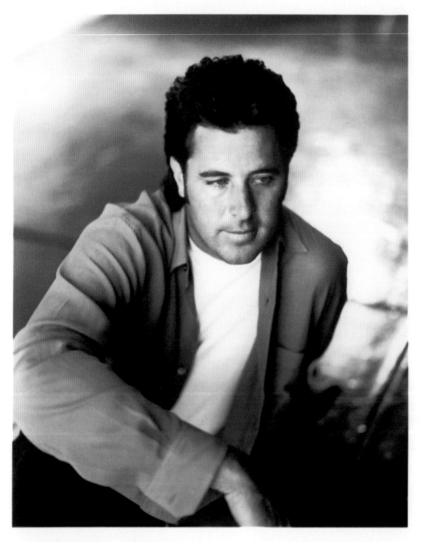

VINCE GILL

photo: Victoria Pearson 0892

MCA.
NASHVILLE

JOHN ANDERSON

BNA ENTERTAINMENT
One Music Circle North
Nashville, TN 37203-4310
615/780-4400

ON RECORD | 1992 | [WYNONNA JUDD | TRISHA YEARWOOD | REBA McENTIRE]

After seven years of the Judds' chart-topping success, **Wynonna Judd** began a solo career with *Wynonna*, an instant smash with four No.1 country singles.

Billboard 200: *Wynonna* (#4)
Billboard Hot 100: "No One Else on Earth" (#83)

Issuing *Hearts in Armor*, her second album, **Trisha Yearwood** gained a huge country hit with "Walkaway Joe," featuring harmony vocals from Don Henley.

Billboard 200: *Hearts in Armor* (#46):

Singer **Reba McEntire**'s *It's Your Call* was marked by "The Heart Won't Lie," a duet with Vince Gill that peaked at No. 1 on the country singles charts.

Billboard 200: *It's Your Call* (#8)

WYNONNA JUDD

CURB. MCA.

TRISHA YEARWOOD

MCA NASHVILLE

photo: Randee St. Nicholas 0492A

REBA McENTIRE

photo: Señor McGuire 1192

MCA NASHVILLE

ON RECORD | 1992 | [AARON TIPPIN | MARTY STUART | TRAVIS TRITT]

Featuring "There Ain't Nothin' Wrong with the Radio," a howling No. 1 country hit, *Read Between the Lines* became **Aaron Tippin**'s first platinum album.

Billboard 200: *Read Between the Lines* (#50):

This One's Gonna Hurt You turned into "hillbilly crusader" **Marty Stuart**'s first gold album, largely on the strength of the title track, a duet with Travis Tritt.

Billboard 200: *This One's Gonna Hurt You* (#77)

The heartfelt "Can I Trust You with My Heart" eased **Travis Tritt**'s rowdier instincts and became his third No. 1 on *Billboard*'s Hot Country Songs chart.

Billboard 200: *T-R-O-U-B-L-E* (#27)

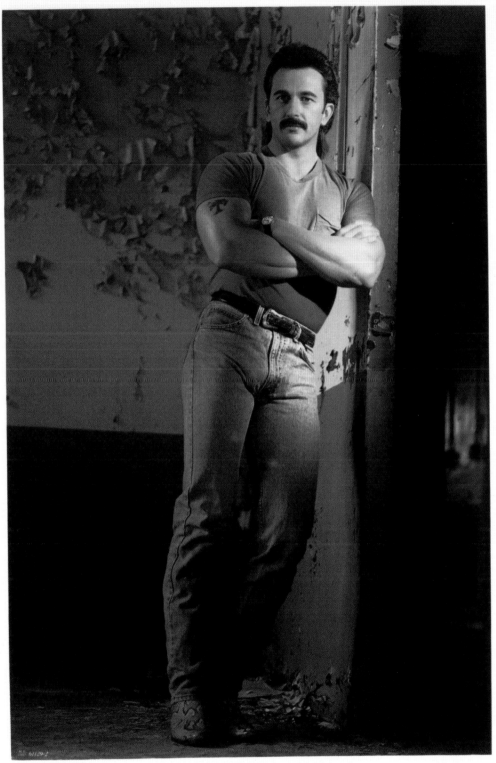

LABEL: RCA Records 615/664-1200
MANAGEMENT: Starstruck Ent. 615/742-8835
AGENCY: William Morris 615/385-0310

AARON TIPPIN

photo: Frank Ockenfels

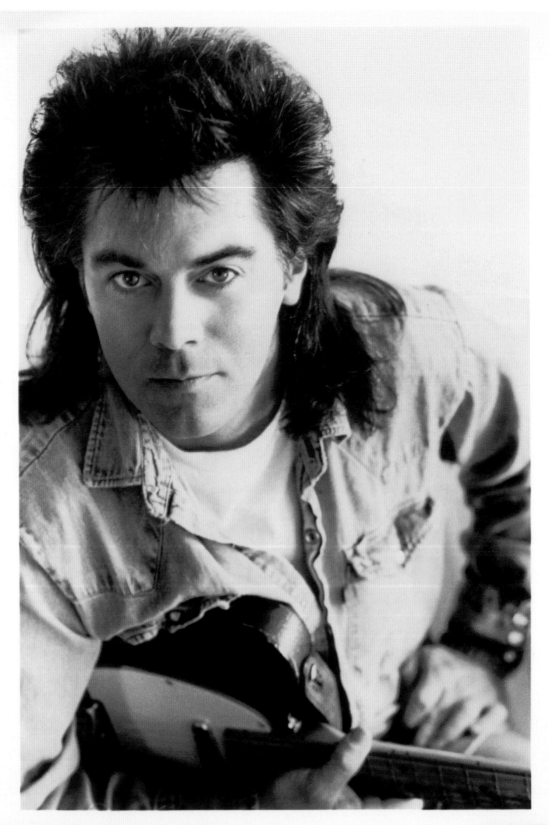

MARTY STUART

photo: Randee St. Nicholas 0692B

MCA
NASHVILLE

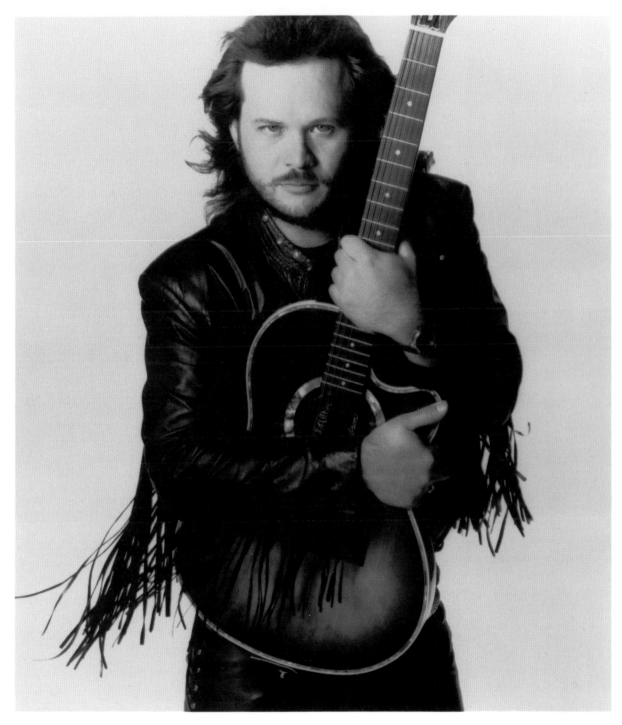

TRAVIS TRITT

photo: Randee St. Nicholas

© 1992 Warner Bros. Records/Permission to reproduce limited to editorial uses in newspapers and other regularly published periodicals and television news programming.

[ON RECORD | 1992 | PAM TILLIS | CONFEDERATE RAILROAD | ALABAMA]

Pam Tillis' gradual rise through the ranks of contemporary country stars continued when four singles from *Homeward Looking Angel* reached the charts.

Billboard 200: *Homeward Looking Angel* (#82)

Confederate Railroad fused the boisterous energy of Southern rock with the probity of outlaw country to create hits, such as fan favorite "Trashy Women."

Billboard 200: *Confederate Railroad* (#53)

Country hits continued for **Alabama**—"Take a Little Trip," "Once Upon a Lifetime," "Hometown Honeymoon" and "I'm in a Hurry (And Don't Know Why)."

Billboard 200: *American Pride* (#46)

Mike Robertson Management
P.O. Box 120073
Nashville, TN 37212
383-4299 Fax: 383-5125

PAM TILLIS

1 MUSIC CIRCLE NORTH
NASHVILLE, TN 37203
615/780-9100

TRIAD ARTISTS, INC.
TALENT AND LITERARY AGENCY
1114 17th AVENUE SOUTH
NASHVILLE, TENNESSEE 37212
TELEPHONE 615-321-4090

Lisa Shively
The Press Network
P.O. Box 26840
Los Angeles, CA 90026
213/664-3392
Fax 213/664-8370

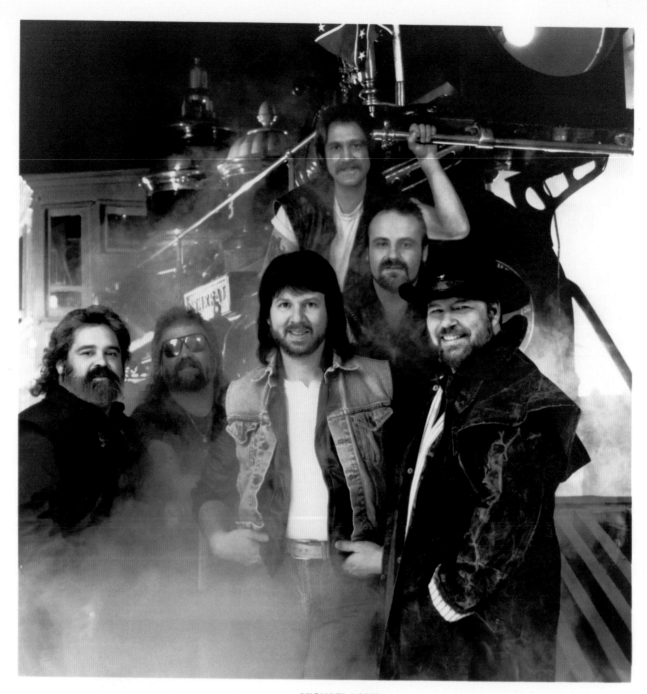

MICHAEL LAMB
WAYNE SECREST MARK DuFRESNE DANNY SHIRLEY CHRIS McDANIEL
GATES NICHOLS

CONFEDERATE RAILROAD

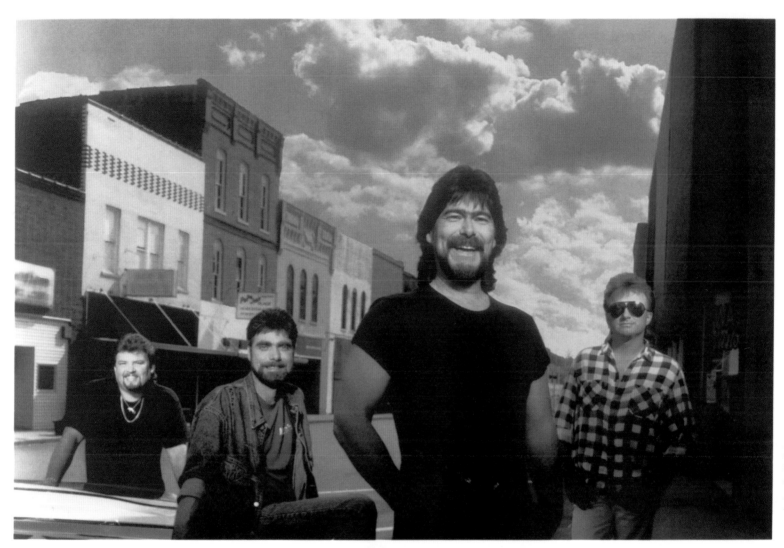

Record Label: RCA Records 615/664-1200
Management: Dale Morris and Associates 615/327-3400
Booking: Morris and Associates 615/327-3400

photo: Jim McGuire

ON RECORD | **1992** | [GEORGE STRAIT | GEORGE JONES | DOUG STONE]

George Strait played the likable lead role in *Pure Country* and recorded the movie's soundtrack, a No. 1 country album and the biggest seller of his career.

Billboard 200: *Pure Country* (#6):

Country music legend **George Jones** cut "I Don't Need Your Rockin' Chair," a claim to his longevity despite his difficulty getting significant radio airplay.

Billboard 200: *Walls Can Fall* (#77)

After bypass surgery, country balladeer **Doug Stone** offered *From the Heart* and the No. 1 hits "Too Busy Being in Love" and "Why Didn't I Think of That."

Billboard 200: *From the Heart* (#99)

GEORGE STRAIT

MCA NASHVILLE

From the motion picture PURE COUNTRY

GEORGE JONES

MCA NASHVILLE

photo: Peter Nash 1092A

DOUG STONE

photo: Randee St. Nicholas

9207

©1992 Sony Music Permission to reproduce this photography is limited to editorial uses in regular issues of newspapers and other regularly published periodicals and television news programming.

Grunge and alternative rock notwithstanding, **FireHouse** nabbed a top spot on the charts with another prime power ballad, "When I Look into Your Eyes."

Billboard 200: *Hold Your Fire* (#23)
Billboard Hot 100: "Reach for the Sky" (#83);
"When I Look into Your Eyes" (#8); "Sleeping with You" (#78):

Extreme's *III Sides to Every Story*, an ambitious concept album in three segregated sections, showcased a No. 1 mainstream rock track, "Rest in Peace."

Billboard 200: *III Sides to Every Story* (#10)
Billboard Hot 100: "Rest in Peace" (#96); "Stop the World" (#95)

A hard-rock band from Miami, **Saigon Kick** watched its second album spawn a gold single and MTV smash, the gentle acoustic song "Love Is on the Way."

Billboard 200: *The Lizard* (#80)
Billboard Hot 100: "Love Is on the Way" (#12)

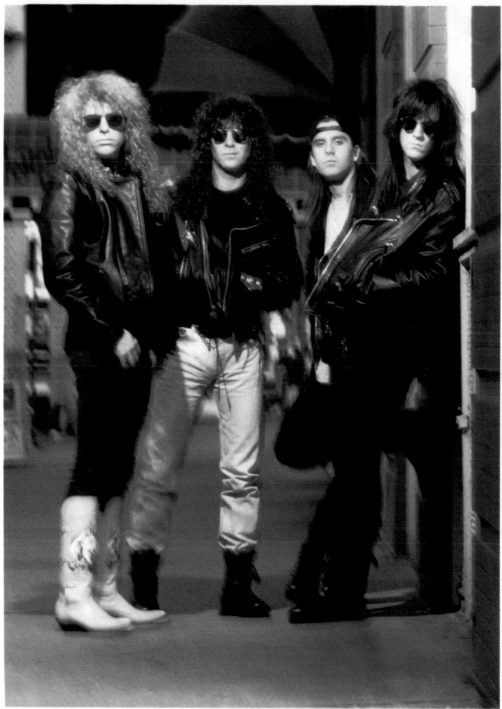

PERRY RICHARDSON C.J. SNARE MICHAEL FOSTER BILL LEVERTY

FireHouse

9204

"Epic" Reg. U.S. Pat. & Tm. Off. Marca Registrada./ ≋ is a trademark of Sony Music Entertainment Inc./© 1992 Sony Music Entertainment Inc.

PHOTO CREDIT: MARK LEIALOHA

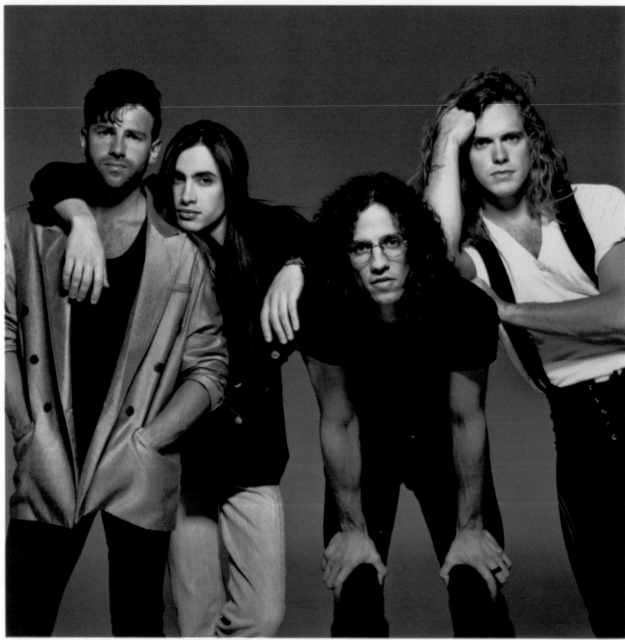

Paul Geary Nuno Bettencourt Gary Cherone Pat Badger

Photo:Michael Lavine 9/92

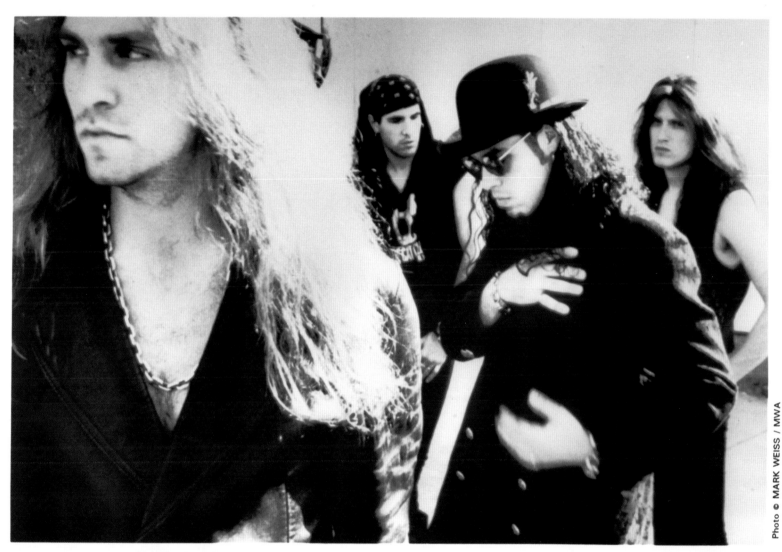

MATT KRAMER PHIL VARONE JASON BIELER CHRIS McLERNON

SAIGON KICK

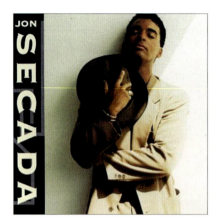

Mentored by Gloria Estefan's Miami Sound Machine, Cuban-born singer **Jon Secada** delivered a debut album that catapulted him to global pop stardom.

Billboard 200: *Jon Secada* (#15)
Billboard Hot 100: "Just Another Day" (#5); "Do You Believe in Us" (#13); "Angel" (#18)

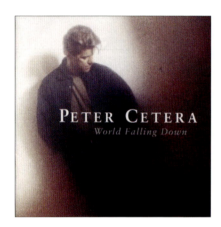

Peter Cetera was all over adult contemporary radio with the hits "Restless Heart," "Feels Like Heaven" with Chaka Khan and "Even a Fool Can See."

Billboard 200: *World Falling Down* (#163)
Billboard Hot 100: "Restless Heart" (#35); "Feels Like Heaven" (#71); "Even a Fool Can See" (#68)

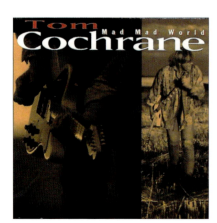

A star in his native land as a member of Red Rider, Canadian rocker **Tom Cochrane** launched a solo career with the stateside smash "Life Is a Highway."

Billboard 200: *Mad Mad World* (#46)
Billboard Hot 100: "Life Is a Highway" (#6)

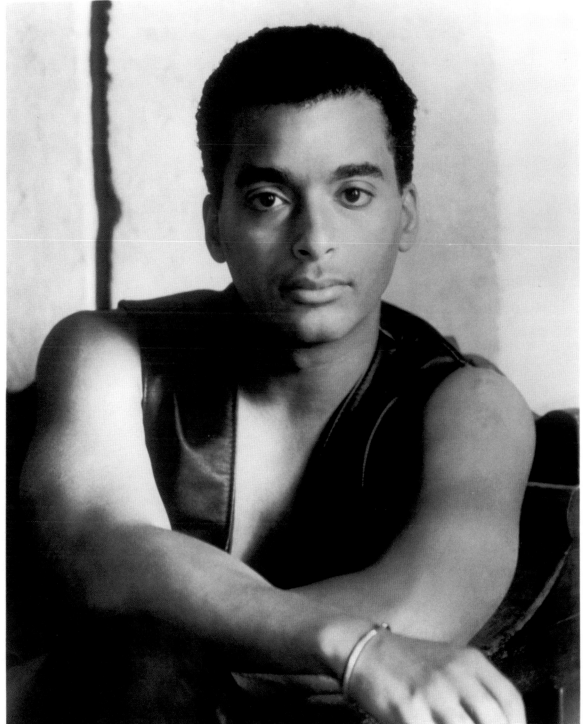

Jon Secada

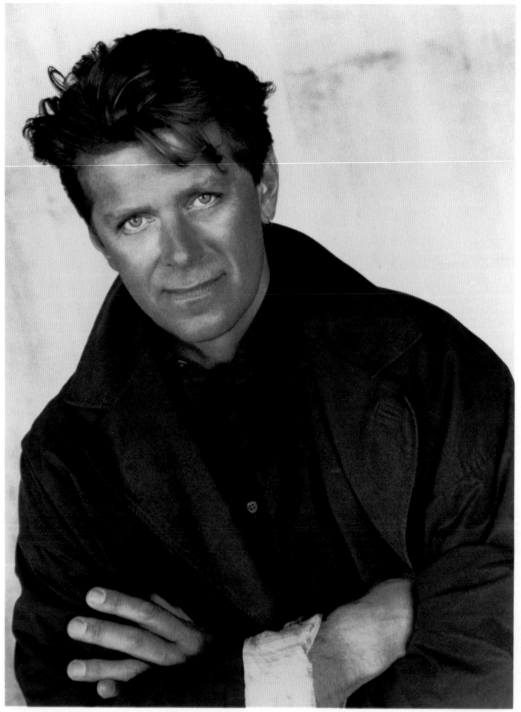

PETER CETERA

Photo Credit: Merlyn Rosenberg

© 1992 Warner Bros. Records/Permission to reproduce limited to editorial uses in newspapers and other regularly published periodicals and television news programming.

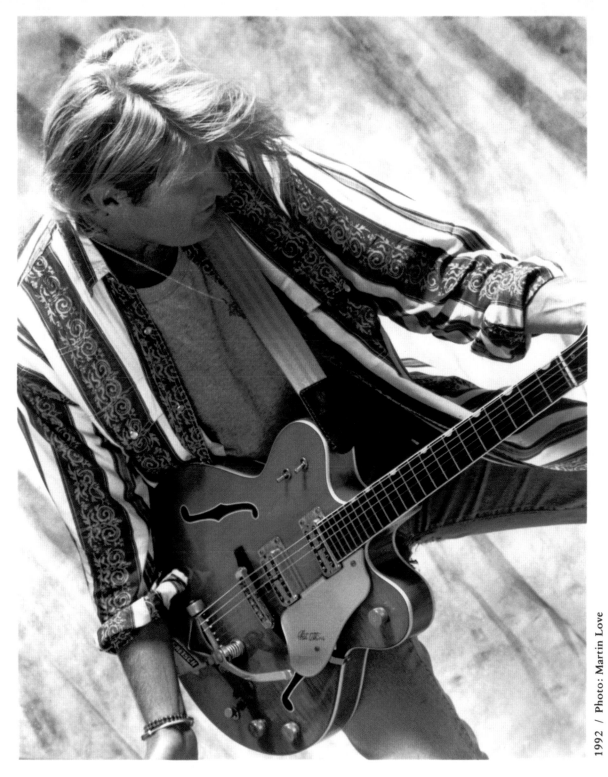

Tom Cochrane

1992 / Photo: Martin Love

ON RECORD | **1992** | **[GO WEST | STACY EARL | MIKI HOWARD]**

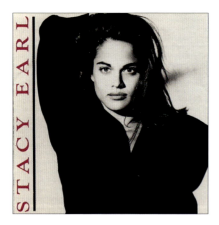

UK pop duo **Go West**'s *Indian Summer* featured the hits "King of Wishful Thinking," which had appeared on the *Pretty Woman* soundtrack, and "Faithful."

Billboard 200: *Indian Summer* (#154)
Billboard Hot 100: "King of Wishful Thinking" (#8); "Faithful" (#14); "What You Won't Do for Love" (#55)

Dance-pop singer **Stacy Earl** hit the Top 40 with her singles "Love Me All Up" and "Romeo & Juliet," slices of party action colored by a hint of romance.

Billboard Hot 100: "Love Me All Up" (#26); "Romeo & Juliet" (#27)

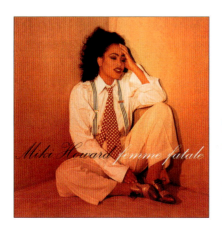

Miki Howard portrayed the legendary Billie Holiday in Spike Lee's epic *Malcolm X* while her song "Ain't Nobody Like You" made No. 1 on the R&B chart.

Billboard 200: *Femme Fatale* (#110)
Billboard Hot 100: "Ain't Nobody Like You" (#64)

GO WEST

Photo credit: TIMOTHY WHITE

EMI Records Group

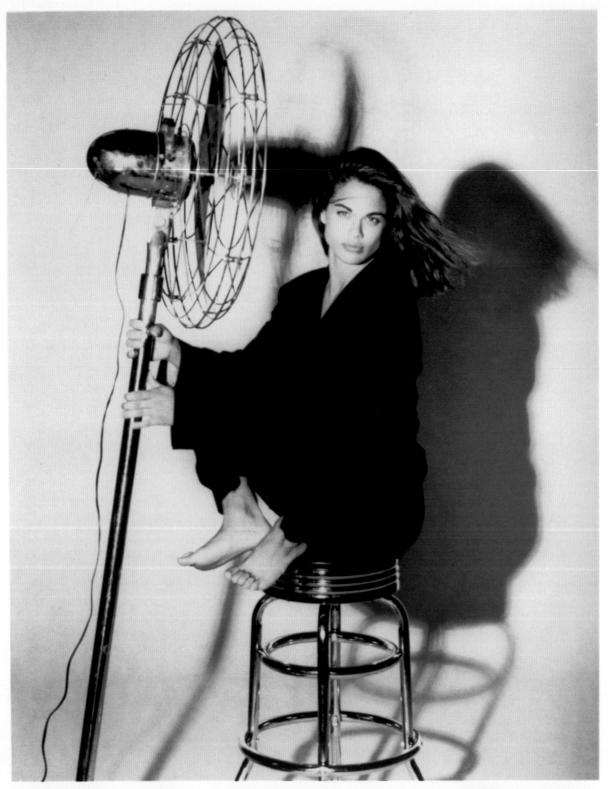

STACY EARL

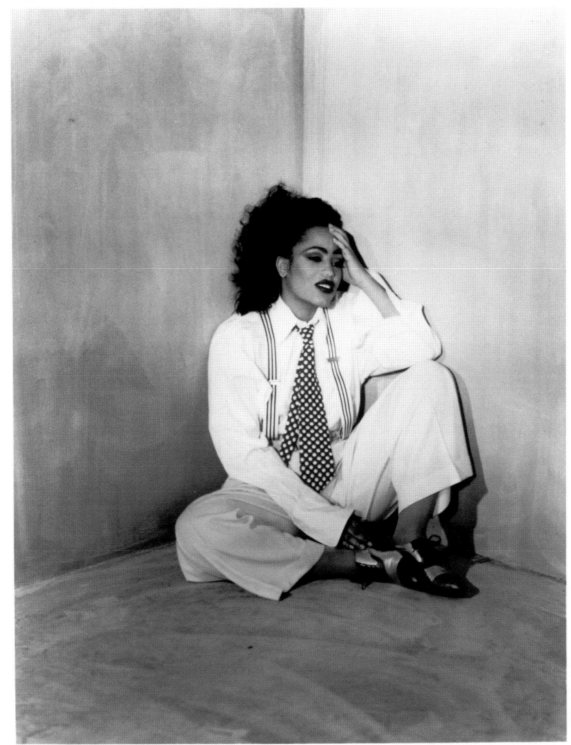

Miki Howard

Photo Credit: Bonnie Lewis

© 1992 Reprise Records/Permission to reproduce limited to editorial uses in newspapers and other regularly published periodicals and television news programming.

British trio **Right Said Fred**, hatched by brothers Fred and Richard Fairbrass, leaped to No. 1 in 32 countries with its campy debut single "I'm Too Sexy."

Billboard 200: *Up* (#46)
Billboard Hot 100: "I'm Too Sexy" (No. 1); "Don't Talk Just Kiss" (#76)

Indie alternative rockers **Ween** released a major-label debut, *Pure Guava*, garnering media and MTV notice with the aberrant "Push th' Little Daisies."

The Wolfgang Press, "avant-dance groovers" on *Queer*, romped through the single "A Girl Like You" and Randy Newman's "Mama Told Me Not to Come."

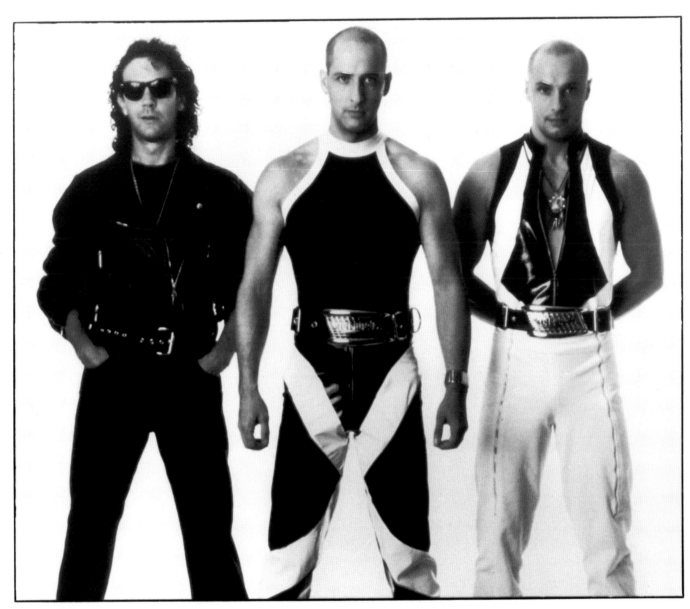

 charisma

Right Said Fred

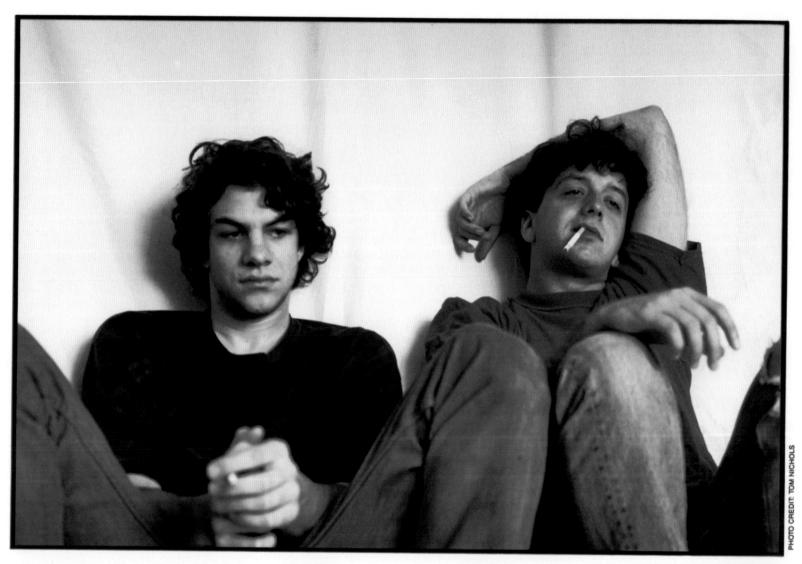

DEAN WEEN GENE WEEN

Elektra Entertainment

PHOTO CREDIT: TOM NICHOLS

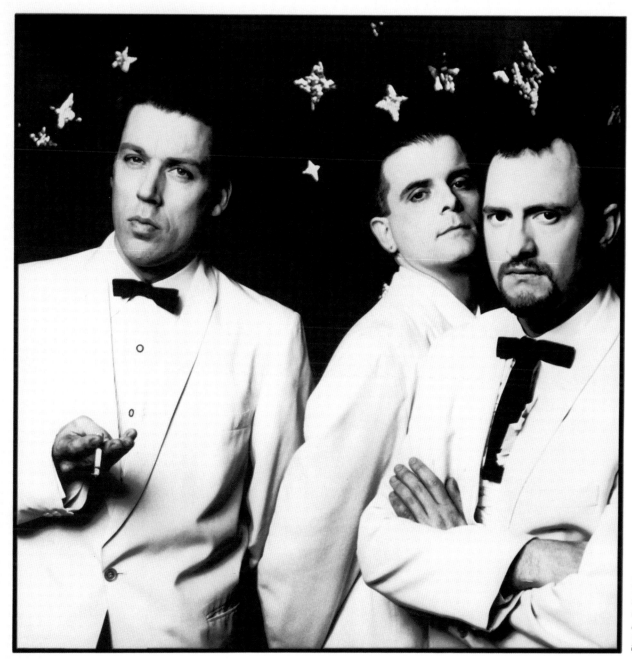

Mick Allen Mark Cox Andrew Gray

© 1992 Warner Bros Records Permission to reproduce limited to editorial uses in newspapers and other regularly published periodicals and television news programming

Photo Credit: Matt Anker

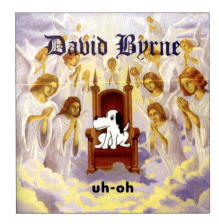

Uh-Oh, **David Byrne**'s second solo album after leaving Talking Heads, was driven by Latin beats, big band horns and his familiar rhythmic funk-rock edge.

Billboard 200: *Uh-Oh* (#125)

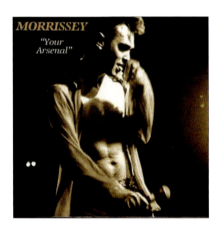

With the modern-rock hits "We Hate It When Our Friends Become Successful" and "Tomorrow," "aggressive loner" **Morrissey** commanded acceptance.

Billboard 200: *Your Arsenal* (#21)

Sustaining alternative fame with *Holy Smoke* and the swirling "The Sweetest Drop," **Peter Murphy** concluded work with his backing band, the Hundred Men.

Billboard 200: *Holy Smoke* (#108)

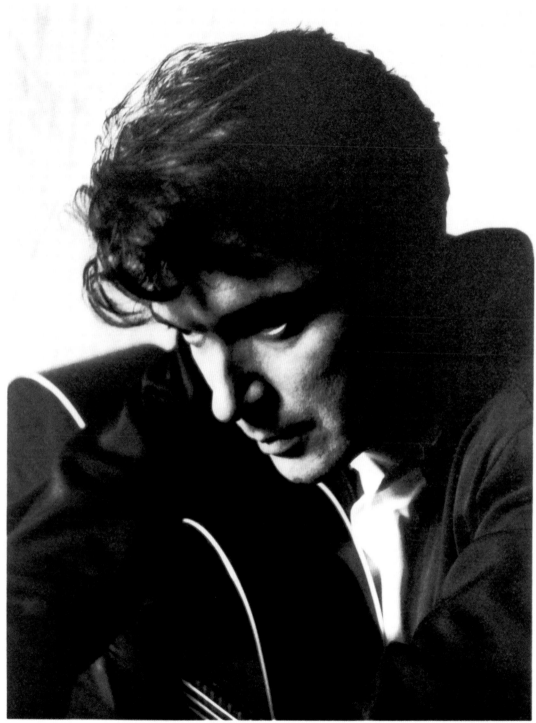

David Byrne

Photo Credit: Bonnie Schiffman

Luka Bop / © 1992 Warner Bros. Records / Permission to reproduce limited to editorial uses in newspapers and other regularly published periodicals and television news programming.

MORRISSEY

© 1992 Reprise Records/Permission to reproduce limited to editorial uses in news-
papers and other regularly published periodicals and television news programming.

Photo Credit: Anton Corbijn

Peter Murphy.

"The Ballad of Peter Pumpkinhead," crafted by **XTC**'s Andy Partridge for the patently British pop band's *Nonsuch*, peaked at No. 1 on the alternative charts.

Billboard 200: *Nonsuch* (#97)

The Sugarcubes' *Stick Around for Joy*, the Icelandic band's third album, featured a modern-rock biggie, "Hit," and a dance smash, "Leash Called Love."

Billboard 200: *Stick Around for Joy* (#95)

The Sundays' sophomore release, *Blind*, was grounded in ambient music, birthing a hit, "Love," and a haunting cover of the Rolling Stones' "Wild Horses."

Billboard 200: *Blind* (#103)

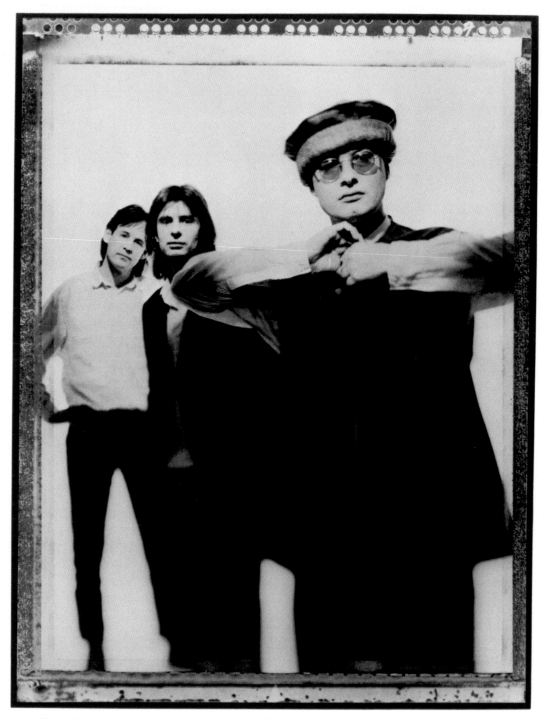

Dave Gregory Colin Moulding Andy Partridge

GEFFEN

© 1992 The David Geffen Company / Permission to reproduce limited to editorial uses in newspapers and other regularly published periodicals and television news programming.

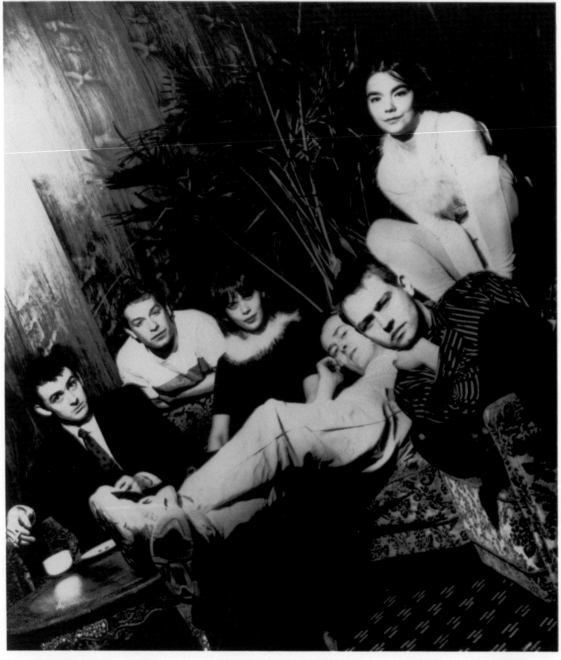

BRAGI THOR MAGGA SIGGI EINAR BJORK

PHOTO CREDIT: KEVIN WESTENBERG

Elektra Entertainment

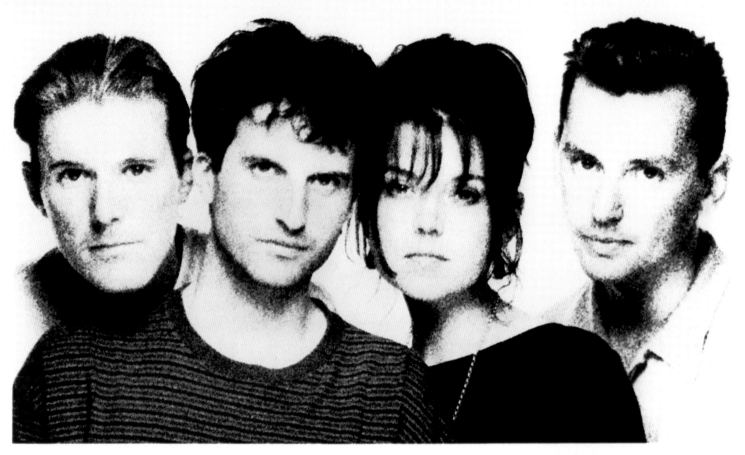

Paul Brindley David Gavurin Harriet Wheeler Patrick Hannan

The SUNDAYS

DAVID GEFFEN COMPANY

© 1992 The David Geffen Company/Permission to reproduce limited to editorial uses in newspapers and other regularly published periodicals and television news programming.

Photo Credit: Nick Knight

ON RECORD | 1992 | [SONIC YOUTH | MUDHONEY | SOCIAL DISTORTION]

With *Dirty*, Sonic Youth's second major-label album, and the single "100%," the noise-rock band courted the mainstream without softening its sound.

Billboard 200: *Dirty* (#83)

Pioneering Seattle grunge band Mudhoney landed with a big record company and delivered the off-center *Piece of Cake* and the fury of "Suck You Dry."

Billboard 200: *Piece of Cake* (#189)

Social Distortion's *Somewhere Between Heaven and Hell* and the track "Bad Luck" showed the punk band's taste for primal Fifties country and rockabilly.

Billboard 200: *Somewhere Between Heaven and Hell* (#76)

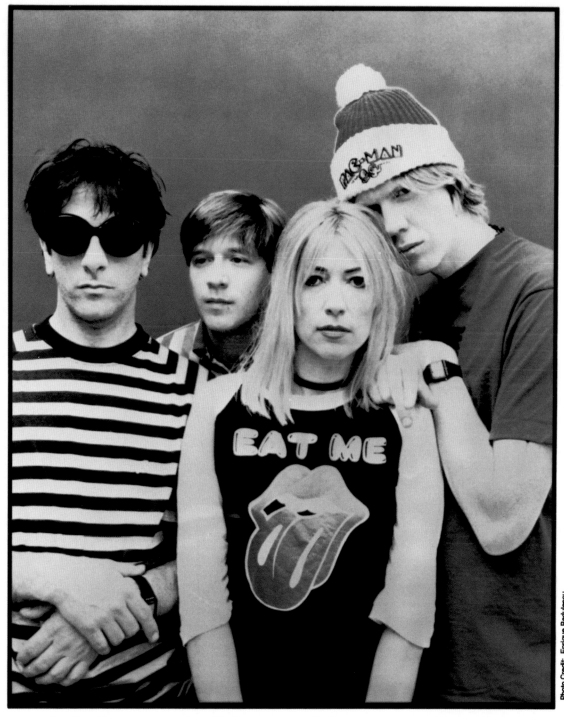

Lee Ranaldo Steve Shelley Kim Gordon Thurston Moore

SONIC YOUTH

DAVID GEFFEN COMPANY

© 1992 The David Geffen Company/Permission to reproduce limited to editorial uses in newspapers and other regularly published periodicals and television news programming.

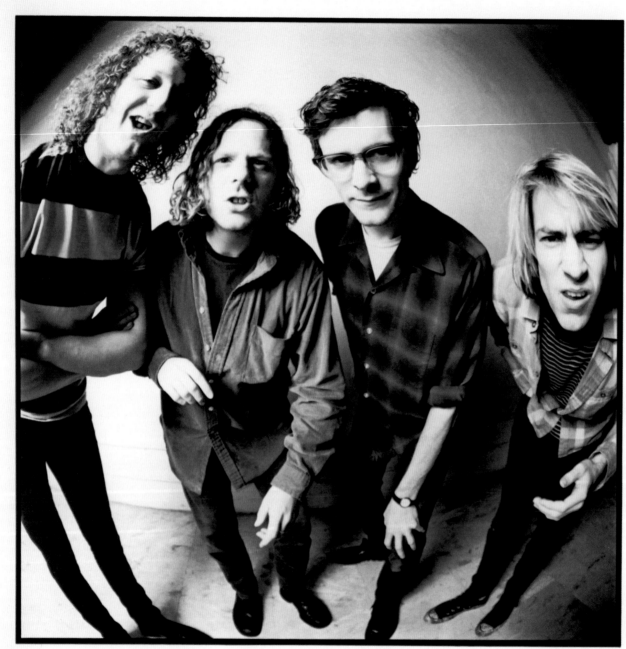

Matt Lukin Dan Peters Steve Turner Mark Arm

Photo Credit: Chris Cuffaro

© 1992 Reprise Records/Permission to reproduce limited to editorial uses in newspapers and other regularly published periodicals and television news programming.

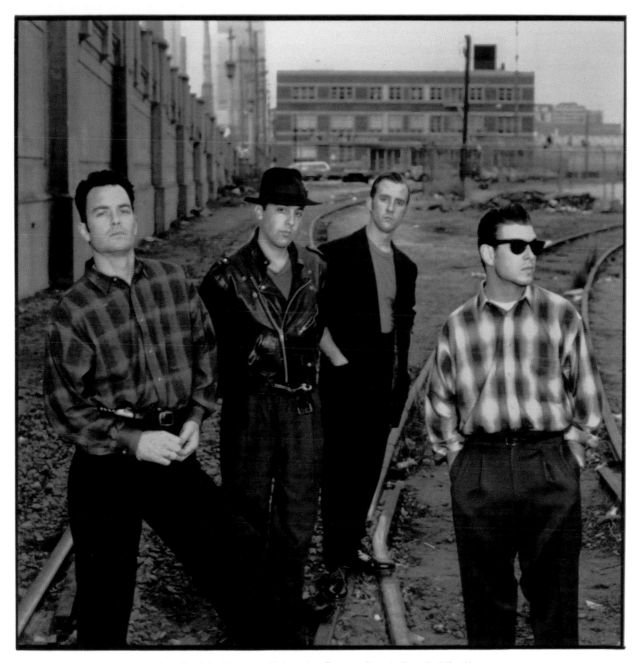

L to R: John Maurer Christopher Reece, Dennis Danell, Mike Ness

Photo Credit: Dorothy Low

SOCIAL DISTORTION

epic

9201

© 1992 Sony Music. Permission to reproduce this photography is limited to editorial uses in regular issues of newspapers and other regularly published periodicals and television news programming.

1992 — [LEMONHEADS | 4 NON BLONDES | CONCRETE BLONDE]

Led by slacker icon Evan Dando, the alt-rock band **Lemonheads** grew its fame with *It's a Shame about Ray* and a punky cover version of "Mrs. Robinson."

Billboard 200: *It's a Shame About Ray* (#68)

"What's Up," written by **4 Non Blondes**' dreadlocked singer Linda Perry, earned the Bay Area band a gold record in the US and a No. 1 hit in several countries.

Billboard 200: *Bigger, Better, Faster, More!* (#13)
Billboard Hot 100: "What's Up?" (#14)

Back with its original lineup, **Concrete Blonde** followed the gold album *Bloodletting* with *Walking in London* and the track "Ghost of a Texas Ladies' Man."

Billboard 200: *Walking in London* (#73)

EVAN DANDO OF
Lemonheads

Photo © JOHN BENTHAM

Linda Perry　　Christa Hillhouse　　Dawn Richardson　　Roger Rocha

© 1992 Interscope Records, Inc./Permission to reproduce limited to editorial uses in newspapers and other regularly published periodicals and television news programming. All other rights reserved.

Photo Credit: Ross Pelton 1992

Concrete Blonde

photo: Annie Sperling

I.R.S.

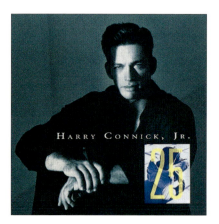

The Chieftains' *Another Country*, a joint effort between the Irish ensemble and top country artists, won the Grammy for Best Contemporary Folk Album.

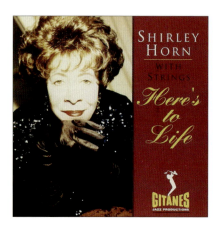

Performing on solo piano, Harry Connick, Jr. effectuated a confident, able artistic vision on *25*, his broad collection of jazz and pop standards.

Billboard 200: *25* (#19)

Jazz singer and pianist Shirley Horn made *Here's to Life* with an orchestra arranged by Johnny Mandel, and the title track became a modern-day classic.

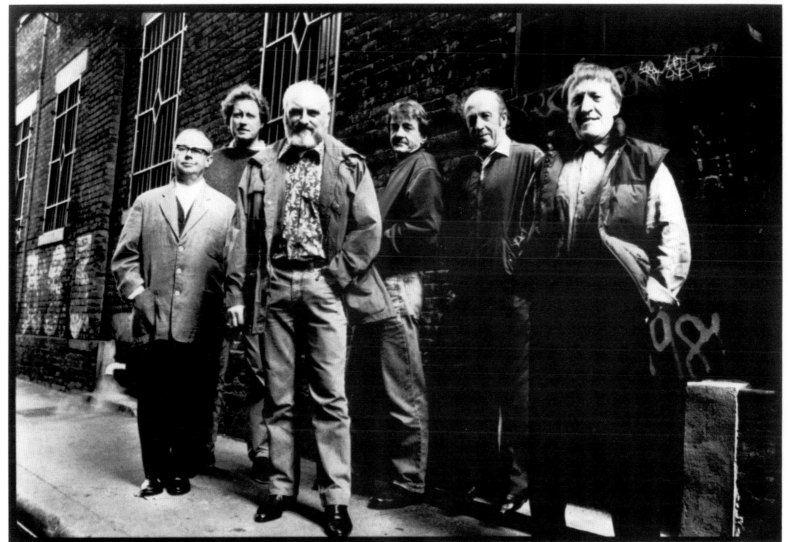

THE CHIEFTAINS

PHOTO: Caroline Greyshock/Courtesy of RCA Victor

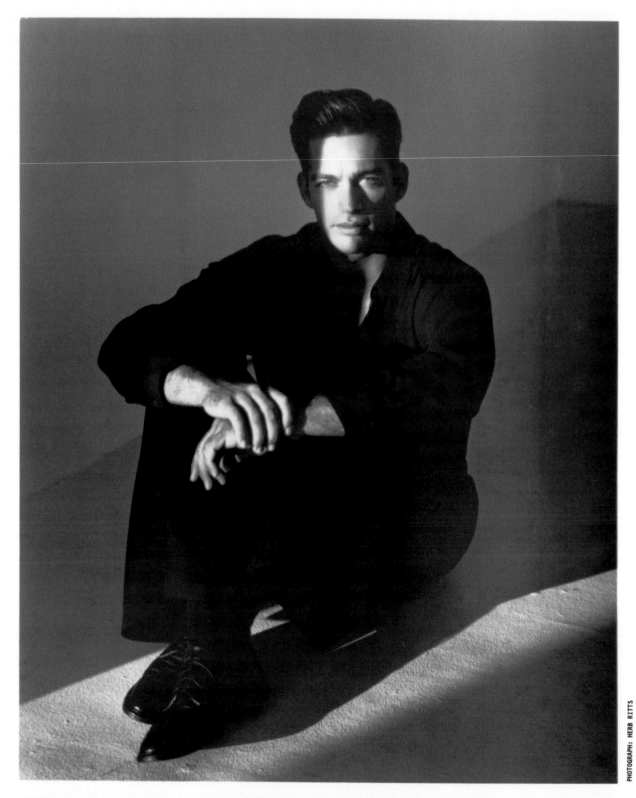

HARRY CONNICK, JR.

©1992 Sony Music Permission to reproduce this photography is limited to editorial uses in regular issues of newspapers and other regularly published periodicals and television news programming.

COLUMBIA
9211

PHOTOGRAPH: HERB RITTS

SHIRLEY HORN
Here's To Life

Photo: Carol Friedman

ON RECORD | 1992 | [MILES DAVIS | BRANFORD MARSALIS | DON BYRON]

Released posthumously, *Doo-Bop*, legendary jazz trumpeter **Miles Davis**' last studio recording before his death, was a collaboration with rapper Easy Mo Bee.

Billboard 200: *Doo-Bop* (#190)

Examining the blues tradition, saxophonist **Branford Marsalis** topped the jazz album charts and won a Grammy Award for *I Heard You Twice the First Time*.

A sideman and collaborator revivifying the clarinet's jazz profile, **Don Byron** gained immediate fame on *Tuskegee Experiments*, his first album as a leader.

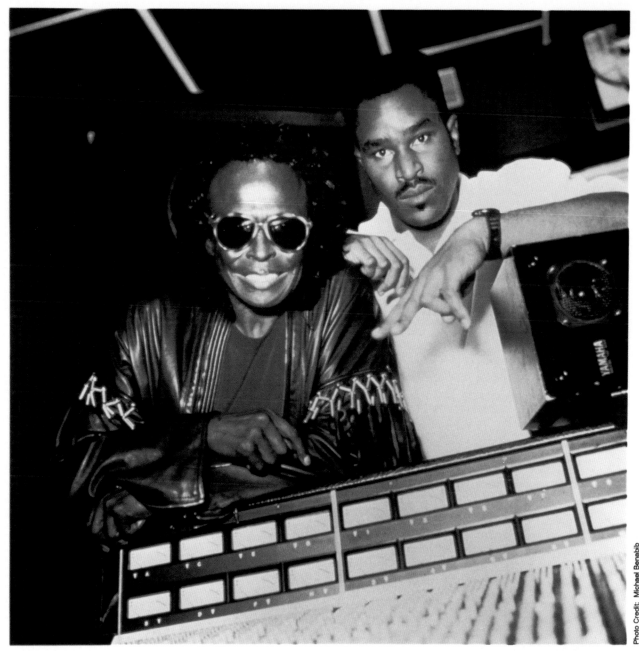

Miles Davis with Eazy Mo Bee

© 1992 Warner Bros. Records/Permission to reproduce limited to editorial uses in newspapers and other regularly published periodicals and television news programming.

Photo Credit: Michael Benabib

BRANFORD MARSALIS

COLUMBIA
9208

DON BYRON
"Tuskegee Experiments" (79280)

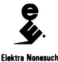
Elektra Nonesuch

The Disposable Heroes of Hiphoprisy—"artists of conscience" Michael Franti and Rono Tse—tackled big issues on *Hypocrisy Is the Greatest Luxury*.

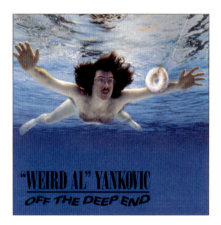

"Weird Al" Yankovic's "Smells Like Nirvana," a send-up of Nirvana's massive hit "Smells Like Teen Spirit," renewed the career of rock's prime parodist.

Billboard 200: *Off the Deep End* (#17)
Billboard Hot 100: "Smells Like Nirvana" (#35)

Jammin' in New York, the audio performance of **George Carlin**'s eighth stand-up special for HBO, won the Grammy for Best Spoken Comedy Album.

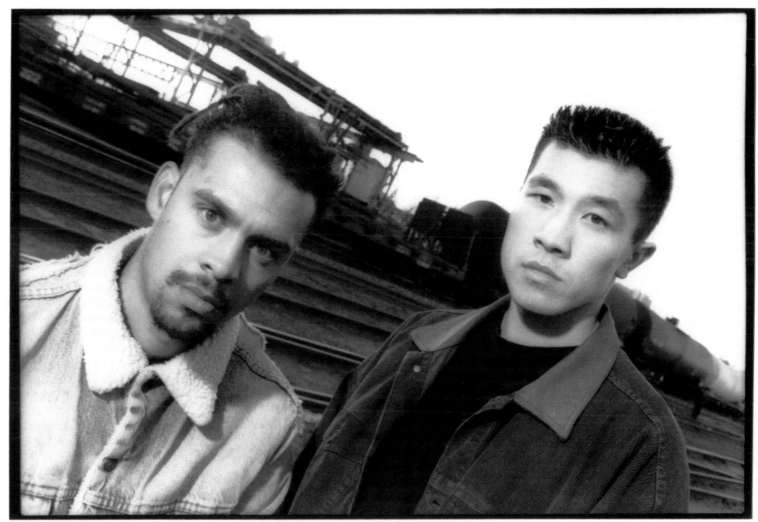

MICHAEL FRANTI　　　　　RONO TSE

DISPOSABLE HEROES OF HIPHOPRISY

PHOTO CREDIT: JAY BLAKESBERG

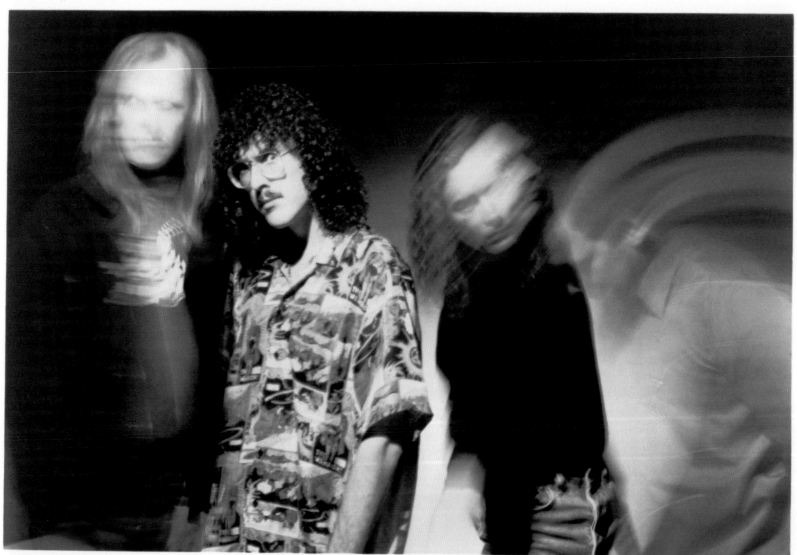

IMAGINARY ENTERTAINMENT
LOS ANGELES, CALIFORNIA

"WEIRD AL" YANKOVIC

©1992 Scotti Bros. Permission to reproduce this photography is limited to editorial uses in regular issues of newspapers and other regularly published periodicals and television news programming.

GEORGE CARLIN

ON RECORD | 1992 | [MARIAH CAREY | R. KELLY & PUBLIC ANNOUNCEMENT | SNAP!]

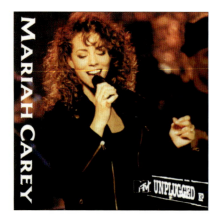

Recorded live for the show *MTV Unplugged*, **Mariah Carey**'s cover of the Jackson 5's 1970 chart-topper "I'll Be There" became the singer's sixth No. 1 single.

Billboard 200: *MTV Unplugged* (#3)
Billboard Hot 100: "I'll Be There" (No. 1)

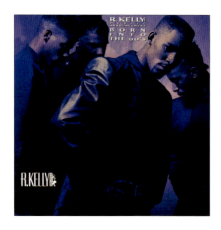

Co-credited to **R. Kelly & Public Announcement**, *Born into the 90's*, Kelly's only partnership with his new jack swing group, became an instant R&B hit.

Billboard 200: *Born into the 90's* (#42)
Billboard Hot 100: "She's Got That Vibe" (#59); "Honey Love" (#39); "Slow Dance (Hey Mr. DJ)" (#43); "Dedicated" (#31)

The German electronic dance ensemble **Snap!** rocketed to the No. 1 spot in multiple European countries—and Top 5 in the US—with "Rhythm Is a Dancer."

Billboard 200: *The Madman's Return* (#121)
Billboard Hot 100: "Rhythm Is a Dancer" (#5)

Vallejo, California's **N2Deep** moved up the charts with the hit "Back to the Hotel," produced by Johnny Z., the creative force behind the Chicano rappers.

Billboard 200: *Back to the Hotel* (#55)
Billboard Hot 100: "Back to the Hotel" (#14); "Toss-Up" (#92)

The Five Blind Boys of Alabama featuring Clarence Fountain, the gospel act's leader and founder, celebrated *Deep River,* produced by Booker T. Jones.

Archivist Tary Owens sought out **Grey Ghost** (Roosevelt Williams) and arranged for the Texas blues pianist to make his first studio album at the age of 89.

ON RECORD | 1992 | [PAVEMENT | SUBLIME | THE LIGHTNING SEEDS]

Slanted and Enchanted, **Pavement**'s debut album, arose as an indie-rock landmark, its lo-fi aesthetic typified in the song "Summer Babe (Winter Version)."

Sublime's *40oz. to Freedom*, an independent release featuring the song "Date Rape," slowly strengthened the ska-punk band's Southern California following.

Billboard 200: *40oz. to Freedom* (#140)

The Lightning Seeds, an English group directed by Ian Broudie, crafted the album *Sense* and the song "The Life of Riley," written by Broudie for his son.

Billboard 200: *Sense* (#154)
Billboard Hot 100: "The Life of Riley" (#98)

Tony Bennett put out the thematic work *Perfectly Frank*, a tribute to Frank Sinatra, which topped *Billboard*'s jazz charts and achieved gold-record status.

Billboard 200: *Perfectly Frank* (#102)

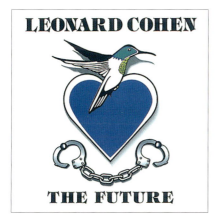

Leonard Cohen's *The Future*, an aural report recorded while the 1992 Los Angeles riots were taking place, dwelled on the cultural malaise facing mankind.

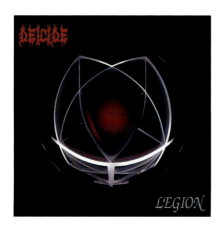

Adopting Satanic ideology, **Deicide** repulsed the mainstream with the brutal *Legion*, the death-metal band's second foray into despair and degradation.

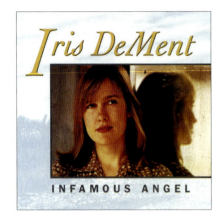

Infamous Angel, singer-songwriter **Iris DeMent**'s debut, contained "Our Town" and "Let the Mystery Be," country-folk songs of remarkable observation.

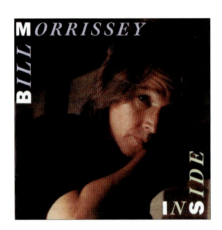

An insightful songwriter and distinctive singer, folk music's **Bill Morrissey** stepped forward with *Inside*, employing Suzanne Vega to duet on the title cut.

Having pursued different solo paths, siblings **Hugh & Katy Moffatt** combined skills to craft *Dance Me Outside*, an album of country songs about two-timing.

[SAWYER BROWN | REVEREND BILLY C. WIRTZ | ALVIN & THE CHIPMUNKS] 1992 ON RECORD

From the album *The Dirt Road*, the band **Sawyer Brown** produced a fan favorite with "Some Girls Do," another No. 1 hit on *Billboard*'s country music chart.

Billboard 200: *The Dirt Road* (#68)

Reverend Billy C. Wirtz, "the manic minister of mirth," cut both studio and solo live tracks for *A Turn for the Wirtz: Confessions of a Hillbilly Love God*.

Enduring pop culture icons **Alvin & the Chipmunks** took a stab at country music with *Chipmunks in Low Places*, the animated group's first platinum record.

Billboard 200: *Chipmunks in Low Places* (#21)

{ IN MEMORY OF BRUCE VAN DYKE }

ACKNOWLEDGMENTS

Many people were essential to the creation of this book. My first thanks go to my amazing publishing team—Jon Rizzi for bringing his special brand of editorial wit and intelligence, and Kate Glassner Brainerd for her design artistry and unflagging pursuit of excellence. Special appreciation goes to the Michael & Patricia Matthews Fund, as well as John Cerullo, Annette Hobbs Magier, and Kevin Votel and his colleagues at Publishers Group West.

Mike Dickson, Chip Garofalo, Jennifer Soulé, Mark Zaremba, Peter Marcus, Matt Rue, Jay Elowsky, Dave Zobl and Mark Lewis contributed expertise and resources. I am especially indebted to my dear friend Michael Jensen, as well as Sue Satriano, Janice Azrak, Bryn Bridenthal, Byron Hontas, Kathy Acquaviva, Shelly Selover, Sue Sawyer, Glen Brunman, Rick Ambrose, Bob Merlis, Bill Bentley, Heidi Ellen Robinson, Les Schwartz, Rick Gershon, Jim Merlis, Judi Kerr and Susan Blond—all of whom supported my efforts.

I specifically treasure the beneficence of Dave Rothstein, Greg Phifer, John Tope, Kevin Knee, Dick Merkle, Jeff Cook, Michael Brannen, Zak Phillips, Rich Garcia, Jason Minkler, Burt Baumgartner, Mitch Kampf, Don Zucker, Carl Walters, Charlie Reardon, Robin Wren, Jimmy Smith, Sharona White, John Ryland, Geina Horton, Michael Linehan, Mike Prince and Jeffrey Naumann, who all graciously furnished information and assistance.

I gratefully acknowledge the editing and reviewing skills of Dick Kreck, Tom Walker, Diane Carman, Mike Rudeen, Ed Smith, Jay Whearley, Mark Sims, Jeff Bradley and Peggy McKay.

I also salute David Gans, Leland Rucker, Steve Knopper, David Menconi, Jon Iverson, Gil Asakawa, Mark Bliesener, Butch Hause, Ricardo Baca, John Moore, Justin Mitchell, Michael Mehle and Harvey Kubernik, whose writings formed a vital index for the music-obsessed.

Finally, I would like to acknowledge with gratitude my beloved wife, Bridget, for her constant devotion and kindness. I cherish her—the love of my life.

EDITOR | **JON RIZZI**
ART DIRECTOR | **KATE GLASSNER BRAINERD**

Copyright ©2024 Colorado Music Experience
ALL RIGHTS RESERVED. No portion of this book may be reproduced, stored in retreival system, or transmitted in any form,
by any means, mechanical, electronic, photocopying, recording or otherwise, without the written permission of the publisher.

ISBN 979-8-9885329-2-7 PRINTED IN CHINA | Asia Pacific Offset

Next in the *ON RECORD* book series

Vol.10 1983

ON RECORD 1983

IMAGES, INTERVIEWS & INSIGHTS FROM THE YEAR IN MUSIC > G. BROWN